DATE DUE

JA 8 '93		
MY 27'94		
MR 17 '95		
NO 1 '96		
AP 7'97		
AP 29'97		
JY 14 97		
NO2 9 99		
NV 26 0		
DE 5 02		
DE 21 02		
MY 30 07		

DEMCO 38-296

TOULOUSE-LAUTREC

San Diego Museum of Art

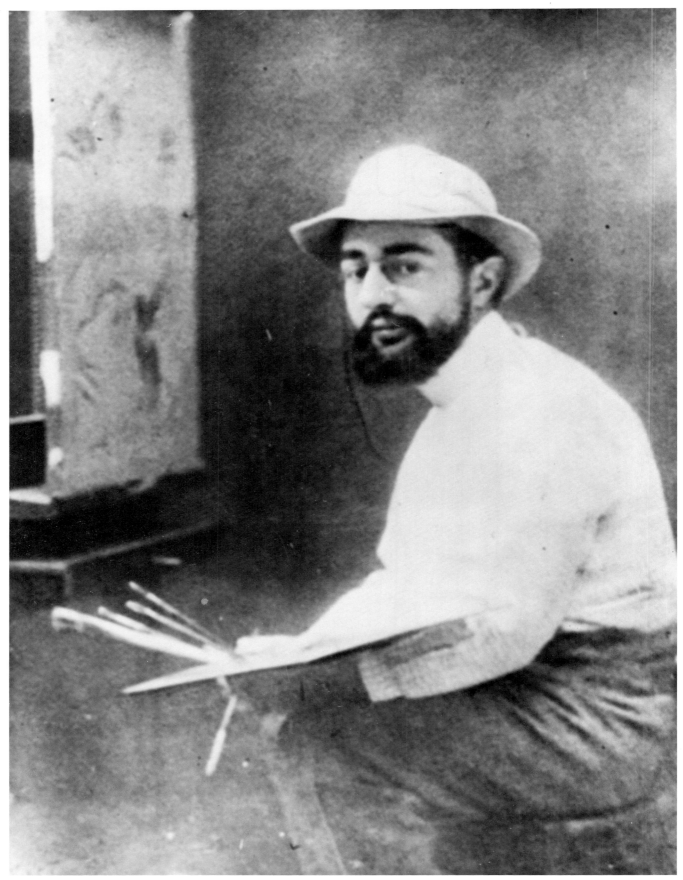

Posed studio portrait of Toulouse-Lautrec, c. 1889, signed Provost. (Photo: Musée Toulouse-Lautrec, Albi)

TOULOUSE-LAUTREC

The Baldwin M. Baldwin Collection
San Diego Museum of Art

Nora Desloge
Curator of European Art

With essays by

Phillip Dennis Cate
Director
The Jane Voorhees Zimmerli Art Museum
Rutgers, The State University of New Jersey

Julia Frey
Associate Professor
Department of French and Italian
University of Colorado at Boulder

Distributed by the University of Washington Press Seattle and London

**Exhibition at the
San Diego Museum of Art,
October 15–December 31, 1988**

Design: David Alcorn
 Visual Communications
Editing: Dagmar Grimm
Typography: Central Graphics
Separations and Lithography:
 Frye and Smith
Photography: Philipp Scholz Rittermann

Publication production coordinated by
David Hewitt, Head of Publications and
Sales, San Diego Museum of Art.

Library of Congress catalog card
number 88-062438
ISBN 0-937108-07-3
Second edition
© 1989 San Diego Museum of Art

Contents

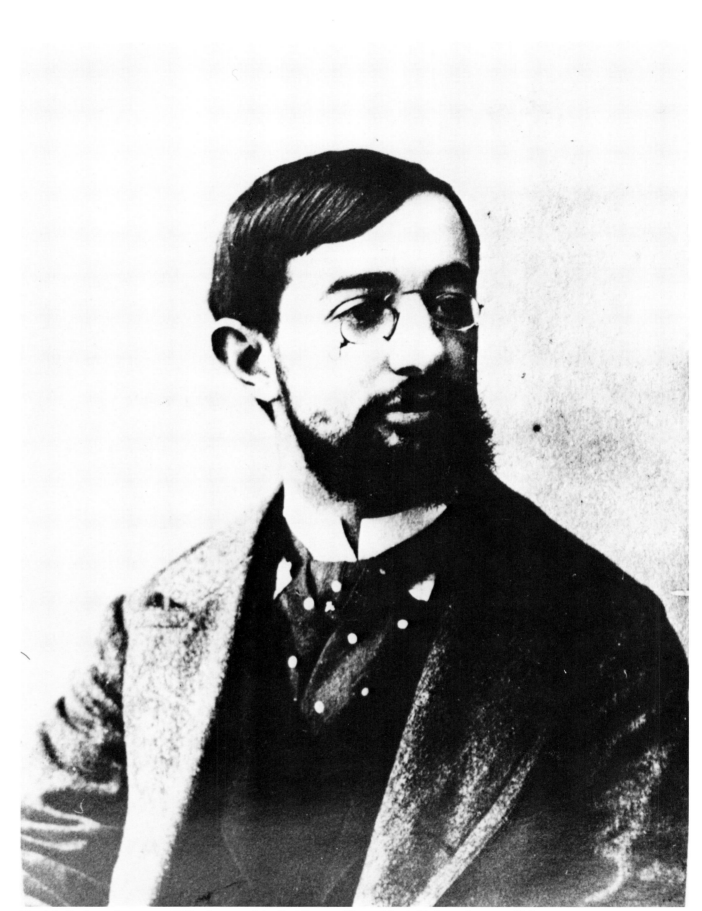

Henri de Toulouse-Lautrec, c. 1892, photograph by Paul Sescau. (Photo: Musée Toulouse-Lautrec, Albi)

Preface

On behalf of the Board of Trustees of the San Diego Museum of Art, I wish to express our gratitude and enthusiasm for one of the most important donations in our institution's history. In 1987 the Museum received from the Baldwin M. Baldwin Foundation a large collection of works by Henri de Toulouse-Lautrec. Twice during the past two decades we have had the opportunity to exhibit this collection, and it is with a great deal of pride that we present the exhibition today as part of our permanent holdings.

Maruja Baldwin Hodges *is* the Baldwin Foundation, and it was her decision to select San Diego as the steward of these important works of art, a choice with which we are, of course, delighted. We thank Mrs. Hodges for this valuable contribution to us and to future generations who will inherit the benefits of her gift.

The Baldwin Collection will bring pleasure to those who know and love fine prints. It is also a resource for all of us who find that looking at art affects the way we perceive ourselves and our fellows. The broad concerns of Toulouse-Lautrec's art — frivolity, human interaction on all fronts, the panorama of urban life and its accompanying emotions — are still valid today. More than most artists, Lautrec speaks our language, and we offer our thanks to Maruja Baldwin Hodges for the opportunity of this dialogue.

Joseph W. Hibben
President
San Diego Museum of Art

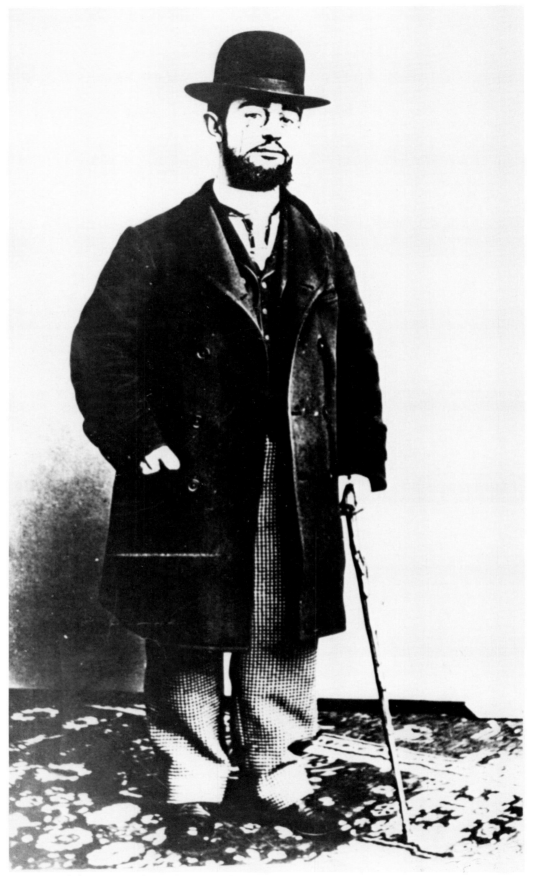

Lautrec, with his cane, c. 1892. (Photo: Musée de Toulouse-Lautrec, Albi)

Foreword

It was, for many, the best of times—an era when the fundamental character of the future sprang forth into the daily lives of people who had, only fifty years earlier, existed in almost medieval conditions. The 1880s and 1890s saw the first rewards of the modern industrialized world in mass-produced abundance. It was the era of "more"—more bread and wine, more newspapers and books, more textiles and fashionable garments, and opportunities for modish extravagance. There were more places to go—music halls and vaudeville shows and popular entertainment at the circus, the race tracks, and brothels; more fun to be had and pipers to pay.

The *fin de siècle* brought the dawning of a new age and a new attitude toward life in France. It was an era when the differences between a once strictly stratified social order dissipated and the mores, social customs and expectations of the citizenry grew more similar. And it was as some social historians have characterized it, the dawning of the age of material novelties, heard in the clatter of the telegraph and the jingle of the telephone, the cacophony of the first mass-produced typewriters, and experienced in the eerie sense of ascent on the first elevator rides, the dazzling aura of the electric light, and the new, democratic mobility of the bicycle.

Popular reaction to these overwhelming changes set the optimistic character of the times. Most people held the very real expectation that they could accede to these new advantages and, through a process often tumultuous and galvanizing, their right to do so was henceforth assured. The burgeoning new middle class finally not only had a voice and a visible presence, but also reaped the rewards of their economic impact. Nowhere was their presence more apparent than in the increased desire for popular entertainment, which in only the recent past had been limited by the paucity of consumable material and scarce leisure time in which to indulge. Now, the environment exploded into one of dazzling images and countless affordable spectacles—brightly rendered in posters, gaudy calendars, riveting advertisements, all catching the attention of the passerby at a glance.

Lautrec's graphic works represent the heart and soul of this era. Bold, lucid and profane, they captured the passionate vitality of Paris in a celebration of time and place synonymous with *joie de vivre* and prosperity. The works are a pastiche of the symbols and personalities that invigorated the epoch with a spirit which, even to the contemporary mind, suggests a ribald and refreshing commemoration of good times, bountiful revelry, and the *beau geste*.

The Baldwin Collection is distinguished by eight drawings, two paintings and eighty five lithographs, including all of Lautrec's posters. A meticulously assembled selection, it is highlighted by a particularly fine, complete set of the *Elles* series. The great monuments of Lautrec's graphic art are represented with remarkable examples including the four renowned Aristide Bruant images and the poster which has become a benchmark for the monumental poster: the *Moulin Rouge*. It is in short, a magnificent collection which reflects both the energy and connoisseurship of its donor.

The relationship between the museum and the Baldwin Foundation has been a long and rewarding one. Since 1972, when the museum first presented the collection to a hugely enthusiastic public, through more than a decade of support and encouragement from the Foundation's president, Maruja Baldwin Hodges, the museum and community have benefitted greatly from the association. The donation of the collection culminates fifteen years of collaboration and friendship which is celebrated in this exhibition, and we are deeply indebted to the good will and generosity of Mrs. Hodges for all that follows.

The museum has also been the recipient, once again, of generous support from The Allied-Signal West Foundation, and we are extremely grateful for such committed, long-term corporate largesse.

Steven L. Brezzo
Director
San Diego Museum of Art

9

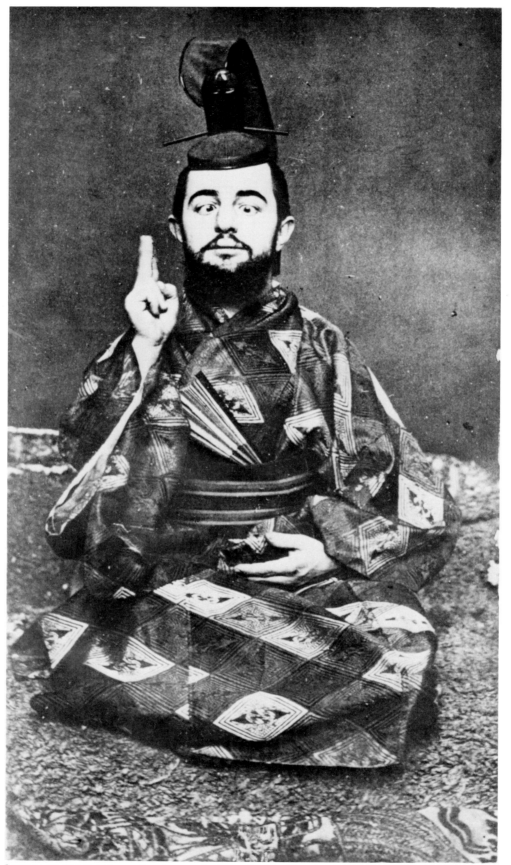

Lautrec posing in a samurai costume, photographed by Maurice Guibert, c. 1892.
(Photo: Bibliothèque Nationale, Paris)

Introduction
Nora Desloge

The Baldwin M. Baldwin Collection represents ninety-five drawings, paintings, and prints which chart the extraordinary life and art of Henri de Toulouse-Lautrec. Its range spans the whole of Lautrec's creative chronology, from drawings made during the early days in Paris to lithographs and posters from the years just before his death in 1901. Two paintings separated by a decade reveal not only the differences in Lautrec's early and mature styles but also his varying modes of spontaneous sketch and formally composed study. Many of the artist's best-known subjects, the personalities depicted in the posters for example, provide a familiar backdrop to several very rare lithographs, and among the posters themselves, the Baldwin Collection represents examples not often found in public or private holdings. This primary collection has been supplemented with fourteen other works owned by the museum to create an exhibition drawn entirely from the permanent collections of the San Diego Museum of Art.

Toulouse-Lautrec (1864-1901) lived during the height of what have been called "the banquet years" of Paris[1] — the fat years of leisure when the city and her inhabitants shook off the last lingering vestiges of the Empire's rituals and took up ways of behaving, thinking, playing and perceiving that begot the twentieth century before its time. Looking at Lautrec's art, it is sometimes difficult to realize that the year of his birth was bounded on either side by Delacroix's death and Abraham Lincoln's assassination, while one of his subjects (the actress Cléo de Mérode, cat. no. 71) died only in 1966. He thus appears to us as chronologically ambivalent, belonging to the nineteenth century yet reaching into the twentieth. Had he lived beyond his thirty-seven years, we might have claimed him as one of *our* modern artists. Indeed, his visual perspective and themes inform the art of Picasso and Matisse, and his openness to media outside the "major" art forms of painting and sculpture seems as close to modern esthetics as to those of Art Nouveau. He consistently elected to portray the most contemporary aspects of his times, and although we may be nostalgic for "the good old days" of the gay nineties, Lautrec's interpretation of them is defiantly unsentimental. His objectivity often anticipates twentieth-century disillusionment.

Lautrec was socially outlandish. Along with van Gogh, he is perhaps the most memorable artistic character since Rembrandt, a status recognized years ago by novelists and the film industry, and one which contributes to the continuing stereotype of the modern artist as an anti-establishment bohemian.[2] However, the popular mystique of his revolt against social conventions, which casts him as a drunken pleasure-seeker, tends to obscure the significance of his parallel revolt against artistic conventionalism, begun early in his career and carried out with sober determination in the 1890s.

In 1884, when Lautrec was just nineteen, his fellow students staged an "insurrection" against their academic master, Fernand Cormon. Henri joined them, at least in principle.

At the Atelier [wrote his colleague, François Gauzi] Lautrec shows disdain for the subject-matter recommended by Cormon, themes chosen from the Bible, mythology, and history. He considers that the Greeks ought to be left to the Pantheon and firemen's helmets to David. He derides painters [who are] obsessed by the technicalities of their profession He loathes gloss[3]

Lautrec's pedagogical revolt was part of a larger, well-established revolution, and although he brought his own waggish ways to Montmartre, he entered an art scene that for two decades had been rebelliously anti-academic: The 1863 exhibition of Manet's "scandalous" *Déjeuner sur l'herbe* in the Salon des Refusés set the precedent for the vanguard's assault on the enemy, the official Salon. A biennial juried exhibition controlled by the Academy of Fine Arts, which had reigned over the fate of artists since David, the Salon enforced all that Lautrec objected to at Atelier Cormon (fig. 1). But despite the frustrations and hardships it imposed (see cat. no. 106), this barricade of academic despotism provided enough of a common focus to rally a group of artists, disparagingly dubbed "the Impressionists," in eight anti-establishment exhibitions held from 1874-86.

Lautrec belonged to the younger generation of rebels (his hero Edgar Degas was thirty years his senior). Not being Impressionists, the members of this group formed their own Society of Independent Artists in 1884 (exactly when Lautrec was testing his wings at Cormon's) and staged the first jury-free Salon des Indépendants in 1886, coinciding with the last Impressionist exhibition.[4] The new generation's artistic heterodoxy and continuing stance against the Academy is perhaps better expressed in the name, "Independents", than the purely chronological label, "Post-Impressionists." Lautrec indeed was independent, and, although he worked parallel to the many new "isms" of the late 'eighties and 'nineties, he never joined them, maintaining a position similar to van Gogh in Arles or Cézanne in Aix but a physical location in the thick of the Paris fray.

His recognized career began in 1888-91, years which saw the 1889 opening of the Paris World's Fair, lighted by electricity and landmarked by the just-completed Eiffel Tower; the informal founding of the Nabis by Maurice Denis, Vuillard, Sérusier, and Bonnard; the principles of divisionism established by Seurat and Signac; the flourishing of *japonisme* and other new interests in non-western culture stimulated by the fair; the opening of the Moulin Rouge in 1889; Erik Satie hired as piano player at the café Le Chat Noir (three years *after* he had composed the *Gymnopédies*); Aristide Bruant's ascendancy to notoriety; the Louvre's rejection of Manet's *Olympia* (not accepted until 1907); van Gogh's suicide in 1890 (Lautrec had known him as a fellow student in 1886-87); Gauguin's "schools" at Pont-Aven and Le Pouldu, and his flight to Tahiti in 1891; the consolidation of the Symbolists in art (Redon), music

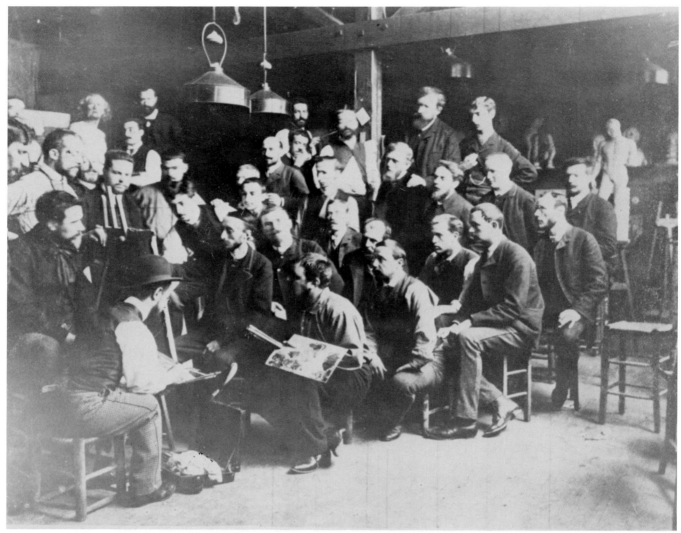

Fig. 1. Fernand Cormon, center, in annual studio portrait with students, c. 1883. Lautrec is seated, front left. (Photo: Musée Toulouse-Lautrec, Albi)

(Debussy), and literature (Mallarmé, Verlaine, et al.); anarchist bombings protesting against the government; and the continuing sallies against the Academy by the Incohérents (an "anything goes" group as the name implies),[5] the Indépendants, and their newly founded journalistic mouthpieces.

These myriad events and non-events, but a few which enveloped Lautrec's artistic beginnings, were perceived through the kaleidoscope of Paris itself, a whirling panorama of bicycles, the odd motor car, horseraces, carriages parading the *haute-* and *demi-monde*; restaurants and bars which served the potent new "American cocktails;" music halls, immense public ballrooms and dances of such kicks and gyrations that a "master of morals" was employed to watch for indecent exposure. Scandalous fashions, books, and brothels made their debuts along with new plays and stage personalities (Oscar Wilde, Ibsen, Sarah Bernhardt and Yvette Guilbert), new music, ranging from Satie to Bruant, and new art of such disparate ends as Henri Rousseau and Henri de Toulouse-Lautrec.

From this banquet of Paris, multiplicitous and unstructured, Lautrec derived the primary themes of his work and also found enough personal and professional freedom to sustain his eccentric lifestyle and artistic irreverence. From 1889 he exhibited almost every year in the Salon des Indépendants and other avant-garde exhibitions held in Paris and Brussels, taking part in the group stance against the Academy. Since the first Impressionist exhibition in 1874, these "rogue salons" had been the avant-garde's primary vehicle of reaching the public and critics.[6] However, Lautrec also launched his work into other arenas of high visibility by embracing the printing industry. He continued to paint but took up lithography, virtually revolutionizing color lithography and graphic design. His work was published in news and intellectual journals, and his posters were plastered on the walls of Paris, exhibited in the "salon of the streets."

He was serious about printmaking in the old tradition of the *peintre-graveur* and considered it no less a part of his oeuvre than the "fine art" of painting. For each of the major lithographs there exist numbers of preparatory drawings and oil sketches, demonstrating the subsidiary position painting sometimes held for him and the real *work* which he invested toward the brilliant results he achieved.[7] He was remarkably open to the unorthodox types of commissions which his graphic success won him, illustrating songs for music publishers, menus for friends, theatre programs, and accepting

consignments to make advertising posters for books, journals, plays, art exhibitions, café and theatre stars, and such banal products as domestic furnishings, confetti, printing ink, and bicycle chains.

Although his lithographs were put to commercial purposes, Lautrec created, published, and exhibited them as legitimate works of art, and they received serious critical attention as such (see cat. no. 82). He further maintained an artistic autonomy by distancing his imagery from the product advertised: *Irish and American Bar* (cat. no. 97) and *La Revue blanche* (cat. no. 94), for example, publicize magazines; *The Passenger of Cabin 54* (cat. no. 99) was used as an exhibition poster and *At the Concert* (cat. no. 107), as an advertisement for printers' ink. By avoiding the illustrative, he also avoided pandering flattery, maintaining his own acuity, despite its sometimes offensive characterizations which resulted in personal and journalistic criticism of his depictions as "ugly" (for example, the café performer Yvette Guilbert, cat. nos. 38, 40).

The iconographic and stylistic independence of his printed works (and here we might remember the label "Indépendant") is matched by the novel venues in which they were exhibited. More than the works of his contemporaries or even his own paintings which were presented at the various salons, Lautrec's posters and lithographs, as art which touched the public's everyday lives, were a persistently present form of anti-academic propaganda. By taking his work to the street, he engaged in a subtle but classic form of anarchism, perhaps a forum of revolt more real than the avant-garde salons ever were.

Lautrec's financial independence would have allowed him the freedom *not* to pursue populist avenues of visibility; he could have retreated into comfortable aristocratic bohemianism. That he consistently produced (368 prints in comparison with Degas' 66), readily accepted commissions, and actively sought the sale, publication, and display of his graphic work marks him as a determined activist in all manifest aspects of art production. The substance of his art, however, is quite another precinct, and here he functioned as a true, creative artist, without the slightest hint of propaganda or self-promotion, perceiving and portraying his subjects with an independence of vision and hand which ran far deeper than that of any esthetic cause (cat. no. 99).

Of the themes which fascinated Lautrec only a few are missing from the Baldwin Collection: erotica and self-portraits which were recorded in caricature drawings, and portraiture outside the pointed characterizations of friends and performers who populate compositions of narrative, humorous, or promotional purposes throughout the collection. People were his subject. He painted only three still lifes, as a student, and radically differed from the Impressionists, Symbolists, and Divisionists in his attitude toward landscape. "Nothing exists but the figure," he told his friend and dealer, Maurice Joyant, in 1896, ". . . landscape is nothing, and should be nothing, but an accessory If Monet had not given up figure painting, what might he not have accomplished."[8] Lautrec's vistas were urban, primarily the interior of Paris at night in bars and cabarets, theatres, and brothels—a topography of dance floor, stage, box seats, lounge, and bedclothes. Footlights, gas lamps, and the glare of new electric bulbs were his sun, and he developed a remarkable range of colors, tones, and techniques to depict this artificially lit world. When subjects do involve the out-of-doors, they are set at night or in abbreviated streets.[9] Only in sporting subjects (cat. nos. 77, 105) is there any expanse of land, and then it serves merely as a *mis en scène*.

Only once did Lautrec treat an historical theme, in the lithograph *Napoleon* (cat. no. 46), and just twice do we see his nod to social realism, in the posters *At the Foot of the Gallows* and *L'Aube* (cat. nos. 87, 102). The Academy would have classified his primary themes as genre, while progressive critics such as Gustave Geffroy, Roger-Marx and Octave Mirbeau extolled them as "modern life" in the tradition of Baudelaire, Zola, Manet, the Goncourts, Huysmann, and Degas. Drawn from the exuberant café society (fig. 2), the theatre, circus, brothels or the *demi-monde*, and to a lesser extent the street life and sporting events of Paris, the themes of Lautrec's lithographs and posters are narrowly circumscribed within the leisure pursuits of Paris and fall within the subjects explored by Constantine Guys and Paul Gavarni, Manet and Degas, Jean-Louis Forain, Emile Bernard and others. His iconography is unique only in its particular humor (ranging from the licentious to the comic) or pungent characterization, its candor or the visual punch of its pictorial transcription. In this he is distinctive beyond his predecessors or peers, and his work is immediately recognizable as his own. The Baldwin Collection reveals the full range of Lautrec's expressive innovations in works which are landmarks of his art and of the history of printmaking.

Julia Frey's catalogue essay on the artist brings to these works of art the rich biographical texture of which they are composed. More than most artists, Lautrec left traces of himself—his family, friends, and daily activities, his physical and psychological surroundings—which are congruent with the lines he drew on the lithographic stone. In similar proximity to his art were the particular environs and perspectives shared by the avant-garde from Manet to Picasso, and Dennis Cate's essay locates the imagery of the exhibition within the circuses and cafés and brothels which formed the landscape of Lautrec's Paris. These institutions of leisure were his social haunts where he also found his thematic and expressive bearings. The last essay examines Lautrec's lithographs with an eye to the stuff of their making that is still visible today. While the images themselves are the point, paper, stamps, and other marks of the prints' physical composition, execution, distribution, and use are residues of their technical histories. These subsidiary aspects provide discrete sources of information, and perhaps of added enjoyment. The final catalogue section is arranged chronologically and by media, and comments on subject matter, style, or technique. This section is intended primarily as a guide to Lautrec's visual vocabulary, which is universally perceptible on one level, but specific to his era in its details. Whenever possible, people, publications, locations, and purposes related to each work are noted.

In recent years, an immense amount of Lautrec material has been published, including the 1985 catalogue raisonné of prints by Wolfgang Wittrock and several important exhibition catalogues to which both Frey and Cate have contributed. Our intentions therefore are to bring to bear on the Baldwin Collection specifically, information which will add to understanding and enjoyment of the exhibition. Prior to its donation in 1987, the collection was featured by the museum as a temporary exhibition in 1972 and 1980, and Martin Petersen's cata-

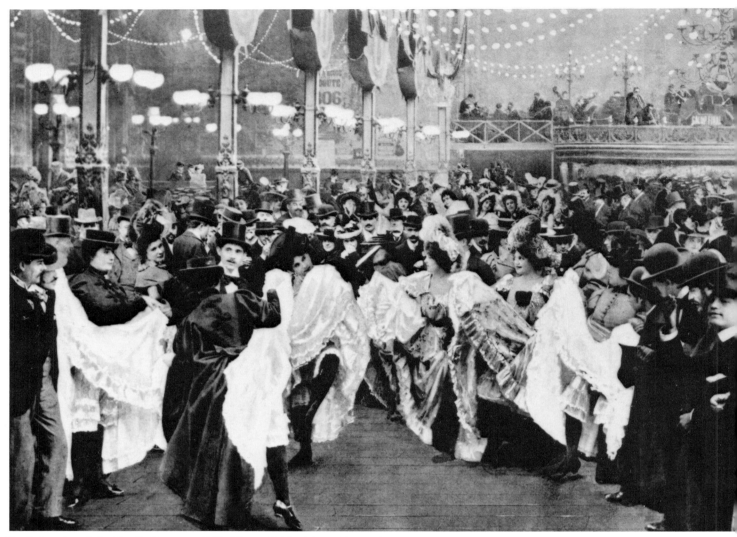

Fig. 2. Interior of the Moulin Rouge, c. 1895. (Photo: Bibliothèque Nationale, Paris)

logues of those exhibitions ably introduced visitors and the present authors to the works addressed here.

Many members of the museum staff have been involved in producing this exhibition, and I wish to extend special thanks to Anne Streicher, Assistant Registrar, for her superb management of the works of art during the several months and tasks of the exhibition's preparation. Sharon Childers' secretarial assistance was tireless and precise; she knows the exhibition by heart and by hand. David Hewitt, Head of Publications and Sales, guided the production of the catalogue with both forgiving patience and well-paced enthusiasm. Lucy Schwab, Exhibition Coordinator, arranged the exhibition's tour which she and Registrar Louis Goldich have overseen in its many details.

Several individuals have been more than generous with their time and knowledge, and I am especially grateful to Ruth Ziegler, Vice President, Department of Prints, Sotheby's New York; to Janis Ekdahl, Librarian, Museum of Modern Art, New York; to catalogue essayists Julia Frey and Phillip Dennis Cate, who contributed much more than their excellent texts to the exhibition; and to Robert E. Paige, whose love of prints is wonderfully contagious. Finally, the enthusiasm of Maruja Baldwin Hodges, warmly and graciously expressed at every turn, has made this exhibition a great pleasure to curate.

Toulouse-Lautrec has been a collaborative endeavor which could not have succeeded without the labors of love and otherwise contributed by the following individuals, each of whom deserves hearty thanks:

David Alcorn Graphic Designer
Michael Field Preparator
Mitchell Gaul Head of Design and Installation
Dagmar Grimm Editorial Consultant
Scot Jaffe Installation Supervisor
David Kencik Receptionist/Operator
Carmen Lacey Curatorial Secretary
Nancy Owens Graphic Designer
Daniel Ratcliff Assistant to the Registrar
Philipp Scholz Rittermann Photographer
Leah Roschke Graphic Designer
Mardi Snow Public Information Coordinator
Mary Stofflet Curator of Education

Nora Desloge

14

1. See Shattuck (1968), pp. 3-28.

2. For example, Pierre La Mure, *Moulin Rouge*, New York, 1950; and *Moulin Rouge*, 1952, with Jose Ferrer as Toulouse-Lautrec, directed by John Huston.

3. Quoted in Huisman and Dortu (1968), p. 62. See also Adriani (1987), p. 297, and Rewald (1978), p. 20.

4. See Martha Ward in Moffett (1986), pp. 422 ff.

5. Cate (1985), p. 15.

6. Moffett (1986), p. 21.

7. More than 250 of the almost 1,900 drawings and paintings which Lautrec made between 1892 and 1900 are preparatory studies for lithographs. Adriani (1987), p.145.

8. Quoted in Mack (1953), p. 58.

9. For example, *Shooting Stars* (cat. no. 45), *The Alarm Bell* (cat. no. 98) or *Babylon of Germany* (cat. no. 91) and *L'Aube* (cat. no. 102).

Lautrec, around age thirty, c. 1896. (Photo: Musée Toulouse-Lautrec, Albi)

Henri de Toulouse-Lautrec:
Life as Art

Julia Frey

"I have two lives," Lautrec said to his friend Thadée Natanson. One of them, his life in the theatres, sports arenas, cabarets, dance halls and brothels of Paris is the primary subject of the works in this exhibition. These are the works which have made his reputation and the reputation of a whole era—the Belle Époque—whose superficial gaiety, high living and hypocrisy are belied by the grey underpinnings of poverty, crime and exploitation which often show in his art.

His other life, as the only surviving son of the count of Toulouse-Lautrec, in tight conflict with his wealthy noble family, was equally if not more important to him. He would leave his grubby studio in Paris to visit huge provincial estates where he was surrounded by grandparents, cousins, horses, and dogs, and adored and dominated by a rigidly Catholic mother. Both lives, so diametrically opposed, are the constant subject of his work.

The life he portrayed in his prints and posters—the most public forms of his art—was a life his family deplored, and would have liked him to keep secret. They longed to rescue him from his preferred milieu, to lure him back from the dangerous influences of the underworld of artists, cabaret singers and Jewish intellectuals he had chosen for company. To insist on making this world public—publishing a series of lithographs done in brothels, for instance (cf. *Elles*, cat. nos. 49-61) was to thumb his nose at his family's conservatism and snobbishness. And yet he spent most of his free time with his mother and two cousins who also lived in Paris: Louis Pascal and Gabriel Tapié de Céleyran. Although he often did portraits of family members, his works showing them utilize more intimate, individual art forms—drawing and painting.

All his work, even pieces identified with storylines or intended to illustrate specific literary texts, depicts people and places he actually knew. It invariably reflects his preoccupations of the moment, and in that sense is autobiographical. If we could reconstitute the entire body of his work, and accurately place it in chronological order, we would have a day-by-day visual diary of the places he went and the people he saw. Even incomplete and ill-dated as we know it today, his work, in addition to its purely artistic value, is an invaluable historical document not only of the artist's own life, but of the special world he lived in—Belle Époque Paris and the nocturnal haunts of the butte Montmartre.

Lautrec lived just under thirty-seven years, his adulthood marred by physical handicaps, alcoholism and illness. In this short life he produced a phenomenal quantity of work. The 1971 catalogue raisonné of his oeuvre, which even before its publication was recognized as incomplete, listed 737 canvases, 275 watercolors, 368 prints and posters, and 4,784 drawings, not including lost works; an occasional sculpture, ceramic or stained-glass window; and about 300 erotic and pornographic works. He sketched constantly, often in a series of tiny notebooks he pulled out of his pocket at a dinner or in a *café concert*, sometimes even on napkins and tablecloths. At least one drawing still exists which was done with a burnt match. A friend commented that as he was often drunk, these notebooks were sometimes left behind, forgotten in the move to the next party, the next drink.

Such losses were common, for Lautrec had a paradoxical relation to his art. He was intensely involved in its actual production, repeating certain shapes and images over and over, tracing significant lines, personally verifying the accuracy of colors and the definition of blacks when works were being printed. And yet, if a model quit or a prop disappeared, he would set an unfinished canvas aside and completely ignore it. Once the moment was past or the work was completed, although he could be compulsive about the conditions under which it was to be reproduced or sold, he no longer seemed to value the work itself. Thus he drew and painted on highly destructible materials— cardboard, cheap paper, unprepared canvas or whatever came to hand, and on at least one occasion, he abandoned some eighty-seven canvases in a studio when he moved out, apparently unconcerned that they might subsequently be used as kindling or to plug holes in a leaky roof.

An odd neglect has surrounded critical study of Lautrec until very recently. Because he was not a theorist and belonged to no school, because he culled techniques that suited him from Impressionism as well as academic painting, from Japanese prints and Cloisonism as well as social caricature, he has been difficult to classify. In addition, Lautrec's subject matter is controversial to the point of being scandalous. Art historians, a notoriously well-bred bunch, have tended to fix on other artists. But Lautrec was no artistic lightweight. The very mass of his production over such a short lifespan shows that he must have worked continuously, even obsessively, sick or well, drunk or sober, alone or in public.

The Artist's Day

Letters and contemporary accounts have left a vivid portrait of Lautrec's days. He generally did not live in his studios, but in an apartment nearby—often with a friend. Profoundly lonely, he surrounded himself continuously with people. Hours of every day were spent with others partying, eating, drinking, going on wild excursions, taking the train to the country, sailing, or merely doing the rounds of the nightspots of Montmartre.

He got up late, usually with a hangover, and set out before lunch to do the official business of the day: dealing with printers and publishers, gallery owners and newspapers. He habitually finished the morning verifying the colors of ink to be used on the lithographic stones which later would be printed by Stern, his trusted printer, close friend and drinking partner. Often the two of them went to lunch together in a small neighborhood bistro, consuming substantial quantities of wine. After lunch, to recuperate, Lautrec took a nap in his

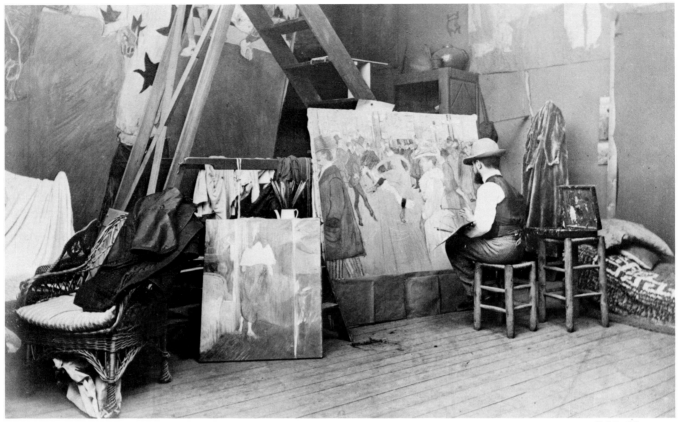

Fig. 3. Toulouse-Lautrec painting in his studio at 27 rue Caulaincourt (with missing circus paintings), c. 1891. (Photo: Biblothèque Nationale, Paris)

studio. Then, for three or four hours he did the true labor of his art, painting, drawing on lithographic stones which he had brought, prepared, to his studio, or reworking various projects until time for the before-dinner aperitif. He seemed to like having visitors at the studio, and would show his work to friends, family members and strangers alike, using their visits as an excuse to stop working to prepare his own versions of "American cocktails" which he manufactured at his "bar" — a rectangular marble-topped café table he had set up at one end of the studio. These drinks were famous for their exoticism and their potency. A friend reported that on one occasion Lautrec served him a "solid cocktail" — a revolting mix of vodka and sardines.

His studio was described by visitors as messy, dirty, and thick with dust, for although he had a maid to do the shopping and light the fire, she was forbidden to touch or move anything. It had a huge fifteenth-century oak coffer, dumbbells to strengthen his arms, artist's equipment, costumes, and hardly any place to sit. There were just two stools, a divan, and a couple of wicker garden chairs. He had made some eccentric attempts at English-style decor, inspired by trips to England. He had ". . . furniture from Maple's . . . stiff, cold, without decoration," but which stood out by ". . . the beauty of its material, the fineness of the grain, the faultless workmanship." To dress up the mattress he kept directly on the floor, Lautrec had covered it with material from Liberty's, the famous London dry-goods store, and a bearskin instead of an eiderdown.[1]

The studio revealed much about his interests, habits and state of mind. Near his easels, away from the "cocktail bar" was another marble-topped café table with wrought-iron legs. It was cluttered with empty drinking glasses, dried-up paint cups, and an accumulation of curious objects: a Japanese wig, a ballet slipper, a woman's high-buttoned shoe, photographs, the score to a popular song, reproductions of classic art works. All over his studios such items were hanging on the walls and lying on the floor — he was an inveterate collector, and anything which interested him was squirreled away.

There was a platform for posing models and a stepladder he used in the 1890s to reach large canvases (fig. 3). Cardboard portfolios full of prints were stacked around. Lithographic stones lay on the floor. His paintings were not only hanging on the walls but also standing upright on the floor, against the wall. He worked most frequently when painting at a conventional easel sitting on a low stool, but had a large table for spreading out lithographic stones, which he worked flat.

At the end of the day, Lautrec left his studio for an aperitif. For many years he took a carriage to the fashionable "Chez Achille" whose official name was the Irish and American Bar, in the rue Royale (cat. no. 96), where he held court. There he would meet people for business purposes, and be found by friends who dropped in, at times tyranically deciding who could and couldn't be served by "Ralf" (Ralph), the bartender. The bar was like his own private salon.

For dinner, he almost always went to his mother's apartment, a spacious, high-ceilinged, bourgeois foothold at 9, rue de Douai, which she had rented in Paris in 1883, to be close to her son, whose studios were always in Montmartre. A relative described this apartment as being at the extreme limit of a

neighborhood "where she could decently live," and it is certain that she felt the barrier between her world and the world her son inhabited. Only he went freely back and forth between the two existences (fig. 4).

When he left her after dinner, it was to return to his other world—the night world of Montmartre, making the round of his favorite bars, dance halls and cabarets, often until dawn.

Living as a Legend

Lautrec's life story is full of legendary acts and anecdotes. It is frequently hard to decipher the truth— particularly since he himself promoted the stories and myths which created his personage—his public personality. To read this life story is to accept that while some facts are clearly known, and others are portrayed in his work, the legends also have their place—for he wanted them there. He always said, for instance, that his artistic vocation appeared early, at the christening of his brother Richard, when Lautrec was two. Barely able to toddle, he noticed that all the guests were signing the register as they left the ceremony, and insisted on signing too. When his mother, who had a sense of humor, pointed out to him that he didn't yet know how to write, he responded. "That doesn't matter, I'll draw an ox." The fine points of the story have been contested by surviving members of his family. The incident, it appears, really happened nearly a year later, at the christening of a cousin. But the facts are unimportant. It is interesting that for Lautrec the moment was significant enough to recount many times.

Lautrec liked to provoke legends as well as re-tell them. In accounts by his contemporaries, exactly the same anecdote is told by different persons as having happened to them on separate occasions. Finally a pattern appears: Lautrec, once he had discovered a gesture which appeared to him to be particularly poignant, repeated it over and over. In one example, he would mysteriously lead friends through myriad backstreets, into a sordid doorway and up a black staircase to the fifth floor, where he knocked on a low door. The door was always opened by a stooped, very wrinkled old woman, nearly bald. With infinite politeness, Lautrec would offer her a box of candy and introduce her to her visitors: "This is Victorine Meurant, the model for Manet's *Olympia*."

Repetition is characteristic of Lautrec. He repeated stories, acts, images. He is said to have gone twenty nights in a row to see Marcelle Lender dance the bolero in the comic opera *Chilpéric*, because, as he explained, she had a beautiful back. He had a series of "furias" as he called them—passionate attractions to a person, place or activity—which would dominate his life and art for a time, and just as suddenly disappear. "Nouveau guitare" ("new guitar") he would comment, as he turned to something else, an expression from his own particular vocabulary which meant, "I need a change."

The Aristocrat

What elements formed this man, this paradoxical character who was to become one of the greatest artists of his time? Lautrec was born before dawn during a violent thunderstorm, on November 24, 1864, in one of the bedrooms of the Hôtel du Bosc in Albi, fifty miles north of Toulouse. His mother had gone to this large townhouse, one of the many properties owned by the combined families of his grandparents, to bear the first child of the new generation, attended by her mother and her mother-in-law who, as it happened, were sisters.

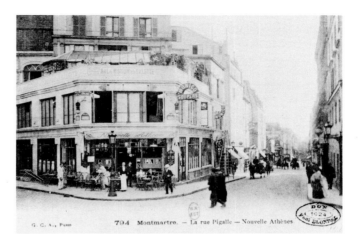

Fig. 4 . Montmartre, rue Pigalle, c. 1900. The café La Nouvelle Athènes was mid-way between Lautrec's last studio at 15, avenue Frochot and his mother's apartment in the rue de Douai. He was a regular there, along with other writers and artists, including Renoir, Monet, Zola, Verlaine and others. In the early 1890s, Erik Satie was the piano player there.

Christened Henri Marie Raymond de Toulouse-Lautrec Montfa,[2] Lautrec was the eldest son of an eldest son. Although he was trained from childhood to be the count of Toulouse-Lautrec someday, he would never bear the title. His father outlived him by a dozen years.

His family, part of a lengthy tradition of deeply conservative, profoundly Catholic, totally unregenerate monarchists, even seventy-five years after the French Revolution, was still hoping the rightful king (Henry V, Comte de Chambord) would be returned to the throne of France. For the Toulouse-Lautrecs, nobility was ordained by birth, not by acts. They spelled their son's name Henry, in honor of their king in exile.

Lautrec's family was very wealthy, so wealthy that one of the legends prevalent in his childhood was that they had a "chest full of money" into which they dipped at will. However, his mother was oddly thrifty, systematically underpaying her servants and complaining about the cost of hiring carriages. When her father-in-law died, she sold a new raincoat to a friend before buying a black one for the period of mourning. As an adult, Lautrec received a middle-sized but not extravagant annual allowance from his family—the equivalent of about $45,000 in 1988. Among Montmartre artists this was not unusual. They were often the sons of wealthy families. His friend René Grenier received substantially more.

Perhaps because his parents got on so badly that they chose not to live together, Lautrec never had one home he could consider his own. He spent his entire childhood traveling from chateau to spa to palatial townhouse. Life was spent in seasons, the winter in Nice or Paris or at his father's hunting lodge, the summer at one of his grandmothers' estates, usually at the whim of his mother.

He could not, however, have been called insecure. Greater than the security of a home was the security of being bound by a huge extended family and a vast and impressive heritage. His family was descended from a secondary branch of one of the oldest and most prestigious families in France, the Toulouse dynasty, which had ruled the regions of Toulouse and Aquitaine a thousand years before he was born. Through suc-

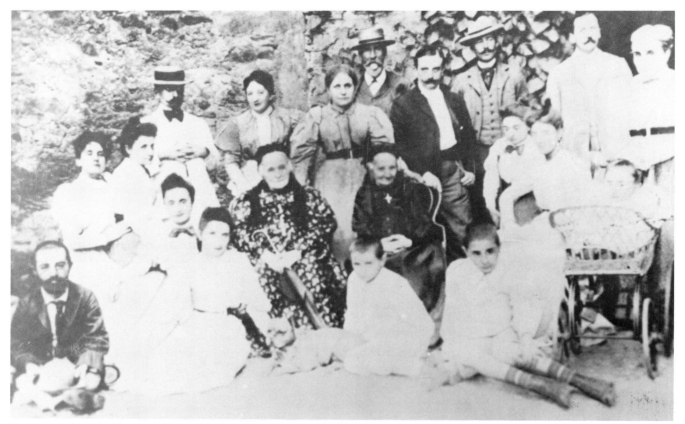

Fig. 5. Portrait of the Toulouse-Lautrec and Tapié de Céleyran families during a family reunion at the Chateau du Bosc in 1896. Lautrec is at left. Three dwarfed cousins are also visible in photo: "Bibou" (Geneviève), [third female from left], "Kiki" (Beatrix), [fourth female from right, with crutch under her right arm], and Fides, age 7, in large baby carriage on right. Toulouse-Lautrec's mother stands between his two grandmothers. (Photo: Musée Toulouse-Lautrec, Albi)

cessive generations his bloodline had produced a series of powerful leaders whose physical strength, mental energy, audacity, and violent ambition made one count of Toulouse after another famous throughout the land. These characteristics often created men who believed they were law unto themselves. Brothers attacked and killed brothers, warred relentlessly with neighbors, and struggled for continued independence from both king and pope. They conquered, stole, and sometimes purchased enough land to make them at one time the absolute rulers of the entire south of France.

By the time of Lautrec's birth, his immediate family had long been reduced to living much like everyone else. Their time was largely spent hunting and managing their provincial estates, making them closer in many ways to their farming neighbors than they were to royalty. However, they were profoundly snobbish, perhaps because they could no longer equal the glory of their forebears. Such "country gentlemen" are often pejoratively called *hobereaux*, a term originally referring to hunting with falcons. In fact, falconry, which was an unusual though not unknown sport in late nineteenth-century France, was the great passion of Lautrec's father, Alphonse de Toulouse-Lautrec. He maintained a visible nostalgia for the old life, before the counts of Toulouse had become subjects of the king of France. One Lautrec legend has him turning earnestly to an archbishop at dinner to say, "Ah, Monseigneur, the days are gone when the counts of Toulouse could sodomize a monk and hang him afterwards, if it so pleased them."[3]

None of the Toulouse-Lautrecs yet knew that their young heir bore another legacy. In families like his, intermarriage among

cousins was not uncommon. It resolved two aristocratic concerns: the danger of family wealth being dispersed, and the problem of finding a mate with a pedigree as illustrious as one's own. Lautrec's parents were first cousins. The subsequent marriage of his mother's brother with his father's sister produced a generation of children who inherited a recessive gene which, true to Mendelian law, struck one child in four. In the two families, a total of fifteen offspring survived infancy. Of these, four were dwarfed as adults, and another died at fifteen after several years of treatment for problems with her legs (fig. 5). In a family proud of its noble lineage, the presence of children with birth defects was not only a tragedy but also a humiliation. Nowhere in any of the family correspondence are such problems mentioned. The children are always referred to as fragile, or sickly, if their health is mentioned at all.

But Lautrec was the first child of the intermarriages, and no one suspected that he suffered from a genetic mishap. His smallness, health problems and "clumsiness" were quite honestly interpreted as individual incidents until he was around ten years old.

At that time, his mother made a momentous decision: she took him out of school and sent him to live in the house of a man named Verrier, in Neuilly, on the outskirts of Paris, for "treatments" for his legs. Although remaining documents are vague as to what these treatments may have been, the young Lautrec was forced to lie down several hours a day while he received them, and they did not hurt. It is perfectly imaginable that the intrepid Mr. Verrier tried to rectify Lautrec's growth problems by putting him in traction, stretching his legs with

pulleys and weights. In any case, Lautrec did not improve, and his mother finally was forced to admit that Verrier was quite possibly a charlatan. After nearly two years of almost constant immobilization, Lautrec began a series of visits to spas, where he was showered, dunked and forced to drink the sulphurous waters, all in the hopes that something might cure him.

The crisis of Lautrec's malady came when he was thirteen years old. He was very small, and his voice still had not changed. He already walked with a cane. He and both his parents were in Albi, spending the 1878 Easter holidays with his Uncle Charles and Aunt Emilie, Alphonse's brother and sister-in-law, when he slipped while using his cane to help push himself up out of a low chair. As his family rushed to pick him up from the waxed floor, they were astonished to realize that he had broken the strongest bone in the human skeleton: his femur. Although it healed in time, just over a year later he fell again, into a dry ditch about three feet deep, and this time the other thigh-bone broke. All long-bone growth stopped. He was just over four feet eleven inches tall. By the time he was sixteen, he no longer had long periods of great suffering as he had between the ages of eleven and fifteen, but he was permanently dwarfed, and the bone breaks had crippled him, so that as an adult he walked as infrequently as possible, in a kind of duck-like stagger (fig. 6).

Subsequent family accounts of his accidents were somewhat ambiguous. In a letter after his first fall, his mother tried to imply he had fallen off a high beam: ". . . I regret that my poor Henry ever happened to come across the beam. . . ."[4] Later stories about his short legs mentioned a fall from a horse, and an incompetent doctor who had set his legs so badly they had stopped growing.

Lautrec, however, made no attempt to hide what had happened, and readily admitted he had fallen off a chair. As an adult, he perversely took pains to explode his family's secrecy, making fun of his own hereditary malady. In one anecdote, two women in a café were having an argument about the pet bulldog belonging to one of the women. Her friend was claiming that the dog was so ugly it must be a mongrel. Exasperated, the dog's owner finally engaged Lautrec who, by chance, was seated next to them, to support her point of view: "Isn't it possible, Monsieur," she said, "for an animal to be a purebread and still be ugly?" "You're telling me!" he responded, rising on his crippled legs, and painfully hobbling out of the café.[5]

In some ways, Lautrec was fortunate to have lived his childhood as a "normal" child (fig. 7), for his personality had developed in an atmosphere where he was perceived as the leader of a veritable gang of cousins who all lived and played together for months every year. He was educated at home, by his mother and occasional tutors. As his brother Richard, mysteriously frail, had died in infancy, and his father only crossed his path a few times a year, the basic family unit was reduced to Lautrec and his mother, with whom he developed a love-hate relationship which was a continual source of conflict for him. He wrote tender letters to "Maman", but called her

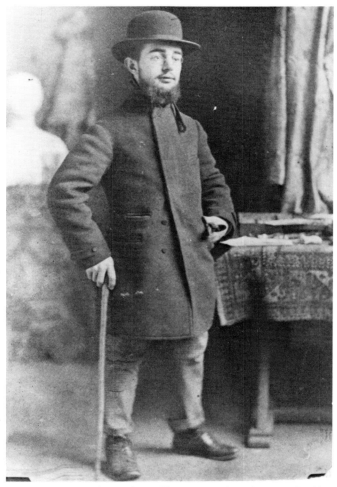

Fig. 6. Lautrec in the studio at Place Vintimille, photographed by Maurice Joyant, c. 1893. (Photo: Musée Toulouse-Lautrec, Albi)

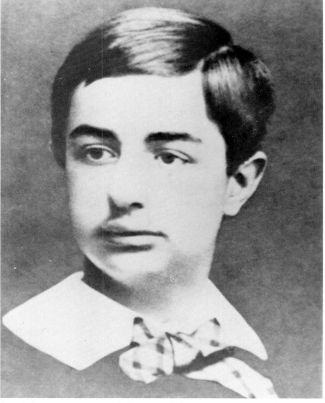

Fig. 7. Lautrec at around the age of thirteen, c. 1877. (Photo: Musée Toulouse-Lautrec, Albi)

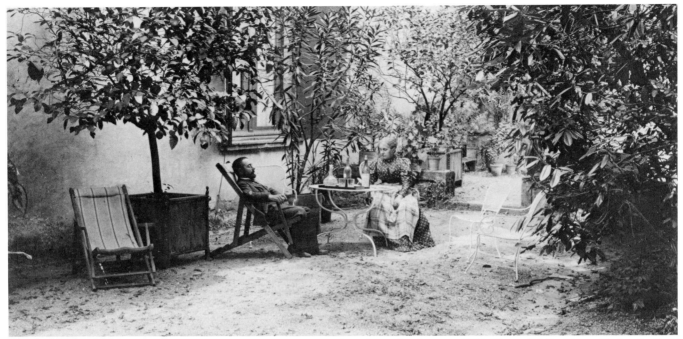

Fig. 8. Lautrec and his mother in the garden of her Chateau de Malromé near Bordeaux c. 1896.(Photo: Bibliothèque Nationale, Paris)

"Adèle" behind her back. He sometimes referred to her as "ma pauvre sainte femme de mère" (my poor sainted mother). This certainly was the role she defined for herself. Profoundly pious, she chose to be long-suffering, bearing her many burdens as a good Christian martyr. Left with only the one child for company, she served and protected him with well-meaning but iron-willed vigilance (fig. 8). Mother and son regularly slept in the same bed until Lautrec was eight or nine years old.

His father, whom everyone called Alph, was not only a superb athlete, but was reputed to be an incorrigible womanizer, favoring housemaids and peasant girls. He possessed the temperament of a minor Indian maharajah, using his unlimited wealth, boredom, and freedom from accountability as an excuse to be an outrageous eccentric. Alphonse's embarrassing tendency to appear in costume and behave in harmless but attention-getting ways may have had its source in a frustrated need to express his aristocratic prowess. Obsessed with hunting, which he considered to be the only activity worthy of an aristocrat's serious attention, he was fascinated by birds of prey. He hunted with falcons, hawks, owls, and cormorants, not to mention dogs and ferrets (fig. 9). On at least one occasion, he tied the cages of his hunting birds under the axles of his carriage in Paris, and took them driving, "to get some air". He traveled great distances to acquire authentic hunt costumes, which he wore with pride (fig. 10). He also enjoyed folkloric rituals, such as dismounting from his mare in the Bois de Boulogne to milk her into a silver goblet and offer a drink to passers-by. His son quickly learned that he could not compete with such a colorful figure. "If Papa is there, " he commented to a grandmother, "one is sure not to be the most remarkable."[6] He was right. No matter how exhibitionistic or scandalous Lautrec chose to be, he could never outdo his father in gratuitous eccentricity.

With perspective, it becomes clear that many of Lautrec's passions as an adult—his drawing and sketching, his dressing in costumes, his love of animals and women—duplicated things he had seen his father do. As he went to school for the first time in Paris, at the age of nine, his otherwise good marks were lowered by punishments for cutting up in class. He attended the Lycée Condorcet in Paris for less than a year overall. He was so small that the other students called him "petit bonhomme," and the doctors his mother had been taking him to warned her not to let him go into the schoolyard during recreations, for fear that he would be hurt by the roughhousing.

Alphonse expressed fierce opposition to all the treatments suggested by Lautrec's mother. He even used Lautrec as a pawn in his struggles with Adèle by trying to get the boy him-

Fig. 9. Lautrec's father, Comte Alphonse de Toulouse-Lautrec [at right] holding one of his falcons, c. 1910. The man at left is probably Lautrec's uncle, Charles de Toulouse-Lautrec. The dog also belonged to Lautrec's father. (Photo: Musée Toulouse-Lautrec, Albi)

self to refuse any treatment but exercise and visits to the sea-side. Otherwise the count showed little interest in his son, and rarely visited him. According to pediatric specialists, such neglect by a father of a handicapped child is far more frequent than one might imagine, and appears to operate at the level of the subconscious. The phenomenon is most common among men like Alphonse—strong athletes who are expert at reading physical characteristics and movement. It is they who tend instinctively, although certainly unintentionally, to reject a malformed child, almost as an animal would push the weakest offspring from a litter. Mothers, according to the specialists, do just the opposite, clinging beyond all evidence to the conviction that their child is normal. It had always been thus in Lautrec's family. Alphonse had left Albi to go hunting just a few days after Lautrec's birth, and all responsibility for the child had been taken by Adèle, who denied to herself for years that anything could be wrong with her son. Alphonse only showed interest in the child at two times: immediately after Lautrec's brother Richard died, and once it was finally resolved that Lautrec was truly, irrevocably deformed. Then his father made some efforts to support Lautrec in establishing a life that would give him the satisfactions he would never be able to get through hunting and riding.

Fig. 11. Lautrec, after one of his bone-breaks, drew himself propped up in bed drawing, c. 1879. (Photo: Musée Toulouse-Lautrec, Albi)

As an adult, Lautrec's head, arms and torso were all of normal proportions, but his legs were tragically knock-kneed and fore-shortened. In addition, he had developed a set of physical characteristics that were singularly unattractive, and may well have been related to his hereditary malady. His facial features had coarsened, along with his hair, which was thick and bushy. He had a prominent nose with large nostrils. His lips seemed abnormally red and bulbous, and his tongue had thickened, intensifying the distinct lisp which had seemed charming in him as a child, but less so in an adult whom people already had a tendency to infantilize. He also had chronic sinus trouble, an habitual sniffle which punctuated his staccato, rapid-fire speech, and an embarrassing tendency to drool. He cultivated his strong Gascon accent, and used a mixture of regional dialect, Parisian street slang and an unusual vocabulary of his own invention to embellish his entertaining stories. Only his large dark-brown eyes compensated for his otherwise unpromising presence, and as he was very nearsighted, they were always hidden behind a pince-nez attached to his lapel by a black ribbon (p. 16).

Fortunately, Lautrec possessed some resources to help him confront his radical change in expectations. Even as a child, Lautrec had been sunny, humorous and generous, energetic and full of ideas. He had always made friends easily, despite the authoritarian manner of the invalid who insists on having all his whims granted. "Kind-hearted and full of the devil," as his grandmother said, he bore many of the characteristics attributed to the Gascon inhabitants of the region where he grew up.[7] They are known historically as theatrical, extravagant, loyal people, lovers of good stories and wit, quick to laugh, to anger and to make up, but rebellious when confronted, preferring to die before submitting to outside domination. Now the painful months of inactivity had developed new strengths in him: uncomplaining cheerfulness when faced with things he could not change, and fierce persistence and determination to make the most of the things he could have.

Lautrec caused strong reactions in those who met him. Although many were repelled by his physique and his outspoken personal style, he was always surrounded by a group of intensely loyal friends. Henri Rachou, a painter from Toulouse, whom Lautrec knew well in Paris, later described the crippled artist's compelling charm:

> His most striking characteristics, it seems to me, were his outstanding intelligence and constant alertness, his abun-

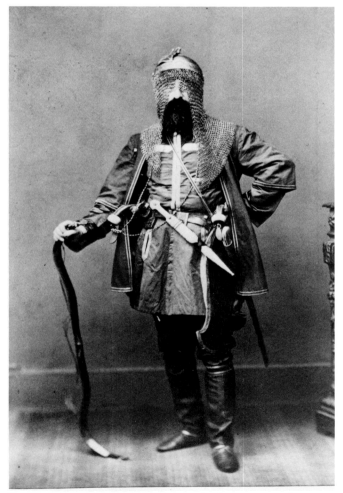

Fig. 10. Alphonse de Toulouse-Lautrec in the costume of a Circassian warrior, c. 1890. (Photo: Bibliothèque Nationale, Paris)

Fig. 12. Lautrec's cartoon of himself and Professor Bonnat, c. 1881. (Photo: Musée Toulouse-Lautrec, Albi)

dant good will towards his devoted friends, and his profound understanding of his fellow men. I never knew him to be mistaken in his appraisal of any of our friends. He had remarkable psychological insight, put his trust only in those whose friendship had been tested, and occasionally addressed himself to outsiders with a brusqueness bordering on asperity. Impeccable as was his habitual code of behaviour, he was nevertheless able to adapt it to any milieu in which he found himself.[8]

The greatest quality which came to his aid, helping him to tolerate long illnesses, painful operations and finally the recognition that he was permanently deformed, was his abundant imagination, and its most important aspect—his gift for art. During the convalescences from his accidents in 1878 and 1879, he turned to art as his major activity, even sketching himself in bed, sketching (fig. 11).

This talent was not unfamiliar in his family, for at least three generations of Toulouse-Lautrec men had shown artistic ability. During his childhood visits to the Chateau du Bosc, he had watched and imitated his father and uncles Charles and Odon as they sat around the salon table together on rainy afternoons, painting watercolors of hunt scenes, or modeling in wax.

When Lautrec was living in Paris with his parents at around age twelve, they often saw a deaf-mute painter named René Princeteau, whose fashionable paintings of horses and "sportsmen" Alph greatly admired. Princeteau liked to amuse the frail boy by drawing sketches for him, and had given art lessons to Alph. Thus it was natural for Lautrec, passionately interested in his own art, to turn to his father's teacher for advice.

Princeteau was charmed by the boy's quickness and his accurate observation of animals and movement. All his life Lautrec had been surrounded by horses and dogs, his father's hunting birds and his grandmother's pet parrots and monkeys. He had an innate skill and excellent memory for motion, which allowed him instinctively to catch their gestures on paper. In the south of France he had been tutored by his Uncle Charles, who had already recognized the boy's talent, although Lautrec himself had no illusions about his abilities. He was eager to learn. Now in Paris, Lautrec copied Princeteau's work diligently, and became so adept that sometimes even his master couldn't tell which drawings he had done himself and which were by his young pupil. Lautrec drew constantly, covering his schoolbooks as well as his sketchbooks with drawings of ani-

mals and caricatures of people. He was beginning to show a gift for human likeness, and even as an adult, the two subjects which interested him most were the varieties of human expression and living things in motion.

His mother, however, was beginning to express concern about his "real" work—his schoolwork. Images interested him far more than German or history, and finally he had to take his high-school baccalaureate exam twice in 1881 before he passed it. After the first failure, with typical verve, he referred to himself as "Henri de Toulouse-Lautrec, Reject of Letters."

This reference, like his refusal to hide the facts of his malady, was part of an attitude which marked his behavior as an adult. He had developed a hatred for the hypocrisy and sentimentality which masked people's treatment of him, and as he was coming to realize, all their human relations. Always an aristocrat, he now became an iconoclast, resolutely destroying false pretensions with a sharp word or a sabre slash of pencil on paper. By extension, he insisted on being the first to point out his own limitations, but this perhaps was a defensive gesture— as if by making fun of them himself, he could fend off similar remarks by others.

Once he had finally passed the "bac" on the second try, his education was complete—a gentleman was not expected to go any further—but he now had to face the painful recognition that he was growing to be an adult in a world utterly different from the one he had expected. Naturally, a Toulouse-Lautrec was not expected to work for a living, but his handicaps rendered him unfit for any of the usual occupations of his class and generation: serving as officers in the army, riding and hunting on horseback, managing a huge country estate—not to mention such snobbish exhibitionism as promenading in the Bois de Boulogne with a beautiful, elegantly dressed mistress on one's arm. The kinds of prowess and beauty admired in his world were now denied him. His family would have liked him to live quietly at home in one of their chateaux, painting and drawing to amuse himself, being waited on hand and foot like an invalid, and staying out of sight. He chose instead to enter another world, and it is to his parents' credit that they allowed him, at least at first, to pursue his desires.

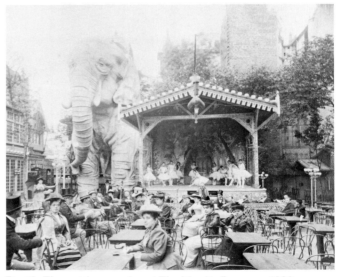

Fig. 13. The outdoor garden at The Moulin Rouge, c. 1889. (Photo: Bibliothèque Nationale, Paris)

Fig. 14. Cha-u-ka-o, gymnast and Moulin Rouge dancer. (Photo: Bibliothèque Nationale, Paris)

Becoming an Artist

Since he wanted nothing except to be an artist, they went with him to Paris, to choose an art school. Predictably, his mother's primary concern was not the quality of his artistic training, but that he be placed where there were other boys of good family. Although they considered enrolling him in the Ecole des Beaux Arts, he finally went to the atelier of Léon Bonnat, a southerner like themselves, because the son of acquaintances from Toulouse worked there and could introduce Lautrec to the right people. Bonnat was a profoundly conservative, highly successful academic painter who lived very well from expensive government commissions and portraits of society ladies. He disliked both Lautrec's person and his art, going so far in later years, after Lautrec's death, as to insist that the French National Museum Council reject the donation of a Lautrec work to the Luxembourg Museum.

Lautrec, undaunted, was able to look at his art training as unsentimentally as he looked at the rest of the world. Accustomed to confronting challenges, he learned a great deal during the year he spent in Bonnat's atelier, and seemed to prefer Bonnat's biting criticism to the easygoing comments of his later teacher, Fernand Cormon. In the studio he learned anatomy, perspective and classical painting techniques. When he finished his formal training after about five years of academic studies, Lautrec had acquired artistic discipline and technical perfection. His work from this period seems stiff and artificial compared to his dynamic adolescent sketches, but in the long run his training marked his highly individual personal style, giving it a firm base of impeccable draftsmanship. Expert in rendering perspective and volumes, he could now abandon them to explore other possibilities.

To Lautrec's pride and his family's astonishment, he began receiving recognition for his art rather quickly. When he was nineteen, he and another student from Cormon's were selected to help Cormon illustrate a deluxe edition of Victor Hugo's *La Légende des siècles*. Lautrec received a huge commission of 500 francs (about $1500 in 1988) and worked for months on the drawings, which finally were not used. But his career was launched, and he now set about doing illustrations for publication, particularly in the popular journals and on the covers of song sheets, to develop a reputation.

Suddenly a glimmer of suspicion entered the family consciousness. Delighted as they were to have their crippled offspring find a place for himself by studying art and even being a successful amateur—they were proud for example when he exhibited in the fashionable shows at the Cercle Volney—the Toulouse-Lautrecs were not at all prepared for him to do something so vulgar as publish illustrations for erotic magazines like the *Fin de siècle* or *La Vie parisienne*. They would be further embarrassed when he drew the covers for soft-core sex novels by the Polish immigrant who wrote under the pseudonym of Victor Joze (cat. no. 82). And they probably were appalled when at the height of the Dreyfus scandal, in which they naturally supported the army and the Catholic church, their son illustrated a pro-Jewish work by Georges Clemenceau, *Au Pied du Sinaï*.

Alphonse repeatedly tried to convince Lautrec to use a *nom de plume*. He was particularly concerned that the glorious Toulouse name not be "misused" by his son. He must have started discussing the issue the first year Lautrec was in Paris, for during the summer after his beginnings at Bonnat's, Lautrec did charcoal portraits of most of his family, which he signed "Monfa" (fig. 12). He signed a charcoal caricature of himself sitting on a chamber pot with the name "Lost", a bilingual English-French pun based on the name Toulouse, "to lose", and quite probably a comment on how it felt to be denied use of his name. Over the years he used a series of pseudonyms, particularly Tréclau, an anagram of Lautrec, and an auditory reference to the words *très clos*, "very closed". In the long run he signed himself "H.T. Lautrec," or just his initials, "H. T. L."

In and out of the atelier over the next years, Lautrec painted in oils and drew in charcoal, pastel, and ink. He imitated a technique developed by a slightly older artist, Jean-François Raffaëlli, and began painting on raw cardboard with a brush dipped in oil greatly thinned with turpentine. The absorbent surface gave the paint a powdery, almost chalky texture as it dried. Perhaps as a result of his growing disdain for the kind of

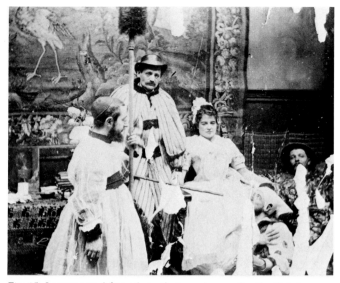

Fig. 15. Lautrec and friends in their costumes for the Bal du Courrier français, 1889. (Photo: Bibliothèque Nationale, Paris)

painting which won prizes at the offical salons, he developed an absolute hatred for varnished painting, for any surface which was falsely sealed and glossy. Perhaps the varnish and affectation of such works was similar to the pretentiousness which surrounded bourgeois social conventions. He was increasingly sensitive to anyone's attempts at putting on appearances. His greatest artistic skill perhaps was psychological acuity: the ability to get behind his models' surface defenses and petty vanities to reveal their vulnerabilities and vices.

Montmartre

His mother, although content with his progress as an artist, quickly realized many of her other fears were well-founded. Lautrec almost immediately had become very involved in atelier life and in exploring Montmartre, a part of Paris Adèle considered to be downright dangerous. A village which, in 1860, had been incorporated into the boundaries of Paris, Montmartre had remained rural because it was on a steep hill and had only one well. Its skyline was marked with windmills and ramshackle outbuildings. Otherwise it was essentially a collection of small truck gardens, and the people who lived there had to struggle to make a living, raising goats and planting scraggly orchards and vineyards.

However, its poverty and isolation, as well as its tangled thickets, had for centuries made it a hiding place for cutthroats and outlaws. Even in 1882, when Lautrec went to work at Bonnat's atelier, which was at the bottom of the hill and thus slightly more civilized, Montmartre had retained its bad reputation and licentious character. On the dirt paths surrounding the scaffolding of the half-built Sacré Coeur basilica, destitute, often homeless *pierreuses* (streetwalkers) offered themselves to passers-by. The butte, as locals called it, was still a haven for the poorest, most marginal members of society, and since 1850 had become a neighborhood of predilection for artists. Renoir and Degas both lived there. Bonnat and Cormon had their ateliers near the place Clichy, at the foot of the butte, where a number of taverns, cafés and dance halls had opened up, catering to a clientele of locals and artists. Soon, all along the wide boulevards at the foot of the hill, a series of dubious

nightclubs sprang up, and as their reputation for wildness and bohemianism spread, they began to attract visitors from the rest of Paris: slumming aristocrats and *demi-mondaines*, bourgeois tourists and now and then a representative from the police morals squad, on the watch to be sure the *chahuteuses* (can can dancers) were wearing underwear.

Cormon had told his students to go sketch models in their normal environments, and Lautrec used this as an excuse to begin visiting the bars and dance halls of the butte with friends from the atelier, his sketchbook at the ready. Although he told his family he only went out of professional necessity, he quickly developed the habit of going out every night for long evenings of pub crawling that not infrequently ended in rowdiness and public scandal. In some ways he must have liked letting his mother know that he was a grown-up now, for he introduced his cousins to his haunts, and his activities could hardly have remained secret. In the process, he became dependent on alcohol.

He could be found nightly in the most notorious nightspots, prominently seated, often at an habitual table in the front row, drinking and sketching, joking with friends and occasionally being joined at his table by one or more of the dancers who were the evening's entertainment. He was quick to offer rounds of drinks. Because of his conspicuous appearance and regularity, he quickly became a recognized part of the passing show at such places as the Moulin de la Galette, the Elysée Montmartre, the Chat Noir, and Aristide Bruant's Mirliton cabaret.

Fame

At age twenty-six, after nine years in Paris, Lautrec was already rather well known for his illustrations and his exhibitions in group shows. In 1891, when he made his first poster, *Moulin Rouge-La Goulue* (cat. no. 80), he became famous overnight. After the dancehall had been built in 1889, its trademark, a fake red windmill with electric lights outlining its vanes, quickly became a symbol of a certain kind of Paris—the decadent, declassé Paris of high-kicking dancers and easy morality. Tourists from all nations flocked to its outdoor garden to enjoy the *chahuteuses* and their "unconcealed glories" (fig. 13).[9]

The next year, 1892, his posters of Bruant (cat. nos. 83 and 84) created another sensation, confirming his reputation as a poster artist. There followed a great deal of commissioned work— posters, portraits, book illustrations, advertising, stage decors, and the covers of sheet music. His artistic honesty created some tense moments with his models, including the famous note Yvette Guilbert wrote when he asked her if she liked a drawing he had made of her. *"Petit monstre!! Mais vous avez fait une horreur!!"* (You little monster!! Why, you've created a horror!!) she scrawled across the drawing (cat. no. 40). Lautrec always had unstable, complicated relations with women. It would have been difficult, if not unthinkable, for him to make a conventional marriage to a woman of his own class. So far as is known, he had no sustained love relationships with women, although he is said to have had a number of mistresses, many of them prostitutes, and at least one love affair with a fellow artist, Suzanne Valadon, the mother of Maurice Utrillo. According to often-repeated myth, she exploited him and he broke off with her abruptly in 1890 because she had feigned a suicide threat in an attempt to get him to marry her.

The only concrete evidence of any love affair which remains today is a note dated December 4, 1890, full of misspellings

and faulty grammar, from a woman named Suzanne Mignon, inviting Lautrec to "Come sleep over whenever you want, only not before 12:30. That's all. I give you a kiss on your (little old slipper, etc.) [*Sic*]."[10] Lautrec was always extremely discreet about the details of his love life, and apparently would only talk about women at all when he had had too much to drink.

We are left to surmise from the artistic evidence and from the numerous anecdotes about his sexual exploits what his love life may really have been like. He was particularly attracted to women of a certain type: redheads who had passed their prime, who were beginning to lose their muscle tone. Their images haunt his drawings and paintings.

Perhaps the most startling testimony on the subject comes from Thadée Natanson, one of the editors of *La Revue blanche*, who, with his wife Misia, befriended Lautrec when he began selling illustrations to the magazine around 1894 (cat. no. 94). According to Natanson, more than anything else Lautrec wanted tenderness from a woman, and ". . . was seen bestowing the gentlest caresses on sluts who were astonished but moved"[11] According to Natanson, Lautrec often accepted a servile and unequal relationship with women, whether there was sex involved or not. This led to his establishing puppy-love relations with a number of the women he admired, including Jane Avril, Yvette Guilbert, and Natanson's wife, Misia. Although he was able to meet his sensual needs in the brothels, Lautrec quite naturally also turned to his friendships with men to meet his more profound emotional needs. However, the intensity of his friendships was such that stories of his tyrannical domination of his cousin Gabriel Tapié de

Céleyran, or the absolute allegiance he required from other friends, obliging them to participate in his pranks and submit to his whims, are common.

As with his intense passions for people, Lautrec developed a series of fascinations with different milieux and art forms. His works identify them and show that they followed a pattern: first he would be obsessed with a place, frequent and draw it repeatedly, then lose interest and find a new subject. Thus, in turn, he was excited by the backstage scenes of young ballerinas at the Paris Opera, Bruant's cabaret, and the Montmartre dance halls, the Moulin de la Galette and the Elysée Montmartre. He was strongly attracted to the work of Edgar Degas, and many of his early paintings explore subjects and techniques of the older artist.

It was at the Moulin de la Galette that he did his first drawings of La Goulue and Valentin le Désossé. As he was fascinated by animals, he was also fascinated by humans who moved with animal vitality, and his drawings of these two dancers, as he followed their careers from cabaret to cabaret, and finally to the Moulin Rouge, confirmed his fame among his contemporaries and recorded theirs for posterity. When he lost interest in La Goulue's dancing, he began to do repeated works based on the ritual postures taken by Jane Avril, another Moulin Rouge dancer (cat nos. 85, 90). As an adult, he clung to a childhood habit he had with Princeteau, of going to the circus to draw. Many works represent bareback riders, gymnasts, clowns, and trained animals (fig. 14). He was fascinated by the fad of costume balls given by *Le Courrier français* and other popular journals (fig. 15). He was attracted by the masked licentiousness and the fantasy of unrestrained sexual encounter at these balls.

Lautrec was particularly attracted to anything new or modern: he was extremely interested in photography, although there is no evidence that he ever took photographs himself. However, two friends, Paul Sescau, a professional photographer, and Maurice Guibert, often took photographs of Lautrec, and sometimes of his posed models. In many works, Lautrec produced a painting or print from photographs. His series of actors and actresses were entirely drawn from publicity postcards of his subjects (cat. nos. 67-71). Lautrec's friends were always taking photographs of each other, particularly when they dressed up in costume. As a result, numerous photographs of Lautrec dressed as a Japanese, a Muezzin and frequently as a woman still exist today (fig. 16). Another fascination periodically pursued by Lautrec was a passion for the theater, and he did paintings and prints of a number of actresses and actors. He also painted the spectators in their *loges*. He drew programs for André Antoine's revolutionary Théâtre Libre, and helped paint the sets for the scandalous premiere of Alfred Jarry's *Ubu roi* at the Théâtre de l'Oeuvre, December 11, 1896. He went to the *cafés concerts* and the music halls and did perceptive portraits of a whole series of music hall and café singers and comedians: Yvette Guilbert, May Milton, May Belfort, and Caudieux. Then his attention would turn to other subjects. During a period in 1892 he spent all his Saturdays at the hospital with his medical student cousin, Gabriel Tapié de Céleyran, even entering the operating room so he could watch Dr. Péan, one of the most famous surgeons of his time, operate with a white linen napkin tied around his neck. Legal problems also interested him, and he observed and sketched at a number of trials. It is unlikely,

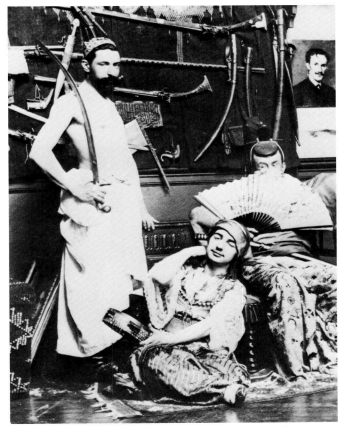

Fig. 16. Lautrec (center), dressed as a gypsy dancer, with two friends, c. 1882. (Photo: Bibliothèque Nationale, Paris)

27

Fig. 17. "The Moorish Room," an elegantly decorated chamber at the brothel in the rue des Moulins where Lautrec resided for a time.

however, that he visited the London courtroom where the celebrated Oscar Wilde was being tried for sodomy. He apparently met Wilde, possibly through a mutual friend, but as Wilde refused to sit for a portrait, Lautrec's famous lithograph of him presumably was done from memory (cat. no. 47).

In the early 1890s he began openly and assiduously frequenting brothels, both painting and paying for pleasure. It is almost certain that in his early twenties he had already contracted syphilis. A number of accounts by his contemporaries refer to it, saying that his long-time housemate, a doctor named Henri Bourges, treated the then incurable disease with mercury, a poison in itself, which had the unpleasant side effect of turning one's teeth black. In numerous full-face photographs, Lautrec's teeth never show. Bourges subsequently wrote several treatises on the treatment of syphilis. Lautrec himself expresses depression about health problems and refers to his "impure kiss" in the mid 1880s.[12] One of his oddest habits was to become an occasional lodger in brothels, where he would convince the madam to rent him a room. On more than one occasion he was known to live there for brief periods, car-

rying on business as usual, and giving the brothel as his address for business appointments.

Thus he resided for a while in the rue des Moulins, near the Opera, in a luxurious brothel famous for having rooms decorated in different styles, from medieval to Moorish to Louis XVI, according to the fantasies of the men who frequented it (fig. 17). There he had a special status, almost like a member of the family. "Monsieur Henri", as they called him, took his meals with the women when they were off duty, and he committed this experience to print in the 1896 *Elles* series (cat. nos. 49-61). His scenes of these interiors are among the most telling and honest portrayals of that life to have ever been done.

In more conventional haunts, he drank in the bar at Les Ambassadeurs, and sketched its elegant denizens. He followed Misia Natanson to a skating rink and drew fashionable women gliding or sitting with their lovers at the tiny tables beside the ice (cat. no. 94). Then he fell in love with bicycle racing and frequented the new Paris velodrome run by Tristan Bernard, where he could watch the racers. He did posters and advertisements for bicycle parts (cat. nos. 104, 105). As he grew depressed and alcohol-dependent, he frequented lesbian bars and tried to catch on paper the intense emotions of the couples there.

By late 1897, when Lautrec was thirty-three years old, all his friends knew that he was in serious emotional trouble and that he was hopelessly addicted to alcohol. His productivity fell off, and he spent more and more time in the bars. Early the next year he wrote to his mother that he was in ". . . a rare state of lethargy. The least effort is impossible for me. My painting itself is suffering . . . also no ideas."[13] From November 1898 until the end of February 1899 only five works remain: a poster and four drawings. By this time, Lautrec was in an emotional crisis caused by alcoholism and very likely by the appearance of tertiary syphilis. He was almost always drunk and suffered from hallucinations, paranoid fears, amnesia, and uncontrollable shaking. He was agressive, obscene, insomniac, and confused, and frequently alienated those who might otherwise have tried to help him. It was around this time that he made his first dry-point, *Bonjour M. Robin* (cat. no. 66), which is sketchy and incoherent, strikingly different from his usual work.

Decline

Family documents reveal that Lautrec suffered a mental breakdown in February 1899, and at the beginning of March was committed to a private mental hospital.[14] Once he was hospitalized and unable to drink, Lautrec improved rapidly, and wanted to be released. However, his family was terrified he had become permanently insane, or at least that he would start drinking uncontrollably again. The doctors in the posh private mental hospital were in no particular hurry to lose a well-paying guest, either. However, Lautrec was very well-known in Paris, both as an artist and as a popular Montmartre regular. The newspapers exploited the story to the hilt, creating a scandal that made the doctors at the asylum, not to mention Lautrec's family, most uncomfortable. In addition, Lautrec decided that the way to secure his release was to do a series of drawings from memory, thus proving not only that he was able to do his work, which was his art, but also that his amnesia was gone.

Fig. 18. Lautrec at Malromé in 1901, just before his death at age 36. (Photo: Musée Toulouse-Lautrec, Albi)

The series of circus drawings he produced in the hospital, using colored pencil on paper, are very tight and rigid—much more conservative than Lautrec's usual work. But the figures in them are recognizable from circus acts Lautrec had seen in Paris over five years earlier. The doctors were either convinced he was well, or afraid of further scandal, and released him after less than three months of confinement. He left Paris, and went to his family home at Le Bosc, in the Aveyron, thirty miles from Albi. After a brief stay there, which reassured his family immeasurably about his sanity, he traveled slowly back to Paris accompanied by a friend, Paul Viaud, whom his mother had hired to see that Lautrec didn't drink. But his resolution, even with his friend for moral support, did not last long. When he began drinking again, his symptoms immediately returned. He left Paris again after several months, working his way down the Atlantic coast with Viaud, and spending a winter in Bordeaux, still painting, although he was far less productive than before.

His depression was the hopelessness of a man who is slowly killing himself, and somehow unable or unwilling to stop. In August 1901, at the coastal resort Taussat, he suffered a stroke and was taken to his mother's estate at Malromé, not far from Bordeaux (fig. 18). He fell into a coma, and finally died on September 9. At the time, a rumor spread among his Paris friends. Jules Renard quoted it in his journal: "Paris, October, 1901. Toulouse-Lautrec was lying on his bed, dying, when his father, an old eccentric, came to see him and began killing flies. Lautrec said: 'Old Fool!' and died."[15]

In 1892, when he had visited Toulouse to supervise the printing of a poster, *The Hanged Man* (cat. no. 81), he had already remarked to Arthur Huc, editor-in-chief of the local newspaper, "I can paint until I'm forty. After that I intend to dry

up."[16] With hindsight, the signs of premonition and death seem obvious. No matter what exterior appearances he might have maintained, either Lautrec realized drink was killing him, or else he intentionally was using alcohol to shorten his painful existence. Deadening his feelings with frenzied living, he finally allowed his lifestyle itself to resolve his ambivalence.

1. Gauzi (1954), pp. 66 ff.
2. Montfa is the spelling that appears on Lautrec's birth certificate. It is also the spelling generally used by his family. His father used the Chateau de Montfa as a hunting lodge from 1866 until his death. The commonly accepted spelling, Monfa, was used by Lautrec to sign a number of drawings around 1882.
3. Perruchot (1960), p. 28.
4. ALS [Autograph letter, signed] Lake Collection, University of Texas, Austin: Adèle de Toulouse-Lautrec to her sister-in-law, Alix Tapié de Céleyran, Albi, 20 May [1878]. This, and all letters cited from the Lake Collection are the property of the Humanities Research Center, University of Texas, Austin. The author would like to thank the center for granting access to this rich collection of unpublished material, and for permission to quote from its documents.
5. Leclerq (1954), pp. 22-23.
6. Quoted in Huisman and Dortu (1968), p. 14.
7. ALS [Lake] Louise Tapié de Céleyran to Gabrielle de Toulouse-Lautrec Céleyran, 30 May 1968.
8. Huisman and Dortu (1968), p. 44.
9. Quoted in Mack (1938), p. 50.
10. On permanent exhibition, Musée Toulouse-Lautrec, Albi.
11. Natanson (1951), p. 19.
12. Goldschmidt and Schimmel (French ed. 1969), p. 105.
13. Goldschmidt and Schimmel (1969), pp. 194-195.
14. A number of these documents are reproduced in Goldschmidt and Schimmel (1969).
15. Renard (1964), p. 138.
16. Homodei [Arthur Huc] (1899).

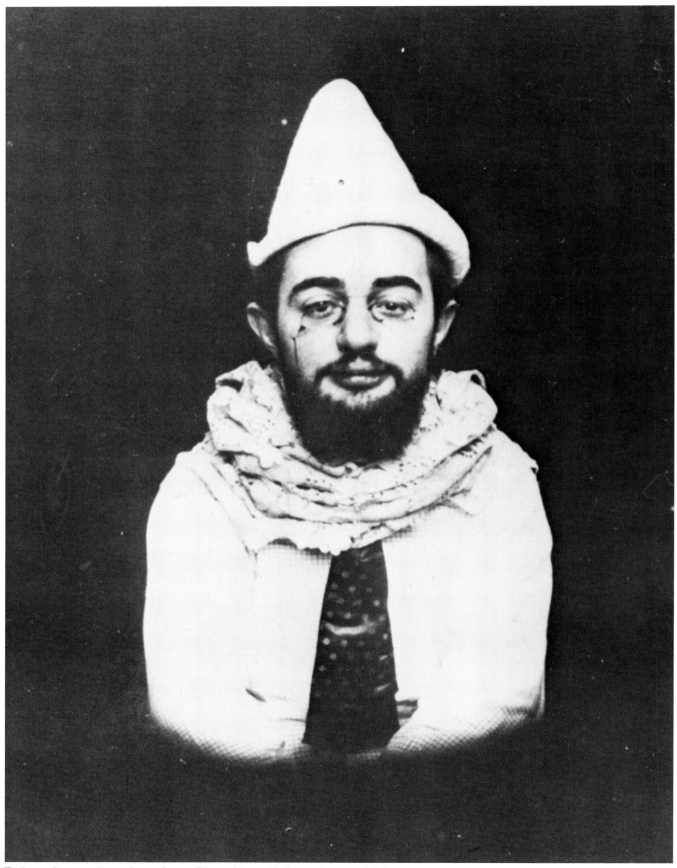

Toulouse-Lautrec dressed as a clown. (Photo: Musée Toulouse-Lautrec, Albi).

"Parades," Paris and Prostitutes
Thematic Concerns of Lautrec and
His Contemporaries
Phillip Dennis Cate

Henri de Toulouse-Lautrec was an artist endowed with an often humorous but unemotional and unpoliticizing sensitivity to humanity. While it is partially this empathetic, non-judgemental concern for people that makes him unique from the other artists with whom he associated during the 1880s and 1890s, he was also very much an artist caught up within the environment and period in which he worked. He not only influenced but was influenced. The thematic concerns of his art parallel those of many of his contemporaries and strongly define the *fin de siècle* Parisian avant-garde. In particular, three themes, which are common to the work of the young anti-academic artists living in Montmartre at the end of the nineteenth century were 1. the circus and/or fairs, often represented by the "parade," 2. Paris itself, especially that epitomized by the lively dance halls, *café concerts* and cabarets, and 3. prostitutes and bordellos. Artists chose to live in Montmartre, the eighteenth arrondissement and the northernmost part of Paris, because it was inexpensive and, essentially, an anti-establishment, bohemian environment. They virtually never had to leave that district in order to experience the subjects depicted in their art. Montmartre's population was primarily composed of three classes: the completely impoverished, the poor working class, and artists and intellectuals rebelling against past traditions. Montmartre was synonymous with a particular way of life which was in theory, at least, anti-bourgeoisie.

There were a number of artists living and working in Montmartre who, like Lautrec, wished to depict the life of Paris which surrounded them and in which they actively participated. They retreated from romantic and allegorical themes which did not deal with "modern life." They preferred a realism which related directly to their own experience. This meant that their subjects included not only the destitute, street people, laborers, and entertainers but also their colleagues and themselves.[1]

While there were numerous artists who associated with Lautrec, and whose art reveals similar thematic concerns, the work of three particular artists serves well to place his art into perspective and will be emphasized here. Théophile-Alexandre Steinlen (1859-1923), Henri-Gabriel Ibels (1867-1936), and Emile Bernard (1868-1941) were very much a part of the artistic milieu of Montmartre, and either studied with, socialized and/or collaborated with Lautrec during his short but prolific career.

In 1896 Ibels illustrated the book *Demi-Cabots (Ham Performers)* which dealt with the themes of the *café concerts*, the circus, and *forains* (itinerant buskers and performers).[2] Each topic was described by the text of a particular writer, and each text was accompanied by reproductions of drawings or prints made by Ibels over the previous few years. Throughout Paris, including Montmartre, just as today, there were *forains* or street performers such as acrobats, fire eaters, strong men and wrestlers moving from one busy intersection to another, prac-

ticing their art and earning a minimal existence. There were also a number of established circuses in Paris, such as the Cirque d'Eté on the Champs-Elysées, The Nouveau Cirque on the rue St. Honoré and the Cirque Fernando in Montmartre. The Hippodrome on the avenue de L'Alma, *café concerts* such as the Folies Bergères, Les Ambassadeurs, L'Horloge, and the Moulin Rouge dance hall also frequently presented circus acts. In addition there was the amateur Cirque Molier, in which the performers were non-professional but highly talented aristocrats and artists.

Between these two extremes — the peripatetic street performers and the established circuses — were those *forains* who, since medieval times, traveled in their wagons throughout France from one city to another performing at fairs. Paris had two major annual fairs. The Foire au Pain d'epice (gingerbread fair), on the avenue du Trône on the east side of the city, occurred each year at Easter time. The highlight of the year was the Fête de Neuilly in June on the avenue de Neuilly, near the Bois de Boulogne in the west. In *Demi-Cabots*, Georges d'Esparbès describes the status of the *fêtes forains* and the role of the artists in preserving it for posterity:

> Over there, the bell-ringer of the final hour appears. He walks quickly; he will soon be near us. At the sound of his bell, boards fall and curtains fold. On the way towards somewhere else! Thus the itinerant fairs, the "exhibitions" will vanish. But something of them will remain in these pages. This book of sketches represents the complete attention of an artist; it is the last glance, I think, which will be cast on the already deserted grounds of the festival.

There was time for the sketcher to note the excitement, the bizarre faces, the disconsolate poses. Tomorrow, this phantasmagoria will be gone, like all things in the modern tend-

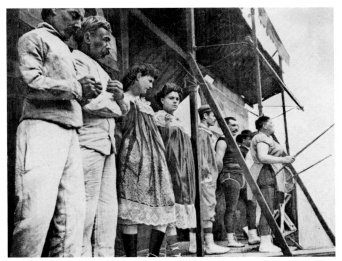

Fig. 19. The "parade," illustration in **Le Figaro illustre**, no. 92, November, 1987, p. 213.

Fig. 20. Henri-Gabriel Ibels, *Le Grappin et L'Affranchie*, Théâtre Libre program, 1892-93, color lithograph, Jane Voorhees Zimmerli Art Museum, New Brunswick.

Fig. 21. Fernand Pelez, *Gare! Voila, La Vache Enragée* (Look out! It's the Enraged Cow), 1897, color lithographic poster, Jane Voorhees Zimmerli Art Museum, New Brunswick.

ency to move on; and the evening having come, in vain we will seek these phantoms which frightened and amused our childhood.

There are no small emotions, no small thrills. What happens in the soul is a copy of humanity. After five centuries, that which affected us at the annual fairs of Trône and Neuilly, was it not the spirit of the Middle Ages?—a spirit open and monstrous, which we discovered again with each step, in the bands and grimaces; in the faith and joy of the crowd's respect for strength, with its Biblical animals; the crowd's love of the inexplicable, a passion for the bizarre which bordered on fear and occasionally roused to disgust our own complicated soul, [which is] too modern to be accustomed to these impulses. This festival was like a tomb that opened to reveal a corpse.[3]

At these fairs performers set up their tents along the boulevard and coaxed the audience inside with promises of startling, superhuman acts, and presentations by freaks and clairvoyants. Performers, enticingly dressed in exotic, colorful costumes, often stood on stages installed in front of these tents, and played music to attract customers. This was the "parade" (fig. 19). It was a subject which attracted Ibels over and over again (fig. 20) and, in 1894, was to be the inspiration for Lautrec's quick sketch *La Parade*, (cat. no. 7) executed in india ink in a calligraphic style, similar to a number of drawings by Ibels in *Demi-Cabots*. As in some of Ibels' renditions of the "parade," Lautrec views his subjects, a muzzled bear, its trainer and a clown, from behind. Consistent with many of his own circus, cabaret and brothel depictions, Lautrec is a voyeur, behind the scene rather than part of the audience. He defines for himself a more intimate relationship with the *forains* who, as artists, are on the fringe of or outside "normal" society, as is he. As such, in Lautrec's view, they represent a greater reality.

Unlike many of his associates who were fascinated with the Parisian cityscape, Lautrec rarely depicted the physical characteristics of the city. Therefore, Lautrec's 1893 cover for Jean Goudezki's *The Old Stories* (cat. no. 12) and the 1896 poster for the artist Adolphe Willette's journal, *La Vache enragée*, (cat. no. 106) are unusual in his work. The book cover depicts accurately (but reversed by the printing process) the composer

Désiré Dihau leading a bear (Goudezki) by a leash on the right bank of the Seine, ready to cross the Pont des arts towards the Institute. While there is no specific location identifiable in the poster, the steep cobble-stoned street is typical of Montmartre, and the message of the poster is that of the rebellious artists living there.

In 1885 the montmartrois poet Emile Goudeau wrote the novel *Vache Enragée*. It is a tongue-in-cheek story of a struggling young artist in Montmartre. The term "vache enragée" soon became accepted within avant-garde artistic circles to refer to the lean, hard years of an artist. The "enraged cow" in the poster symbolizes the rebellious young artist who allows nothing to stand in his path to success. Willette's new journal, which was irregularly published, was to be an organ for the writers and artists of Montmartre in which they could express their disdain for the bourgeoisie. On the poster, Lautrec depicted an elderly academician, typically envisioned as crotchety and intractable, being chased down the streets of Montmartre by the *vache enragée*. Gleefully following is Willette himself, represented by the *pierrot* (clown) on a bicycle. Willette used the sympathetic figure of the *pierrot* in his art as his own alter ego and as the symbol of the vulnerable artistic spirit.

The poster also refers to the first elaborate *vache enragée* artists' procession, organized by Willette and his partner, A. Roedel, which took place on March 14, 1896, three days after the first issue of the journal appeared. The second *vache enragée* procession, with floats designed and constructed by artists, and for which Fernand Pelez created a poster (fig. 21), paraded through the streets of Montmartre on June 20, 1897. But, like Willette's shortlived journal, the procession was discontinued the following year because of a lack of funds. Lautrec's poster, nevertheless, suggests by caricature the theoretical battle of the artists on the butte Montmartre against an entrenched and established Paris below.

For Lautrec, Paris life existed not in the streets, as for instance in the work of Steinlen, but rather within the walls of dance halls, *café concerts*, circuses and brothels; for him it was a city of night, illuminated by gas and electricity; a city in which, unlike the work of Pierre Bonnard and Edouard Vuillard, the bourgeois family played no part. Paris at night was a world all its own. It was not for Lautrec, however, a world of superficial entertainment as the term "Belle Époque" implies; instead, through his eyes, it was a world of idiosyncratic entertainers who performed their art and, like Lautrec, often lived desperate lives. He first encountered such unique performers as Aristide Bruant, Valentin le Désossé and La Goulue as a student at Cormon's, when he and his friends, Louis Anquetin, Francois Gauzi, René Grenier and others visited the Chat Noir, the Mirliton, the Elysée Montmartre and other provocative haunts of Montmartre. This early exposure to the intoxicating and exhilarating seamier side of Parisian life was to give focus to his art for the rest of his life.

The Chat Noir cabaret, founded in December 1881 by Rodolphe Salis at 84 boulevard Rochechouart, soon became the center where avant-garde artists, writers, poets and composers socialized and performed. It was such a success that by June 1885 Salis found it necessary to relocate to larger quarters. In a July 1886 letter to his mother, Lautrec relates his experience at the famous "cabaret artistique:"

Fig. 23. Henri de Toulouse-Lautrec, *Le Refrain de la Chaise Louis XIII au Mirliton*, 1885-86, oil on paper, ex. collection Metropolitan Museum of Art, New York.

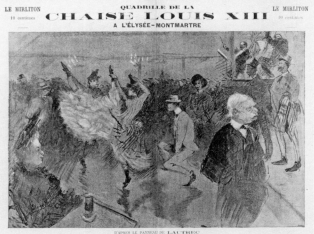

Fig. 22. Henri de Toulouse-Lautrec, *La Quadrille de la Chaise Louis XIII à l'Elysée Montmartre*. Illustration in *Le Mirliton*, December 29, 1986.

I've been having a very good time lately here at the Chat Noir. We organized an orchestra and got the people dancing. It was great fun, only we didn't get to bed until five in the morning, which made my work suffer a little that morning.[4]

It was undoubtedly at the Chat Noir that Lautrec first encountered Aristide Bruant, an arrogant performer of crude, brash monologues and songs which he presented in the argot of the poor and unsavory population of Paris. Bruant's abrasive manner, although appealing to Lautrec, alienated many others, including Salis; when the latter moved his cabaret, Bruant stayed back and converted the old Chat Noir into his own cabaret, the Mirliton. Salis accidentally left behind one of the Chat Noir's medieval furnishings, a Louis XIII chair. Bruant defiantly nailed it to the wall of the Mirliton and would not return it to Salis. That dramatic and spiteful event became the inspiration for a can can dance at the Elysée Montmartre and for two paintings by Lautrec (figs. 22, 23). While Bruant's cabaret became competition for Salis, it never acquired the same sophistication or broad artistic character as the Chat Noir. Defined primarily by the personality of Bruant, the Mirliton's fame was overshadowed by that of the performer himself, whose name and reputation were assured for posterity by Steinlen's hundreds of illustrations of his songs and monologues (fig. 24), and by Lautrec's four iconic posters (cat. nos. 83, 84, 88, 89).

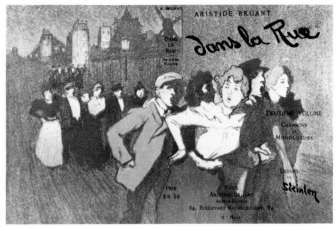

Fig. 24. Théophile-Alexandre Steinlen, cover for **Dans la Rue**, 1895, color lithograph, Jane Voorhees Zimmerli Art Museum, New Brunswick, gift of Norma Bartman.

While the Chat Noir and the Mirliton fall clearly into the category of "cabaret artistique" because of their mix of literary and artistic entertainment, *café concerts*, on the other hand, were essentially cafés with a stage that attracted a broader public. Some of the largest and most elegant were the *concerts* Les Ambassadeurs, the Alcazar d'Eté and the Horloge located along the Champs-Elysées, and La Scala on the boulevard Strasbourg. The Montmartre *café concert* best remembered today is the Divan Japonais, which was made famous almost entirely by Lautrec's poster (cat. no. 90). It was, in fact, not so popular, and was quite small, to the degree that the petite entertainer Yvette Guilbert complained of the close, hot lights and the inability to raise her hands above her head without touching the ceiling. Lautrec's boldly designed poster suggests the cramped quarters of the café by compressing the fore-, middle-, and backgrounds onto the same plane, and by cropping the head of Guilbert, who is performing on stage.

Lautrec's commitment to realism is typified by the two figures overlooking the orchestra pit who are identifiable as the dancer Jane Avril and the art critic Edouard Dujardin. Indeed, in 1893 when Lautrec collaborated with Ibels on the album of twenty-two lithographs entitled *Le Café Concert*, both artists depicted particular performers such as Avril, Guilbert, Paula Brébion, Mary Hamilton, Edmée Lescot, Caudieux, and Bruant among others. Ibels' cover for the album, in fact, features Brébion on stage, and Francisque Sarcey, the drama critic for *Le Temps*, in the audience being served a drink (fig. 25). Georges Montorgueil wrote the introduction for the album and was also responsible for the essay on *café concerts* in Ibels' *Demi-Cabots*. In the preface to the album, Montorgueil sums up the two basic criteria for a good entertainer in his description of the qualities of Yvette Guilbert:

> What one sings at the *café concert* is not as immaterial as many stars suppose. An intelligently chosen repertoire confers certain advantages. The spectacular success of Yvette Guilbert is the result of two things: her own outstanding talent, her mordant voice, her dress sense, her air of mournful gaiety which for us is the latest thing in laughter; but the other thing is her repertoire. She sang differently and she ·sang different things. She became the muse of people with

dry wits, the translator of a very odd sort of humour, a humour which was splenetic and ingenuously immoral.[5]

To express in his art an individual's unique character and personality was of the utmost importance to Lautrec. At times, this mania created problems with his models when the latter were not prepared for such an honest approach. Yvette Guilbert flatly rejected Lautrec's studies for a poster announcing her 1894-95 season at the Ambassadeurs because she felt they made her ugly. She instead commissioned Steinlen to produce the official poster (fig. 26). That same year Lautrec created his album of sixteen lithographs depicting Guilbert on stage, and five years later his album of eight lithographs of the singer was published in England (cat. no. 72). It is with the drawings and lithographs by Lautrec, not the poster by Steinlen, that the character of Guilbert is best revealed and remembered.

In the mid-1880s, the two established and popular dance halls in Montmartre were the Moulin de la Galette, at the top of the butte, and the Elysée Montmartre (cat. no. 6) on the broad boulevard Rochechouart. The Moulin de la Galette catered primarily to a poor and working class clientele and had a reputation for being the gathering place of ruffians, pimps and prostitutes (fig. 27). On Saturday nights extra police were called to keep the peace. Indeed, when Lautrec frequented the Moulin de la Galette he would be sure to be accompanied by two larger companions, such as fellow students Anquetin and Grenier. It was the energetic atmosphere of dance halls and the titillating performances of the professional dancers

Fig. 25. Henri-Gabriel Ibels, cover for the **Café Concert**, 1893, lithograph, San Diego Museum of Art.

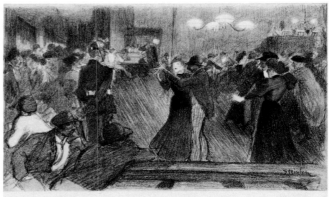

Fig. 27. Théophile-Alexandre Steinlen, **Bal de barrière** from **L'Estampe Moderne**, June, 1898, color collotype, Jane Voorhees Zimmerli Art Museum, New Brunswick, gift of Mr. and Mrs. Herbert D. Schimmel.

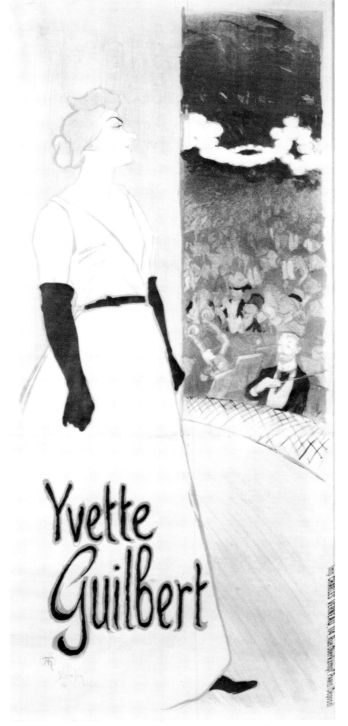

Fig. 26. Théophile-Alexandre Steinlen, **Yvette Guilbert, Ambassadeurs**, 1894, color lithographic poster, Jane Voorhees Zimmerli Art Museum, New Brunswick.

such as La Goulue and Valentin le Désossé that enthralled Lautrec, and which inspired him to record the character and intensity of the performers over and over again.

An 1887 article by Jules Rogues in *Le Courrier français* describes the Elysée Montmartre when it was at the peak of its popularity:

> They always like dancing in Montmartre, as if on a volcano, and since the closing of the Reine-Blanche and the Boule-Noire, the Elysée is certainly, along with the Moulin de la Galette, the only ballroom in the area.

> The Elysée Montmartre's clientele is, above all, an artistic one. Just as Bullier [a dance hall on the left bank] evokes images of high school pupils, university students and bar girls, the Elysée can be depicted as a mixture of painters, models, actors, playboys, newspapermen, writers of all ages and talents, gigolos of all types . . .

> It is at the Elysée that La Goulue first kicked up her heels with Louisette, who is today a lady of the best demi-monde. Without a doubt, la Goulue and her partner Valentin le Désossé were the first creators of the naturalistic *quadrilles* [can can] which have been exploited by most of the *cafés concerts* for the last two years.[6]

Although the Moulin de la Galette and the Elysée Montmartre were the subjects of numerous works by Lautrec (see cat. no. 6), it is the Moulin Rouge with which he is most associated. Founded in 1889, the year of the Paris International Exposition, within a short time it became the most popular entertainment hall in Montmartre. By 1891, when Lautrec created his poster for the Moulin Rouge, La Goulue and Valentin le Désossé were firmly identified with the dance hall; it was essential therefore for Lautrec to include them in his poster design (cat. no. 80). Rather than an exterior view of the building or a depiction of ladies riding on donkeys in its garden, as presented by Jules Chéret in his 1889 poster for the Moulin Rouge, Lautrec suggested the lurid and intense sexuality of the performances which by now had become its trademark.

Steinlen's illustration for George Auriol's short story, "Hilarity," published in the April 14, 1894 issue of *Gil Blas illustré*, humorously and subtly refers to Lautrec's predilection for visiting and

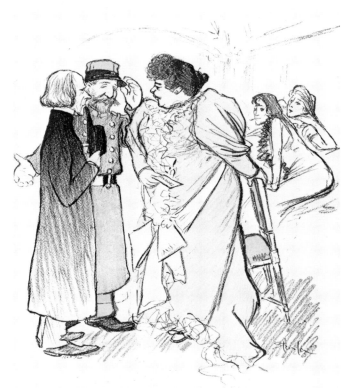

Fig. 28. Théophile-Alexandre Steinlen, **The Introduction**, color photo relief proof for cover of **Gil Blas illustré**, April 14, 1894, Jane Voorhees Zimmerli Art Museum, New Brunswick, gift of Allan and Marion Maitlin.

living at brothels (fig. 28). The story tells of the brief visit to Paris by a Church of England minister who seeks empirical information on Parisian entertainment spots for a book he is writing on social evils. As a favor to a friend, an old soldier dutifully introduces the minister to the infamous dance halls and cabarets of Paris. As final research for his book, the minister requests to be shown a bordello. It is this scene which Steinlen illustrates. The minister is presented to the madame who holds in her hand his card of introduction on which one reads the name "Treclau" which, in reality, was the pseudonym used by Lautrec in the 1880s. In the story, because of his vast experience in these matters, Treclau was asked to recommend an appropriate bordello for the minister's visit. Thus Steinlen, in his illustration, visually presents Auriol's humorous reference to their mutual friend's notorious sexual exploits.

Prostitutes and bordellos were frequent subject matter for major artists in the second half of the nineteenth century such as Edouard Manet, Edgar Degas and Vincent Van Gogh, who sought to deal with all aspects of modern life. Lautrec and his associates, Steinlen, Ibels and Bernard were, therefore, addressing a relatively recent concern of avant-garde artists when they too dealt with the subject of prostitution. As an artist engaged in social protest, Steinlen sympathetically depicted the streetwalkers of Paris, emphasizing their poverty and difficult existence (fig. 29). Ibels' images often deal with the visits

of newly recruited foot soldiers to *brasseries de femmes*, which were cheap bars whose waitresses doubled as prostitutes, catering to the loneliness of these unsophisticated young men (fig. 30).

Lautrec not only depicted but participated in the world of prostitutes and bordellos, which became a dominant part of his art during the early and mid-1890s. He regularly visited houses or *maisons closes* on the rue Joubert, the rue d'Amboise, and the rue des Moulins on the right bank, and Le Hanneton at 75, rue Pigalle in Montmartre, a *brasserie de femmes* which specialized in lesbians. In 1894, Lautrec took up residence at the brothel on the rue des Moulins, where he produced many drawings and paintings of the women of the house as they relaxed, slept or were otherwise uninvolved in their profession. The 1896 *Elles* series of lithographs is the final result of this prolonged visit and is the artist's most eloquent homage to the women of the rue des Moulins and others of their profession (e.g., cat. no. 57).

However, it was not the first attempt by an artist of Lautrec's circle to dedicate an album of images to a bordello. In the fall of 1888, Emile Bernard created an album of eleven watercolors entitled *Au Bordel (At the Brothel)*; it was inscribed "to friend Vincent these stupid sketches E. Bernard, 1888" and sent to Vincent van Gogh in Arles.[7] Each watercolor has a caption, and each deals frankly with the personal and professional concerns of the women in the brothel (fig. 31). Of course, Bernard's watercolors were private efforts and, unlike the *Elles* series, were not published as prints for public distribution. Yet, Bernard's album reveals once again the pervasive and ongoing commitment of artists from Lautrec's generation to a similar brand of realism and, sometimes, to normally taboo subjects.

1. For information on artists who associated with Lautrec, see Cate (1985).
2. D'Esparbès et al. (1896), pp. 201 ff.
3. *Ibid.*, pp. 201-202.
4. Goldschmidt and Schimmel (1969), p. 101.
5. Georges Montorgueil, introduction, *Café Concert,*1893.
6. Cate (1988), p. 28.
7. Cate and Welsh-Ovcharov (1988).

Fig. 29. Théophile-Alexandre Steinlen, **The Raid**, color photo relief proof for **Gil Blas illustré**, June 18, 1895. Jane Voorhees Zimmerli Art Museum, New Brunswick, gift of Allan and Marion Maitlin.

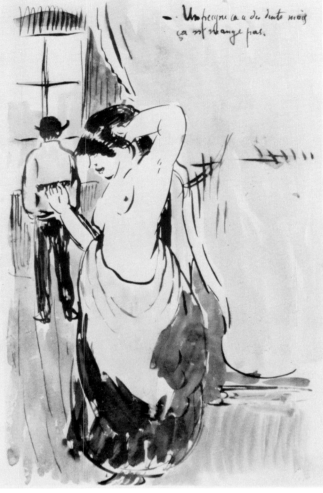

Fig. 31. Emile Bernard, **A Prostitute Partly Undressed, Combing Her Hair**, 1888, watercolor (caption reads, "A comb has teeth but it doesn't eat"), Rijksmuseum Vincent van Gogh, Amsterdam.

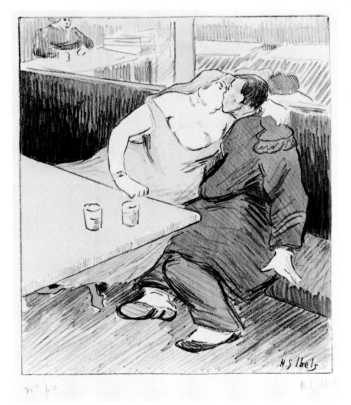

Fig. 30. Henri Gabriel Ibels, **Le "27"**, 1895, lithographic music sheet cover, Jane Voorhees Zimmerli Art Museum, New Brunswick, Norma Bartman purchase fund.

37

Henri de Toulouse-Lautrec, **Self-Caricature**, 1896, crayon on paper, inscribed *à Pellet, l'intrepide editeur/H T Lautrec* (to Pellet, the intrepid editor), Musée Toulouse-Lautrec, Albi.

The Makers' Marks
Nora Desloge

Two artistic activities produced the work of Toulouse-Lautrec—drawing and painting. Between the paintings and the prints, draughtsmanship is the connecting gesture, and drawing is the activity most fundamental to Lautrec's lithographs. This simple fact makes the lithographs readily understandable as original works of art. The lines and dots and scribbles which we see in the prints are Lautrec's marks, drawn by him with crayon or brush on thick limestone slabs which were then inked and run through a press, transferring the drawing to a sheet of paper.[1]

Visible in a detail from *Brandès and Le Bargy* (fig. 32) are Lautrec's drawing gestures, made directly on the lithographic stone with a crayon, and recorded in the print without the slightest loss of their original immediacy, texture or varying pressure. The spatter, applied by Lautrec in the same greasy ink trapped by his crayon marks, adds color and atmosphere. By applying a paper stencil or masking medium to the stone before printing, he reserved an area of uninked paper to create the reverse "color" of the statuette in the upper left. Along this corner of the image, by accident, the lithographic ink collected under the pressure of the printing press, creating a visible mark of the outer edge of the lithographic stone. It is only this unusual stonemark that reveals the mechanical process of printing.

As original as drawings or paintings, lithographs generally are not unique, and the multiple property of lithographic execution and use involved numbers of people beyond the artist himself. While Lautrec's images would not exist without their primary maker, they nevertheless would not have been produced as lithographs without the participation of printers, publishers, distributors and others who can be described as secondary makers. Like the artist, they left their marks, in the form of names, initials, insignia, and stamps which are visible on the prints themselves. These are informative deposits of the prints' technical and, sometimes, social history and belong to the most basic reality of the works of art as physical objects.

Lautrec's marks began with the simple outlines seen in the early posters and lithographs of 1891–93—for example, the strident contours of the Aristide Bruant posters (cat nos. 83, 84, 88), or the precise brush and crayon lines of The *Milliner, Renée Vert* and *The Old Stories* (cat. nos. 11, 12). From 1893 and forward, his drawings on the lithographic stone became richer and freer in a remarkable range of draughtsmanship seen in such contrasting lines as the delicate crayon scribbles of the 1894 *Yvette Guilbert* (fig. 33), the rich, descriptive hatching and scumbling of the 1898 lithographs *The Pony Philibert, Di Ti Fellow,* and *Guy and Mealy* (cat. nos. 73-75), or the schematic assurance which so brilliantly draws the characters in the 1899 *Promenade* (cat. no. 76).

A similar progression to the pictorial effects achieved in the later color lithographs can be traced from Lautrec's first attempt at lithography in the 1891 poster *Moulin Rouge* (cat.

no. 80). Already, boldly outlined color areas are combined with the technique of *crachis* to modulate color and create a sense of atmosphere.[2] Using a *grille à crachis*, an iron screen across which a stiff brush (a tooth brush or nail brush) loaded with ink was scraped, Lautrec neutralized large areas of the yellow floor with blue spatter. In the 1893 poster *Divan Japonais*, a mechanically patterned transfer screen of dots (fig. 34) was used to differentiate the unlighted orchestra from the dramatic lighting of the stage, where a denser *crachis* was applied. Both posters, although conceived as clearly outlined areas filled with color or pattern, foretell the painterly style of the 1896 *Seated Clowness* (fig. 35) in which crayon, brush, spatter, and scraper were employed. The blue *crachis*, added to the face, chest, and hair of the clowness only as a late correction before the edition was printed, served to darken the underlying red spatter and deepen the tragic mood of the figure. With the exception of the yellow ruff and black pantaloons, which were laid in with a brush, the entire surface of this print is filled with spatter, creating a transparent film through which the underlying white paper glows. No longer used for its neutralizing effect, the *crachis* is actively exploited for its luminous and coloristic properties.

Fig. 32. Henri de Toulouse-Lautrec, ***Brandès and Le Bargy in "The Charlatans"*** (detail), 1894, cat. no. 33.

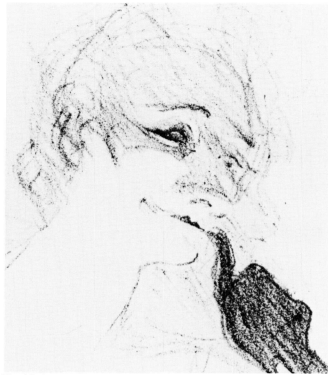

Fig. 33. Henri de Toulouse-Lautrec, **Yvette Guilbert in "Columbine to Pierrot"** (detail), 1894, cat. no. 38.

On the other hand, Lautrec never gave up his predilection for the simplified shapes, strong patterns, dense areas of color, and stark contrasts that served as eye-catchers in the early entertainment posters. For this reason the stylistic and technical range of the posters is more unified than that of the lithographs. The last posters Lautrec produced, *Jane Avril* and *The Gypsy* dating from 1899 (cat. nos. 108 and 109), show basic similarities with those made eight or nine years before. Nonetheless, several posters turned out at the height of Lautrec's lithographic pictorialism in 1895-97 incorporate this tendency. A detail of *Irish and American Bar* (fig. 36) reveals a variety of techniques used to create the scenic effects of reflective mirrors, glaring interior light, spatial dimension and descriptive surfaces. The 1895 *Napoleon* (cat. no. 46), conceived as a poster although never produced as one, makes remarkable use of *crachis* to achieve a painterly vibrancy of color while formally integrating the figures into their surrounding atmosphere. In the *Alarm Bell* and *L'Aube*, two posters of 1896 (cat. nos. 98, 102), a heavy, atmospheric effect of darkness was achieved by a tint stone, that is, covering the paper entirely with a transparent ink before the drawing was printed.[3]

Lautrec eventually came to select a wide range of colored inks, such tints as deep violet, turquoise, curry yellow, pink, and olive-brown obtainable from the ink manufacturing firm Charles Lorrilleux, whose name is printed in the lower margin of *Irish and American Bar* (cat. no. 97). However, the early posters again set the precedent. Most often Lautrec used the primary colors, red, blue, and yellow, with black or olive green for the keystone, that is, the first printing stone on which the outlines of the image were drawn. Although chromolithography by his day had the sophistication to print dozens of colors

for one print, Lautrec usually chose four or five, occasionally used six (the 1899 *Jockey*, cat. no. 77) and only on rare occasion expanded to eight colors, for example the 1895 lithograph of Marcelle Lender (cat no. 42), which was printed in an olive-green keystone, with color stones (one for each color) in yellow, red, dark pink, turquoise-green, blue, grey, and yellow-green. Usually, however, coloristic effects were created by subtle juxtapositions of a few colors and modulations of *crachis*.

This is as far as Lautrec's direct activity on the lithographic stone went—drawing, the application of patterns, spatter, and areas for color. His last mark to be considered, which was placed directly on the stone and printed along with the image, was his signature or monogram or both. The *Moulin Rouge* is among the very few early works that bear a printed signature alone; thereafter Lautrec regularly used the famous chop mark which combines his initials HTL *à la japonaise* (fig. 37).[4] Beginning in 1895, he often placed his monogram within a little elephant (fig. 38), a device which has been related to the huge wooden elephant in the garden of the Moulin Rouge (fig. 13) and to a statuary elephant which appeared in Lautrec's design for an 1894-95 theatre program.[5] However, his fascination with elephants can be seen in drawings made as early as 1874, rang-

Fig. 34 Henri de Toulouse-Lautrec, **Divan Japonais** (detail), 1893, cat. no. 90.

ing from scatalogical cartoons to naturalistic descriptions. The elephant monogram appears to have been based on a long-standing, personal meaning, but its precise significance is unexplained.[6]

In addition to the *printed* monograms, a red monogram was sometimes stamped on the finished lithograph. Lautrec used a bright red-orange ink, for example the stamp in the lower right of *Ida Heath at the Bar* (cat. no. 36), and on a few occasions, a blue stamp (cat. 60, 62). After his death, his friend, dealer, and executor, Maurice Joyant, used Lautrec's stamp with a dark red ink to mark works remaining in the estate.[7] The red monogram stamp appears on many works in the Baldwin Collection, although by no means all.[8] Many of Lautrec's prints were never signed or numbered outside the stone monogram, and a lack of such in no way detracts from authenticity.[9] The Baldwin Collection does, however, present several examples of Lautrec's pencilled signature (fig. 40).[10]

Various of Lautrec's lithographs have been reproduced, faked, or posthumously re-edited. Reproductions of the *Elles* series appeared as early as 1910 and continue to be produced. These are discernible by the inferior quality of printing, the size and quality of paper, and the lack of proper watermarks.[11] Other tell-tale signs of deceptive reproductions are often known to cataloguers, and Wolfgang Wittrock lists these in the catalogue raisonné of Lautrec's prints. They include such differences from the original as size, inconsistent areas of spatter, uneven registration, or the use of a grey tint stone on the reverse to make the print look old.[12] There are, however, legitimate lithographs which were printed after Lautrec's death from the original lithographic stones. We have included one such re-edition in the exhibition, *Study of a Woman* (cat. no. 13). Printed and published by Henri Floury in conjunction with Maurice Joyant's 1927 book, *Lautrec 1864-1901, Dessins— Estampes— Affiches*, four-hundred impressions of this lithograph bear Floury's monogram (fig. 39), which is clearly distinguishable from Lautrec's.[13]

Lautrec never printed his own lithographs, relying on a number of commercial firms whose names are printed in small type or insignia along the edges of the posters, (fig. 38). The names Bougerie et Cie, Chaix, and Verneau appear on several posters, but Lautrec's primary association was with the firm of Edward Ancourt. Because it used small hand presses, Ancourt printed mainly smaller posters or prints in short runs of *éditions de têtes*, i.e., editions printed before the text was added which were made for the collectors' market. Two outstanding examples in the Baldwin Collection are *Yvette Guilbert in "Columbine to Pierrot"* and the beautiful impression of *The Alarm Bell* (cat. nos. 38, 98.)[14] Nonetheless Ancourt produced several large posters, including *Ambassadeurs: Aristide Bruant* and *Aristide Bruant in His Cabaret* (cat. nos. 83, 88) which, because of their size, were printed on two sheets of paper, the joins clearly visible, while the slightly smaller *Divan Japonais* (cat. no. 90) was printed on one sheet.

Lautrec's favorite printer at Ancourt was Henri Stern to whom the artist regularly dedicated one impression of each edition that Stern printed. The Baldwin Collection presents one of these rare impressions in *Irish and American Bar* (cat. no. 96), which Lautrec inscribed "à Henry TH Lautrec" (fig. 40). It is noteworthy that while Stern obviously printed the small pre-

Fig. 35. Henri de Toulouse-Lautrec, *The Seated Clowness* (detail), from *Elles*, 1896, cat. no. 52.

text edition of 100 impressions, the much longer run of the poster edition was printed by the firm of Chaix (see cat. no. 97). The estimated size of poster editions for commercial use is approximately two thousand (most of which were actually plastered to walls, and thus no longer exist.)[15] Huge steam-driven presses were required for this size of job, which characterized the song sheets, book covers, and theatre programs. Lautrec's stones, if small, were physically transported from the Ancourt presses to another firm capable of printing such long runs, or if large, impressions of each stone were made on paper and transferred to new stones at another printing shop.

Eventually Stern left Ancourt and started his own business; his name alone appears on the late *Jane Avril* poster (cat. no. 108), which was a small, privately commissioned work. Stern, along with his master, Le Père Cotelle, and Auguste Clot were the primary technicians who effected the brilliant results Lautrec and his publishers demanded. Clot is responsible for the superb printing quality of the *Elles* series (see cat. no. 52), and it is primarily quality that remains on the lithographs as the

Fig. 36. Henri de Toulouse-Lautrec, *Irish and American Bar, rue Royale—The Chap Book* (detail), 1895, cat. no. 97.

"mark" of the printer. Color lithography particularly required an expert in making color corrections and in registering the paper. A complex lithograph such as the eight-color *Bust of Miss Marcelle Lender* (cat. no. 42) required separate pulls through the press for each of the color stones, and all exactly aligned with the keystone image. Registration marks, visible in *Lender* and in the upper left corner of figure 36, are one of few technical traces of the printer's procedures and central part in producing the lithographs.[16]

On occasion Lautrec published his own editions, that is, paid the costs for paper, inks, printing, and oversaw the lithographs' sale. But more often he was commissioned to make an image by a publisher who paid for his design, assumed the production costs and distribution, and returned to the artist a percentage of the sales profits. Boussod et Valadon, who took over Goupil & Cie, the famous specialists in reproductive printmaking, published several of the early and late prints; André Marty published the *Café Concert* series (cat. nos. 17-29) and *Supper in London* (cat. no. 63). The journals *La Revue blanche* and *La Plume* published posters (cat. nos. 94, 99); and several music publishers, especially Ondet, were involved in commissioning and publishing Lautrec's images on song sheet covers.

From 1893-95 Lautrec's dealer was Edouard Kleinmann, who both exhibited and published his work. His blindstamp appears on *Mademoiselle Lender in "Madame Satan"* (fig. 41), and he published some thirty lithographs of performers by Lautrec. He also distributed collectors' editions of posters and song sheets printed before the commercial runs were made. For example, the *Jane Avril* poster (cat. no. 85), which was commissioned and published by Jardin de Paris, bears a small text in the lower center, *Depot Chez Kleinmann*, and Ondet's song sheet edition of *Sick Carnot!* (cat. no. 15) bears a faint red stamp advertising Kleinmann's collectors' edition (cat. no. 14).

Evidence of one more of Lautrec's publishers, Gustave Pellet, is recorded on the *Elles* lithographs. It was he who commissioned and published the series in 1896 (cat. nos. 49-61) and despite its financial failure, continued to publish several of Lautrec's 1897 color lithographs. The artist inscribed a caricature drawing of himself made late in 1896 after the fate of the *Elles* had become a fiscal reality (illust., p. 38), "To Pellet, the intrepid

Fig. 37. Lautrec's monogram, from *Guy and Mealy in "Paris on the Move,"* 1898, cat. no. 75.

editor," indicating the publisher's role in supporting his work. Pellet took extraordinary interest in the *Elles* lithographs which he published as a lavish portfolio. More than most of Lautrec's publishers, he assumed an active and esthetic role in directing the production standards and process. He personally oversaw the printing, and numbered, monogrammed, and stamped each impression (fig. 42).

Pellet also had special paper made exclusively for the *Elles* bearing his and Lautrec's names in the watermark. Paper itself plays a significant role in the esthetics of Lautrec's lithographs. While there are various grades of wove paper, Pellet's was of the highest. The paper which appears in figure 41 is a waffle weave paper, on which *At the Maison d'Or* (cat. no. 64) is printed also, while figure 43 shows a detail of a magnificent sheet of laid china paper, as well as the Goupil & Cie blindstamp used by Boussod, Manzi, Joyant, and Cie, indicating that the lithograph was published by Lautrec's friend and dealer, Maurice Joyant. Lautrec's lithographs were often printed on different types of paper, according to the cost of an edition. The regular edition of the *Café Concert* series is on wove paper and the deluxe edition, on japan paper made from the mulberry plant and particulary receptive to ink (cat. no. 20). "Imitation japan" is a smooth yellowish paper made in the west on which *Guy and Mealy* is printed (cat. no. 75), and a detail from *Eldorado: Aristide Bruant* (fig. 44) reveals the typical low-grade wove paper used for most of the posters.

The final marks to be examined are those telling of the prints' purposes and uses—the text of a poster or print which advertises the product promoted. Some of these, such as the words in the top register of *Moulin Rouge* and those of the early entertainment posters, were designed and executed by Lautrec himself. *Irish and American Bar* (fig. 36) is a particularly artistic design which complements the image, although it may not have been designed by Lautrec himself. Others, for example, *At the Foot of the Gallows* (cat. no. 87), suffer from the imposition of mechanical type.

Fig. 39. Henri Floury's monogram, detail from **Study of a Woman**, 1893, cat. no. 13.

The humble character of many of the products advertised in the posters initially would suggest surprisingly commercial ventures for a "fine art" painter and printmaker. Yet most of these commissions either came to Lautrec through his friends and artistic associates, or were thematically related to his interests. Both cases are true in the posters for Victor Joze's novels on the *demi-monde* and the sultry moral atmosphere of Berlin society (cat. nos. 82, 91). Unlike the intellectual writers and editors Lautrec knew at the journals *La Revue blanche* and *La Plume*, Joze wrote in a genre of popular sensationalism, but the subjects of his novels were those explored by Lautrec throughout his career. In other commissions, personal connections played the major part. *The Hanged Man* and *The Alarm Bell* (cat. nos. 81, 98) were commissioned by Lautrec's "home town" newspaper, the *Dépêche de Toulouse*, to advertise serialized nov-

Fig. 38. Lautrec's elephant monogram and the Chaix insignia, detail from **Cycle Michaël**, 1896, cat. no. 104.

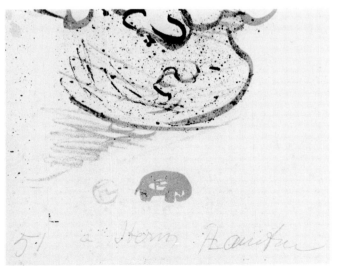

Fig. 40. Inscription to the printer Henri Stern, detail from **Irish and American Bar, rue Royale — The Chap Book**, 1895, cat. no. 96.

Fig. 41. Edouard Kleinmann's blindstamp, detail from **Miss Lender in "Madame Satan,"** 1894, cat. no. 32.

Fig. 42. Gustave Pellet's inscribed monogram and stamp, detail from **Woman with a Tray—Breakfast, Elles**, 1896, cat. no. 53.

els which the paper published. The photographer Paul Sescau (see cat. no. 101) was a close friend of the artist, while André Marty, who commissioned a poster to advertise his line of home furnishings (cat. no. 103), was a long-time publisher of Lautrec's lithographs. Finally, the cycling posters of 1896 (cat. nos. 104, 105) reflect Lautrec's passion for the new sport, and the commission came to him no doubt through his good friend, Tristan Bernard, the most important figure in Paris cycling, whom Lautrec regularly accompanied to the velodromes to watch and sketch the races.

Generally, if a poster were to be hung out of doors and bore the address of the advertiser, French law (although inconsistently applied) required a tax stamp authorizing the display (fig. 44).[18] These are visible on *Moulin Rouge, Queen of Joy, Babylon of Germany,* and *The Simpson Chain* (cat. nos. 80, 82, 91, 105). Years before Lautrec, French law had reserved white posters for official government announcements, and poster artists had long employed spatter to cover large areas of white on their "lay" posters, thus locating the genesis of the esthetic

crachis in the social history of the poster.[19] Similarly the practice of papering poster bills one next to another may stand as a factor behind the extraordinary graphic strength and colors of Lautrec's designs; his work had to actively compete for attention.[20]

Many of the lithographs do not bear text and were intended as works of art for collectors, who in turn left their stamps as evidence. The drawing *Boulou* (cat. no. 3) and print *Playthings of Paris* (cat. no. 78) are stamped with collectors' marks.[21] Poster dealers advertised Lautrec's posters for sale to collectors as early as 1892. These were generally backed with linen and bore no tax stamp,[22] and, as mentioned above, small pre-text runs of posters were issued specifically for the collectors' market. That Lautrec was able to transcend the commercial purposes for which much of his graphic art was commissioned, creating works of art that have stimulated the acquisitive urges of collectors for almost one-hundred years, is evidence of the primacy of his mark on the history of modern printmaking.

Fig. 43. Blindstamp of Goupil & Cie and enlargement of laid paper, detail from **Di Ti Fellow—Englishwoman at the Café Concert**, 1898, cat. no. 74.

Fig. 44. Tax stamp, detail from **Eldorado: Aristide Bruant**, 1892, cat. no. 84.

1. For a synopsis of the lithographic process, see Griffiths, in Wittrock (1985), I, pp. 35 ff; and Felix Brunner, *A Handbook of Graphic Reproduction Processes*, St. Gall, Switzerland, 1962.

2. Although *crachis* has become synonymous with Lautrec, it was first used for esthetic purposes by the master poster artist, Jules Chéret who employed it for its decorative effects and for traditional shading. It was Lautrec, however, who exploited the potential of *crachis* as suggestive of space, light, and atmosphere.

3. Tint stones were also used for *Woman Combing her Hair*, and *Weariness* from the *Elles* (cat. nos. 58, 61) and *Cover for "La Tribu d'Isidore"* (cat. no. 65).

4. Derived from the Japanese signature stamp, the *inkan*, Lautrec's chop tersely summarizes the broad extent of the influences of Japanese prints on his art. His chop is Lugt 1338.

5. Feinblatt (1985), pp. 24, 37, 40.

6. Dortu D. 150-153 and *passim*. The verso of *Boulou* (cat. no. 3) depicts elephants and locomotives. The shadow plays, presented at the Chat Noir, began every evening with Henry Somm's *L' Eléphant* in silhouette. Cate (1986), p. 19.

7. Joyant (1926-27), II, p. 250; Wittrock (1985), I, p. 50. On his death in 1890, Théo van Gogh's place at Boussod et Valadon was assumed by Maurice Joyant, and by 1893 the gallery was called Boussod, Manzi, and Joyant. Joyant was Lautrec's closest friend and supporter, and the first cataloguer of his works; and it was at an exhibition organized by Joyant in 1893 that Lautrec's posters first received serious critical attention. Cate, in Museum of Modern Art (1985), p. 83.

8. For example, cat. nos. 6, 9, 11, 36, 73, and others.

9. Griffiths, in Wittrock (1985) I, p. 43. For example the impression number of *Cycle Michaël* was not entered into the space reserved for it (fig. 38).

10. See also cat. nos. 10, 46, 49, 63, 74.

11. Wittrock (1985) I, pp. 374.

12. See for example, Wittrock (1985) II, p. 776, for reproductions of *Divan Japonais*.

13. Wittrock (1985) I, pp. 74 ff.

14. Griffiths, in Wittrock (1985) I, p. 37. Others in the Baldwin Collection include *Sick Carnot!* (cat no. 14), *Cover for "La Tribu d'Isidore"* (cat. no. 65), and *Irish and American Bar* (cat. no. 96).

15. Wittrock (1985) I, p. 49. Still larger editions remain a possibility.

16. Registration marks are visible in many of the lithographs and posters; see cat. nos. 62, 99, 106 and elsewhere.

17. For further information on Lautrec's publishers, see Cate, in Museum of Modern Art (1985), p. 84.

18. Cate, in Museum of Modern Art (1985), p. 89; and Feinblatt (1985), p. 10.

19. Griffiths, in Wittrock (1985) I, p. 36.

20. See Castleman, in Museum of Modern Art (1985), fig. 2.

21. *Boulou* came from the Séré de Rivière family, probably Georges, who was from Toulouse, a judge, and friend of Lautrec in Paris. *Playthings of Paris* belonged to A. F. Lotz-Brissoneau, a Nantes print collector whose collection was sold in Paris in 1918 (Lugt 83).

22. Cate, in Museum of Modern Art (1985), pp. 89, 92 n. 26.

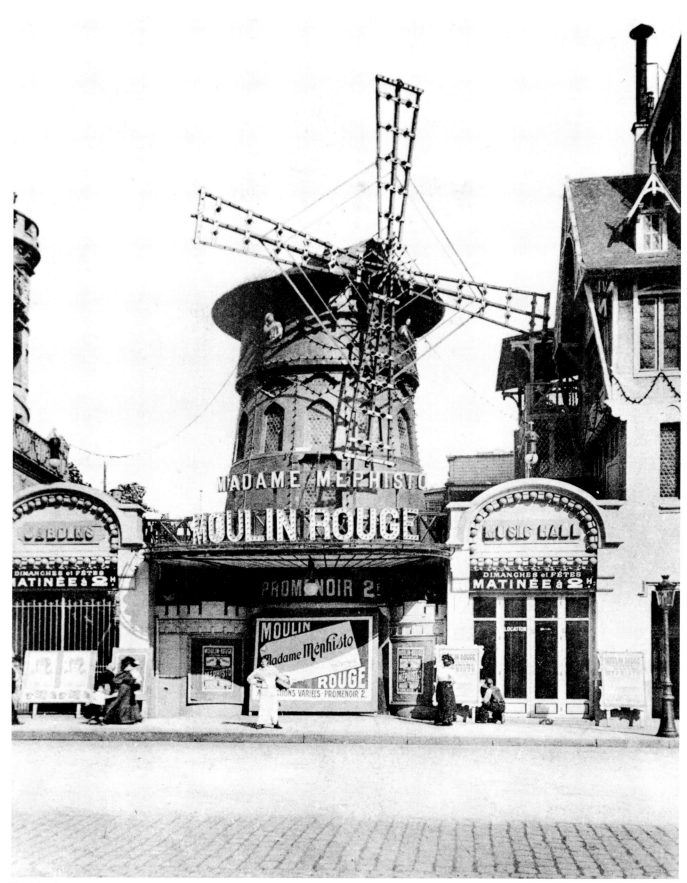

The Moulin Rouge, place Blanche, 90 boulevard de Clichy. (Photo: Ludwig Charell Archive, Museum of Modern Art, New York)

46

Catalogue of the Exhibition
Nora Desloge

D rawings and paintings are grouped together chronologically and catalogued according to M. G. Dortu, *Toulouse-Lautrec et son oeuvre*, 6 vols. (New York, 1971). *Dortu* numbers refer to paintings, drawings, watercolors or ceramics. The order of the prints and posters follows Wolfgang Wittrock, *Toulouse-Lautrec, The Complete Prints*, 2 vols. (London, 1985). W numbers refer to Wittrock and D numbers refer to Loys Delteil, *Le peintre-graveur illustré—H. de Toulouse-Lautrec*, vols. X-XI (Paris, 1920.) Other references are abbreviated, with the author's name and date of publication. Complete citations are found in the bibliography.

Titles are given in English followed by French. Dimensions are in inches, height before width. Provenance, exhibition history, and bibliography other than catalogue raisonné references are cited only for drawings and paintings.

Unless otherwise indicated, all works are donations by the Baldwin M. Baldwin Foundation to the San Diego Museum of Art. The Baldwin Collection has been exhibited partially or in entirety as follows: Municipal Art Gallery, Los Angeles, 1959; California Palace of the Legion of Honor, San Francisco, 1965; San Diego Museum of Art, San Diego, 1972 and 1980. In 1982-84 the San Diego Museum of Art circulated the Baldwin Collection through the Smithsonian Institution Traveling Exhibition Service (SITES).

Drawings and Paintings (cat. nos. 1–10)

1. At the Races
(Aux courses) c.1881-82

Dortu D. 1078
Pen and ink
Stamped with red monogram, lower left
9 x 14-1/4 inches
SDMA 87:14

Collections: Madame Dortu, Paris; acquired by Baldwin M. Baldwin, 1952.

References: Joyant (1926/27), II, p.179. San Diego Museum of Art (1972), cat. no. 1; San Diego Museum of Art (1980), cat. no. 1.

Exhibitions: Los Angeles, 1959; San Francisco, 1965; San Diego, 1972, 1980.

Drawings of animals span the whole of Lautrec's creative life, from casual boyhood sketches of horses and family pets, made when he was fourteen or fifteen years old, to twenty-three lithographs of individual mammals and birds in the set of *Histoires Naturelles*, published in 1899. Outside this series and an occasional cat, only horses and dogs were subjects in themselves. Lautrec's first teacher, René Princeteau, specialized in horse paintings, and his second master, the academic realist Léon Bonnat, had witnessed Eadweard Mybridge's photographic demonstrations of the movements of horses in motion.[1] These artists, and the rich tradition of equestrian themes in nineteenth century French art, represented by Delacroix, Géricault, Meissonier, and Degas, provided Lautrec with ample models in developing his own fascination with the subject.

His first interest in depicting horses stemmed from childhood experiences of being set astride by his father, and from his admiration of that sport-loving, aristocratic father, the antithesis of his crippled son. Count Alphonse had recommended horsemanship to Henri at an early age, and Lautrec's portraits of his father on horseback (Dortu P.91 and P.221) reveal a kindred magnificence of man and mount. Although father and son had their differences in later years, and dwarfism relegated sporting pursuits outside Lautrec's direct experience, horses retained for him something of his boyhood memories and optimism.

Racing in particular interested him, and although scenes of the hunt or driving outnumber his racing themes, on three occasions he concentrated on the track—in 1881-82, in 1895 when he illustrated Romain Coolus' serial novel, *Le Bon Jockey*, and in 1899-1900 when he revived his early equestrian interest in several drawings and lithographs. *At the Races* appears to have been sketched from life at a steeplechase event. Dated 1879-80 by Dortu, it is more probably related to the drawings *The Track* and *At Rest* (D.2418 and 2419) of 1881-82, which possess the same lively calligraphy as our sketch. While earlier drawings depict hunting scenes, this one is related to the 1881-82 paintings of the racetracks at Longchamp and in the Bois de Boulogne.

It is among Lautrec's most assured, cursory renderings of one of his primary interests—the depiction of motion. The wiry line which captures the speed and rhythms of the steeplechase later would describe the steps and kicks of can can dancers (cat. no. 100), or the telling gesture that gives away a personality (cat. no. 38), or the headlong thrust of rider and horse in the masterful climax of equestrian works, the lithograph *The Jockey* (cat. no. 77). This first work of the Baldwin Collection is a schematic prelude to major concerns of Lautrec's art: the depiction of a world in motion; the distillation of images from his own biography; and the portrayal of the leisure pursuits of late nineteenth century Parisian society. Finally, the brilliance of Lautrec's prints lies essentially in his draughtsmanship, providing a direct link between the drawings and lithographs.

1. Stuckey (1979), p.59

2. The Paddock
(Le paddock) c.1881-82

Dortu D.2397
Pencil on paper
Monogram, lower left
6-3/4 x 10-1/4 inches
Verso: *At a Gallop*
Dortu D.2398
SDMA 87:15

Collections: D. Viau; Loliée; Baldwin
M. Baldwin.

References: San Diego Museum of Art
(1972) cat. no. 2; San Diego Museum of
Art (1980), cat. no. 2.

Exhibitions: Los Angeles, 1959; San
Francisco, 1965; San Diego, 1972, 1980.

Perhaps earlier than the previous draw-
ing, this delicate, carefully hatched
sketch of a racehorse and stable boy re-
cords Lautrec's habit of depicting
behind-the-scenes. With extraordinary
economy of line, he contrasted the top-
hatted and composed reviewer on the
left with the bowler-hatted, bow-legged
stable boy leading his horse. Lautrec
deftly varied the pressure of his pencil to
describe small details, such as the
horse's braided mane, taped front legs,
saddle and hood, and by punctuating his
graphic strokes, clearly indicated that
the horse in the right background has
moved into a slow trot. Like *At the Races*
(cat. 1), this drawing is a precursor to the
more fully developed racetrack scenes
from 1899, in particular the
unpublished color lithograph *The Pad-
dock* (W 310).

3. Boulou c. 1891

Dortu D.2681
Pencil on paper
8-1/2 x 7 inches
Verso: *Elephants and Locomotives*
Dortu D.2682
SDMA 87:16

Collections: Comtesse de Toulouse-Lautrec; Georges Séré de Rivières; Libraries Sources; private collection; Baldwin M. Baldwin.

References: San Diego Museum of Art (1972), cat. no. 3; San Diego Museum of Art (1980), cat. no. 3.

Exhibitions: Los Angeles, 1959; San Francisco, 1965; San Diego 1972, 1980.

On several occasions, Lautrec made drawings or paintings of bulldogs (actually bull terriers), the most famous of which was the notorious "Bouboule" of Madame Palmyre, who was the proprietress of the lesbian bar, La Souris, where Lautrec often went in the later 1890s. In 1897 he made an oil sketch and a lithograph of this naughty pooch who was a well-known "personality" in the Parisian café scene.[1] Earlier, in 1891, Lautrec painted another bulldog in profile, the identification of which is made clear by his inscription on the panel, "Boulou, 1891, Toulouse-Lautrec."[2] A third bulldog, a family pet named Tuck (Touc), was the subject of two watercolors and two paintings assigned to 1879-81.[3]

Of the three bulldogs, our drawing must represent Boulou, as both Tuck and Bouboule were male. The wavy line along the belly of the dog represented here describes her as a female (although admittedly this is a fine iconographic point!) Dortu assigned the drawing to c.1882, but it is probably closer to the painting of Boulou which Lautrec signed and dated in 1891.[4] The drawing came down through the collections of Lautrec's mother and the Séré de Rivières family from Albi, so we may assume at least that the engaging Boulou, shown here with tail wagging, was a favorite pet of Lautrec's family (fig. 45).

1. Dortu P.646 and W 186. Bouboule was famous for lifting his leg on the dresses of bothersome patrons at La Souris. Stuckey (1979), p. 275.

2. Dortu P.408.

3. Dortu A.125 and 194 and P.29 and 30.

4. For Dortu's sometimes inaccurate datings, see Murray (1978), pp. 179-182.

Fig. 45. Toulouse-Lautrec and his dogs, probably Boulou and her pup, c. 1891. (Photo: Musée Toulouse-Lautrec, Albi)

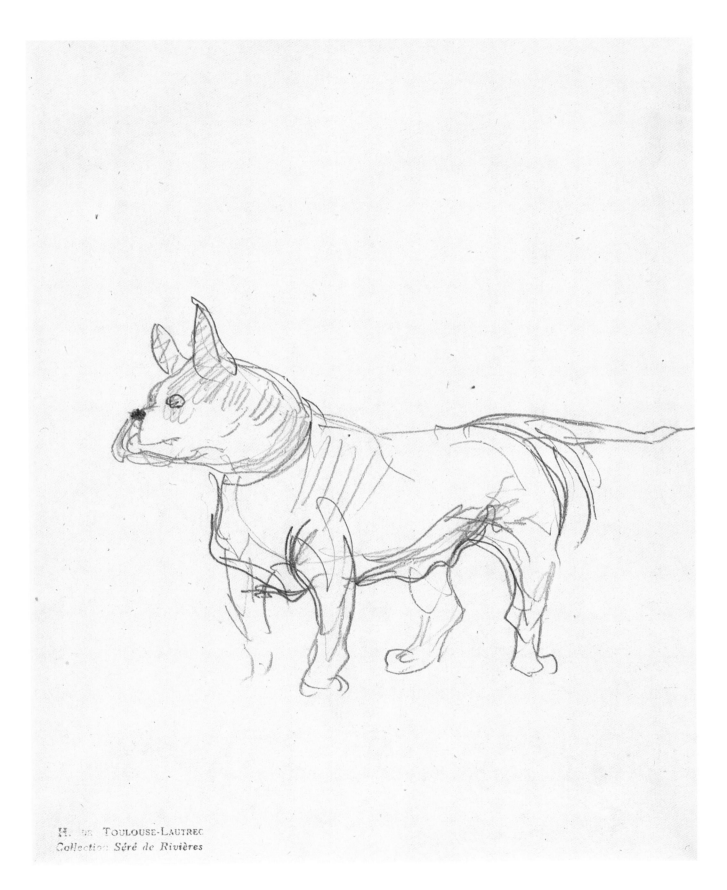

4. Women in Profile
(Femmes de profil) c. 1886

Dortu D.2951
Blue crayon
10-1/4 x 6-1/2 inches
SDMA 87:17

Collections: Madame Dortu; Vigeveno Galleries, Los Angeles; Baldwin M. Baldwin.

References: Joyant (1926/27), II, p.181; San Diego Museum of Art (1972), cat. no. 5; SanDiego Museum of Art, (1980), cat. no. 4 (illust.); cat. no. 5 (entry).

Exhibitions: Los Angeles, 1959; San Francisco; 1965; San Diego, 1972, 1980.

This quick drawing, in which Lautrec barely indicated lines of gesture and then laid in the figural contours with a stronger line, suggests the solicitation of a young girl, with palm held out, from an older, bespectacled lady. It may be a domestic exchange between servants or, more likely, between a proprietress (with her elbows resting on a counter) and a barmaid. If the latter, then this drawing possibly is a study for Lautrec's first published work, the illustration *Gin-Cocktail*, in the magazine *Le Courrier français*, No. 39, 26 September, 1886, in which two women of similar type to ours serve at the bar.

1. See Dortu D. 2965.

5. Women Seen from Behind (Femmes de dos) c.1886

Dortu D.2952
Red and blue crayon
10-1/4 x 6-1/2 inches
Verso: *Head of a Man*, 1881
Dortu D.1945
SDMA 87:18

Collections: Madame Dortu; Vigeveno Galleries, Los Angeles; Baldwin M. Baldwin.

References: Joyant (1926/27) II, p.181; Edouard Julien, *Lautrec-Dessins*, Paris, 1951, ill., plate 4; San Diego Museum of Art (1972), cat. no. 4; San Diego Museum of Art (1980), cat. no. 5 (illust.), cat. no. 4 (entry).

Exhibitions: Los Angeles, 1959; San Francisco, 1965; San Diego, 1972 and 1980.

In the spirit of caricature, Lautrec caught this "Mutt and Jeff" pair of ladies from behind, allowing him to concentrate on the amusing differences in their postures and figures, almost as a backward double-take. Even in finished works he often showed figures from behind or in a three-quarter lost profile. This added spontaneity to his compositions, appearing less posed and placing the viewer in the role of unseen spectator. Our drawing contains the compositional kernel developed in Lautrec's early color lithograph (1892, W 1) in which he set the viewpoint behind the willowy dancer, La Goulue, entering the Moulin Rouge on the arm of her stout sister.

6. The Masked Ball at the Elysée Montmartre (Bal masqué à L'Elysée Montmartre) c. 1887

Dortu D.283
Oil on canvas
Stamped with red monogram, lower left
21-3/4 x 18-1/8 inches
SDMA 87:116

Collections: Georges Bernheim (sold 7 June, 1935, Paris, Vente de Georges Bernheim, no. 57 (F 7800); J. Metthey; Paccitti; Vigeveno Galleries, Los Angeles; Baldwin M. Baldwin.

References: Joyant, (1926/27), I, p.262; Dortu (1971), II, p.128; Sugana (1969), no. 192; San Diego Museum of Art (1972), cat. no. 6; San Diego Museum of Art (1980), cat. no. 6; Adriani (1987), p. 69, n. 1.

Exhibitions: Paris, 1914, Galerie Manzi-Joyant, Toulouse-Lautrec retrospective, no. 187; Los Angeles, 1956; San Francisco, 1965; San Diego, 1972, 1980.

In 1886 Lautrec left his mother's residence in Paris and moved into a fourth-floor studio in Montmartre. A working-class neighborhood on the outskirts of Paris where rents were cheap, Montmartre was home to artists, writers, and theater people, and was the address of several *café concerts* and public dance halls which Lautrec frequented—the Mirliton (cat. no. 89), the Moulin Rouge (cat. no. 80), the Divan Japonais (cat. no. 90), the Moulin de la Gallette and the Elysée Montmartre. The latter two *bal publics* were the settings of Lautrec's first painted records of the gay Montmartre night life.

Dortu, following Joyant (I, p.262), identified our painting with several others depicting the Moulin de la Galette; however, it belongs to a group of four works showing vignettes of a masked ball at the Elysée Montmartre.[1] A drawing of the painting in Musée d'Albi (fig.46; Dortu D.2960) clearly shows that the woman in the foreground is unconventionally dressed in leotard and tights, the cap of an *apache* (a hooligan), and wears a mask. Although Joyant did not connect the drawing with the Baldwin painting, he recognized that the woman is in costume and titled the drawing *Bal masqué*.[2]

The most risqué of the bals masqués, the Bal des Quat'z' Arts of the art students was only one of the costume events which took place in Paris. The Opera Ball required disguise, and the Bal du Courrier français had a different theme each year. In 1889 Lautrec went as a choirboy (fig. 15). From 1887-94, the Society of the Incohérents, a self-proclaimed ridiculous but artistic society, held its annual bal masqué at the Elysée Montmartre, and it is likely that Lautrec recorded its inaugural event in this painting. His penchant for dressing up would have made a costume ball at the immense Elysée an irresistible spectacle.[3]

Typical of the artist's early style, more like drawing than painting, the hastily scrubbed strokes of this thin oil sketch describe in a blur of movement masqueraders pressing into the thick interior atmosphere, where a glare of light silhouettes their figures. Rather than individualized description, Lautrec instead chose to capture the hurried, jostling anonymity of the crowd. By 1890 he would refine the energetic, hatched brushwork and schematic representations of the dance hall to create the monumental paintings, *At the Moulin de la Galette* (1889, The Art Institute of Chicago) and *The Dance at the Moulin Rouge* (1890, McIlhenny Collection, Philadelphia Museum of Art.) The Baldwin painting also holds the beginnings of crowds set in motion and silhouetted against light, developed in the 1891 poster *Moulin Rouge—La Goulue* (cat. no. 80), and stands at the head of stylistic and thematic concerns that would dominate Lautrec's entire career.

1. Dortu P. 284-286, 301. Dortu titled the Baldwin painting *At the Moulin de la Galette.*

2. Joyant (1926-27), II, p. 188. The drawing's clear outlines suggest that it was made after the painting's execution, perhaps intended as preparation for a magazine illustration. Like other drawings of scenes from the *Elysée Montmartre* (Dortu D.2969, 2974), this one is on tracing paper. See also Adriani (1987), pp.62ff.

3. For more on the dance halls, see Cate, above, p. 34.

Fig. 46. Henri de Toulouse-Lautrec, **Masked Ball**, c. 1887, black chalk on tracing paper, 25-7/8 x 20 inches, Musée Toulouse-Lautrec, Albi.

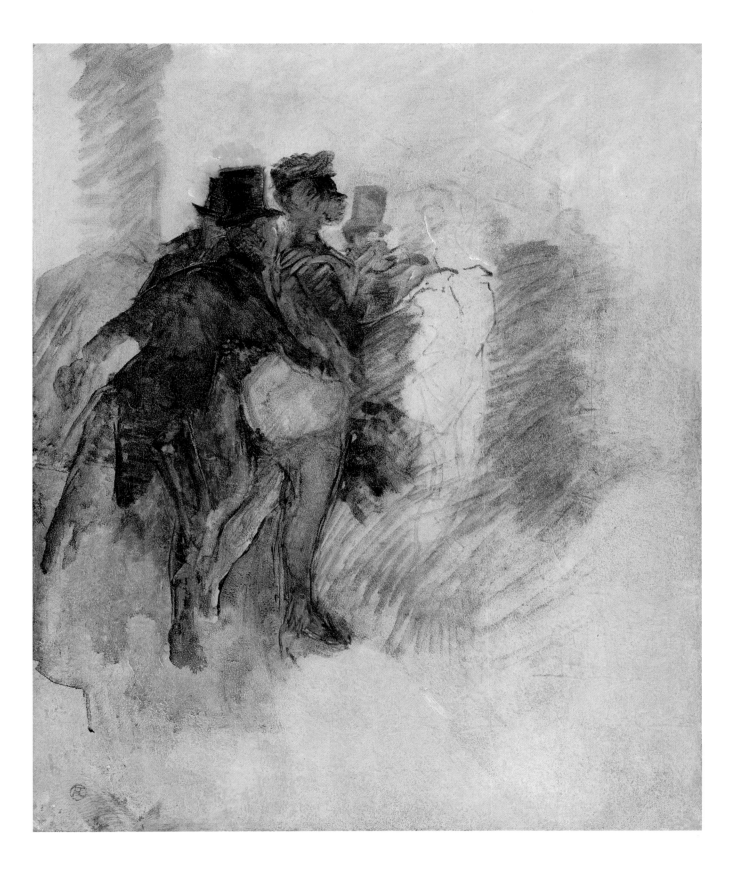

7. The Side Show
(La parade) 1894

Dortu D. 3691
Ink on paper
Stamp of the sale of Thadée Natanson
(*T. N.—H. T. L.*)
9 x 14-1/4 inches
SDMA 87:50

Collections: Thadée Natanson; sold 27 November, 1953, Paris, Vente de Madame Natanson, no. 117 (F 150,000 — M. Prost); Prost; Baldwin M. Baldwin.

References: Thadée Natanson, Toulouse-Lautrec, *Labyrinthe*, 1 June, 1946; San Diego Museum of Art (1972), cat. no. 38; San Diego Museum of Art (1980), cat. no. 38.

Exhibitions: Amsterdam, 1947, Stedelijk Museum, *Toulouse-Lautrec*, no. 90; Brussels, 1947, Palais des Beaux-Arts, *Toulouse-Lautrec*, no. 90; Los Angeles, 1959; San Francisco, 1965; San Diego, 1972, 1980.

This quick sketch records one of the many side shows (*parades*) which took place in the Paris streets or fairs. A muzzled bear, its "military" trainer with a long sword, and a clown line up on a small stage looking out toward the audience. (Cf. Cate above, pp. 31 ff.).

8. Head of a Prostitute
(Tête de femme de maison) 1894

Dortu D.3739
Red and blue pencil
Signed with initials
5-1/2 x 8-1/4 inches
SDMA 87:52

Provenance: Galerie Gailac, Paris;
Vigeveno Galleries, Los Angeles, 1970;
Baldwin M. Baldwin.

References: San Diego Museum of Art
(1972), cat. no. 39; San Diego Museum
of Art (1980), cat. no. 40.

Exhibitions: San Diego Museum of Art
1972, 1980.

In 1893-94 Lautrec began to turn his attention to the *maisons closes*, the brothels. Particularly the house in rue des Moulins became the focus of his artistic study and also the place where he may have resided from time to time. Our drawing is dated 1894, the same year as Lautrec's magnificent painting, *In the Salon, rue des Moulins* in Musée d'Albi. Like this one, most of the preparatory drawings for the painting were made in blue and red crayon or pencil, many of which are portrait studies of individual prostitutes.

The subject of this drawing, with its pert, snub-nosed profile, is probably Lautrec's favorite, the red-haired Rolande. He drew and painted her many times, and a comparison with an oil study of Rolande for the finished painting (Dortu P.558) reveals the same wide-open eyes and a strikingly similar profile to that drawn here (fig. 47). The drawing surely was made from life; its simple lines and expressive spontaneity are signs of an on-the-spot sketch.

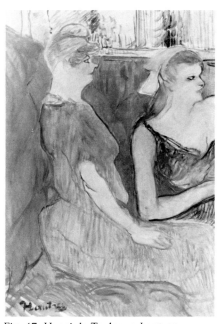

Fig. 47. Henri de Toulouse-Lautrec,
Study for In the Salon, rue des Moulins, 1894, oil on canvas, 15-7/8 x 23-15/16 inches, The Armand Hammer Foundation, Los Angeles.

9. At the Hanneton
(Au Hanneton) 1898

Dortu D. 4389
Pencil on paper
Stamped with red monogram, lower left
7-3/8 x 4-1/2 inches
SDMA 87:98

Collections: Mme. Jeanne Aaron, Paris; Vigeveno galleries, Los Angeles; Baldwin M. Baldwin.

References: Joyant (1926/27) II, p. 228; San Diego Museum of Art (1972), cat. no. 87; San Diego Museum of Art (1980), cat. no. 87.

Exhibitions: Los Angeles, 1959; San Francisco, 1965; San Diego, 1972, 1980.

The Hanneton (June Bug) was a brasserie in the rue Pigalle, frequented by lesbians and run by the mannish, one-eyed Armande Brazier. Our drawing is a preliminary sketch of one of the bar's patronesses. The end result, the 1898 lithograph *Au Hanneton* (W 296), shows a lady in a large hat and ruffled collar, seated on a banquette with her back to a mirror (fig. 48). In the preparatory drawing Lautrec indicated the mirror and back of the banquette, as well as the fluffy sleeves and tilt of the elaborate hat.

One hand is raised and the other rests on the table, the edge of which is suggested by a single diagonal line.

The lovely, delicate lady of the lithograph, whose efforts to mask the signs of age with ruffles and frills Lautrec portrayed so sympathetically, is clearly not the full-figured Madame Brazier, with whom Dortu mistakenly identified her.[1] Our extremely schematic drawing was probably Lautrec's first sketch of his subject, details of which can be seen developing in three related drawings

(Dortu D. 4347, 4387, 4388). Already, however, he conveyed a primness of posture and slightly self-conscious attitude, adding a note of empathy to the dispassionate portrayal of women alone in the bar scenes of Degas, which were Lautrec's generic models.

1. In 1897 Lautrec portrayed Brazier in a painting (Dortu D. 651) and color lithograph (W 177), both titled *The Large Theatre Box*, in which she wears the masculine style of dress seen in *The Promenade* (cat. no. 76).

Fig. 48. Henri de Toulouse-Lautrec, *At the Hanneton*, 1898, lithograph printed in violet-black, 14-1/8 x 10-1/8 inches, Collection, The Museum of Modern Art, New York, Gift of Abby Aldrich Rockefeller.

10. Red-Headed Nude Crouching
(Femme rousse nue accroupie) 1897

Dortu P.649
Oil on cardboard
Signed "H. T. Lautrec 97," lower left
18-1/4 x 23-5/8 inches
SDMA 87:115

Collections: Gustave Pellet; Maurice Exsteens [Pellet's son-in-law, an art dealer]; Mr. and Mrs. Baldwin M. Baldwin.

References: H. Esswein, *Henri de Toulouse-Lautrec*, Munich, 1916, p. 13, ill., as *Aktstudie*; A. Brook, "Henri de Toulouse-Lautrec," *The Arts*, September 1923, ill. p. 165; Joyant (1926), I, p. 296, ill. opposite p. 116; R. Huyghe, "Aspects de Toulouse-Lautrec," *L'Amour de L'Art*, IV (April 1931), pp. 143-157, fig. 60; MacOrlan, "Lautrec," *Floury*, 1934, ill.; E. Schaub-Kock, *Psychanalyse d'un peintre moderne*, ed. Litt. International, 1935, p. 191; E. Rougerat, *Drogues et peintre* No. 14-T.-Lautrec, Innothera c. 1938, ill. 13; J. Bilbo, *Toulouse-Lautrec and Steinlen*, London, 1946, clr. ill. opposite p. 9; J. Lassaigne, *Toulouse-Lautrec*, Paris, 1946, ill. p. 133; R. Cogniat, ed., *Orientations de la Peinture française de David à Picasso*, Nice, 1950, ill. 107; M. G. Dortu, *Toulouse-Lautrec*, Paris, 1952, pl. XV; F. Jourdain and J. Adhémar, *Toulouse Lautrec*, Paris, 1952, ill. p. 89; J. Lassaigne, *Le goût de notre temps—Lautrec*, New York, 1953, p. 98; Cooper (1966), p. 140, ill. p. 141; Dortu (1971), I, p. 109 and ill., P.649, ill.; San Diego Museum of Art (1972), no. 85; Sugana (1969), no. 461a, p. 116; Stuckey (1979), p. 281, ill. p. 280; San Diego Museum of Art (1980), no. 86, ill.; Adriani (1987), p. 218, n. 1.

Exhibitions: Paris, Musée des Arts Decoratifs, April-May 1931, *Toulouse-Lautrec, trentenaire*, no. 162, ill., pl. 13; Paris, Galerie Durand-Ruel, 1932, *Quelques oeuvres importantes*, no. 54; Basel, Kunsthalle, 1947, *Toulouse-Lautrec*, no. 178; Amsterdam, Stedelijk Museum, 1947, *Toulouse-Lautrec*, no. 50; Brussels, Palais des Beaux-Arts, 1947, *Toulouse-Lautrec*, no. 50, (Zurich and Geneva, 1947, no. 50); Paris, Galerie Bernhein-Jeune, 1948, *La Femme*, no. 90; Paris, Musée de l'Orangerie, Louvre, 1951, *Toulouse-Lautrec, cinquantenaire*, no. 70; San Diego Museum of Art, 1972, no. 85; The Art Institute of Chicago, 1979, *Toulouse-Lautrec: Paintings*, no. 91; San Diego Museum of Art, 1980, no. 86.

Three times in 1897 Lautrec painted a red-headed model posing in his studio: the nude reclining on a divan, in The Barnes Foundation (Dortu P.648); the nude seated on a divan with her back turned (private collection, Switzerland; Dortu P.650); and the Baldwin Collection's nude crouching on a divan (Dortu P.649). Although finished paintings, they may be called studies from the utter lack of any other contentual pretense than that of a posed nude. All three works share a common conception, palette, and brushwork, and in each Lautrec used the same studio props of a daybed covered with a blue-and-white patterned throw and furry white skin. These can be seen on the extreme right in the photograph of Lautrec working in his studio in rue Caulaincourt (fig. 3), and he must have taken them with him in May 1897 when he moved to avenue Frochot.[1]

Narrative and genre elements are entirely absent from the three avenue Frochot nudes, and despite the model's frank position in our painting, suggestiveness is markedly underplayed. Lautrec's concentration focused instead on the most abstract elements of painting—light and modeling, color and pattern, and spatial dimensionality. It is as if, having just moved into his new (and last) atelier, he determined to return to the basics of painting, to make a new start.

Women in various stages of undress appear throughout his oeuvre, but Lautrec had not painted the nude in the formal tradition of academic study since his early years as a young artist in Bonnat's and Cormon's studios (for example, the 1883 *Nude Seated on a Divan*, Musée d'Albi, Dortu P.170). While the Baldwin painting possesses the integration of subject, setting, and style which derives from the experience of a mature artist knowledgeable in the elements of his craft, there is also a studious mode and mood in this work, bordering on that of an exercise undertaken by Lautrec as a means to push his art forward. It therefore stands in an important position in the chronology and development of his work.

The painting is a loose mosaic of opalescent colors and brushy patterns. Its pastel color scheme and pictorial unity are new in Lautrec's work, in contrast to the strong colors and independent shapes of his earlier paintings. An overall tonality of soft blues, white, violet, green, and coral dapples the background and also models the figure which, like a great pearl, reflects the surrounding colors on every contour. Like many of Lautrec's works, this one is painted on tan cardboard, a medium he had used routinely as an equivalent of flesh. Here, however, it is fully exploited as a warm undertone suffusing the entire painting. A similar conceptual broadening is found in the nude's spatial orientation. The dramatic perspective and croppings, which gave such a high degree of spontaneity to earlier figural works, are replaced by a discreet spatial tension in the model's slight angle to the picture plane. Lautrec, then, consciously deleted many of the "modern" devices of his compositional vocabulary for more traditional values.

The three nude studies of 1897 have been related to Japanese Shunga prints which Lautrec was known to have admired and collected, and certainly by this date *japonisme* had become part of his artistic idiom, but the suggestion that these figures were painted in emulation of the great French tradition of nudes by Fragonard, Boucher, and Degas defines more clearly the spirit in which they were conceived.[2] Following the 1896 publication of the *Elles*, which sold poorly, Lautrec's posters and lithography in general came under critical attack.[3] By returning to painting, in the classic convention of the nude, Lautrec reasserted for himself his status as a true artist.

No posters were produced in 1897, the
Continued on page 68

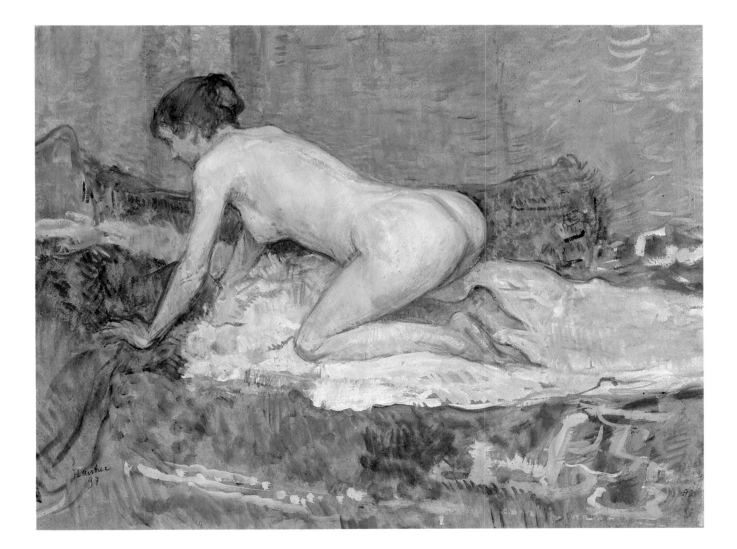

date of this painting, or in 1898, but 1897 was the year when, despite his weakened health, he produced some of his most masterful and painterly color lithographs.[4] The great lithographs of 1898-99 in the Baldwin Collection—*The Pony Philibert, Guy and Mealy, The Promenade,* and *The Jockey* (cat. nos. 73, 75-77)—reveal an increased richness of drawing and a reinterpretation of subjects from his earlier years. The retrenchment evident in these late works, in their more traditional style and thematic recollections, was paradoxically revolutionary. Although from 1897 to 1901 Lautrec's production was severely reduced due to his worsening alcoholism, his moments of brilliance in both printmaking and painting are marked by an artistic maturity which was new, if sporadic.

In paintings such as that depicting Misia Natanson at the piano of 1897 (Kunstmuseum, Bern), or the 1898 *Woman Going to Bed* (from the Phillips Family Collection),[5] there is a consonance of color, pattern, and brushwork, and a reductive concentration on the single figure that develops the painterly exercises of the avenue Frochot nudes. The finale came in 1899 and 1900, in the *belle peinture* of *In a Private Room at the Rat Mort* (Courtauld Institute of Art) and *The Milliner: Mademoiselle Margouin* (Musée d'Albi).[6] At the head of this progression stands the Baldwin Collection's *Crouching Nude,* which records Lautrec's renewed dedication to the art of painting—in defiance of the critics and his own weakened state—and which marks the genesis of his late, last style.

1. Dortu (1971) P.396, following Joyant, identifies the Barnes Foundation nude as in the rue de Frochot atelier. Evident in the background of all three nudes is the *natte* (the straw matting) on the walls mentioned by Francis Jourdain in his description of the housewarming party (the "Fête de Lait"), which Lautrec held on moving into the avenue Frochot studio. Jourdain and Adhémar (1952), p. 77.

2. Cooper (1956), p.140; Sugana (1969), no. 461, p. 116; and Stuckey (1979), p. 281, where the painting is compared to a Degas monotype.

3. Adhémar (1965), p.xxx.

4. *The Large Theatre Box* (W 177), *The Clowness from the Moulin Rouge* (W 178), *Elsa, called the Viennese* (W 180), and *Dance at the Moulin Rouge* (W 181).

5. Dortu P.642 and 678; ill. in Stuckey (1979), cat. nos. 93 and 97.

6. Dortu P. 677, 716; Cooper (1966), pp.144, 148; Stuckey (1979), p. 309.

Lithographs

11. The Milliner, Renée Vert (La modiste, Renée Vert) 1893

W 4 D 13
Brush and spatter lithograph in olive-green ink, color stone in grey-beige on wove paper
Second state with text erased, second edition of 50 impressions
Stamped with red monogram, lower right
18 x 11-1/2 inches
SDMA 87:34

Designed as a menu for a dinner given by the Société des Indépendants on June 23, 1893, the print portrays Renée Vert, a milliner and couturier who was wife of the artist Joseph Albert, one of Lautrec's friends from his student days at the Atelier Cormon. The milliner had entered the iconography of modern painting in the 1870s and '80s with works by Manet, Degas, and Renoir, and thus Lautrec's image would have suggested a familiar theme among the masters of the Indépendants. It even may have been a specific tribute to his hero Degas.[1]

Originally, the menu (which included everything from soup to cognac) was printed in the empty area on the left, beneath the top of the counter. In the second state, the menu was erased, with the single exception of the final "l" of *haricots verts à maitre d'hôtel,* visible in our impression immediately to the left of the counter's vertical edge at the level of the hatbox.

It was usual that the lithographs which Lautrec made for specific purposes—as advertisements, menus, or song sheets—were published either before the text was added (an *édition de tête*) or after the original run, when the text had been erased. The latter is the case here, and Lautrec's dealer, Edouard Kleinmann, published this lithograph in 1893 for sale to collectors.

1. Adhémar (1965), p. xvii.

12. *The Old Stories*, cover-frontispiece (*Les Vieilles Histoires*, couverture-frontispice) 1893

W 5 D 18
Crayon lithograph in olive-green ink on
wove paper
First state, first edition of more than 100
impressions
13-7/8 x 12-1/4 inches
SDMA 87:40

This lithograph was created as the cover of a volume of poems by Jean Goudezki (Jean Goudey), set to music by Désiré Dihau. Lautrec illustrated five poems in the series, which was issued by the sheet music publisher Georges Ondet. The cover image—intentionally ludicrous—shows Dihau leading a muzzled bear representing Goudezki across the pont des Arts toward the august Institut de France.[1] Visible on the horizon is the Eiffel Tower, only five years old at the time, and the dome of Les Invalides. A hot-air balloon flies in the distance above lamp posts along the Seine, where a barge is moored. This charming landscape, rare in Lautrec's work, contrasts monuments of old Paris with emblems of her modernity, a subtle but ironic implication that the "bridge of the arts" which musician and poet intend to cross leads to a relic of times past.

Désiré Dihau was a musician and composer who played the bassoon in the orchestra of the Paris Opera with whom Lautrec was friendly, often visiting his home to see paintings by Degas. Although a serious musician, Dihau, along with Maurice Donnay and others supplied musical scores for poems by Goudezki, Hector Sombré, and Achille Mélandri which were created for the *café concert* trade. This was a brisk business in the mid-1890s; about 275 *café concerts* in Paris presented 10-15,000 new songs a year.[2] The best of these were published, and Lautrec, as seen by the sampling in this exhibition, illustrated many (cat. nos. 12-16, among others.)

The title *Vielles Histoires* (Old Stories) harks back to the village ancestor of the Parisian *café concert*, the *viellée*, a peasant amusement which involved games, meals, and story-telling. Theodore Zeldin points out that the enjoyment of this home-made amusement lay in repeating stories and folk-tales well known to all.[3] As new songs were a constant by the 1890s, those gathered in this series took on the luster of "old favorites" through the album title.

1. See Cate, above p.32.
2. Mack (1953), p.173.
3. Zeldin (1980), p.350.

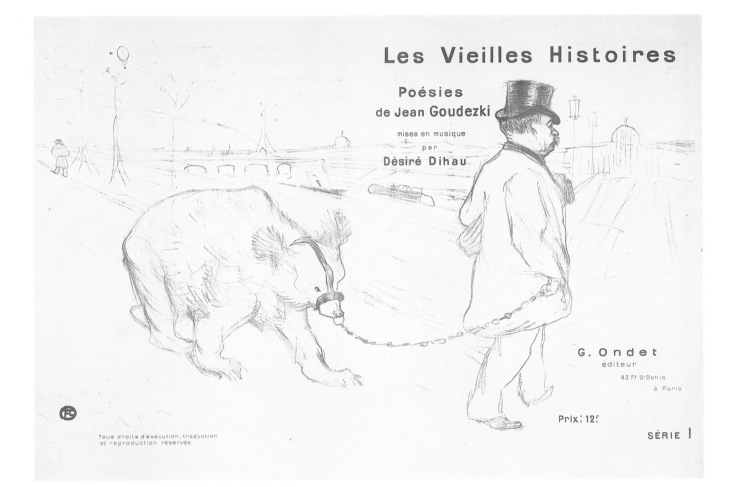

13. Study of a Woman
(Etude de femme) 1893

W 11 D 24
Brush and spatter lithograph in black ink
on wove paper
One state only; 1927 Floury edition of
400 impressions
12-3/4 x 9-7/8 inches
SDMA 87:31

Again, this is a lithograph originally published by Lautrec's dealer, Edouard Kleinmann, and used as a song sheet in Ondet's *Vielles Histoires* (cat. no. 12). Our impression was printed and published by Henri Floury in 1927 for inclusion in the book *Henri de Toulouse-Lautrec 1864-1901 Dessins-Estampes-Affiches* by Maurice Joyant. Each book came with two impressions, one in olive and one in black, of seven Lautrec prints.[1] The image is identical to that of the first edition, with the addition of Floury's monogram to the stone, seen here in the lower left. The preparatory oil sketch of the nude (1893, Musée d'Albi; Dortu P.469) probably depicts a young prostitute from one of the *maisons closes* where Lautrec regularly visited and sought models recorded in his work especially from 1893 to 1896.

1. Wittrock (1985) I, p. 74. See above, p. 41.

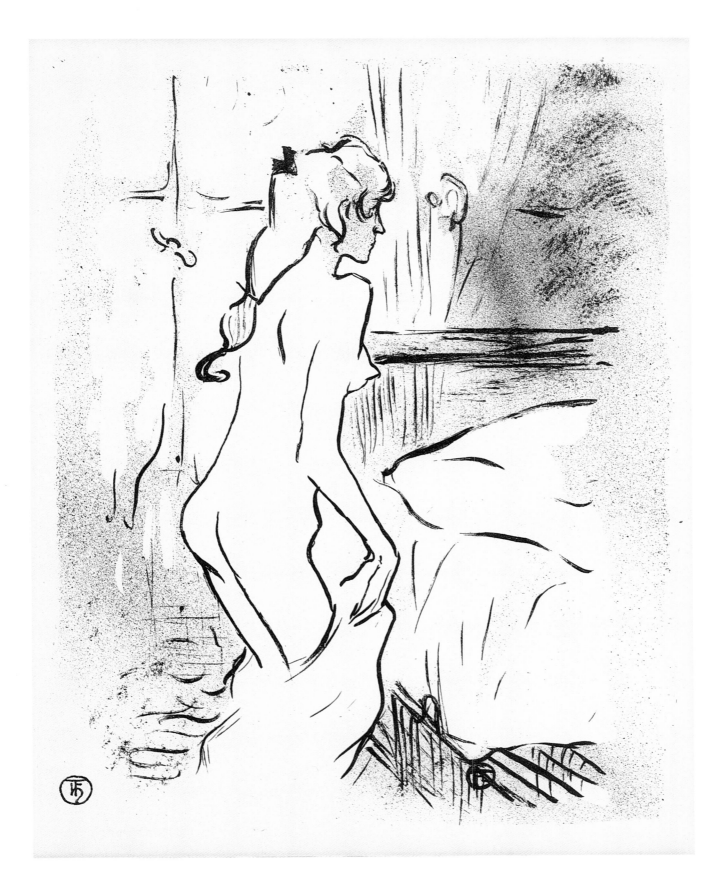

14. Sick Carnot! (Carnot malade!) 1893

W 12 D 25
Brush and spatter lithograph in black ink
with stencil coloring by another hand on
wove paper
One state only; first edition of 100
impressions
9-7/16 x 7-1/4 inches
SDMA 87:29

Carnot malade! was the title of a café monologue satirizing President Sadi Carnot's illness during the summer of 1893 as the government's poor state of health. Here he is shown sick in bed with his "ministers," a doctor taking his pulse and a nun, whose habit looms from the right as a shape of gloom and foreboding. The candle burning down on the night table refers to Carnot's fading life and political term (he did survive this illness but was assassinated in 1894), while the documents slipping off the bed are a reminder of unattended crises of state. Lautrec playfully surrounded the president with frilly linens and topped his night cap with a silly bow.

The two impressions of this lithograph in the Baldwin Collection provide a good illustration of Lautrec's dual avenues of lithographic publication and sale. The present impression is from the edition published by Kleinmann without text, printed for sale to collectors. The song sheet edition (cat. no. 15), published by Ondet, used the same image, transferred to other lithographic stones for printing, and carries the title of Eugène Lemercier's monologue, plus other details concerning it. Just above Lemercier's name, however, is information on the original edition for sale at Kleinmann's. Thus the print was marketed to two distinct audiences, and advertising of the first (collectors') edition was built into the song sheet edition.

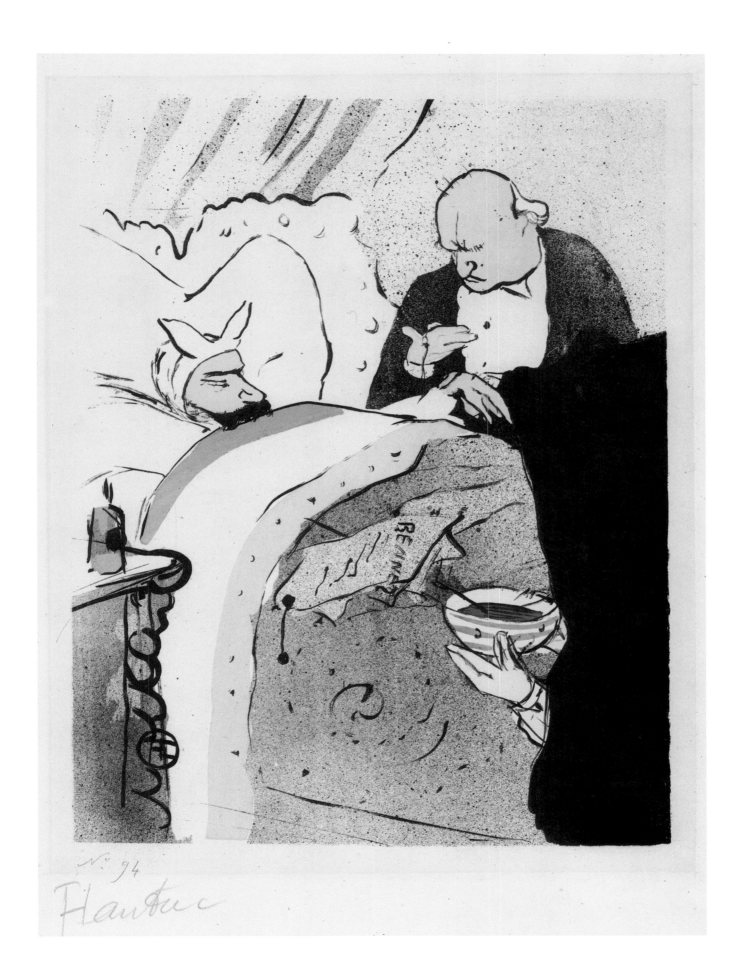

15. Sick Carnot!
(Carnot malade!) 1893

W 12 D 25
Brush and spatter lithograph in black ink
with color stenciling on wove paper
One state only; first song sheet edition,
1893
9-7/16 x 7-1/4 inches
SDMA 87:113

Typical topics of songs and monologues
in the *café concerts* were patriotism and
current politics, adding reversals and sar-
casm as the humorous spice. *Carnot
malade!* was such a monologue (cf. cat.
no. 14). As the text indicates, this routine
was first performed at the Chat Noir, the
cabaret run by Arnold Salis, which was a
famous gathering place for writers and
artists, from Lautrec's earliest days in
Paris to the time of Picasso.

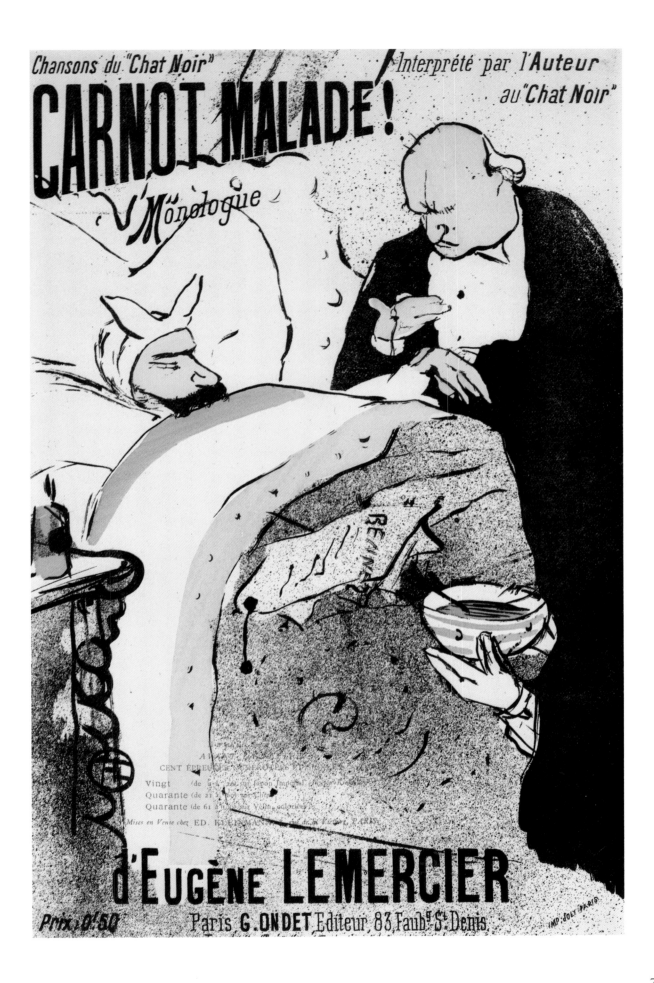

16. The Little Errand Girl
(Le petit trottin) 1893

W 14 D 27
Brush lithograph in olive-green ink with
stencil coloring on wove paper
One state only; third edition after 1901
11 x 7-7/8 inches
SDMA 87:36

In late nineteenth-century Paris, young working women who were out and about the streets were the object of jokes and sexual allusions that entered the routines of café performers. Lautrec, of course, would have known this comic genre from which derived Achille Mélandri's song. This lithograph, made as the cover for the song sheet published by Georges Ondet, shows a *trottin* (delivery girl) scurrying along and casting a flirtatious glance at a fat dandy who winks back through his monocle. The street and also a rather rude innuendo are suggested by the public urinal in the background, a

device employed by Lautrec in a drawing of 1887 in which he explored the same theme (fig. 49 , Dortu D.3001).[1] A more subtle humor is found in the irony of the girl's hatlessness, the emblem of propriety hidden away in the box she is off to deliver.

Mélandri and Lautrec were not the only ones to treat the subject of the *trottin*. In 1898, *La Vie Parisienne* described the errand girls as "young, fresh, and cheaply dressed, but their badly-shod little feet . . . will kick high enough to break down the resistance of every monocle." In the same year the news-

paper *Grand Guignot* published Thomas Chenois' verses:

> They're often the prey
> Of some very indecent propositions
> But they're good girls
> They don't take the plunge,
> The pretty errand girls of
> Montmartre.[2]

1. Published in *Le Mirliton*, February 1887 with the following caption: "How old are you, my girl?" "Fifteen Sir." "Hm. A little too old for my tastes." Mack (1953), p. 100.

2. Adhémar, (1965), no. 18.

Fig. 49. Henri de Toulouse-Lautrec, **In the Street**, 1887, pen and ink over sketch in blue pencil on white board, 18-3/4 x 12-1/2 inches, Sterling and Francine Clark Art Institute, Williamstown.

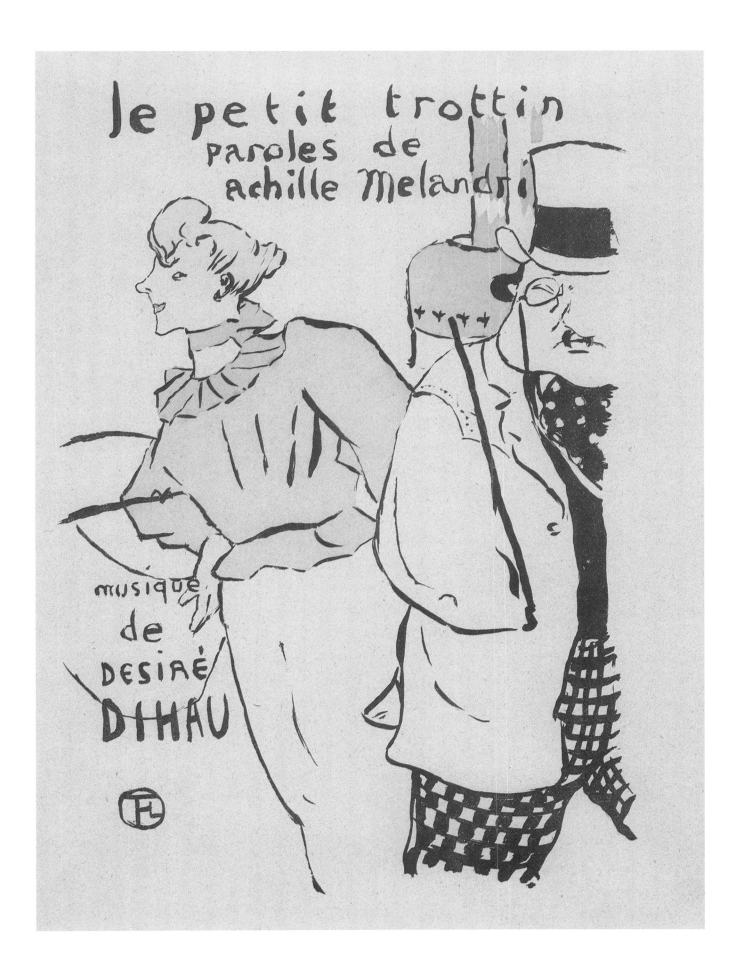

The Café Concert <small>(cat. nos. 17–29)</small>

17. Jane Avril 1893

W 18 D 28
Brush and spatter lithograph in black ink
on wove paper
One state only; regular edition of 500
impressions
10-1/2 x 8-7/16 inches
SDMA 76:185-1 Museum purchase

This is the first of twenty-two prints—eleven by Toulouse-Lautrec, eleven by Henri-Gabriel Ibels (1867-1936)—in the portfolio of lithographs entitled *Le Café Concert*. Published by André Marty, who for several years produced albums of lithographs by Lautrec and his contemporaries,[1] *The Café Concert* was part of a publishing trend of loose leaf "picture books" made by artists for sale to collectors. Unlike their reproductive predecessors, these albums presented original works of art, sometimes thematically oriented, as unique in themselves.[2] The theme of this publication, as indicated by its title, is the Paris cafés which offered entertainment as well as a place to drink, converse, and carouse. Ibels designed the image used on the album's heavy paper cover (fig. 25), and Georges Montorgueil wrote an introductory text, primarily defending the *café concerts* as an entertainment institution for the public good, with a few descriptions of contemporary performers.

Montorgueil facetiously begins by announcing that a master apothecary from Lyons had discovered a new drug—an astringent, tonic, aphrodisiac, digestif, fever-reducer, anti-soporific, and also a musical. This, he says, one of the *"grandes pensées"* of the century, was the *café concert*. It was intended to heal the physical, social, and emotional wounds of everyday life, and it was intended for everyone.[3]

Since the opening of the first *café chantant* in 1848, providing entertainment primarily for a clientele of workmen and clerks, the *café concert* developed and multiplied in the following decades, to its heyday in the 1890s.[4] It became almost synonymous with the spirit and fashions of the age, and, in short, represented "modern life." As such it had entered the subject matter of artists in the 1870s, providing Lautrec with a well-established pictorial tradition from which to draw. Primarily what distinguishes his interpretations from those of Degas and Manet, for example, is his insistent focus on the identity or identifying traits of the performers. This anti-didactic approach to his subjects—depicting them for themselves rather than as anonymous illustrations of *la vie moderne*—is one aspect of the realism and biographical character of his art.

The wide range of *café concerts* in Paris, both geographically and socially, was paralleled by a similar range of talent among the dancers, singers, and comedians who performed in them. The longevity of their fame is often due to Lautrec's posters rather than any memory of their brilliance on stage. Nonetheless, those portrayed by Lautrec and Ibels in this album would have been the most popular at the time, and the two artists researched their subjects at such cabarets as the Petit Casino, the elegant Ambassadeurs, and the noisy former roughhouse, La Scala.

The first plate of the series represents a celebrated entertainment personality who, by virtue of comparison with her peers, can be called a refined talent. Jane Avril (1868-1943) first entered Lautrec's repertoire in 1892. Dancer and artist became close friends, and Lautrec represented her on and off stage for eight years (see cat. nos. 85, 90, 108). She made her stage debut at the Moulin Rouge in 1889 as a self-taught dancer, whose energetic steps won her the nickname *La Mélinite* (an explosive). The poet and *boulevardier* Arthur Symons remembered her as having "an air of depraved virginity,"[5] an effect which she consciously created by the contrast of her wild dances with the girlish bonnets and dresses she wore. Here she is seen on stage in one of these costumes, skirts swirling and little black feet stepping precisely. The distinctive lamps of the Moulin Rouge, recognizable throughout Lautrec's work, establish the setting, and the strong diagonals of the floorboards, a device used by Degas in his ballet scenes, accentuate the dizzying pace of her dance.

1. Cate (1986), p.24; and Cate, in Museum of Modern Art (1985), p. 84.

2. Cate and Hitchings (1978), p. 80; and Ray (1986), pp. 496 ff.

3. Montorgueil (1893), p. 4.

4. Museum of Modern Art (1985), p. 123.

5. Quoted in Adriani (1987), p. 130.

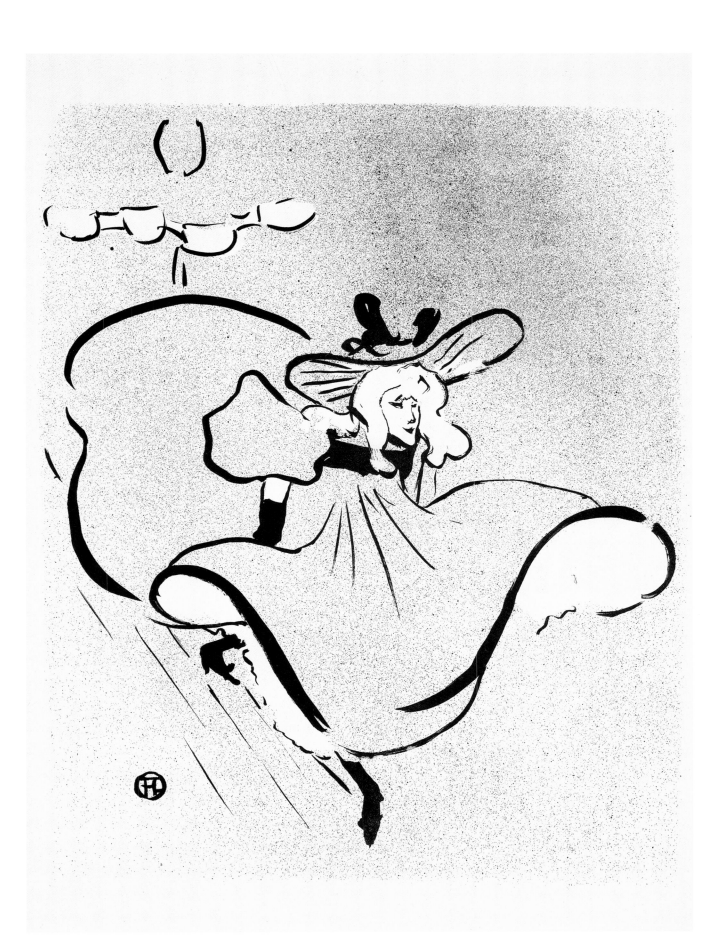

18. Yvette Guilbert 1893

W 19 D 29
Brush and crayon lithograph in
brownish-black ink on wove paper
One state only; regular edition of 500
impressions
9-15/16 x 8-3/4 inches
SDMA 76:185-2 Museum purchase

Perhaps even more than Jane Avril, Yvette Guilbert (1865-1944) was a subject and constant of Toulouse-Lautrec's art and life. One of Paris' most famous performers, she fashioned herself as a gaunt *diseuse* (a reciter of songs) whose vocal style of suggestive, mordant intonation was matched by her repertoire and dress (see cat. no. 40). Lautrec got to know her through the songwriter, Maurice Donnay, with whom she collaborated and whose songs, such as *The Sad Young Man* and *Wounded Eros* (cat. nos. 34, 35), Lautrec illustrated for song sheet covers. In 1894 and 1898 (cat. no. 72), he produced albums of lithographs dedicated solely to depictions of Guilbert in performance.

Yvette Guilbert had style, and Lautrec could never resist pointedly characterizing her as he did here, so distinctive were her face, figure, movements and dress. She constantly complained that he always made her look ugly. In comparison with his other depictions of her, and despite the suggestion of her bony facial structure and skinny neck, this profile flatteringly conveys the intensity of her stage personality, described in Georges Montorgueil's introductory text (see Cate, above, p. 34).

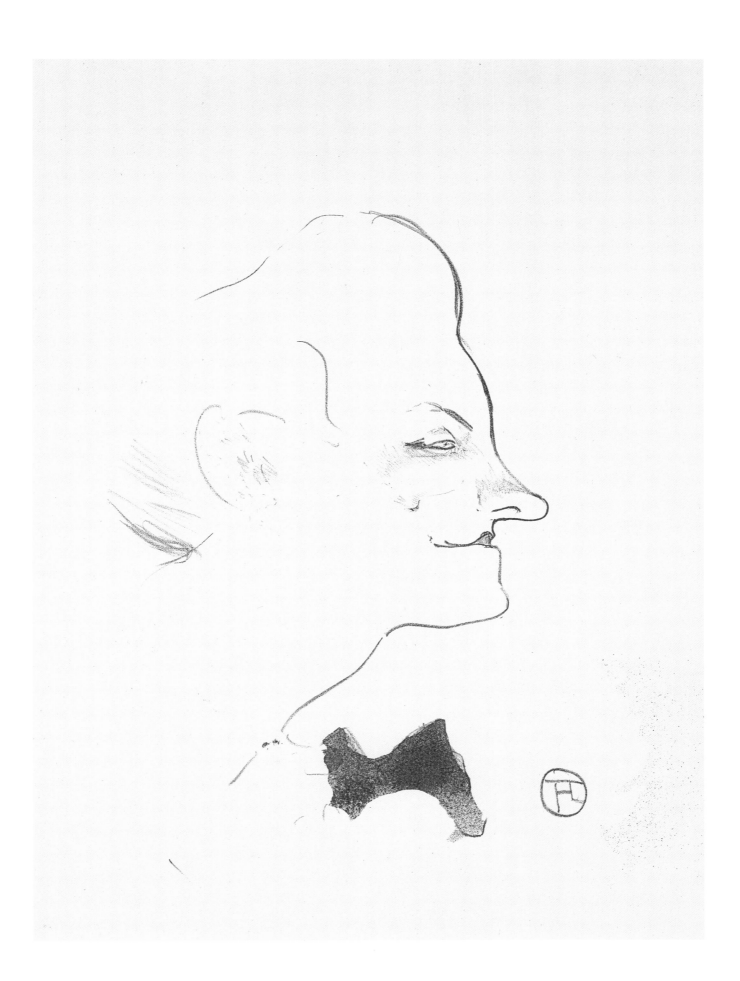

19. Paula Brébion 1893 [Not illustrated]

W 20 D 30
Brush lithograph in olive-green ink on
wove paper
One state only; regular edition of 500
impressions
10-15/16 x 7-3/4 inches
SDMA 76:185-3 Museum purchase

Paula Brébion (born 1860) performed at La Scala, the Eldorado, and Alcazar, singing soldiers' songs in the lisping voice of a little girl while performing contortions.[1] In addition to this plate, she is represented on stage in the background of Ibels' cover illustration for the *Café Concert* album (fig. 25),[2] and the peculiar hand gesture, seen there as well as here, may have been particular to her act. Like Degas' portrayal of the famous singer Theresa, performing "the song of the dog," where she lifts her hands in mimicry of a begging puppy-dog,[3] Paula Brébion's trademark seems to have been an imitation of a petty lieutenant pulling at his moustache and saluting.[4]

Lautrec worked out the clean, sure lines of this lithograph in a black chalk drawing of the same size, which then was transferred to the printing stone as a guide for his brush.[5]

1. Adhémar (1965), no. 30.
2. Cate, above, p. 34.
3. *Au Café Concert, la chanson du chien,* c.1875-77, private collection, U. S. A.; ill. Clark (1984), pl. XXII.
4. Montorgueil (1893), p. 8.
5. Museum Boymans van Beuningen, Rotterdam; ill. in Museum of Modern Art (1985), cat. no. 55.

20. Paula Brébion 1893

W 20 D 30
Brush lithograph in olive-green ink on
laid japan paper
One state only; deluxe edition of 50
impressions
11 x 6-3/4 inches
SDMA 87:35

This beautiful and very rare impression is the third plate of the small, deluxe edition of *Le Café Concert,* also published by André Marty. It differs from the regular edition only in the type of paper, japan rather than wove, and illustrates the contribution made by the paper quality to the esthetic appearance of a print.

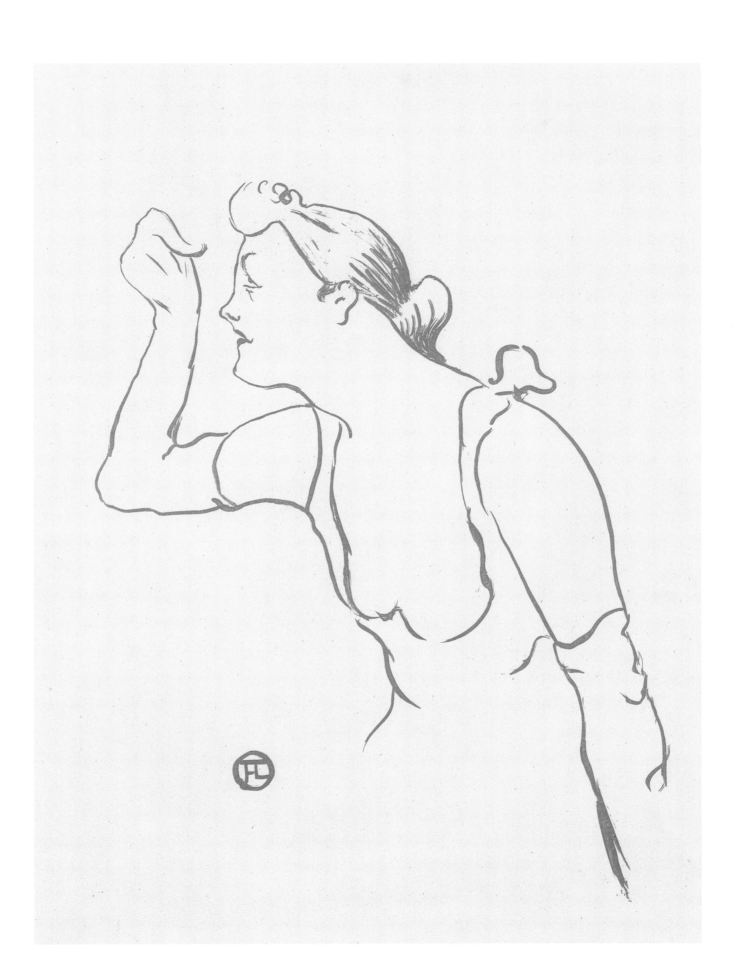

21. Mary Hamilton 1893 [Not illustrated]

W 21 D 31
Brush and crayon lithograph in olive-
green ink on wove paper
One state only; regular edition of 500
impressions
10-9/16 x 6-7/16 inches
SDMA 76:185-4 Museum purchase

Shown onstage with the prompter's
box at her feet, Mary Hamilton was an
English *diseuse* who performed as a
transvestite.[1] In 1894 Lautrec again
represented her onstage in costume
(W 67).

1. Adhémar (1965), no. 31.

22. Mary Hamilton 1893

W 21 D 31
Brush and crayon lithograph in olive-
green ink on laid japan paper
One state only; deluxe edition of 50
impressions
11 x 6-3/4 inches
SDMA 87:33

This impression is another example
from the small deluxe edition of the
Café Concert printed on japan instead
of wove paper.

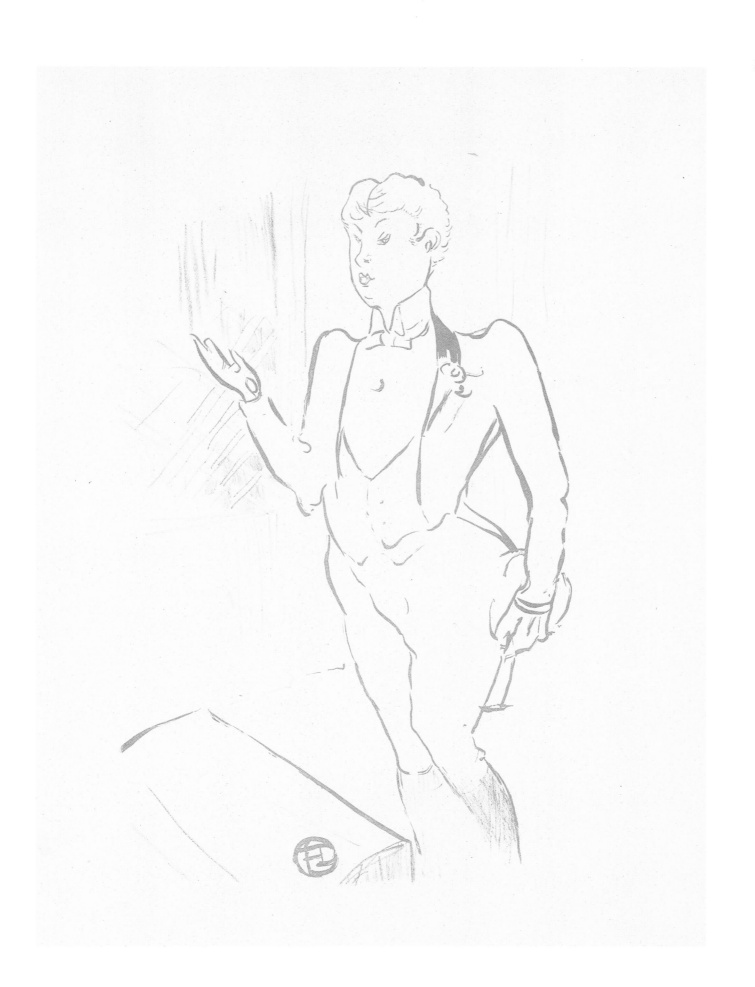

23. Edmée Lescot 1893

W 22 D 32
Brush, crayon, and spatter lithograph in
black ink on wove paper
One state only; regular edition of 500
impressions
10-5/8 x 7-1/2 inches
SDMA 76:185-5 Museum purchase

The fifth plate of the album depicts
Edmée Lescot, a "Spanish" dancer with
castanettes, performing at Les Ambas-
sadeurs.[1] The preparatory drawing is
illustrated in Dortu (1971), D.3426.

1. Adhémar (1965), no. 32.

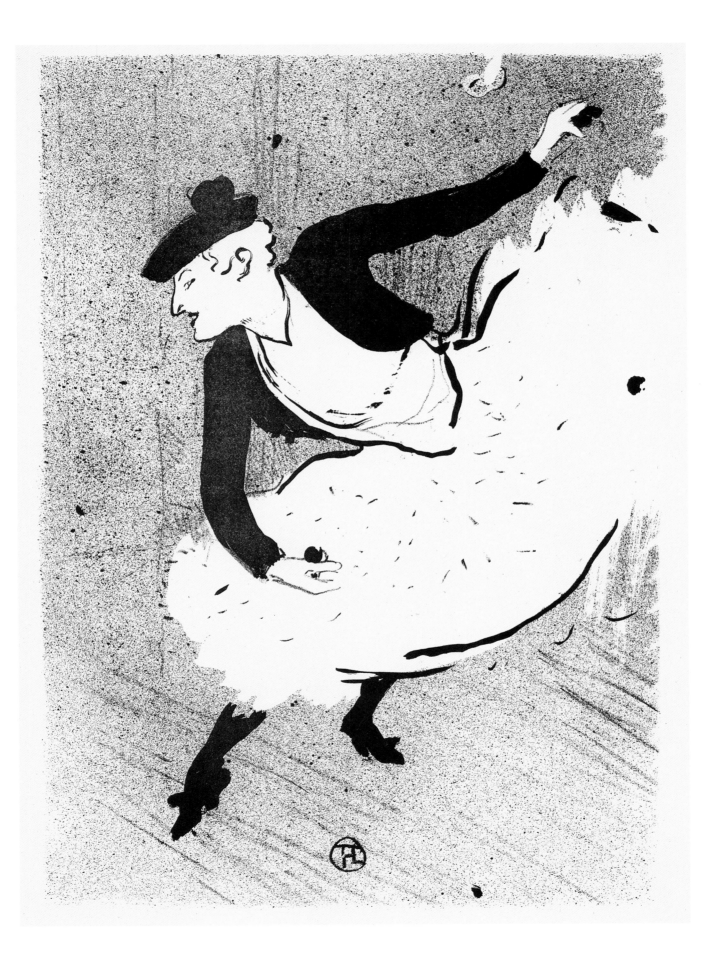

24. Madame Abdala 1893

W 23 D 33
Brush and spatter lithograph with
scraper in black ink on wove paper
One state only; regular edition of 500
impressions
10-5/8 x 7-7/8 inches
SDMA 76:185-6 Museum purchase

Madame Abdala's act was comic inter-
pretations of popular songs which she
performed with facial distortions.
Georges Montorgueil's introductory text
to the *Café Concert* describes her as

> . . . endowed with extraordinary
> scragginess. . . . In a grimacing com-
> petition she would need to win the
> prize . . . her own face would win it
> for her. . . . She does all the things that
> nasty little girls who stick out their
> tongues, squint, make faces, and
> goggle their eyes can think of. . . . She
> takes great pains to make herself ugly.
> . . . Under certain conditions of light
> and shadow Abdala, angular and with
> all her bony structure visible, suggests
> a drawing by Daumier.[1]

To distort her features, Lautrec used the
harsh effects of the footlights, a source
of illumination which he came to exploit
fully in his later prints of the theatre.
The dark blacks were painted on the
lithographic stone with a brush, and the
intermediate tone of grey shadow was
created by spattering the ink from a stiff
brush, while the highlights are the white
of the paper itself.

1. Quoted in Mack (1953), p. 191.

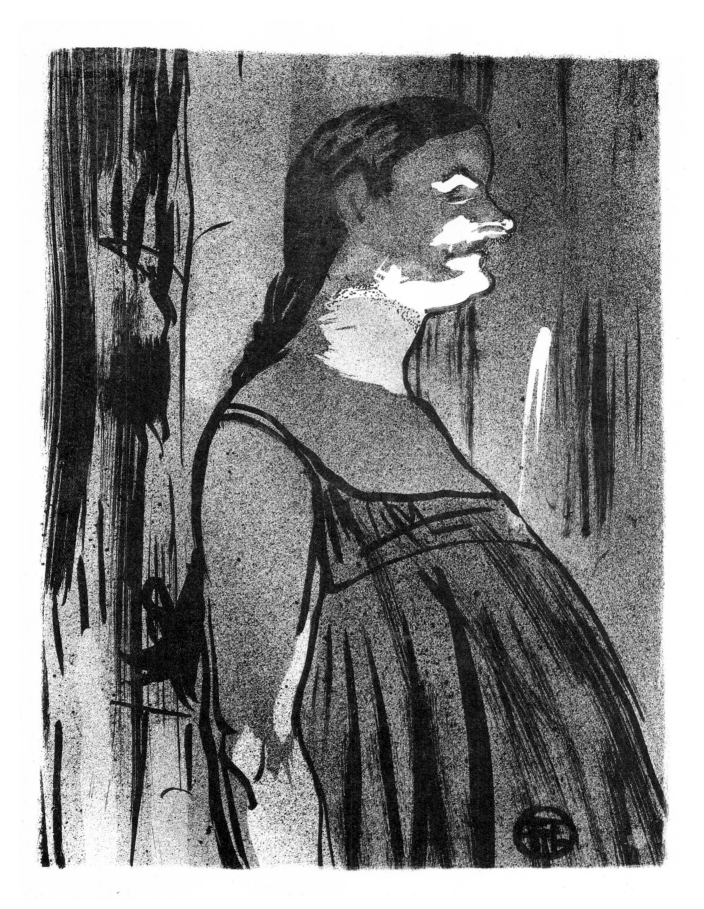

25. Aristide Bruant 1893

W 24 D 34
Brush, crayon and spatter lithograph in
black ink on wove paper
One state only; regular edition of 500
impressions
10-9/16 x 8-7/16 inches
SDMA 76:185-7 Museum purchase

By the time Lautrec made this, the seventh plate of the *Café Concert* series, he had already produced four important posters of Aristide Bruant and knew his subject well.[1] The present image is a variation on the poster for Bruant's performance at the fashionable *café concert* Les Ambassadeurs (cat. no. 83), and it may be that he appears there in this lithograph as well.[2] Unlike the abstractly iconic posters in which the subject's persona is conveyed through assertive design, this depiction is in the manner of a naturalistic portrait. It is the only time in Lautrec's art when the viewer is allowed to look Bruant in the face, to see at close hand the harsh features and surly expression that emerged in his stage personality. Leaning against the door jamb as the viewer "departs" for the carriage waiting in the background, he growls an insulting salutation.

Aristide Bruant (1851-1925) began his career at the old Chat Noir café, which he took over in 1885, renaming it Le Mirliton (the Reed Pipe). There he presided as proprietor and entertainer, writing and singing his own songs in the crude dialect and jargon of the streets. Championing the down-and-out working class was his repertorial theme in songs, jokes, and jibes aimed at abusing his audience. In fact, he made a cult of abusive derision, but juxtaposed his curses and harangues with the human sympathy and sentiment of his lyrics. He was enormously popular, and his songs, published in his magazine which was also called *Le Mirliton* (1885-94), and book, *Dans la rue*, remain as documents of the café crowd's musical taste.

1. See cat. nos. 83, 84, 88, and 89. *The Café Concert* series was registered on 13 December, 1893. Adhémar (1965), p. xviii and xix.

2. Adriani (1987), p. 145.

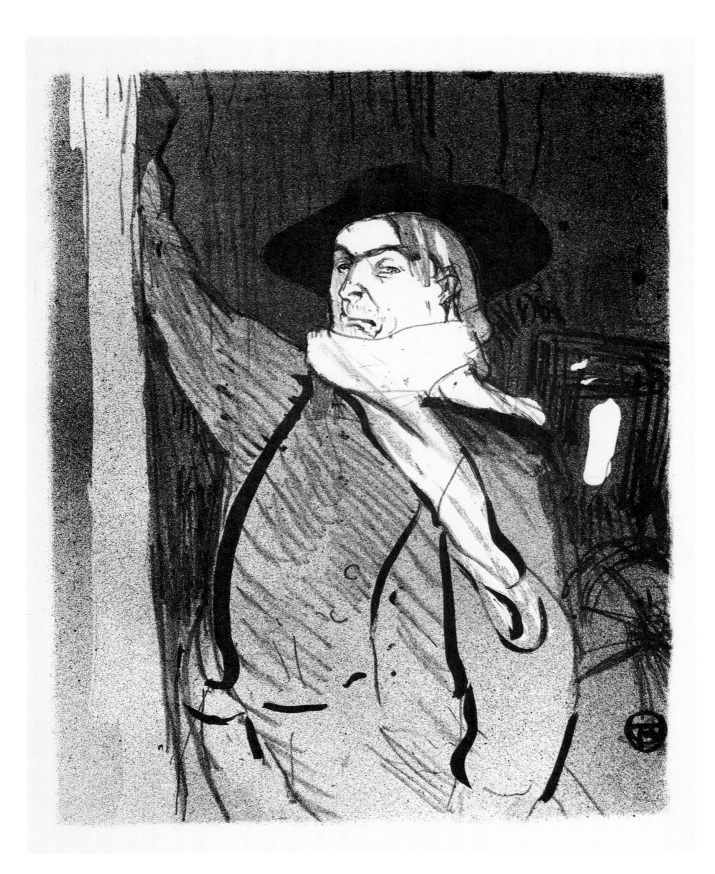

26. Caudieux—Petit Casino 1893

W 25 D 35
Crayon and spatter lithograph with
scraper in black ink on wove paper
One state only; regular edition of 500
impressions
10-13/16 x 8-9/16 inches
SDMA 76:185-8 Museum purchase

There is something quite lovable in "the
infectious élan of this massive bundle of
energy," as Adriani describes the come-
dian Caudieux.[1] The subject of one of
Lautrec's most memorable posters (cat.
no. 86), he is shown dancing a little jig in
his performance at the Petit Casino. The
footlights focus on his pot-bellied torso,
and Lautrec allowed the page to crop his
legs, turning his naturally top-heavy
body into a jolly pinwheel.

1. (1987), p. 142.

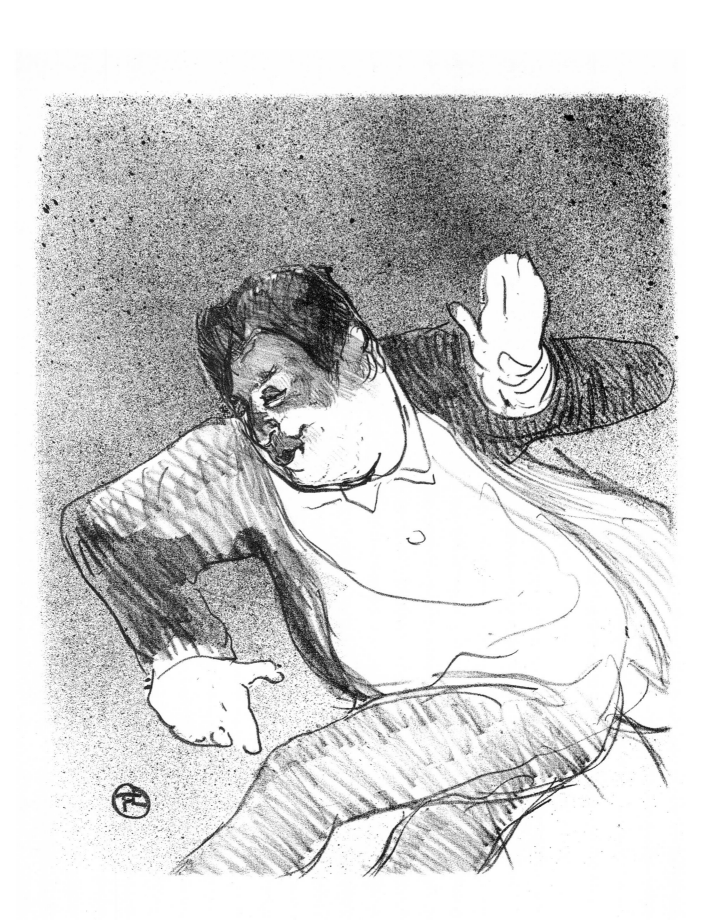

27. Ducarre at the Ambassadeurs (Ducarre aux Ambassadeurs) 1893

W 26 D 36
Brush and spatter lithograph in black ink
on wove paper
One state only; regular edition of 500
impressions
10-1/4 x 7-13/16 inches
SDMA 76:185-9 Museum purchase

Pierre Ducarre was the manager of the
café concert Les Ambassadeurs, who
engaged Aristide Bruant to perform at
his fancy establishment off the Champs-
Elysées when Bruant's reputation had
spread beyond Montmartre. It was on
this occasion in 1893 that Bruant com-
missioned Lautrec for the poster
announcing his appearance there (cat.
no. 83). Ducarre however objected to
the poster strenuously, and only by
Bruant's threat of cancellation did the
manager acquiesce. Perhaps the incident
accounts for Lautrec's starkly unflatter-
ing portrayal in this lithograph.
Ducarre's fat-necked head and churlish
profile are left without a sympathetic
shadow of naturalism, and his rough
demeanor is contrasted with the gen-
tility of the patrons seated behind him.

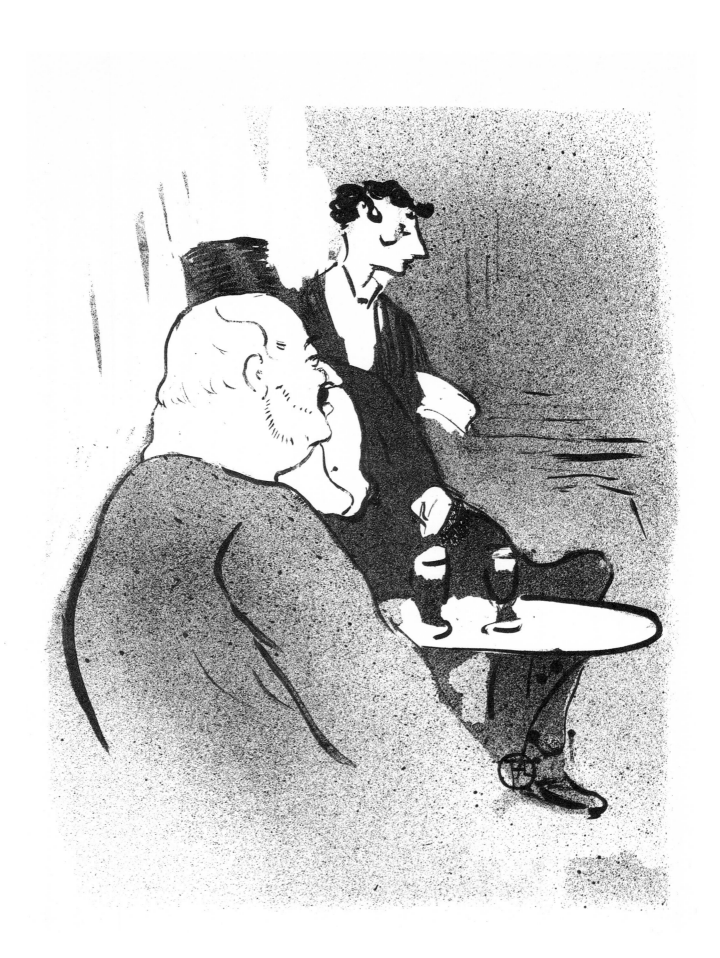

28. A Spectator (Une Spectatrice) 1893

W 27 D 37
Brush and spatter lithograph with
scraper in black ink on wove paper
One state only; regular edition of 500
impressions
10-9/16 x 7-1/4 inches
SDMA 87:185-10 Museum purchase

The composition of this lithograph is modelled on that of the 1893 poster *Divan Japonais* (cat. no. 90.) Instead of the elegantly fashionable Jane Avril, however, the spectator here is a flat-hatted, bourgeois café-goer, chortling to herself in amusement at the act onstage. The performer is Polin, a celebrated comic who sang soldiers' songs in mock-military style.

Lautrec often included the audience in his depictions of the stage, using the spectators as reactors to the performance and as actors in their own right. By combining stage and house in the same scene, he also conveyed the utter lack of sacrosanctity of the show. It was but one element in the noisy, boisterous atmosphere of the *café concerts* whose patrons alternately ignored (cat. no. 74) or joined in the act with applause, hissing, counter-jibes, and singing. An agressive performer like Bruant would jump onto tables in order to capture his audience's attention (fig. 23).

Prior to Lautrec, in the 1870s Degas, and following him, Manet and Renoir had treated the theme of the *café concert*, using the scenic device of showing the stage from the audience's perspective. Like them but more so, Lautrec represented the populism of this audience, defended by Montorgueil in his introduction, and deplored by such earlier writers as the Goncourts as a premonition of revolution.[1] By portraying a decidely bourgeois *spectatrice*, a "regular" lady dressed in the cheap hats lamented by the Goncourts, Lautrec made a political statement — rare in his art — upholding the view that the essential and worthy character of the *café concert* was the extraordinary plurality of its audience.

1. Clark (1984), p.207.

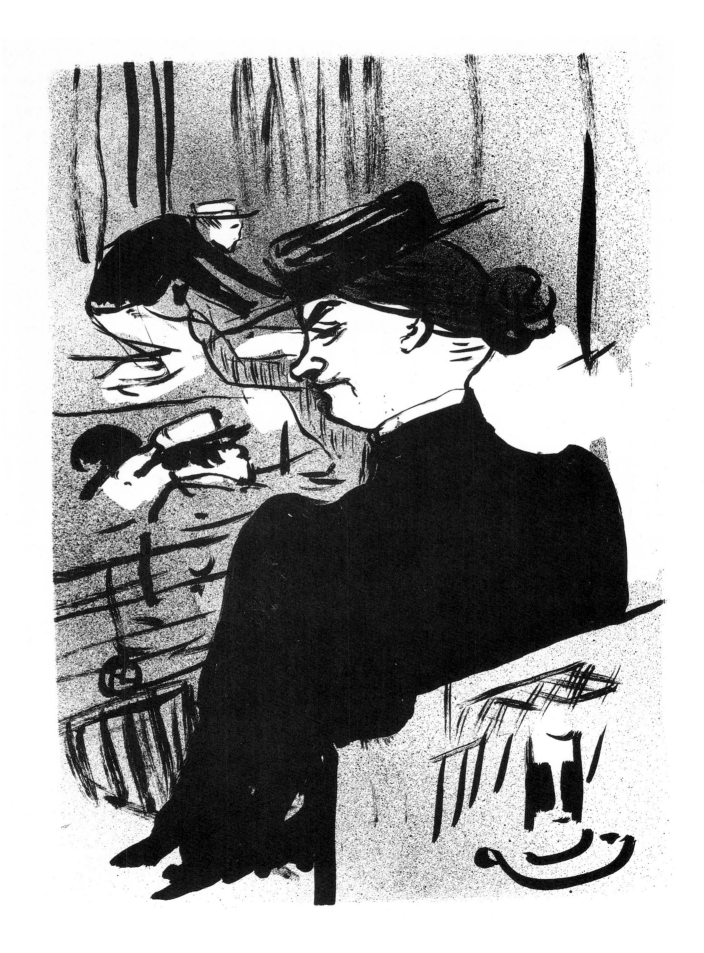

29. An American Singer (Chanteur américain) 1893

W 28 D 38
Brush and spatter lithograph in black ink
on wove paper
One state only; regular edition of 500
impressions
10-15/16 x 8-1/16 inches
SDMA 76:185-11 Museum purchase

Adhémar (no. 34) titles this subject "Eccentric English Comic." The act must have involved impersonation of a drunk. The singer's eyes roll up, his nose is shaded (red), and held behind him by two anonymous hands is what appears to be a seltzer bottle, with thumb poised on the nozzle, ready to release a sobering squirt.

The most telling elements of humor observed in the acts of the *Café Concert* series are quite ordinary—mimicry (Paula Brébion), tranvestism (Mary Hamilton), body and facial distortions (Abdala), a dancing fat man (Caudieux), and drunken singing. This was certainly standard fare, but appreciated all the more by the audience for its familiarity. Jokes centered on the old saws of mothers-in-law, landlords, love, drink, cuckolds, and current politics.[1] The more imaginative performers, such as

Jane Avril, Yvette Guilbert, and Aristide Bruant, stand out as unique, for they were able to infuse the old repertoires with new life, primarily by virtue of their distinctive personalities. For this reason they intrigued Lautrec.

What people found entertaining in the *café concerts* is characterized by Theodore Zeldin as part of the history of humor.

> Popular entertainment of this kind made people laugh for several different reasons. On the one hand it lyricised, romanticised daily life, taking the small talk of ordinary people and giving it brilliance by skillful mimicry and presentation. . . . But there was also another kind of laughter which was to be found here, created by the reverse of roles and situations, and by the public flouting of decency. These *café concerts* were places where the

respectable values of family life could be momentarily mocked.

He continues (and here we are reminded particularly of the dichotomy of Lautrec's aristocratic background and the imagery he searched out in the cafés), that this humor

> . . . shows the reverse side of respectable institutions, and shows that the burdens these institutions imposed were borne only because they were not always taken seriously, or at least because outlets were available where relief from their weight could be found.[2]

Montorgueil simply summarized the *café concert* as a place where one could keep one's hat on and smoke a cigar.

1. Zeldin (1980), p. 352.
2. Zeldin (1980), p. 359.

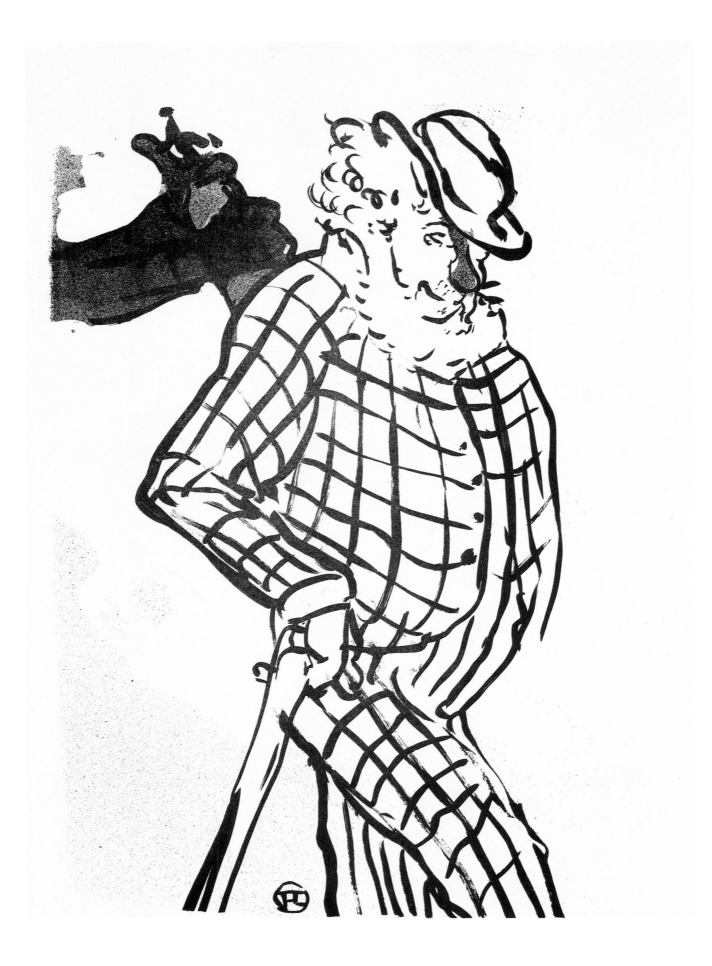

30. At the Variety Theatre: Miss Lender and Brasseur (Aux Variétés: Mademoiselle Lender et Brasseur) 1893

W 31 D 41
Crayon, brush, and spatter lithograph in
olive-green ink on wove paper
Second state, one edition only; number
25 of 100 impressions
Stamped with red monogram, lower left
13-3/8 x 9-7/16 inches
SDMA 87:28

An important part of Lautrec's graphic work was devoted to the theatre. More than the play itself, his interest focused on the stars, capturing their gestures, expressions, and appearance in stage make-up under the lights. In 1893, the short-lived weekly magazine, *L'Escarmouche* (The Skirmish), commissioned Lautrec to produce twelve illustrations, six of which were theatrical subjects (e.g., here and cat. no. 31). Lautrec's early interest in performers culminated in 1898 with the series of thirteen lithographs of actors and actresses (cat. nos. 67-71). He produced scenery, programs, and posters for the intellectual, symbolist theatres (cat. nos. 41, 47, 109), but primarily concentrated on the popular

and conventional stages, such as the Théâtre des Variétés, the Gaieté Roche-chouart, Comédie-Française, and the Théâtre de la Renaissance.

It was at the Variétés that Lautrec first saw Marcelle Lender (Anne-Marie Bastien, 1862-1926), an actress and singer who would have been thirty at the time and whose striking features fascinated him (fig. 50). From 1893-1896, he portrayed her in paintings and prints no less than twenty-six times. Her first appearance in his work is this lithograph, produced as an illustration for the November 19 issue of *L'Escarmouche* in 1893. The scene is isolated from a performance by Lender and the actor Albert Brasseur.

Lautrec simulated the stark, blanching effect of stage lighting with a background spatter of dark ink, reserving the figures in white and distorting Lender's much acclaimed beauty. Brasseur is caught in the midst of an absurdly dramatic gesture, while Lender looks back over her shoulder in what may be the climax of their dialogue, added to the plate by Lautrec:

Est elle grasse?	(Is she plump?
oui	Yes
Est elle ici?	Is she here?
Oui, oui, oui!!!	Yes, yes, yes!!!
C'est vous!!!!!!	It's you!!!!!!)

Fig. 50. Marcelle Lender, from a postcard.

31. At the Gaieté Rochechouart: Nicolle
(A La Gaieté Rochechouart: Nicolle) 1893

W 38 D 48
Crayon, brush, and spatter lithograph in
black ink on wove paper
One state only; one edition only of 100
impressions
Stamped with red monogram, lower left
14-7/16 x 10-1/4 inches
SDMA 87:25

Published by the magazine *L'Escarmouche* and reproduced in the December 31 issue, 1893, this lithograph of the actress/singer Nicolle represents her appearance at the modest music hall, the Gaieté Rochechouart. Her features are set in relief by the shaft of stage lighting directed from below and by Lautrec's low angle of perspective, the somewhat grotesque effects of which are prescient of the ghoulish head of May Milton, emerging from the right corner of the painting *At the Moulin Rouge* (1892-95, The Art Institute of Chicago). These effects of lighting and perspective suggest the appearance of an actual performance and give the viewer an immediate sense of being a member of the audience. In scenes of the theatre, the dance halls, and *café concerts* Lautrec repeatedly placed himself as a spectator. "Being there" is part of the viewer's enjoyment of his art.

This print is a fine example of the rich effects of color, light and atmosphere which Lautrec achieved through the use of crayon, brush, and spatter *(crachis)* to manipulate the ink on the lithographic stone. The outlines of the figure and background were laid in with a waxy crayon, the marks of which are the porous lines seen in the column on the left, the stage curtain, and shadowed forehead of Nicolle. The inky black of her dress, hair, and eyebrows was painted on the stone with a brush, while a spray of tiny ink dots surrounds the figure with an overall dark tonality, using the uninked paper itself to create the bright highlights on the neck and face. In chromolithography, Lautrec worked out his colors and patterns in preliminary sketches, but for this and other black and white prints from 1893 on, he probably drew directly on the printing stone.[1] His increasing familiarity with the medium, allowing free-hand execution, resulted in the extraordinary spontaneity of Nicolle.

1. Griffiths, in Wittrock (1985), I, p. 44.

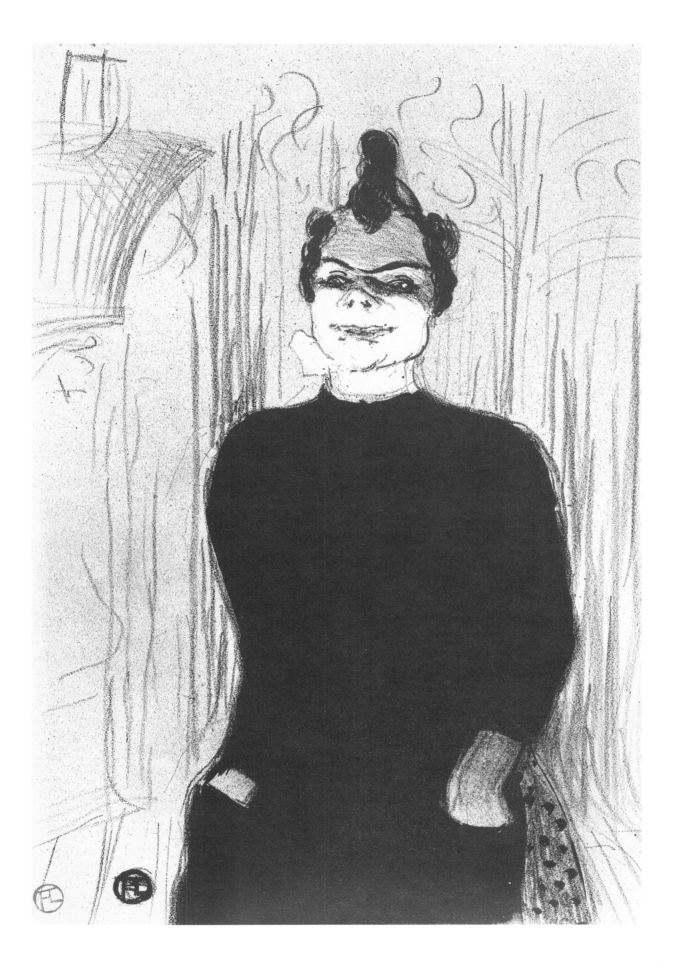

32. Miss Marcelle Lender, in *Madame Satan* (Mademoiselle Marcelle Lender, dans *Madame Satan*) 1893

W 47 D 58
Crayon and spatter lithograph in olive-green ink on wove paper
One state only; one edition only of 50 impressions
Stamped with red monogram, lower right
1-9/16 x 9-13/16 inches
SDMA 87:49

Here Marcelle Lender is shown on stage in *Madame Satan*, a play by Ernst Blum and Raoul Toché , produced at the Théâtre des Variétés. Lender's elegant sense of movement and expressive animation dominate the scene which Lautrec hastily sketched on the lithographic stone with a flair that matches his idol's. It may be that his obsession with Lender caused the artist to publish this print at his own expense, as it was only distributed by Kleinmann, who was usually his publisher.[1]

1. Griffiths, in Wittrock (1985), I, p. 45.

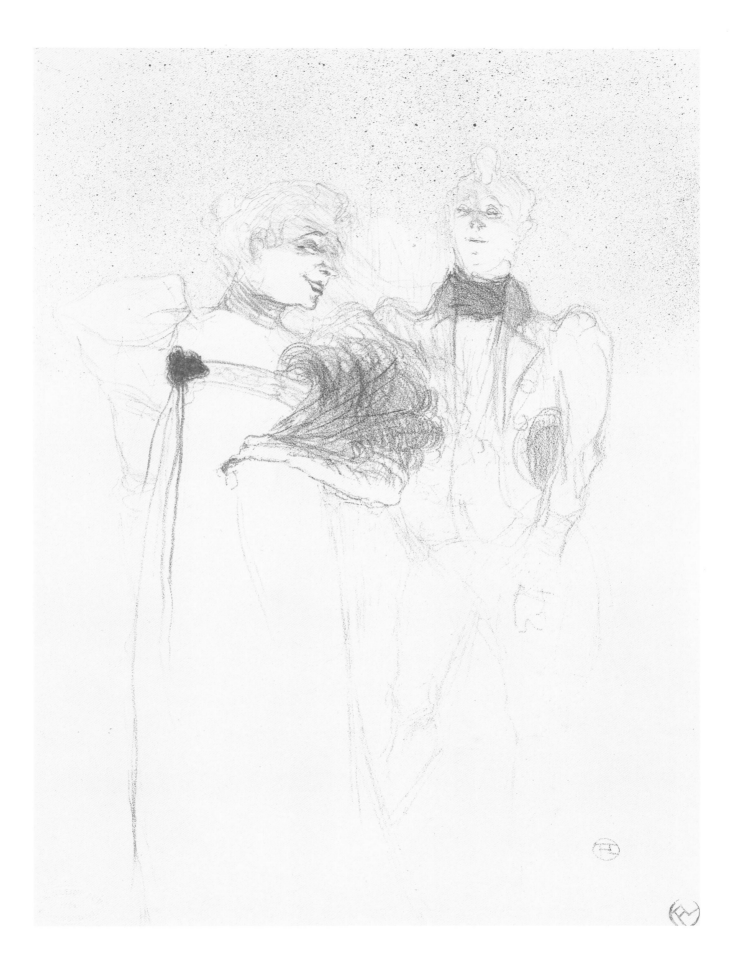

33. Brandès and Le Bargy, in *Charlatans* (Brandès et Le Bargy, dans *Cabotins*) 1894

W 52 D 61
Crayon, brush and spatter lithograph in
olive-green ink on wove paper
One state only; one edition only of 50
impressions
16-7/8 x 13 inches
SDMA 87:44

Marthe Brandès (Marthe-Josephine Brunswig), an actress at the Comédie-Française from 1893-1903, is shown playing opposite the elegant but much less distinguished actor, Charles Le Bargy, in Edouard Pailleron's *Charlatans*, in which she was cast as a middle-aged woman whose rival was a girl of eighteen. The set in this scene is the studio of a sculptor, with plaster casts and a mask shown in the upper left corner.[1] Brandès' intelligent, angular face and intense glower were her trademarks, which Lautrec exaggerated in this and two other lithographs of 1894.

1. Adhémar (1965), p. xxi.

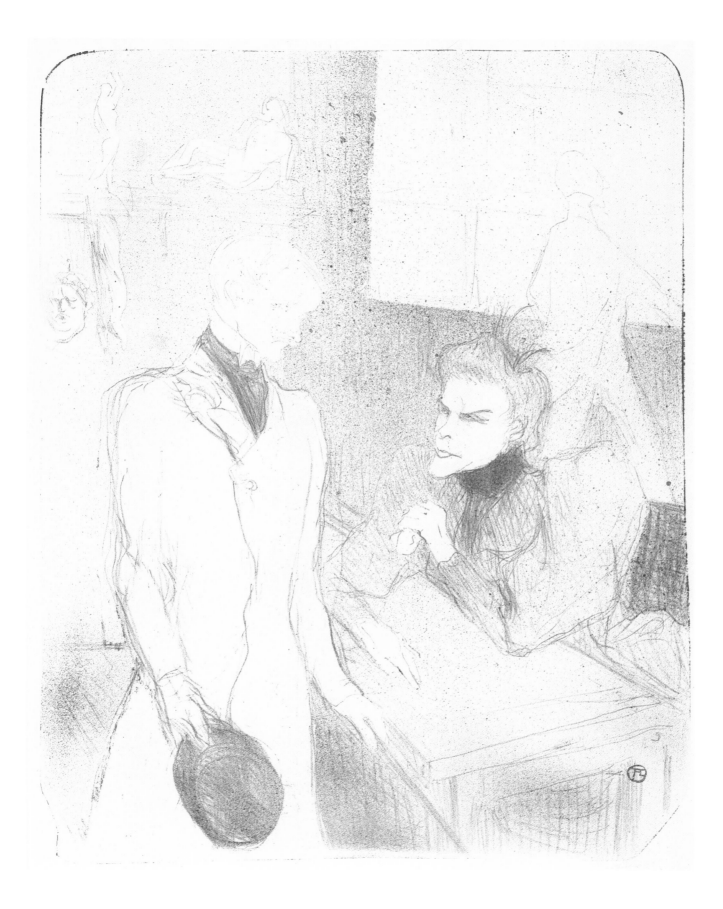

34. Adolphe—The Sad Young Man
(Adolphe—Le jeune homme triste) 1894

W 55 D 73
Crayon lithograph in black ink on wove
paper
One state only; first song sheet edition
1894
10-1/4 x 6-11/16 inches
SDMA 87:41

For once Lautrec cast his painfully shy cousin and constant companion, Gabriel Tapié de Céleyran, in an appropriate role, that of the sad young man in Maurice Donnay's song:

> Politics obsessed him.
> Boulangism tempted him,
> Then he became an Opportunist;
> But he was always very sad.[1]

The words are politically sarcastic, but Gabriel's image fits the title perfectly. First performed at the Chat Noir in 1891, the monologue became a great success of Yvette Guilbert.

On most occasions, Lautrec delighted in portraying his cousin as a womanizer, a role reversal which added topical irony to the artist's lithographic personalities (see cat. no. 76, for example). However, in 1894 he made a masterful portrait of Tapié de Céleyran standing alone in a corridor of the Comédie-Française (Musée d'Albi; Dortu P.521). Not one to miss a little self-parody, Lautrec's image of *le jeune homme triste* is a caricature of that painting, transforming the brooding solitude of Gabriel as urbane theatre-goer to the awkward sheepishness of a lonely guy.

1. Quoted by Thomson, in Wittrock (1985), I, p. 26.

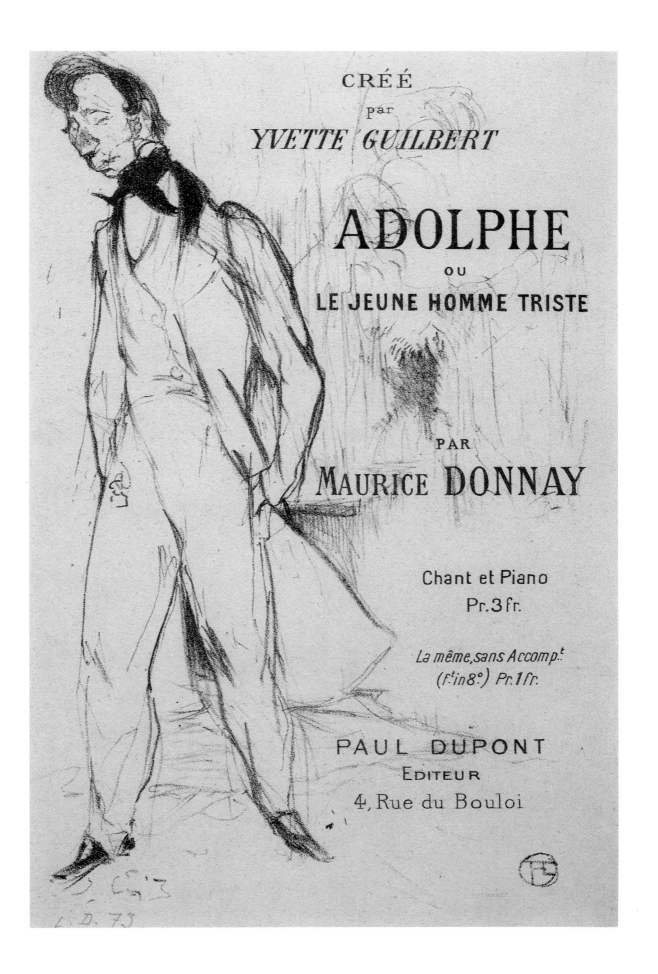

35. Wounded Eros
(Eros vanné) 1894

W 56 D 74
Crayon lithograph in black ink on japan
paper
One state only; second edition before
1910
17 x 11-3/4 inches
SDMA 73:131 Purchased with funds
donated by the Baldwin M. Baldwin
Foundation.

Eros vanné is the title of another clever poem by Maurice Donnay which, like *The Sad Young Man* (cat. no. 34), became part of Yvette Guilbert's repertoire. These songs and monologues were part of the immense amount of cabaret material demanded during the prime of the *café concert.* Guilbert preferred the irony and innuendo of Donnay's songs which complimented her stage personality, and she also must have appreciated Lautrec's visual interpretation, as she wrote to him saying, "Eros vanné is marvellous! I am thrilled with it. Keep on trying, young man, keep trying. Joking apart, I am delighted and send you ten thousand thanks."[1] Her encouragement ("keep on trying") teasingly addresses the artist himself as the frustrated cupid of this lithograph.

Lautrec's illustration, which indeed may have been conceived with a touch of self-parody, adds a sharp edge to Donnay's lament by a crippled and battered Eros who is forced to minister to Sapphic rights.

Trés vieux malgré ses vingt années
usé blasé
Car je suis né
sur un lit de roses fanées
Je suis un Eros vanné

Elles ne sont pas prolifiques
Mes unions, evidemment,
J'assiste aux amours Saphiques
Des femmes qui n'ont point
 d'amants.[2]

(So old despite these twenty years,
spent and jaded
Since I was born
on a bed of faded roses,
I am a battered Eros.

They are not prolific
My unions, apparently,
I assist in Sapphic loves
Of women who are not quite lovers).

Lautrec illustrated the song as a contemporary burlesque on the art and fate of love. Two lesbians at a bar tower above the little cupid, who is completely demythologized, with the exception of his nudity. The lovers, clearly outside his dominion, have reduced him to a crippled beggar boy, wandering the bar Hanneton (cat. no. 9) or La Souris and displaying his broken member, a phallic

pun Lautrec used often.[3] The two women are recognizable from oil sketches made by Lautrec as illustrations for an article, "Le Plaisir à Paris," published by the journal *Le Figaro illustré.*[4] Here they take on the heightened aspect of potent goddesses sacrificing at a modern-day altar.

What Yvette Guilbert's performance of *Eros vanné* would have been like, we can only guess. She loved biting parody and risqué innuendo, and from her letter to Lautrec, his visual wit suited her taste and humor exactly. Among the few written documents which reveal the content of *café concert* acts are the songs, but often Lautrec's illustrations give us an idea of the performers' interpretive tone, and the sense of humor that prevailed in their audiences.

1. Huisman and Dortu (1968), p. 110.

2. Ibid., p. 105.

3. See Stuckey (1979), pp. 224 ff. and 305, for other examples of Lautrec's phallic punning inspired by oriental erotic prints or ancient priapic art.

4. The paintings are in a French private collection and the Musée du Luxembourg (Dortu P.530 and P.531). For Gustave Geffroy's article, see Cate, in Museum of Modern Art (1985), pp. 83 ff.

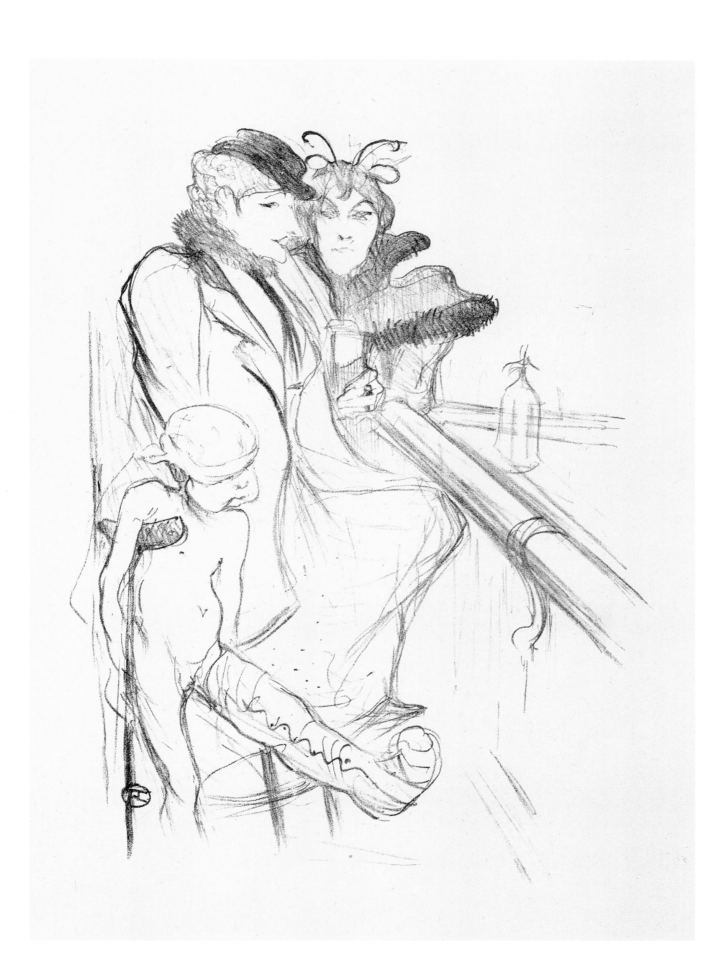

36. Ida Heath at the Bar
(Ida Heath au bar) 1894

W 62 D 59
Crayon, brush, and spatter lithograph in
black ink on wove paper
One state only; one edition only of c. 50
impressions
Stamped with red monogram, lower
right
12-15/16 x 10 inches
SDMA 87:48

This lively conversation between "great noses" obviously amused Lautrec. Ida Heath's unmistakable profile is repeated in the angles of her stance, elbows and hips thrust forward to create a double zig-zag complementing the roly-poly contours of her companion. Lautrec caricatured the pair only to the point of good-natured humor, leaving the impression that he enjoyed the witty and animated conviviality of his fellow barflies.

Ida Heath was an English dancer who appeared in Paris for a short time. As recorded in Lautrec's lithograph of her act on stage (W 64), she performed wildly energetic dances, on the order of La Goulue's (cat. no. 80), but dressed in the tutu and toe shoes of a traditional ballerina. Her decidedly non-ballerina features must have added to the parody.

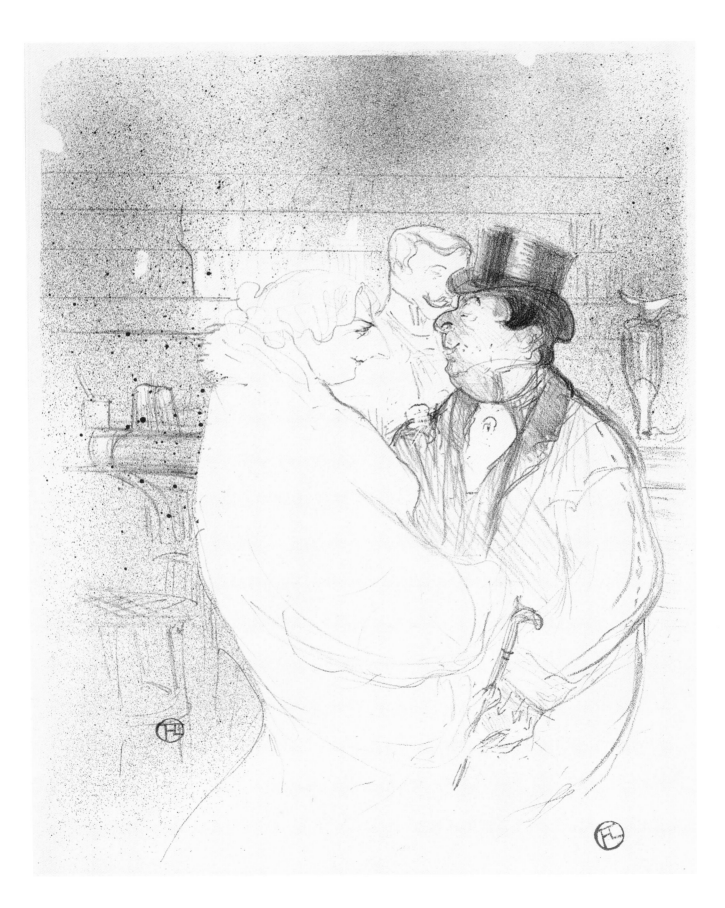

37. The Tige—Moulin Rouge (La Tige—Moulin Rouge) 1894

W 63 D 70
Crayon lithograph in black ink on wove paper
One state only; one edition only of 100 impressions
13-1/2 x 10-1/2 inches
SDMA 87:53

This is a naughty print, but also humorous in its details, and in the character of Maurice Guibert, a great pal of Lautrec who appears as a comic personality in many works (see cat. no. 45). Here he stands in the *promenoir* (or lounge) of the Moulin Rouge, legs aspread and ogling the girls. The object of his desires is the pointy profile, all nose and no chin, caricatured by the fur piece around her neck. Lautrec indulged in a bit of coarse punning in both the imagery and title of this lithograph, in the spirit of a bawdy café song. His fascination with the *promenoir* as an arena of lustful wishing and pursuit made it a setting and theme which he explored throughout his career, from the early painting *In the Promenade, Lust* (1889, private collection, Dortu P.337) to such late lithographs as the promenade scene in cat. no. 76.

Fig. 51. Maurice Guibert on a tricycle.
(Photo: Bibliothèque Nationale, Paris)

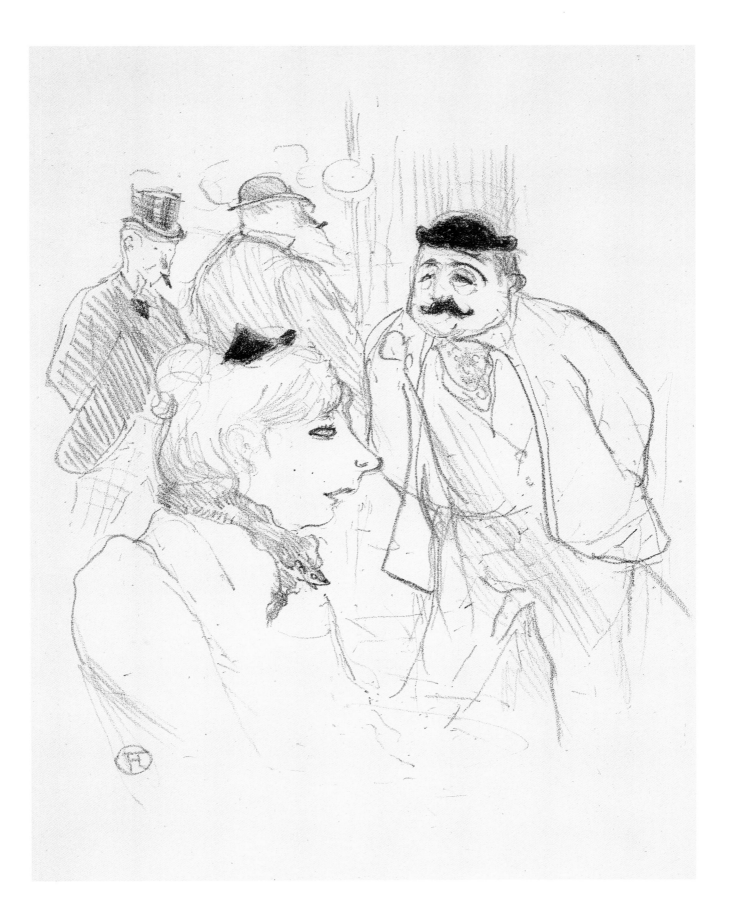

38. Yvette Guilbert, in *Columbine to Pierrot* (Yvette Guilbert, dans *Colombine à Pierrot*) 1894

W 68 D 96
Crayon lithograph in olive-green ink on wove paper
One state only; first edition of 50 impressions
11-1/2 x 8 inches
SDMA 87:55

First seen in the Baldwin Collection as the black-gloved performer on stage in the 1893 poster *Divan Japonais* (cat. no. 90), Yvette Guilbert was included in the *Café Concert* series of the same year. In 1894 Lautrec illustrated several songs from her repertoire, including *Adolphe —the Sad Young Man, Wounded Eros* (cat. nos. 34, 35), and *Columbine to Pierrot*, for which this lithograph was designed as the song sheet cover. Guilbert is shown in performance, cocking her head and placing thumb to mouth in mock modesty as she hesitates over her next line. This gimmick allowed the audience to "prompt" her in the witty but salacious parts of her dialogue, imparting a flirtatious ingenuousness to her stage personality.

In contrast to the display of plump ripeness cultivated by most of the female cabaret artists (Montorgueil mentions the bosom as one of the favorite amusements of the *café concerts*),[1] Guilbert devised a look that was all her own—flat chested, tiny-waisted, willowy and elegant (fig. 52). As seen in this lithograph, she played up these traits in her long decolleté dress and gloves. She later admitted that she was a "faux maigre," and that dress and gloves were consciously designed to move attention away from her hips and legs. Lautrec shows the success of the illusion and the expressive use to which she put her black gloves, a trademark so well-known that they themselves could suggest her entire aura (see cat. no. 72). The delicate drawing of this lithograph does the same.

1. Montorgueil, introduction to the *Café Concert* (1893), p. 8.

Fig. 52. Yvette Guilbert. (Photo: Bibliothèque Nationale, Paris)

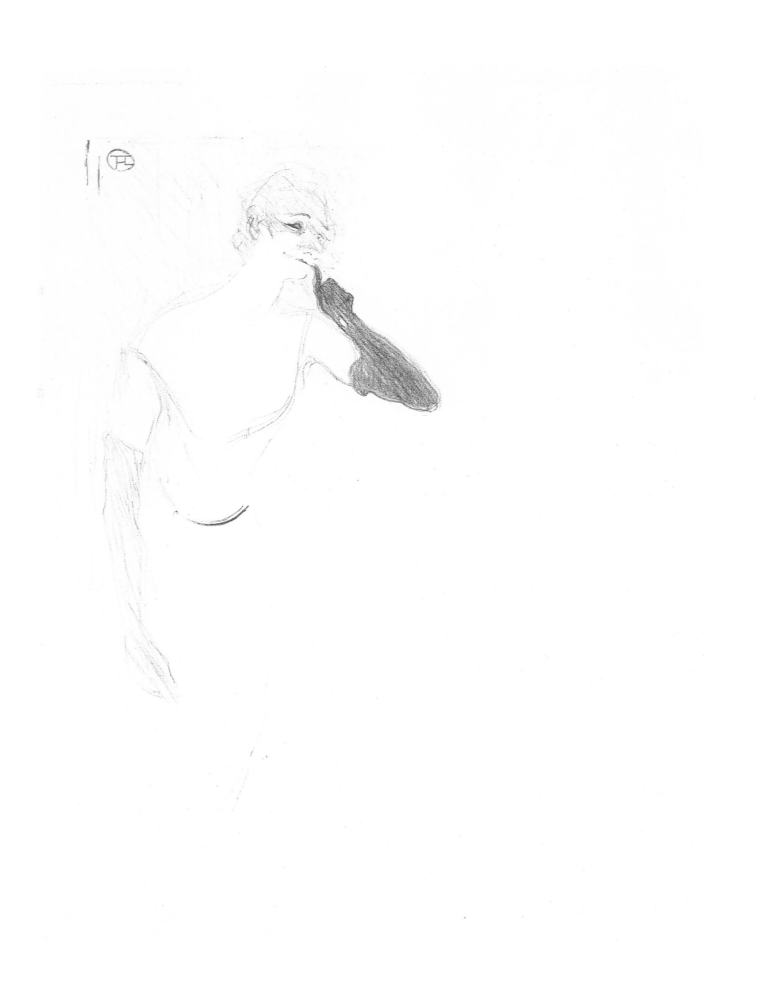

39. Yvette Guilbert, in *Columbine to Pierrot* (Yvette Guilbert, dans *Colombine à Pierrot*)　1894

W 68　D 96
Crayon lithograph in blue ink with blue
stencil coloring on wove paper
One state only; third edition after 1901
11-1/2 x 8 inches
SDMA 87:54

The song sheet edition of this litho-
graph, originally published in 1894, was
issued again after Lautrec's death in this
very rare edition with blue stencil color-
ing. Without the text (cat. no. 38), the
lithograph was published for the collec-
tors' market by Edouard Kleinmann, and
as a song sheet cover by the musical
publishing house of the song's author,
Gaston Habrekorn. As indicated in the
text, Désiré Dihau wrote the music, and
Yvette Guilbert devised the piece
for a performance at the *café concert*
Les Ambassadeurs.

The act was no doubt saucy, taking its
theme from the old Comedia dell'Arte
character Columbine, Harlequin's impu-
dent sweetheart. From the title, Guilbert
in the role of Columbine must be answer-
ing the sad, lovesick clown Pierrot—just
the sort of sexy and sentimental jux-
taposition which appealed to her.

Guilbert's sophisticated appearance and
repertoire set her apart from the usual
obviousness of the cabaret stage. Even-
tually she appeared in legitimate theatre,
married, and became a supporter of the
arts in Paris. She died in 1944, making us
realize how close to our own times were
these personalities from a lost era of
gaiety.

40. Yvette Guilbert 1895

Dortu C.1
Ceramic tile, no. 3 from an edition of
c. 10
Monogram in upper right and inscribed
lower left
Stamped on the reverse, *3* and *Emile
Muller Ivry Paris*, lower right
10-1/2 x 11-1/8 inches
SDMA 31:39 Gift of Mrs. Robert Smart

Collections: Given to Mrs. Robert
Smart by the artist.

References: G. Coquiot, *Lautrec*,
Blaizot, 1913, ill. p. 131; Th. Duret,
Lautrec, Bernheim-Jeune, Paris, 1920,
p. 113; Joyant (1926-27) II, pp. 44, 208,
illust. of another plaque, p. 48; *Art
Digest*, July 1935, pp. 9 ff., illust. of
another plaque; Mack (1953), pp. 200 f.;
M. G. Dortu, *Toulouse-Lautrec*, ed. du
Chène, Paris, 1952, p. 7, illust. of
another plaque; Cooper (1966), p. 30,
illust. of another plaque; G.-M. Michel,
Peintres et sculpteurs que j'ai connus, Paris,
1954, p. 57; H. Perruchot, *La vie de
Toulouse-Lautrec*, Paris, 1958, p. 244;
Huisman and Dortu (1968), p.110; Dortu
(1971), p. 534, illust. of another plaque.

Exhibitions: Atlanta Art Association,
exhibition of French Art, 1955, no. 15.

On three occasions Lautrec ventured
into areas unusual in his oeuvre in
designs for a leather bookbinding, a
stained glass panel, and a ceramic tile.[1]
These pieces from 1893 and 1895 were
produced in the spirit of Art Nouveau,
which sought to broaden the parameters
of "legitimate" art to include the applied
and decorative arts. Before this current,
however, Degas and Pissarro, for exam-
ple, had tried their hands at fan painting
and ceramic decoration in response to
the arts-and-industry movement of the
1870s.[2] At the same time, similar goals
of bringing art to the printing industry
had been fostered, the burgeoning
results of which had given Lautrec his
earliest artistic outlet and in which he
participated throughout his life. So it is
reasonable that he would be responsive
to Art Nouveau's call for expanded
media. His experiments were isolated
but not unconventional for his times.

Yvette Guilbert, the cabaret star and
subject of this tile, later recounted the
circumstances of its creation in her
autobiography.

> One day he [Lautrec] admired a large
> turquoise tile table of mine and I
> expressed the wish to have a tile from
> him to make a little tea table. He did
> not answer but later brought me a car-
> icature of myself to sign. I wrote:

"Mais petit-monstre, vous avez fait
une horreur!! Yvette Guilbert." [But
little monster, you have made a hor-
ror!!] Soon after this incident a tile
made from that sketch with my crit-
icism and my signature arrived. No
one who saw this work of Lautrec at
my house remembers having seen a
double; which leaves me to believe
that it was made expressly for me
and that there is no duplicate in
existence.[3]

In fact, approximately ten casts of the
plaque were made by the potter Emile
Muller at Ivry. Either he or Lautrec
traced the sketch which Guilbert men-
tions, as well as her inscription, onto a
mold from which the tiles were repro-
duced. One ended up in the collection
of the Dihau family with whom Lautrec
was intimate, and the present example
was acquired from the artist by the
donor, suggesting that Lautrec himself
commissioned a small edition, to what
purpose beyond keepsakes is unclear.[4]

The tile's design is similar to a sketch
made the previous year for Yvette
Guilbert, who had commissioned
Lautrec to make a poster. In the end
she rejected his poster proposal as too
unflattering,[5] complaining to him, "But
for the love of heaven, don't make me so
appallingly ugly! Just a little less so! So

many people who saw it here shrieked
with horror at the sight of your coloured
sketch. . . . Not everyone will see the
artistic merit of it . . . so please!"[6]

Although it is by no means certain, that
incident may have inspired Lautrec's'
choice of subject for the ceramic tile as a
little joke between artist and model. It
shows Guilbert in the same chin-first
posture as the rejected poster design,
and like the poster, was something that
Guilbert had requested. She inscribed it
in feigned anger as a great insult.

By that time, however, Lautrec had pro-
duced an album of sixteen lithographs
dedicated solely to Yvette on stage
(1894, W 69-85), a compliment to her
talent if not her face, and one which she
eventually recognized.

1. Dortu (1971), III, p.534, R.1 (1893), V.1 (1895), and
 C.1 (1895).
2. Douglas Druick and Peter Zegers, in Reed and
 Shapiro (1984), pp.xliii ff. and fig. 26. Lautrec too
 painted several fans; see Dortu D.3461, 4625,
 and 4702.
3. Guilbert (1927), p. 273.
4. Dortu III, p. 534, cites nine examples of the plaque,
 including the two mentioned above.
5. Dortu P.519, and Sugana (1969), p.111, no. 383. See
 above, fig. 26, for Steinlen's poster of Yvette
 Guilbert, which she commissioned instead of
 Lautrec's design.
6. Letter quoted in Huisman and Dortu (1968), p. 109.

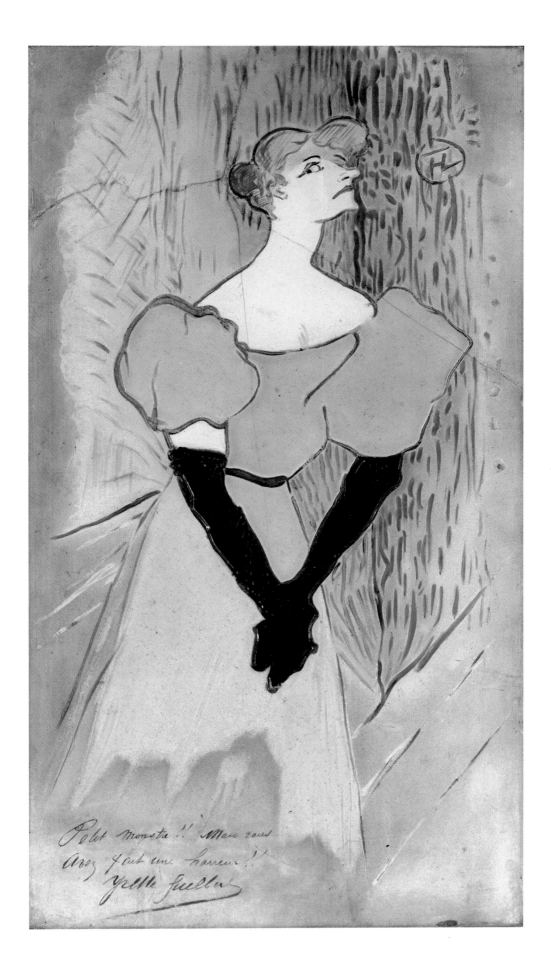

123

41. Program for *L'Argent* (Programme pour *L'Argent*) 1895

W 97 D 15
Brush, crayon, and spatter lithograph in
six colors on wove paper
One state only
12-1/2 x 9-3/8 inches
SDMA 49:19
Museum purchase

In addition to lithographs of performers on the popular stages of Paris, Lautrec also produced works for the intellectual, avant-garde theatres, such as the Théâtre de l'Oeuvre (cat. no. 47) and the Théâtre Libre, for which this lithograph was designed as a program. Its strong shapes and colors are as boldly conceived as a poster.

Founded in 1887 by André Antoine (who, remarkably, was the first to turn out the houselights, focusing the audience's attention on the stage),[1] Théâtre Libre introduced works by new realist playwrights (Zola, Ibsen, and Strindberg), and Antoine also made a practice of commissioning young artists to design his programs.[2] Lautrec produced three, of which this example was his last before the theatre closed in 1896. Emile Fabre's play, *L' Argent*, was considered a masterpiece of cynical comedy. The subject was money and the greedy ambitions of children to seize their inheritance from their mother.[3]

1. Shattuck, (1968), p. 9.
2. Cate (1986), p. 22.
3. Adhémar, no. 148.

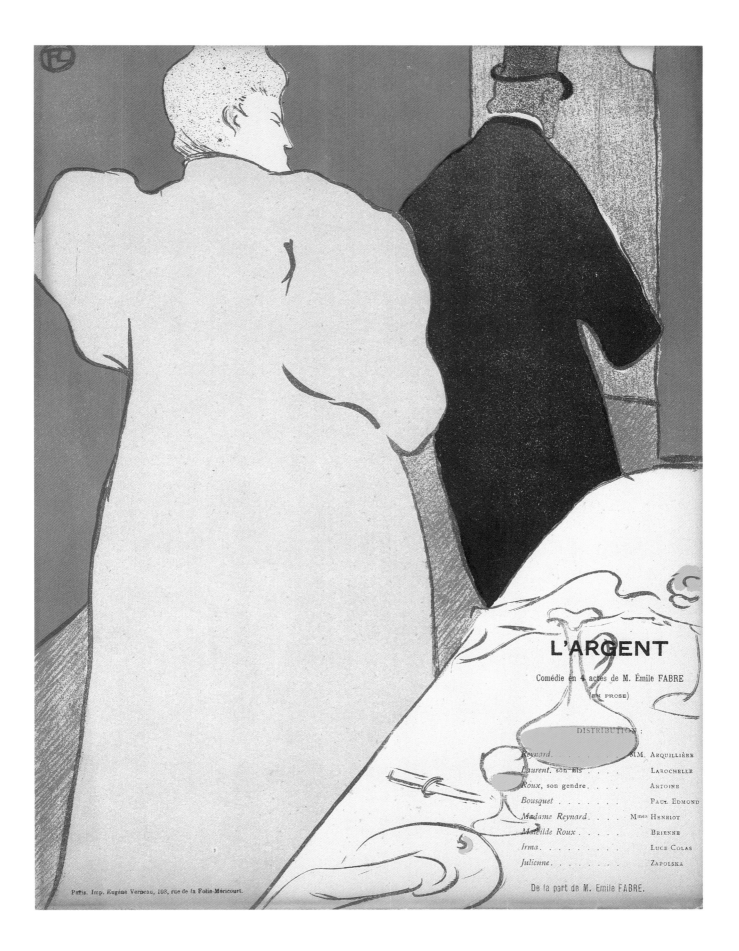

L'ARGENT

Comédie en 4 actes de M. Émile FABRE

(EN PROSE)

DISTRIBUTION :

Reynard. MM. ARQUILLIÈRE
Laurent, son fils LAROCHELLE
Roux, son gendre. ANTOINE
Bousquet PAUL EDMOND
Madame Reynard Mmes HENRIOT
Mathilde Roux BRIENNE
Irma LUCE COLAS
Julienne ZAPOLSKA

De la part de M. Émile FABRE.

42. Bust of Miss Marcelle Lender
(Mademoiselle Marcelle Lender, en buste) 1895

W 99 D 102
Crayon lithograph in eight colors on
wove paper
Fourth state; French *Pan* edition, 1895,
of 100 impressions
Stamped with orange monogram, lower
left, numbered 42/100
12-13/16 x 9-1/2 inches
SDMA 87:63

One of the most brilliantly conceived and executed color lithographs in all of nineteenth century printmaking, this print most clearly expresses the creative inspiration which Lautrec found in the actress Marcelle Lender (fig. 50). In February 1895, Florimond Ronger Hervé's operetta *Chilpéric* was revived at the Théâtre des Variétés with Lender in the starring role of Queen Galswintha. Romain Coolus, a writer and friend whom Lautrec dragged to the performance six times before he could stand it no longer, described the music as "obvious" but agreed that Lender was splendid. Dressed in fantastic Spanish costumes (the headdress of giant poppies shown here), she danced the bolero and fandango in this lavishly staged Merovingian fantasy. It was her greatest success, and Lautrec went nearly twenty times to see her, making sketches from his seat in the audience. These led to the elaborate painting of Lender dancing before King Chilpéric and his court (1896, John Hay Whitney Collection, New York) and to nine lithographs beginning with this most famous one.

It was first published in Berlin by the magazine *Pan* (vol. I, no.3), and our impression is from the rare edition of the magazine's French supplement. Lautrec gave the lithograph to *Pan's* artistic editor, the German art critic Julius Meier-Graefe, who successfully argued for its publication but lost his editorship in the wake of critical controversy.[1] In the mid-1890s Edouard Vuillard, the Nabis, and Art Nouveau employed the dense patterns and swirling linearity which were so shocking to *Pan's* board. Lautrec worked in the same circle as these artists and knew many of them, even dining with Henry Van der Velde (1863-1957), "father" of Art Nouveau, on a trip to Brussels in 1894. But it is likely that he may have shared a common artistic experience with his contemporaries rather than receiving their direct influences.[2]

Technically this lithograph is exceedingly accomplished, printed in eight colors, the key-stone in olive green, with color stones in yellow, red, dark pink, turquoise-green, blue, grey, and yellow-green. Lautrec worked out the design in several sketches and the color scheme in watercolor on a trial proof printed from the key-stone.[3] Subsequently seven more trial proofs, one for each color, were made before the fourth state of the lithograph was printed for the final German and French *Pan* editions.

The intricate job was carried out by Lautrec's trusted printer, Henri Stern, at the small firm of Ancourt (see cat. no. 96). At this date, 1895, and for such a complicated print, artist and printer would have worked in close collaboration.[4] A comparison of this lush lithograph with the small poster printed on zinc instead of stone, *At the Concert* (cat. no. 107), reveals how important the technical aspects of printing were to the esthetic appeal of the final print.

1. Thomson, in Wittrock (1985) I, p. 13.
2. Adriani (1987), p. 316, and Arnold, in Museum of Modern Art (1985), p. 68.
3. Ill., Museum of Modern Art (1985), no. 103; Dortu A.231.
4. See Griffiths, in Wittrock (1985), I, p. 46.

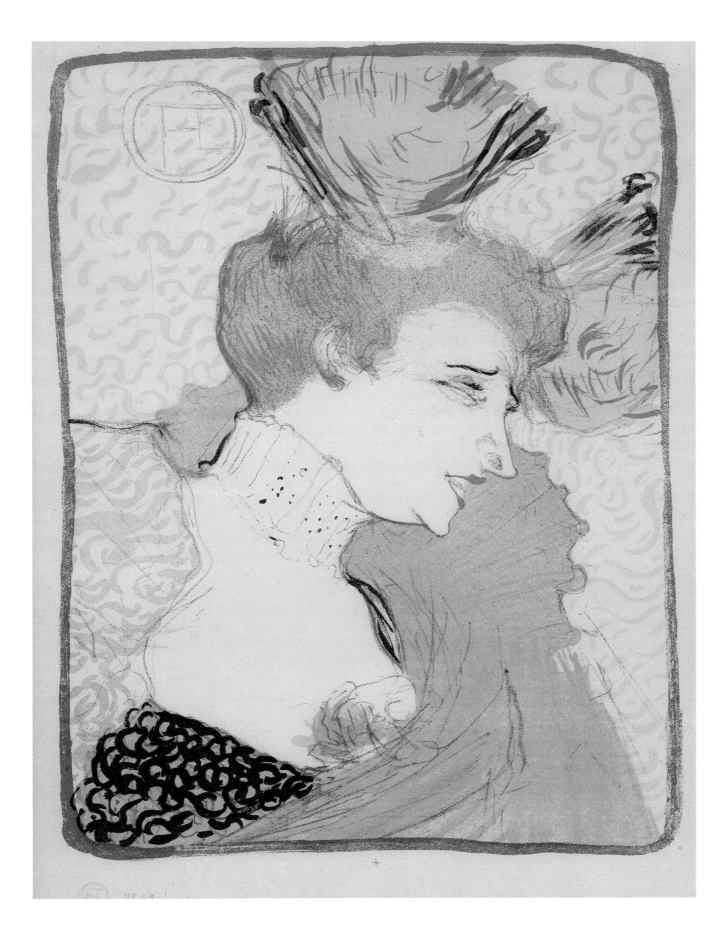

43. Lender and Lavallière in *The Aretine's Son* (Lender et Lavallière, dans *Le Fils de L'Arétin*) 1895

W 109 D 164
Crayon, brush, and spatter lithograph
with scraper in black ink on beige wove
paper
First state; one edition only of 20
impressions
17-3/4 x 13-3/4 inches
SDMA: 87:89

Marcelle Lender insinuates herself into a rare but unresolved lithograph as her final appearance in the Baldwin Collection. In this first state of the print she shares the page with Eva Lavallière in *Le Fils de L'Arétin* by Henri de Bornier, which opened at the Comédie-Française in December 1895.

Because of the inconsistencies in scale and spatial arrangement of the two figures, Adhémar (133) suggested that this print represents Lautrec's experimentations for two distinct compositions. This is probably correct, but as a small edition was actually printed, Lautrec may have been amused by the unwitting parody of the two actresses which resulted — Lender haughtily ignoring the oratory of Lavallière. In the end, he eliminated Lavallière, leaving only the sketchy half-length of Lender in the second state, of which there are only four known impressions.[1]

1. Wittrock (1985), I, p. 280.

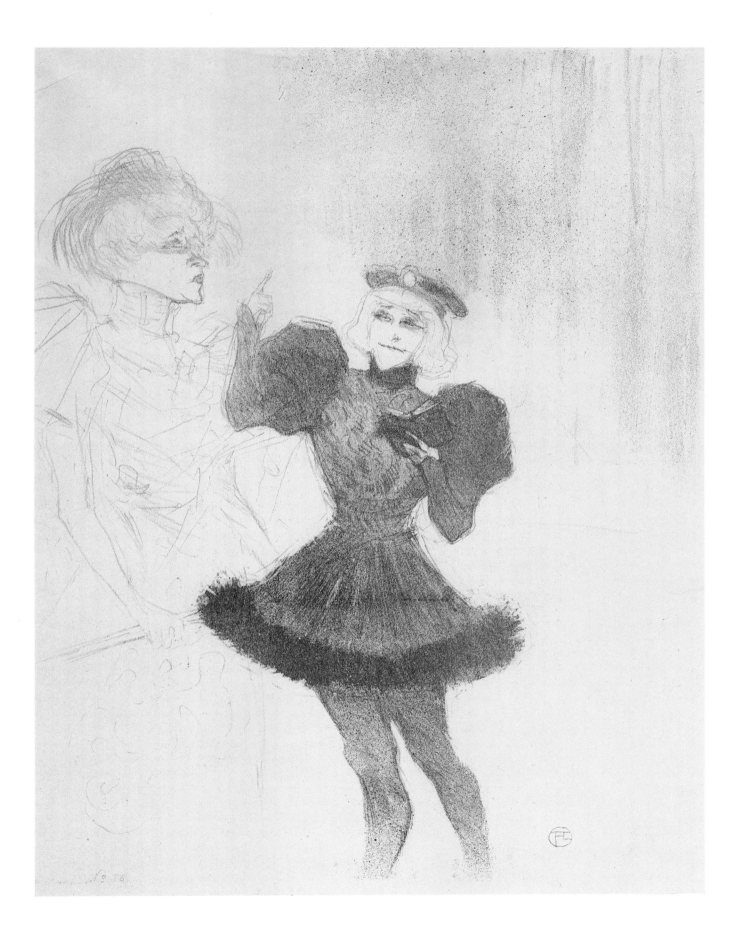

44. The Secret
(Le secret) 1895

W 130 D 135
Crayon lithograph in black ink on
wove paper
One state only; first edition, no. 4 of
20 impressions
Stamped with orange monogram,
lower left
9-3/4 x 7-3/16 inches
SDMA 87:66

This folkloric image of an old woman
and cat warming themselves as the soup
heats is a very rare lithograph published
by C. Joubert, first without text and then
as a song sheet cover. Along with *Shoot-
ing Stars* (cat. no. 45), it is one of the
fourteen lithographs made by Lautrec as
illustrations for the suite *Mélodies de
Désiré Dihau* (W 124-137).

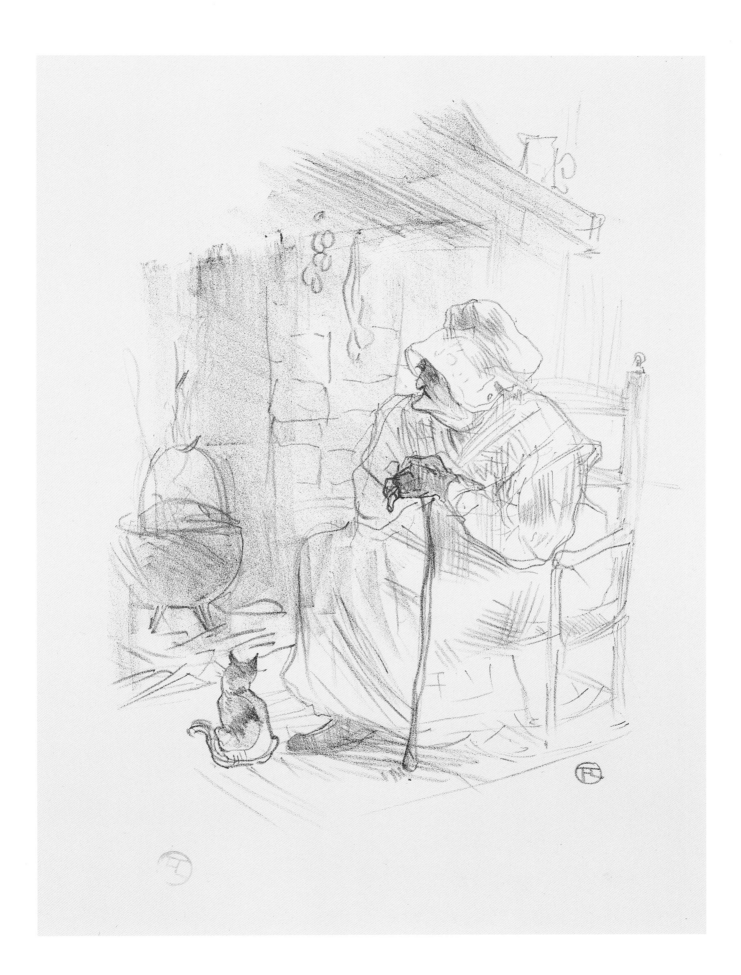

45. Shooting Stars
(Etoiles filantes) 1895

W 131 D 136
Crayon and spatter lithograph with
scraper in black ink on wove paper
Second state; song sheet re-edition, 1895
11-3/4 x 8-5/8 inches
SDMA 87:59

A song sheet cover from Joubert's pub-
lication of fourteen melodies by Désiré
Dihau, this lithograph illustrates Jean
Richepin's lyrics for the song *Shooting
Stars*. Lautrec amusingly portrayed a
drunken pair perched on a balcony,
overlooking rooftops and chimneys.
As the man—a funny caricature of
Lautrec's friend Maurice Guibert to
whom the song is dedicated (fig. 51)—
looks over his shoulder, his sodden orb
reflects the moon and a shooting star.
Originally he was to have exclaimed
dumbly, "Oh no, look, the sun."[1]
Guibert appears as a comical character
in many of Lautrec's works. A great fan-
cier of Paris night-spots, he was an agent
for Moët & Chandon Champagne and
a sometime artist who travelled and
caroused with Lautrec.

The effect of night is created on the
printing stone by a heavy *crachis* which
envelops the figures in the same dark
atmosphere as the sky. The moon and
star are simply areas reserved from the
ink spatter by applying paper stencils or
a masking medium, and the tail of the
star was made by scraping the ink away.
Lautrec was a master of these tech-
niques which he used in simple black
and white lithographs like this one, or in
more complex color lithography, as in
cat. no. 46.

1. "Manon, voici le soleil." Lautrec himself gave this as
 the title of a study made for the lithograph. Sugana,
 p. 112, no. 396, and Dortu P.595.

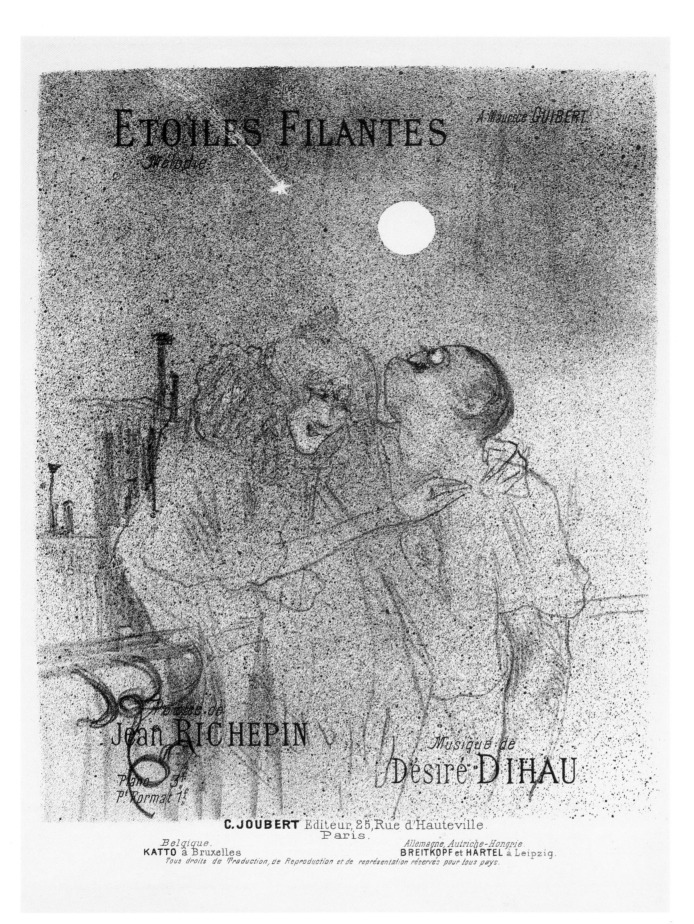

46. Napoleon 1895

W 140 D 358
Crayon, brush, and spatter lithograph in
six colors on wove paper
One state only; one edition only, no. 41
of 100 impressions
Signed in black crayon lower left
23-1/4 x 17-13/16 inches
SDMA 87:64

At the urging of his publisher-dealers, Galerie Boussod et Valadon, Lautrec entered the competition they had organized to select a poster publicizing W. Milligan Sloane's *History of Napoleon I*, being serialized in New York in *The Century Magazine*. The jury was composed of the old-school academic painters Edouard Détaille, Jean-Léon Gérôme, and Georges Vibert, plus the Napoleonic historian Frederic Masson. Naturally, Lautrec did not win. Of the twenty contestants he came in fourth, the prize taken by the illustrator Lucien Métivet, whose design might be described as a "commercialized Ingres"—a static apotheosis of Napoleon in imperial garb, borne up by a spread-winged eagle, with classicizing medallions of Austerlitz and Waterloo, the pyramids and Roman Forum in the background—the works.[1]

In contrast, Lautrec's design is vibrant and evocative. Ebria Feinblatt points out his combination of historical references with human insight into his subject.[2] The Mameluke riding at Napoleon's left and the marshal on his right conjure the victorious Egyptian and European campaigns, while the isolated, sombre figure of the commander riding ahead reveals both his power and tragic end. Recognizing the elevated genre of history, Lautrec composed his subject in the

manner of Meissonier's frontal equestrian figures, known to him in the early eighties from his academic teachers Léon Bonnat and Fernand Cormon.[3] But this bow to the academic tradition was evidently lost to the jurors in the lithograph's foregoing of illusionistic details and surfaces, the airy atmosphere and dynamic cropping of Napoleon's horse. In their eyes Lautrec's design lacked accuracy and finish.[4]

This was a point on which the artist had voiced his opinion on another occasion:

> These people annoy me. They want me to finish things. But I see them in such a way and paint them accordingly. Look, it is so easy to finish things. I can easily paint you a Bastien-Lepâge. . . . Nothing is simpler than to complete pictures in a superficial sense. Never does one lie so cleverly as then.[5]

Lautrec spurned illusionism and finish as false and manual, adhering instead to a veracity that is visual, suggestive and economic, goals which are beautifully exemplified in *Napoleon*. These were goals shared by progressive artists beginning with Manet; their concise pictorial language, however, remained unfamiliar to academic artists and reactionary critics.

Today Lautrec's lithograph conveys to us a content which his victor and jury could illustrate and understand only form by form, image by image. But our modern visual habits have been "trained," by Lautrec and his successors (Picasso, Matisse, and Dufy, to name only the most obvious) who conceived the brevity of the "sketch," not as transitory but as essential. Lautrec's art is built upon this premise of sublimating the extraneous and redundant, and we have been sensitized to the open form and suggestiveness of his synaptic style.

Following his defeat, Lautrec had the printing house of Ancourt pull 100 impressions of *Napoleon*, an edition he may have had printed at his own expense. The Baldwin Collection's is a particularly fine impression, showing the vibrancy of all six colors, particularly the alternating blue and brick-red. This is one of Lautrec's most painterly lithographs, derived from an oil study in the Bührle Collection, Zurich (Dortu P. 573).

1. Cate (1985), fig. 166; and Feinblatt (1985), plate 85.
2. Feinblatt (1985), p. 28.
3. See Stuckey (1979), p. 65, fig. 1.
4. Feinblatt (1985), p. 28.
5. Quoted by Arnold, in Museum of Modern Art (1985), p. 44.

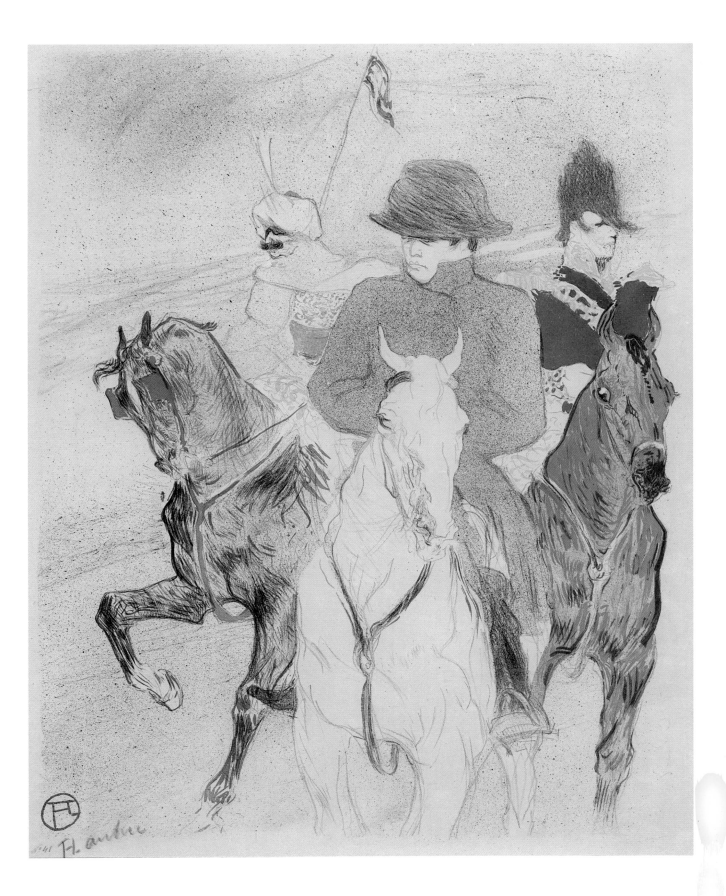

135

47. Oscar Wilde and Romain Coolus (Oscar Wilde et Romain Coolus) 1896

W 146 D 195
Crayon, brush, and spatter lithograph in
black ink on brownish wove paper
One state only; theatre program edition
1896
12 x 19-5/16 inches
SDMA 87:95

Like *L' Argent* (cat. no. 41), this lithograph was designed as a theatre program—one of three that Lautrec created for the Théâtre de l'Oeuvre, an avant-garde theatre established in 1893 which presented symbolist plays by such authors as Ibsen, Mallarmé, and Verlaine.[1] Lautrec had been marginally involved with Théâtre de l'Oeuvre for several years, depicting its founder, the actor Aurélien-Marie Lugné-Poe (1870-1940) in performance, and collaborating with the artist Louis Valtat in 1895 on sets for an esoteric Sanskrit play.

Indicated in the central field of this program, two plays were being presented— *Raphaël* by Romain Coolus and *Salomé* by Oscar Wilde, whose work had been banned in London and was making its debut in Paris. The authors are represented on either side and an artistically-oriented magazine is advertised on the right, a common promotion included in theatre programs.

Romain Coolus (1868-1952) was a writer and poet whom Lautrec came to know through Thadée Natanson and the intellectual group associated with Natanson's magazine, *La Revue blanche* (see cat. no. 94). He may have introduced Lautrec to the theatre, while Lautrec introduced him to the brothel scene. The two became great friends, and the artist made several portrait sketches of Coolus, catching his handsome features and furtive glance, with his distinctive raised eyebrow. Here he is shown, hands shoved in pockets, bracing himself against the wind which whips his greatcoat around him as he strolls past the Arc de Triomphe.

The notorious Oscar Wilde (1854-1900), author of the play *Salomé*, is characterized almost to the point of caricature.

Lautrec had met him in Paris, but he refused to sit for a portrait. Nonetheless, Lautrec portrayed him several times. The present depiction derives from the 1895 *Portrait of Oscar Wilde* in the Lester Collection, Los Angeles, in which he is set in a three-quarter pose against a misty background of the Houses of Parliament. Lautrec portrayed Wilde's face as decadently puffy, his esthete's nature wryly expressed in the raised chin and pouting, rose-bud mouth. Despite this extreme characterization, the artist was in sympathy with the Irish poet and novelist who had lived in Paris under the name of Sebastian Melmoth, and was tried in London on charges of sodomy.

1. Cate (1986), p. 29.

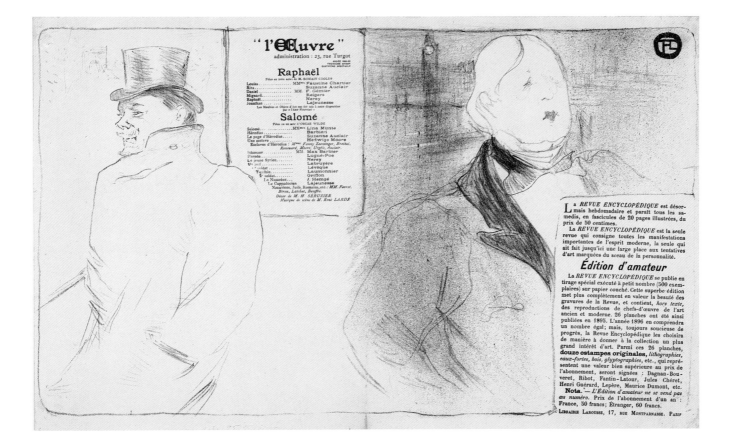

48. Leaving the Theatre (Sortie de théâtre) 1896

W 147 D 169
Crayon lithograph in grey-black ink on
wove paper
One state only; one edition only of c. 20
impressions
12-1/2 x 10-1/4 inches
SDMA 87:91

This very rare lithograph was produced during Lautrec's "brothel period" but also records his continuing interest in the theatre, which he viewed as a complete phenomenon. Like Degas, Mary Cassatt, and Renoir, Lautrec looked at the audience as much as the actors.[1] In earlier works, the stage and audience are shown as counterpoints of performance, but in later works, both painted and printed, Lautrec narrowed his field of vision to the audience alone (cat. no. 107), portraying their private dramas and tragicomedies within the confined setting of the theatre's compartments. The masterpiece of this genre is an uninvited glimpse of a fragile woman departing from her box, leaving her lover to the artificial theatrics on stage (1894, Musée d'Albi).[2]

The mood of the present lithograph is not as emotional but brilliantly conveys something of the despondency of leaving the theatre, emerging from fantasy to re-enter daily life. Here Lautrec portrayed a scene from the public world of the *Elles* — a madame out for a night of entertainment and display, her coiffure and fur hiding the identity of her escort as the pair descends from the loge.[3]

The masquerade of elegance is betrayed, however, by the nude statue on a pedestal, an attribute of both culture and depravity. Lautrec made clear this double meaning by reflecting the statue in the mirror behind and setting the madame's haughty profile against the reflected image. Like the erotic mythologies which decorate the prostitutes' bedrooms in the *Elles* series (cat. nos. 55, 56, 60), this headless statue offers silent commentary on the multiple and sometimes paradoxical levels of reality which Lautrec perceived in his subjects.

1. Stuckey (1979), pp. 201, 273.
2. Dortu P.523; ill., Stuckey (1979), no. 65.
3. Adhémar, no. 218, following Joyant, identifies the woman as a madame whom Lautrec knew.

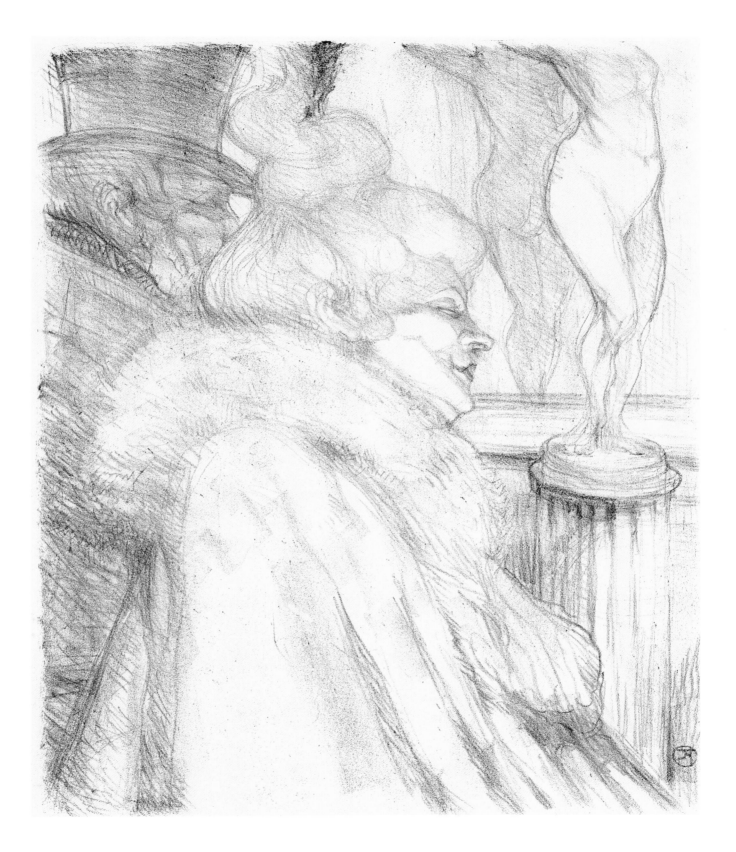

Elles (cat. nos. 49–61)

49. Cover for *Elles* (*Elles*, couverture) 1896

W 155 D 179
Crayon, brush and spatter lithograph in
brown-black ink on laid japan paper
First state; cover edition, no. 33 of
100 impressions
Signed in black crayon, lower right;
numbered in ink by Pellet, with his
stamp and paraph
22-9/16 x 18-7/8 inches
SDMA 87:75

The *Elles* series arguably holds a position in the history of printmaking comparable to Rembrandt's etching, *The Hundred Guilder Print*. The analogy is not so farfetched as it might seem, for both artists extended the pictorial possibilities of their chosen printing medium to achieve fluid and expressive effects previously associated only with painting. The *Elles* marks the definitive change in chromolithography from a utilitarian medium of mass reproduction to an original art form. Lautrec's modern style of flat design often asserts itself over traditional chiaroscuro, but he nonetheless used color, ink density and paper to conjure the mood and atmosphere of light and shadow and to exploit a range of tonal values inherent in lithography itself. The great variety of these effects, of drawing styles and printing techniques, which on occasion has sponsored the criticism that the set lacks cohesion, is nothing less than sheer bravura unconstrained by the limitations of consistency.

The *Elles* is also a milestone of Lautrec's career. Throughout the series there are general reminiscences and almost literal quotations drawn from his thematic exploration of life in the *maisons closes* during the previous four years. The paintings of prostitutes from 1892-95 appear to have been conceived as a series on the mundane, private routines in brothels — women sharing meals, playing cards, combing their hair, getting dressed, and waiting for business.[1] The lithographic series stands then as the epilogue to a major body of work and also as the finale to Lautrec's most productive period.

The *Elles* (which translates as the feminine pronoun *they*) consists of a lithographic cover shown here, a frontispiece of the same image (cat. no. 50) and ten color plates (cat. nos. 52-61). Published in April 1896 by Gustave Pellet (1859-1919), the plates were issued as 100 portfolios intended for the erotic print collectors' market to which Pellet catered. So-called "lithographies libres" had been a marketable genre since the 1820s, and Pellet had a profitable business publishing facile erotic prints by such artists as the Belgian Félicien Rops (1833-1898) and "knock-offs" of Degas and Lautrec by Louis Legrand.[2] He became familiar with Lautrec's work in 1895 through Edouard Kleinmann, and must have viewed the several paintings of lesbian love and brothel life Lautrec produced around that time as ripe material for publication and sale.

The portfolios, however, were a financial failure for him. Rather than erotic, the series is intimate, replacing licentious explicitness with naturalistic honesty, prurient "peeps through the keyhole," as the English writer George Moore described Degas' brothel monotypes, with candid views of daily routine.[3] The art dealer Ambroise Vollard fared no better than Pellet in attempting to sell the *Elles* to the fine art market which, despite its espousal of erotic paintings in the Salon, hiding behind the sanctioned mask of academism, found no recognizable esthetic or charm in these images. Pellet and others were forced to sell single sheets or reduce the series to its more decorative images. Today, therefore, a complete, homogeneous set such as the Baldwin Collection's — all plates are the thirty-third pull of each image — is incredibly rare.

Beyond Pellet's commission, Lautrec's decision to make a series of lithographs on brothel life came from three quarters, all under the umbrella of the subject's longstanding status as a primary modernist theme. The artist's direct experience in the *maisons closes* was one, providing years of "research" which resulted in the unsensational objectivity of his great painting *In the Salon, rue des Moulins*, culminating in the *Elles* (see above, p. 28).[4]

Secondly, in the figure of a woman winding her hair, shown here, and scenes of women preparing for the bath, bathing, and combing their hair (cat. nos. 55, 56, 58), the *Elles* bears clear reference to similar subjects by Edgar Degas, an observation that did not go unrecognized at the time. His quip to the comment that Lautrec was "taking on his mantle" was, "Yes, but he's cutting it down to his size."[5] The older artist had always remained cooly aloof from Lautrec and his art, but as the living *locus classicus* of modern style and subject matter (horses, milliners, dancers, the *café concert*, and brothels) Degas (1834-1917) was idolized by his young challenger. Although Degas never made color lithographs, and the *Elles* presents brothel life in a different mode from his anonymous nudes, he is certainly the mediator between the novelistic whores of Manet and the banal realities which Lautrec represented.

A third influence, shared by two generations of Impressionists and post-

Continued on page 142

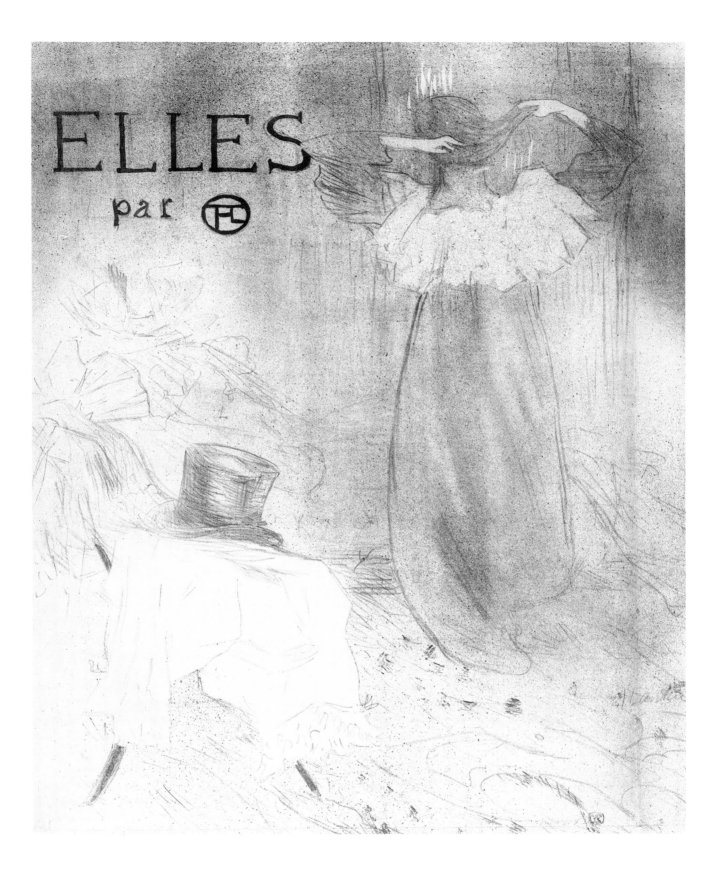

Impressionists since Manet, was the Japanese woodblock print. Coming to the attention of artists in the 1860s, Japanese prints provided fresh alternatives to the time-worn formulae of western art.[6] Many of Lautrec's works reveal their bold croppings, flat patterns, spatial distortions, and asymmetrical rhythms. Besides these formal devices, serial prints of the so-called "green houses" of the Edo district may have inspired him to create a similar album. He was a known admirer and collector of Japanese prints and had acquired in the early 1890s a copy of Utamaro's erotic album, *Uta-makura (Poems of the Pillow)*.[7] While eroticism is not the subject of the *Elles*, "green house" prints provided visual support for Lautrec's quotidian orientation to the theme. In two compositions especially—*Woman at the Tub* (cat. no. 55) and *Woman Combing her Hair* (cat. no. 58)—reliance on Japanese models guided Lautrec's formal solutions and iconographic choices.

Between 1876 and 1880, a rich naturalist literature appeared, including J.-K. Huysmans' *Marthe, histoire d'une fille*, reputed to be the first novel dealing with a prostitute of a licensed brothel;[8] Edmond de Goncourt's *La Fille Elisa*; and Zola's *Nana*, which inspired Manet's 1877 painting of the same title.[9] Lautrec would have known this work as well as others dating from the coincidence of naturalist literature and painting, and as Dennis Cate has shown (above, p. 36), several artists of Lautrec's generation took up the theme.

Lautrec's response to the literary subject, however, was only a general recognition. In 1896, when his dealer, Maurice Joyant, and Edmond de Goncourt asked him to illustrate Goncourt's novel *La Fille Elisa*, he eventually gave up after a few sketches.[10] But this may have prompted a personal resolve to depict what he *knew* of brothel life when Pellet's commission came a short time later.

1. Stuckey (1979), p. 210.
2. Reed and Shapiro (1984), pp. lxii ff., and Arnold, in Museum of Modern Art (1985), p. 71.
3. See Adhémar and Cachin (1974), p. 86. Interestingly, it was Pellet who bought most of Degas' brothel monotypes. Griffiths, in Wittrock (1987), I, p. 48, no. 26.
4. 1894, Musée d'Albi, Dortu P.559.
5. Quoted in Adhémar and Cachin (1974), p. 12.
6. The Paris World Exposition of 1867 brought Japanese prints to the attention of Europeans. See Cate in Weisberg (1975), pp. 53 ff.
7. Adriani (1987), p. 318. Besides Utamaro, Torii Kiyonaga and Hiroshige were influential particularly on the Impressionists and Post-Impressionists.
8. Illustrated by Costantin Guys and Jean Louis Forain. See, Adriani (1987), p. 163.
9. 1877, Kunsthalle, Hamburg. Cachin and Moffett (183), pp. 392 ff. Zola's character, Nana, first appeared in *L'Assommoir* in 1876. For other precursors of Lautrec, see Arnold, in Museum of Modern Art (1985), pp. 38, 41.
10. Huisman and Dortu (1968), p. 168; Dortu A. 237-252.

50. Frontispiece for *Elles* (*Elles*, frontispice) 1896

W 155 D 179
Crayon, brush, and spatter lithograph in three colors on wove paper
Second state; frontispiece edition, no. 33 of 100 impressions
Numbered in ink by Pellet, with his stamp and paraph, and inscribed *Parce-que vous aimez cela/mon cher Clément—Laisse [?] Gustave Pellet/Janvier 1894 [sic]*.
21-1/2 x 15-3/4 inches
SDMA 87:76

The cover, frontispiece, and poster of the *Elles* employ the same image of a woman unknotting her hair before a full-length mirror indicated by vertical strokes of reflected light. It is the same woman and setting depicted in the fourth plate, *Woman at the Tub* (cat. no. 55), for both wear a dark blue frilly-collared robe. Such correspondences and details establish the women in *Elles*

as individuals in contrast to the anonymity of Degas' bathers and prostitutes. Specificity, although abbreviated, was Lautrec's artistic habit but also his personal orientation to the women he knew, called by name, developed preferences for (Mireille and Rolande were his favorites at rue des Moulins), and respected as fellow travellers in an alternative existence.

In 1891 Lautrec made five paintings of women combing their hair. One of these—that in The Ashmolean Museum, Oxford (Dortu P.389)—is the source of the similar figure used for the *Elles* cover and frontispiece, a motif which Degas had treated many times in the 1880s. Thus Lautrec introduced the album with a rethinking of his own work and an unmistakable tribute to Degas. The overture also begins delicately with a tribute to feminine beauty of that aspect most admired in the nineteenth century, a woman's hair, leaving the album's actual theme to reside subtly in the pair of hats in the foreground.

51. Poster for *Elles* (*Elles*, affiche) 1896 [Not illustrated]

W 155 D179
Crayon, brush, and spatter lithograph in four colors on beige wove paper
Third state; poster edition
Text by another hand
21-1/4 x 15-3/4 inches
SDMA 87:74

The *Elles* series was first exhibited on April 22, 1896, at the Salon des cent sponsored by the journal *La Plume*. This was actually the end of the exhibition for which the poster *The Passenger of Cabin 54* (cat. no. 99) was used.[1] To announce the *Elles*, Lautrec converted the frontispiece into a poster which was published by *La Plume*.

1. Cate, in Museum of Modern Art (1985), p. 86.

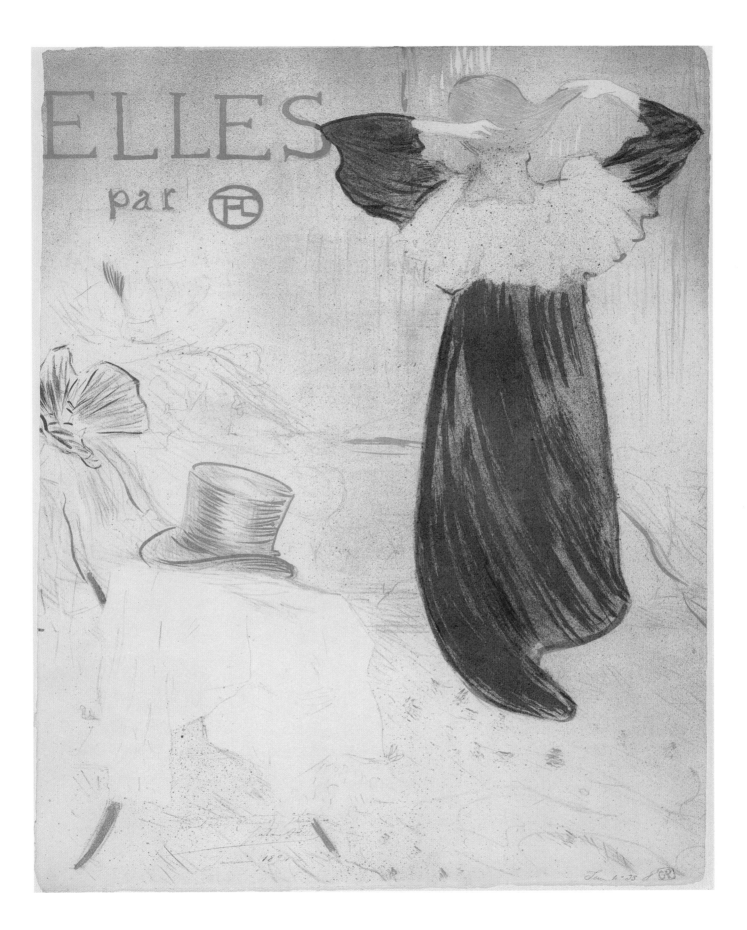

52. The Seated Clowness—Mademoiselle Cha-u-ka-o (La Clowness assise [Mademoiselle Cha-u-ka-o]) 1896

W 156 D 180
Crayon, brush, and spatter lithograph
with scraper in five colors on wove paper
One state only; only edition, no. 33 of
100 impressions

Numbered in ink by Pellet, with his
stamp and paraph
20-1/2 x 15-3/4 inches
SDMA 87:77

The first plate of the *Elles* is its strongest and most enigmatic, portraying the clown who was a well-known performer and acrobat at the Moulin Rouge and Nouveau-Cirque (fig. 14). Her name derives from a wild form of can can called the *chahut*, literally meaning an *uproar*, or in French, *chaos*. When spelled phonetically *chahut-chaos* results in the exotic sounding Cha-u-ka-o. On a banquette before a murky mirror, she sits apart from the masqueraders of the ball beyond. The black stripe of wall further isolates her mood, and both face and posture reveal a melancholy weariness not unrelated to the last plate of the album (cat. no. 61). The gay yellow ruff becomes a mockery against her face, while her spread legs suggest both sexual ambivalence and the defenseless resignation of the actor too disillusioned to go on with the brave masquerade. This is not the proverbial sad clown but a tragic inversion of "real life."

Cha-u-ka-o's presence in the *Elles* is unusual. A known lesbian, she was associated with prostitution only insofar as her debauched lifestyle. This has led to a proposal that the *Elles* is not about brothel life *per se* but about lesbian love.[1] According to the argument, Cha-u-ka-o is represented here and in the next plate with her lover (cat. no. 53), in *Woman Washing Herself* (cat. no. 56), and in *Woman in Her Corset* with a lover *en travestie* (cat. no. 60). The other plates then would depict her young *amourette*, the whole creating a sort of pictorial short story on the private life of Cha-u-ka-o. Such a scheme, however, seems too narrowly defined, and as Maurer admits (pp. 256 ff.), neither the frontispiece nor the male presence in *Woman in Her Corset* fits the storyline, unless one can recognize the man as a woman in male attire. This still leaves a number of plates unexplained, and the suggested narrational focus con-

tradicts the conceptual breadth of the album's imagery, and robs the male and female hats on the frontispiece of their universally accepted meanings.

Brothel life invariably did involve lesbian intimacy, an observation which Lautrec recorded in eight paintings of 1894 and 1895,[2] and which he recognized by the inclusion of Cha-u-ka-o in the *Elles* and perhaps by the contrasting moods of similar early morning scenes (cat. nos. 53, 59), one intimate, the other familial. But the clowness' presence in the *Elles* is more likely simply arbitrary. In 1895 she was Lautrec's "fascination of the moment."[3] He made four paintings of her, including the preparatory oil sketch for the present plate.[4] This and another painting, *At the Moulin Rouge: The Clowness Cha-u-ka-o* (1895, Oskar Reinhart Collection, Winterthur) were converted to color lithographs, the latter (W 178) published by Pellet in 1897.

Lautrec may have conceived producing a series of prints based on the 1895 paintings devoted to his favorite personality. He did not, but the subject, bold image, and incredibly rich coloration of *The Seated Clowness* find no parallels in the other *Elles* plates. Visually the clowness is a brilliant aberration in an otherwise fairly cohesive set. Without knowledge of the order in which the plates were conceived and printed, it is impossible to determine exactly how or why Cha-u-ka-o fits or departs from the series, but the answer lies more probably in the exigencies of creation and execution than in thematic justifications.

The magnificence of this plate depends almost as much on its technical achievements as on Lautrec's stylistic mastery. All of Pellet's publications were luxurious, and the *Elles* is no exception. The publisher spared no expense, even having special paper made bearing his and Lautrec's names in the watermark. Pel-

let's personal interest in the quality of the prints can be judged by the fact that he himself numbered, stamped and marked with his paraph each impression (fig. 42). His price for the portfolio in 1896 was 300 francs, much more expensive than Lautrec's previous lithographs or posters. The black and white lithograph, *At the Gaiety Rochechouart* (cat. no. 31) for example, cost only two and one-half francs, and posters were advertised for between one and one-half and five francs.[5]

Outside the lithographs *Napoleon* and *The Jockey*, the *Elles* are among the largest plates represented in the Baldwin Collection. Averaging 16 x 20 inches, they established the scale and richness of Lautrec's subsequent color prints, and represent the first time Lautrec allowed his image to bleed to the edge of the paper. This tends to create an illusionistic pictorial field much like a painter's canvas, reinforcing the painterly quality of several plates, or alternatively endowing the paper itself with a greater illusion of three-dimensional space and light (cat. nos. 53, 54). *The Seated Clowness* is also exemplary of Lautrec's masterful use of *crachis*, or spatter, to create rich atmospheric and coloristic effects. While the posters are essentially line drawings on which areas are in-filled with colors, Lautrec used a much more painterly, synthetic technique in color lithographs executed from the *Elles* forward.

The most sumptuously printed plate of the portfolio, *The Seated Clowness* is also technically the most complex. A full nine trial proofs were pulled before the stones were ready for the final run.[6] Five colors were used, meaning five stones and five separate passes through the press for each of 100 impressions. Careful attention was paid to the smallest details, adding extra spatter, scraping away tiny areas, and cleverly disguising

Continued on page 146

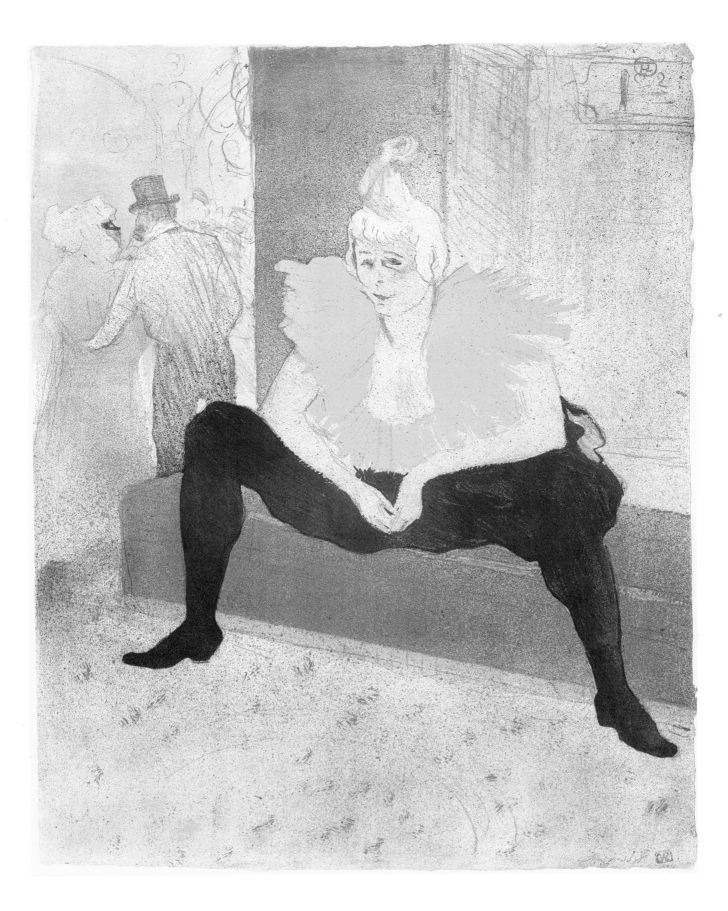

the registration marks. The technician in charge was an independent printer named Auguste Clot, whom Pellet amd Ambroise Vollard often used.[7] Lautrec's varied range of drawing styles and desired pictorial effects, combined with Pellet's demand for exquisite quality, required the active participation of a master printer. Clot's control over the processes of color lithography is part of the *Elles'* remarkable testimony to the brilliant results which could be achieved through the collaboration of a master technician and an artist of Lautrec's vision and daring.

1. Naomi Maurer in Stuckey (1979), pp. 255 ff. Maurer's lesbian reading of the *Elles* is based on Thadée Natanson's comment that Lautrec's inspiration for the album came from his observation of "the two bodies of a lesbian couple" (pp. 255 ff.). Nowhere in the series, however, is such an inspiration given pictorial form.

2. Dortu P.436-439, 545, 547, 597, 598, and 602.

3. See Julia Frey, above, p. 27.

4. Dortu P.580. The other paintings (Dortu P.581-583) are a three-quarter length portrait and scenes of Cha-u-ka-o getting into costume and wandering the Moulin Rouge as a clown. As suggested here, Lautrec may have been considering an album on the clowness, and if so, these sorts of subjects would have been commensurate with the imagery of other albums devoted to performers—the *Café Concert* series and the Yvette Guilbert albums of 1894 and 1898.

5. Griffiths, in Wittrock (1985) I, p. 40.

6. Wittrock (1985) I, p. 380.

7. Griffiths, in Wittrock (1985) I, p. 46.

53. Woman with a Tray—Breakfast; Madame Baron and Mademoiselle Popo

(Femme au plateau—Petit déjeuner [Madame Baron et Mademoiselle Popo]) 1896

W 157 D 181
Crayon lithograph with scraper in sanguine ink on wove paper
One state only; one edition only, no. 33 of 100 impressions
Numbered in ink by Pellet, with his stamp and paraph
15-3/4 x 20-1/2 inches
SDMA 87:80

In contrast to the thick night atmosphere and artificial illumination of *The Seated Clowness*, a sense of fresh air and daylight is created in this plate. Lautrec achieved the effect with the most economic means possible, allowing the paper itself to stand as filtered morning light. It bleaches the room of shadows, and Lautrec described the figures almost entirely by a minimal contour drawing in sanguine crayon. The mood is as light and optimistic as *Lassitude* (cat. no. 61) is the opposite. Both plates, however, were executed with exactly the same principles of using an overall ground color (in this case, simply the white of the paper) and line drawing alone to express form, atmosphere, and emotional content.

Joyant identified the ladies as Madame Baron, mistress of the *maison close* in rue des Moulins, and her daughter Paulette, called "Popo." Maurer, on the other hand, sees a resemblance of Cha-u-ka-o in the woman carrying a tray and finds that "the facial expressions of the two women indicate some sensual involvement that in mother and daughter would border on incest."[1] A similar early morning scene, (cat. no. 59) *Woman in Bed, Profile*, appears to represent still another pair. Whatever expressions we may read into these women, the nominal subject of both plates seems to be the sympathy with which the prostitutes treated each other in "off" hours.

1. Maurer in Stuckey (1979), p. 256. There are no specific indications in the large preparatory drawing for this plate (Dortu D.4269) that Cha-u-ka-o is depicted.

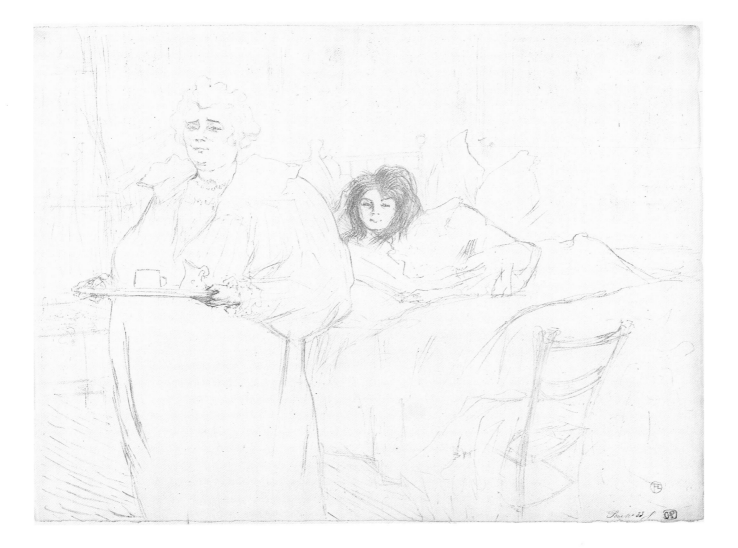

147

54. Sleeping Woman—Awakening (Femme couchée—Réveil) 1896

W 158 D 182
Crayon lithograph with scraper in olive-grey ink on wove paper
One state only; one edition only, no. 33 of 100 impressions
Numbered by Pellet, with his stamp and paraph
15-3/4 x 20-1/2 inches
SDMA 87:82

A remarkable decency permeates the imagery of the *Elles*. In only one plate is there explicit reference made to the activities of prostitution normally associated with brothel life (cat. no. 60). Nor did Lautrec exploit potential titillation of the viewer. The *fille* whom we have just awakened is neither nude nor suggestively posed but rather a picture of innocence hidden among mountains of bedclothes and pillows. The beautiful hatched drawing of this plate is related in ink color and style to *Woman Washing Herself* (cat. no. 56).

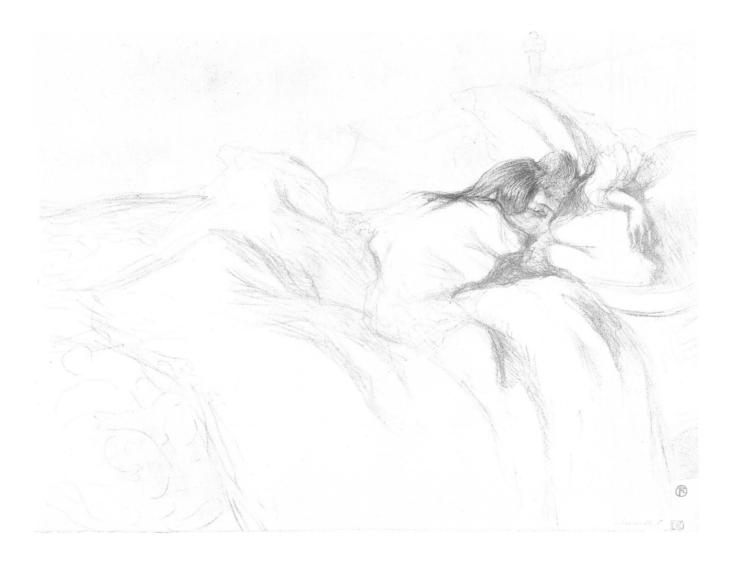

55. Woman at the Tub—The Tub (Femme au tub—Le tub) 1896

W 159 D 183
Crayon, brush, and spatter lithograph in
five colors on wove paper
One state only; one edition only, no. 33
of 100 impressions
Numbered by Pellet, with his stamp and
paraph
15-3/4 x 20-1/2 inches
SDMA 87:81

The cozy morning scene of a woman preparing her bath bears a strong relationship to similar scenes of the various stages of courtesans' toilettes in Japanese "green house" prints. An architectural grid formed by the fireplace, baseboard, and armoire divides the sheet into four areas of color, locking the figure into flat, assymmetrical fields—a compositional arrangement which relies on eastern convention rather than western realism. Both tub and figure are flattened to silhouettes under the pressure of the picture plane which holds each detail of the room in place.

The precision of line and color area, taken from the Japanese woodblock, gives this image a neat clarity, so that each detail is legible. In the mirror on the right, a rumpled bed is reflected, establishing time of day and setting. On the opposite side, above a fireplace with its hint of warm coals, are another mir-

ror and a clock which reads ten o'clock. Mounted on the clock, an evocative object in itself, a male bust becomes an inanimate voyeur and reminder of who this woman is.

Not unlike the subtly allusive hats in the frontispiece, clever details of interior décor provide the only references to prostitution in this and other plates. The bust and clock, the fan (a reference to the Japanese courtesan as much as to Art Nouveau eclecticism), and a picture of the erotic myth, Leda and the Swan, are aligned as factors whose additive combination equals the other life of the woman who privately prepares for the day.

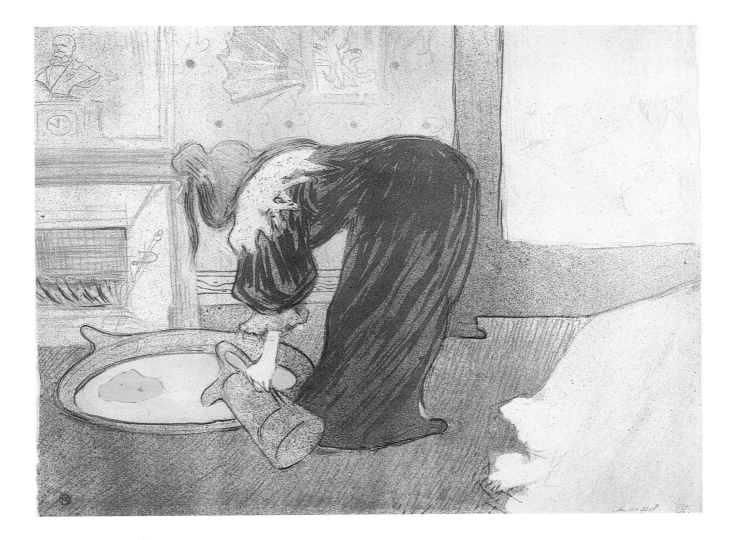

151

56. Woman Washing Herself—The Toilette (Femme qui se lave—La toilette) 1896

W 160 D 184
Crayon lithograph in two colors on wove paper
One state only; one edition only, no. 33 of 100 impressions
Numbered in ink by Pellet, with his stamp and paraph
20-1/2 x 15-3/4 inches
SDMA 87:84

Two paintings were made in preparation for this beautifully drawn figure before her vanity stand—a nude study and vibrant oil sketch of the lithograph's exact image and dimensions.[1] Lautrec was a great admirer of women's backs (his admitted fascination with the actress Marcelle Lender) and this is a particularly eloquent rendering, as precise as a silver point drawing, as controlled as Ingres. These displays of virtuosity in some plates, modern brevity in others, rococo delicacy countered with bold design, set the *Elles* as a showpiece of Lautrec's stylistic range. In this image especially, which simultaneously shows the figure from the back and reflected from the front, there is a reminiscence of the boastful *paragone* paintings of the old masters, the *Rokeby Venus* of Velazquez for example, which Lautrec could have known from his trips to London.[2]

Free to roam a number of levels however, he also reflected the sensuality of the female body, but unlike Degas who would have stopped there, Lautrec introduced the picture of nymph and satyr above the mirror as a half-symbol, half-parody (fig. 53). Although here the reference to prostitution is obvious, such pictures decorated any bourgeois interior, and it is possible that Lautrec refers both to the old master origins of this nude's conception and to the overtly erotic nature of "old" art, meaning academic art happily accepted by the bourgeoisie. Under Cormon's tutelage he had executed a "golden age" allegory of fauns and nymphs, so he was personally conversant with the hollow vocabulary of modern mythological painting.[3] On an entirely different level, the satyr in the picture may be the satyr Lautrec, hiding behind the guise of art much like the photographer Sescau under his camera cloth (cat. no. 101).

1. Dortu P.606 and 616.
2. 1644-48, National Gallery, London. The paragone painting developed in the Renaissance as a demonstration of the artist's mastery of illusionism, capable of showing several simultaneous views through reflection in mirrors or water. Theoretically based, it became a well-known pictorial device, but always retained something of its original testimony of the artist's skill.
3. *Allegory: The Spring of Life*, 1883, Musée d'Albi; Dortu P.205; ill. in Stuckey (1979), p. 84.

Fig. 53. Henri de Toulouse-Lautrec, **Woman Washing Herself** (detail) from **Elles**, 1896.

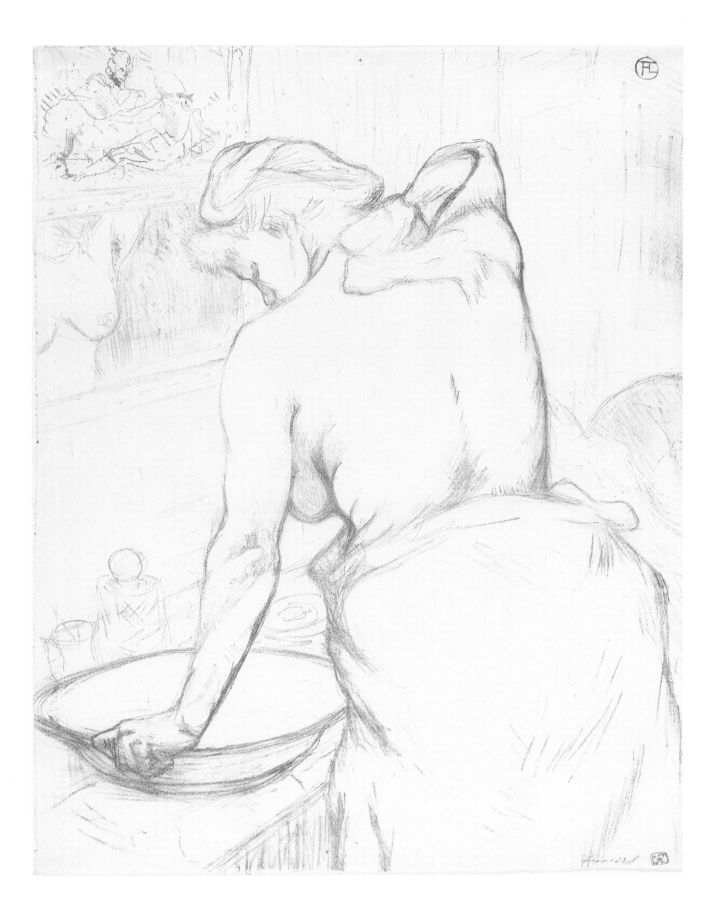

153

57. Woman with Mirror—The Hand Mirror (Femme à glace—La glace à main) 1896

W 161 D 185
Crayon, brush, and spatter lithograph in three colors on wove paper
One state only; one edition only, no. 33 of 100 impressions
Numbered in ink by Pellet, with his stamp and paraph
20-1/2 x 15-3/4 inches
SDMA 87:78

In comparison with the white paper and beige and yellow tones which have characterized other plates as morning scenes, the blue and brown inks used in *Woman with a Mirror* connote an evening light. The neatly placed slippers and turned-down sheets indicate a before-bed dialogue with the mirror in a melancholy review of the day's damage. Vanity and moral introspection historically were represented by a woman looking into a mirror, often finding a death's head looking back, as a reminder of the transitory nature of all human vanities. Lautrec relied on the old theme, and represented the certainty of passing time—which carries with it all things

human, especially a woman's beauty—in the clock on the mantle. Reclining on top of it is a draped nude, certainly a little reproduction of Canova's famous monument to female hubris and beauty, *Paulina Borghese as Venus*, conjuring the theme of the toilette of Venus, as the goddess prepared for love.

Lautrec exploited well-known symbols naturalized in contemporary surroundings to suggest multiple meanings and emotions. He handled these with great insight; while the woman beginning her day (cat. no. 55) remains busily oblivious to the decorative reminders of her profession, they tend to hit home in the late hours.

In paintings of 1897 and 1898, Lautrec deleted allegorical props altogether, simply placing women at their dressing tables looking into the mirror.[1] In the 1897 *Nude Woman before a Mirror*,[2] a full-length nude prostitute regards herself in the armoire mirror without the protective veneer of explicit allegorical conventions. Tragically and ironically the woman who stares back is a brutal image of reality. No death's head is needed to supplement the meaning of the nude, bed, and mirror.

1. See for example *At Her Dressing Table, Madame Poupoule* (Dortu P.668), ill. in Stuckey (1979), p. 292.

2. Private collection, New York (Dortu P.636).

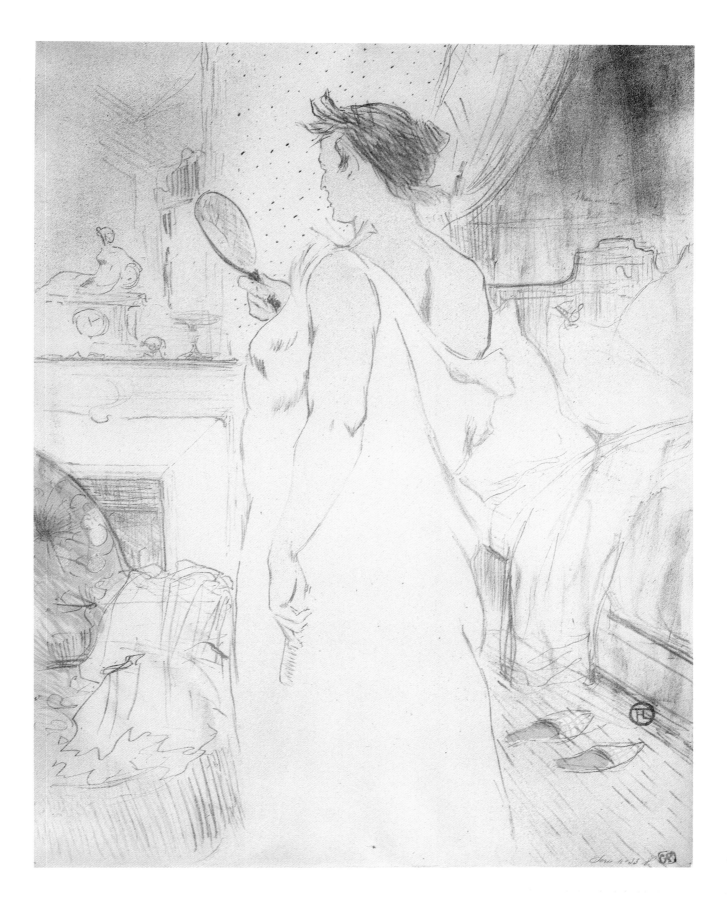

58. Woman Combing Her Hair—The Coiffure (Femme qui se peigne—La coiffure) 1896

W 162 D 186
Crayon, brush, and spatter lithograph in
two colors on wove paper
One state only; one edition only, no. 33
of 100 impressions
Numbered in ink by Pellet, with his
stamp and paraph
20-1/2 x 15-3/4 inches
SDMA 87:85

In paintings from 1891 and again in 1896 Lautrec experimented with fore-shortened views of models seen from above.[1] Degas had done the same in paintings and monotypes of the late 'seventies and 'eighties. These, however, are naturalistically rendered in logical perspective and settings when compared with this torso floating on a surface of transparent color.

The extraordinary conception of the figure as an isolated area of uninked paper, compressed into a single, continuous shape, is a daring elaboration on the color reversals and figural stylizations of Japanese prints. The woman's seated position, with legs crossed, further consolidates her form as viewed from a radi-cal point of prespective, and reinforces the oriental genesis of the composition. Potentially the most erotic of the women of *Elles*, the merging and echoing of arms and bosom denies the overt anatomical legibility of western realism. Instead, by condensing and isolating the woman's body, Lautrec conveyed a private shoring up of self in the fundamental introversion of the daily toilette. Only the open drawer of the washstand hints of the outside world in a line of neatly arranged shoes.

Technically as well as stylistically, Lautrec sought a highly abstracted result. The figure was first worked out in a loose oil sketch, from which a drawing of the same dimensions as the lithograph was made.[2] It is likely that the drawing, which is rendered in strong, sure lines, served as the pattern on the lithographic stone. The procedure of retracing the figure's contours onto the stone further clarified its abstract shape, and the overall olive-brown tint of the background, from which the image is reserved, reinforced the self-contained isolation of the woman's body and private activity.

1. For example, *Seated Red-Headed Woman*, 1891 (Dortu P.610); *Woman Combing Her Hair*, 1891 (Dortu P.389); and *Model Resting*, 1896 (Dortu P.611). See Stuckey (1979), pp. 176 ff.

2. Dortu P.622 and D.3736. The oil sketch, preparatory drawing, and lithograph all measure approximately 550 x 400 mm.

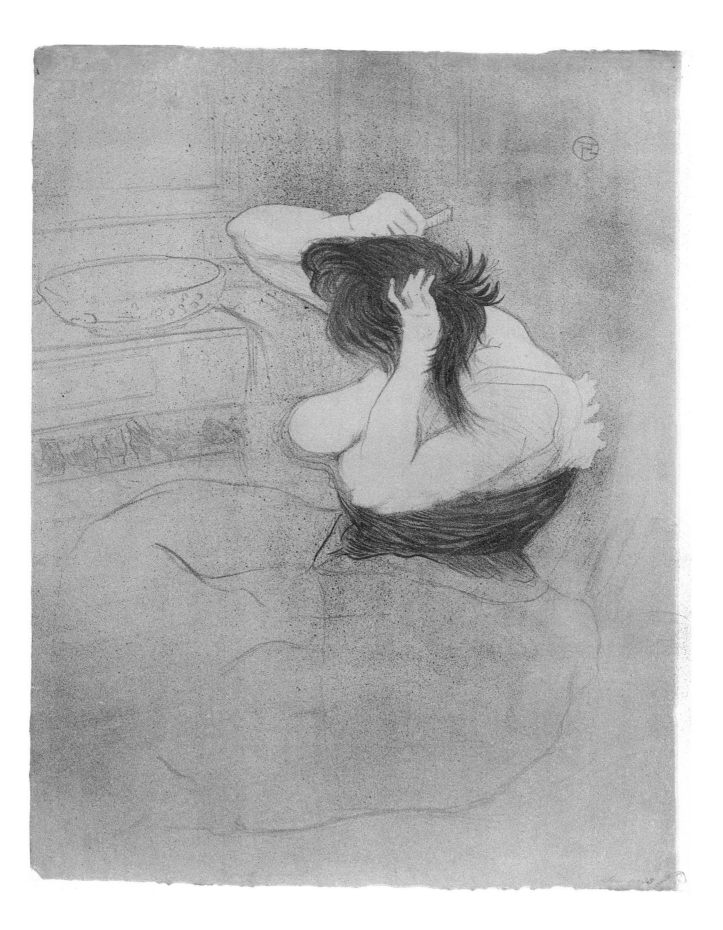

59. Woman in Bed, Profile—Awakening (Femme au lit, profil—Au petit lever) 1896

W 163 D 187
Crayon, brush, and spatter lithograph
with scraper, in four colors on wove
paper
One state only; one edition only, no. 33
of 100 impressions
Numbered in ink by Pellet, with his
stamp and paraph
15-3/4 x 20-1/2 inches
SDMA 87:79

This plate and *Woman at the Tub* (cat. no. 55) are related in their color schemes and planar divisions into areas of color and pattern. The white bulk of the woman on the right establishes her as a vertical field in her own right, while the young girl is incorporated into the white bedclothes, creating a visual dialogue between assertive strength and soft fragility. Profile countering profile, the figures are separated by a stripe of red, across which reach two delicate arms in contrast to the closed solidity of the massive silhouette. Whether or not the pair are mother and daughter, as suggested,[1] they represent similar archetypes—youth and age, beauty and loss of it, innocence and experience, dreams and disillusionment.

In these women Lautrec recognized the essential tragedy of the prostitute's life—it led to very little beyond growing old and ugly. A variation on the theme of *Woman with a Mirror* (cat. no. 57)—only here the young girl looks at her reflection across the years—this is a contemporary and tragic vision of the "ages of man," recognized by two women in unspoken sympathy.

1. Adhémar (1965), no. 208, suggests they are Madame Baron and Popo, and this seems quite likely. The pair, however, differ considerably from the figures in cat. no. 53, who have traditionally been identified as the madame and her daughter.

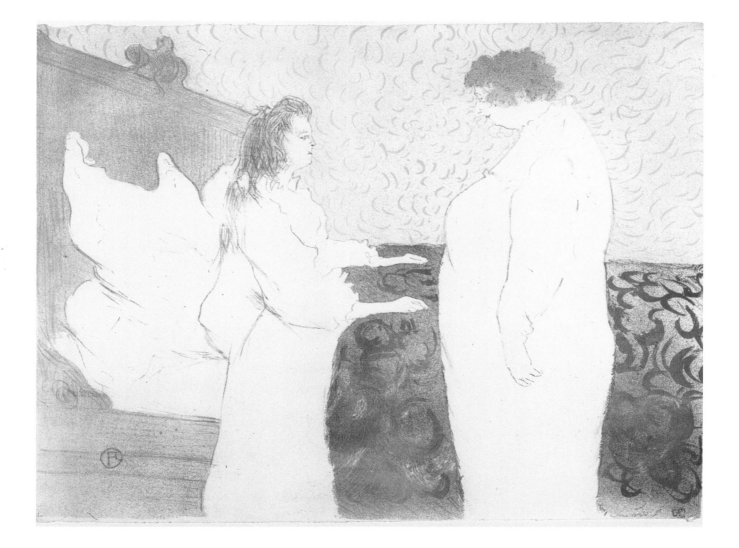

60. Woman in Her Corset—Passing Conquest (Femme en corset—Conquête de passage) 1896

W 164 D 188
Crayon, brush, and spatter lithograph
with scraper, in five colors on wove
paper
One state only; one edition only, no. 33
of 100 impressions
Blue monogram stamp, lower left
Numbered in ink by Pellet, with his
stamp and paraph
20-1/2 x 15-3/4 inches
SDMA 87:83

The ninth plate of the *Elles* is the only image which deals directly with the business of prostitution, but like the others, eroticism is left to the pictures on the wall (cat. nos. 55, 56). The voyeuristic pleasure of watching a prostitute dress was saucily portrayed in Manet's *Nana*, a painting which Lautrec undoubtedly saw when it was exhibited at the Durand-Ruel gallery in 1895.[1] But Manet's painting, although it informs Lautrec's subject, is fictionalized romance in comparison with the rote performance carried on here. A customer, in hat, gloves, and holding his walking stick, watches while a woman struggles into her corset (that it is going on rather than coming off is made clear in the preparatory painting and by her gesture of cinching her waist to tighten the laces).

Lautrec's vibrant oil sketch for the print casts the man as a sophisticated rake, leering at the woman with obvious relish.[2] In the lithograph he appears primly attentive, and the dashing energy of petticoats, flounced chemise, and zig-zag dressing screen in the painting has turned to tired laundry and old curtains in the lithograph. Between painting and print Lautrec seems to have edited himself, reducing the novelistic imagination of his original conception to more accurately reflect the prostitute's point of view. While the customer might see himself in the flashy painting, for the woman the scene is a routine one, lacking any such romance or visual excitement.

1. Cachin and Moffett (1983), p. 392
2. Musée des Augustins, Toulouse (Dortu P.616); ill. in Adriani (1987), pl. 87.

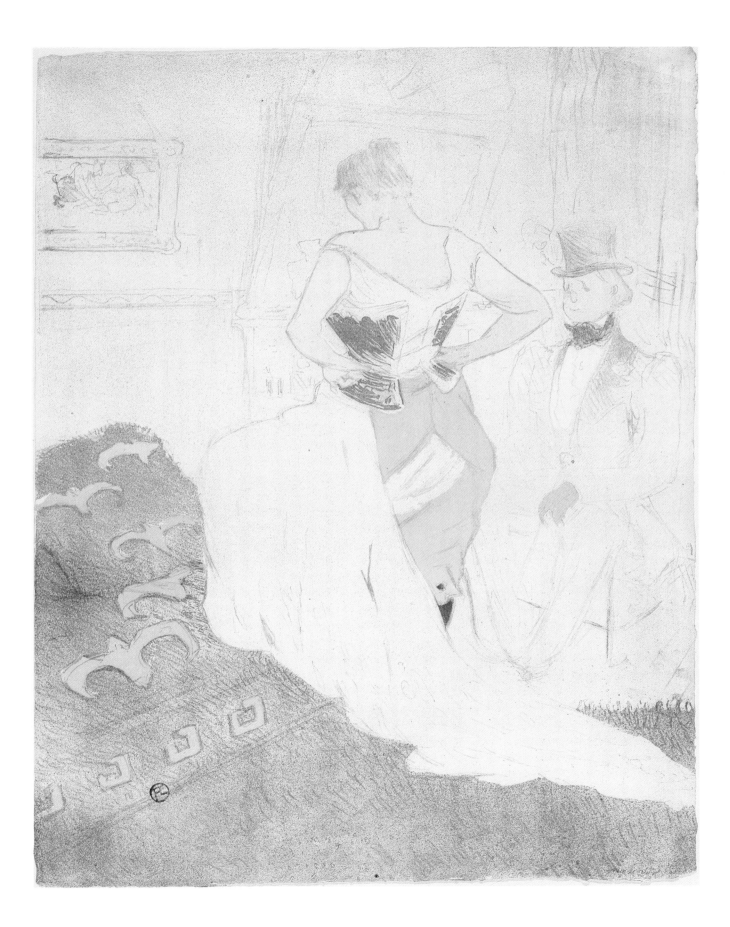

61. Reclining Woman—Weariness (Femme sur le dos—Lassitude) 1896

W 165 D 189
Crayon lithograph in two colors on wove
paper
One state only; one edition only, no. 33
of 100 impressions
Numbered in ink by Pellet, with his
stamp and paraph
15-3/4 x 20-1/2 inches
SDMA 87:86

An olive-green tint stone was used to cover the paper with a uniform ground color over which a sanguine crayon drawing was laid. In the veiled darkness created, a slim figure is revealed lying across a bed. Partially dressed in a chemise and one black stocking, she appears to have taken off the clothes and hat seen in the background and collapsed in a release to exhaustion. Unlike the women in the fourth and sixth plates of the *Elles* (cat. no. 55, 57) who retain some marginal remoteness through the use of allegorical references, or other plates in which the activities of the toilette preserve vestiges of a recognizable tradition from the eighteenth century forward, the young woman lying on her bed is left exposed in her own contemporary meaning.

This is not a reclining Venus of Titian, the *Naked Maja* of Goya, or Manet's *grande horizontale, Olympia*, love goddesses whose poses are meant to convey sensual languor and luxury. Nor is this the proverbial "lazy whore" of social commentary. Rather, the reclining prostitute summarizes what Lautrec had learned from his visits to brothels and what he conveyed throughout the *Elles* —that beneath the false romance or melodrama recorded by Goncourt and other naturalist writers, and beyond the dispassionate studies of Degas, the prostitute was a woman of bodily exhaustion and world-weary spirit. The subtitle of the *Elles* could be *Lassitude*; the series begins on that note with Cha-u-ka-o and continues with intermittent morning optimism until the last plate.

Although the order and titles of the plates were established by later cataloguers, the rhythm seen here is probably similar to Lautrec's original intention. No matter how one shuffles the images, however, the same collective information surfaces in scenes of the most elemental forms of privacy, of individual optimism or introspection, and the essential conflict between individuality and masquerade in the business of prostitution. The information is not profound, but sensitively and subtly given. Lautrec's much-vaunted objectivity in the *Elles* is not so much a journalistic record of brothel life as a recorded journal. His empathy with the women in the rue des Moulins and other houses was unemotional but ran deep, for it stemmed from his own conflicts in seeking a meaningful, normal existence, a "real life," as Van Gogh had expressed it.

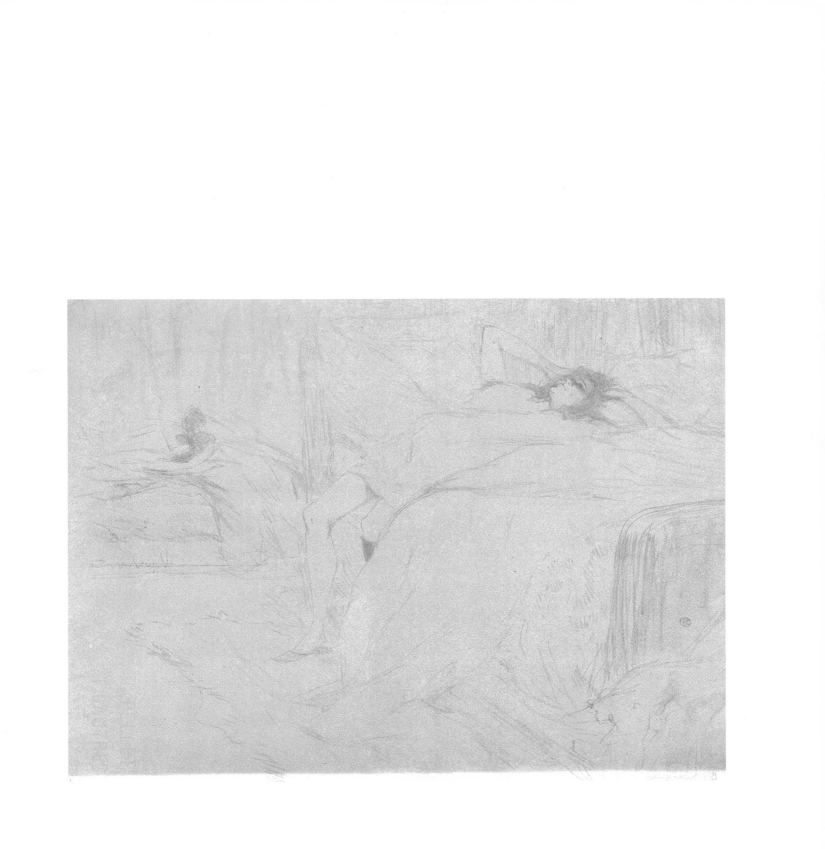

62. Debauchery (Second Plate)
(Débauche [deuxième planche]) 1896

W 167 D 178
Crayon, brush and splatter lithograph in
three colors on wove paper
Second state; second edition
9-1/2 x 12-7/8 inches
SDMA 87:73

This lithograph, one of the most fluidly drawn of Lautrec's entire graphic production, modifies two drawings and a black and white first plate (W 166) in which drunkenness makes the seduction aggressively erotic. Here, however, a sensual arabesque of the red-head in negligée contrasts with the amusing zig-zag of her seducer's legs. The Casanova is another one of Lautrec's jocular miscastings—Maxime Dethomas, a painter-printmaker friend of Lautrec who was known to be proper and restrained (fig. 54).[1] Something of his personality emerges, though, in his surprised glance as he hesitantly proceeds. The lady's champagne glass gives away the old ploy.

1. On Maxime Dethomas as an artist, see Cate (1985), pp. 101 ff.

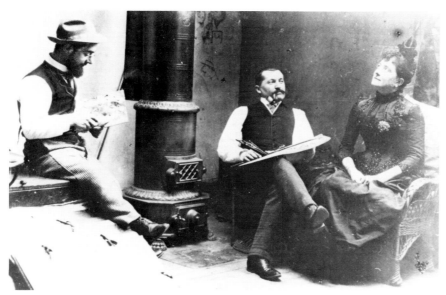

Fig. 54. Toulouse-Lautrec and Maxime Dethomas in Dethomas' studio with a friend, c. 1897. (Photo: Musée Toulouse-Lautrec, Albi)

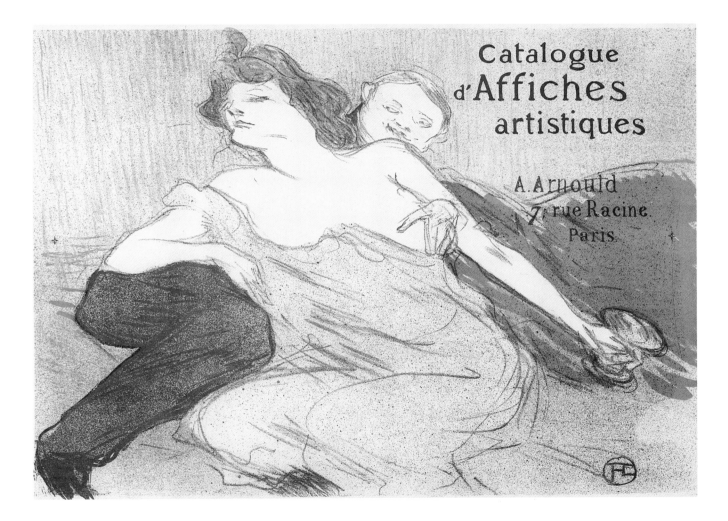

63. Supper in London (Souper à Londres) 1896

W 169 D 167
Crayon lithograph in grey ink on beige
wove paper
One state only; one edition only of
100 impressions
Signed in pencil, lower left
12-1/2 x 17 inches
SDMA 87:92

Although the title is a reminder of Lautrec's trip to London in 1895, this scene of an urbane couple supping *à deux* could have been found in any gay-nineties capital where the *gens chics* moved. Set within a private dining chamber, the foreground is marked by a bottle of champagne, and the background by a discreetly attendant waiter. In between these symbols of luxury, a fashionable *cocotte* (more crudely known as an *horizontale*) entices her dinner partner with a feline cunning that leaves no doubt of her intentions. In contrast to the handsome vacuity of her lover's profile, the sharp description of the woman establishes her as the protagonist of a thematic variation on Lautrec's 1892 poster, *Queen of Joy* (cat. no. 82), created for Victor Joze's novel on the *demi-monde*. This later lithograph, however, takes a lighter tone, more in the mode of Dumas *fils*, and Lautrec's elegant draughtsmanship imparts the glib insouciance of "half-worldly" mores.

Published by the periodical *Le Livre vert*, this print was one of twelve in the series *Etudes de femmes*, to which twelve artists contributed, including Puvis de Chavannes, Jules Chéret, Paul-César Helleu, Théophile-Steinlen, and Adolphe-Alexandre Léon Willette.[1]

1. Wittrock (1985), I, p. 406.

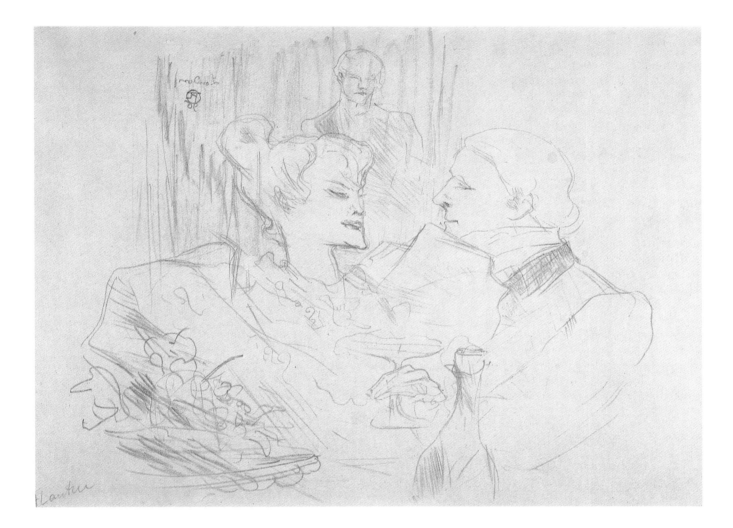

64. At the Maison d'Or
(A la Maison d'Or) 1897

W 229 D 222
Crayon lithograph in black ink on wove
paper
One state only; 12 known impressions
4-3/4 x 6-1/2 inches
SDMA 87:96

One impression of this extremely
rare lithograph was inscribed by the
publisher Kleinmann, "Illustration pour
une Nouvelle non publiée." (Illustration
for an unpublished short story.)[1] The
image is a gentleman dining alone in a
restaurant, sitting on a banquette, with
a waiter in attendance. This is a par-
ticularly beautiful sheet of waffle weave
paper.

1. Delteil (1920), 222.

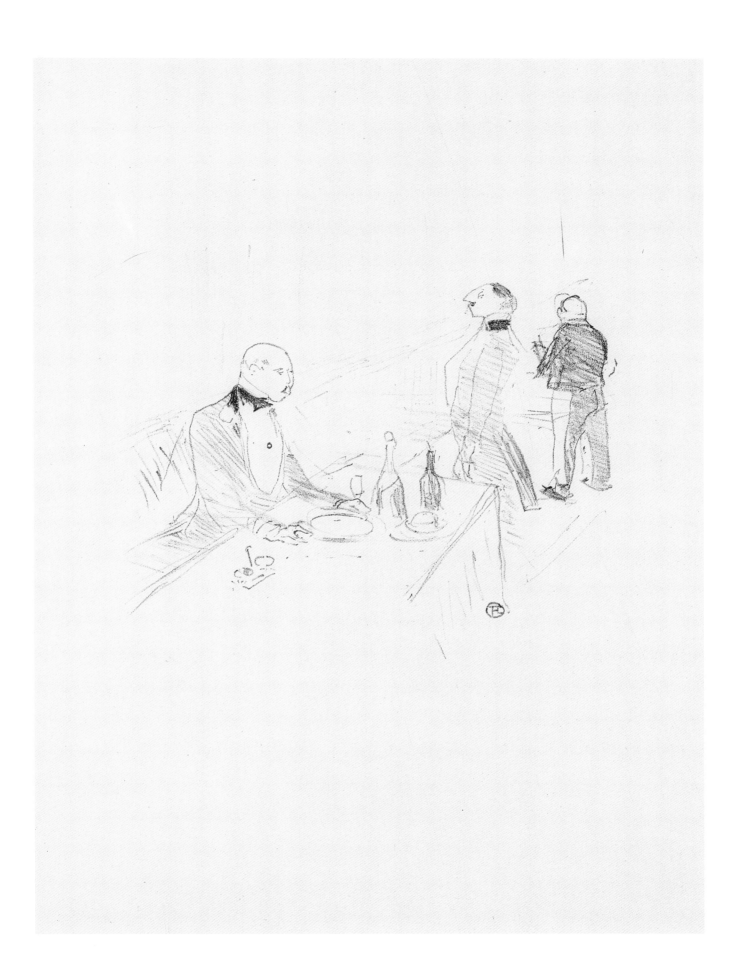

65. Cover for *The Tribe of Isidore* (Couverture pour *La Tribu d'Isidore*) 1897

W 234 D 215
Crayon lithograph in violet-brown ink
with a yellow-beige tint stone on wove
paper
Second state; second edition
7-1/2 x 9 inches
SDMA 87:97

This rare print is the second edition of a lithograph designed as the book jacket for Victor Joze's anti-Semitic novel, *La Tribu d'Isidore*, published in Paris in 1897. The book cover edition bears the subtitle, "roman de moeurs juives," and like other novels by Joze for which Lautrec made posters (*Queen of Joy* and *Babylon of Germany*, cat. nos. 82, 91), this one is part of a series called *La Ménagerie Sociale* and belongs to the tawdry literary genre of sensationalizing anti-establishment "morals."

The illustration of man and dog riding in a trap is surprisingly cropped, giving the carriage and horse a jaunty sense of diagonal movement across and off the page. In the same year that he produced this lithograph, Lautrec made two other prints of driving scenes, *Trap in Tandem* (W 227) and *Country Outing* (W 228), so it is likely that the subject of the book

cover was not a deliberate choice by the artist or author, but simply an image on Lautrec's mind at the moment. Certainly, however, he designed the composition specifically to accommodate the text necessary to its publication function.

The entire sheet, with exception of the man's shirt-front, was printed with a yellow-beige tint stone. In the book cover edition, the title text, printed in blue on an additional stone, overlaps the floating heads in the upper right, integrating them into the composition as strollers on the street that the driver whips down with reins taut.

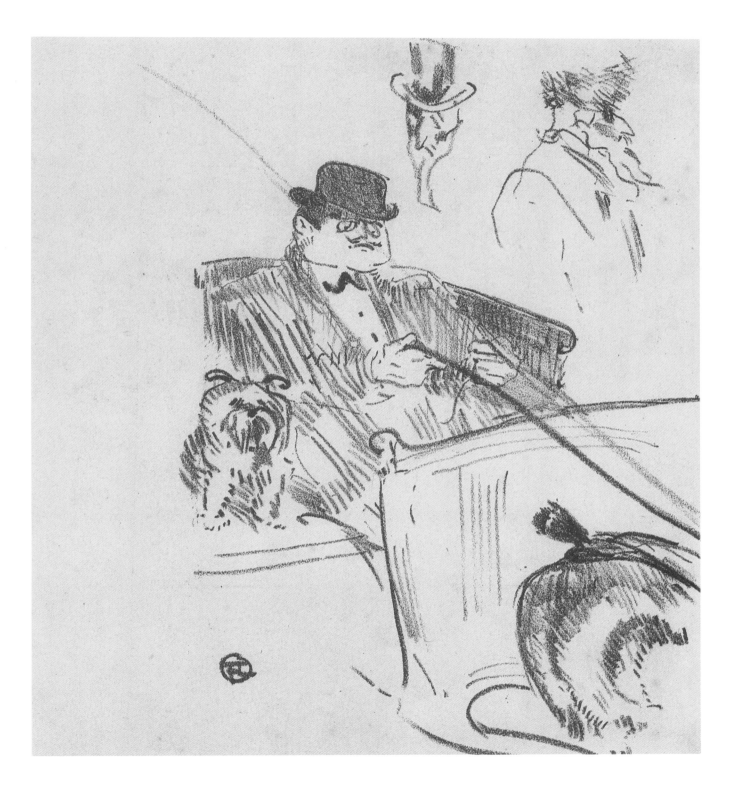

66. Bonjour Monsieur Robin 1898

W 239 D 1
Drypoint on zinc
One state only in dark brown ink on laid
paper
10-5/16 x 4-5/8 inches
SDMA 87:101

Lautrec made only nine drypoints, pro-
duced late in his career and never pub-
lished during his lifetime. He inscribed
this, the first of these drypoints, "bon-
jour Monsieur Robin/1898/25 janvier
1898/mon premier zinc." The plate has
not survived, and only seven impres-
sions are known, that in the Baldwin
Collection as the only one in America.
Apart from its rarity and documentary
value, there is little technically or
artistically to commend it. Most of the

other drypoint prints in the series are
portraits, while this one appears as
distracted doodles, perhaps simply
Lautrec's experimentation with a new
medium, as the words *"mon premier
zinc"* imply. At the very bottom, he drew
his burrin. He may never have consid-
ered the plate as suitable for printing
and thus inscribed it to his neighbor
Robin as a casual gift.

67. Jeanne Granier 1898

W 250 D 154
Crayon lithograph with scraper in black
ink on wove paper
One state only; first edition of 400
impressions before 1906
11-3/4 x 9-1/2 inches
SDMA 87:60

In 1896 the British publisher W. H. B.
Sands, who published Lautrec's 1898
Yvette Guilbert album (cat. no. 72), con-
ceived of a series of thirty lithographic
portraits of Parisian actresses and actors.
Lautrec did not begin the project until
1898 and produced only thirteen images
(W 249-261), five of which are repre-
sented in the Baldwin Collection. The
resulting album, not published by Sands,
did not appear until c. 1906, and details
of its publication remain unclear.[1] Her-
bert Schimmel and Dennis Cate have
shown that Lautrec worked from photo-
graphs in producing the portraits, and
have corrected past misidentifications of
the subjects.

Jeanne Granier (born 1852) was one of
the most successful actresses in Paris
during the 1890s, known for her
haughty disdain, which Lautrec con-
veyed in her expression and erectly held
head. She must have fascinated him, for
he depicted her in two other plates in
the series (W 264, 265).

1. The album was reissued in a small edition c. 1913.
 Wittrock (1985) II, pp. 572 ff. Concerning this
 series, see Schimmel and Cate (1983), pp. 27-32
 and 92-117.

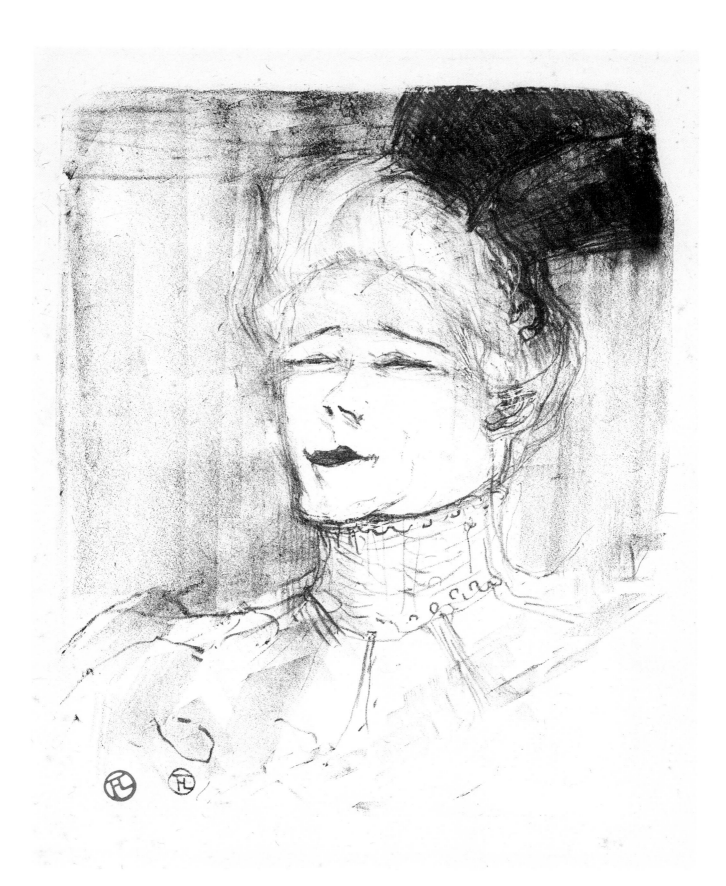

68. Anna Held 1898

W 251 D 156
Crayon lithograph in black ink on beige
wove paper
One state only; first edition of c. 400
impressions before 1906
11-1/2 x 9-1/2 inches
SDMA 74:71 Purchased with funds
donated by Maruja Baldwin Hodges

Anna Held (1865-1918) was a café per-
former at the Eldorado and La Scala, and
leading actress at the Yiddish Theatre
Company in Paris until 1895 when she
moved to New York. She played mainly
in musical comedies and married Flo-
renz Ziegfeld, founder of the Ziegfeld
Follies.[1]

1. Museum of Modern Art (1985), p. 93.

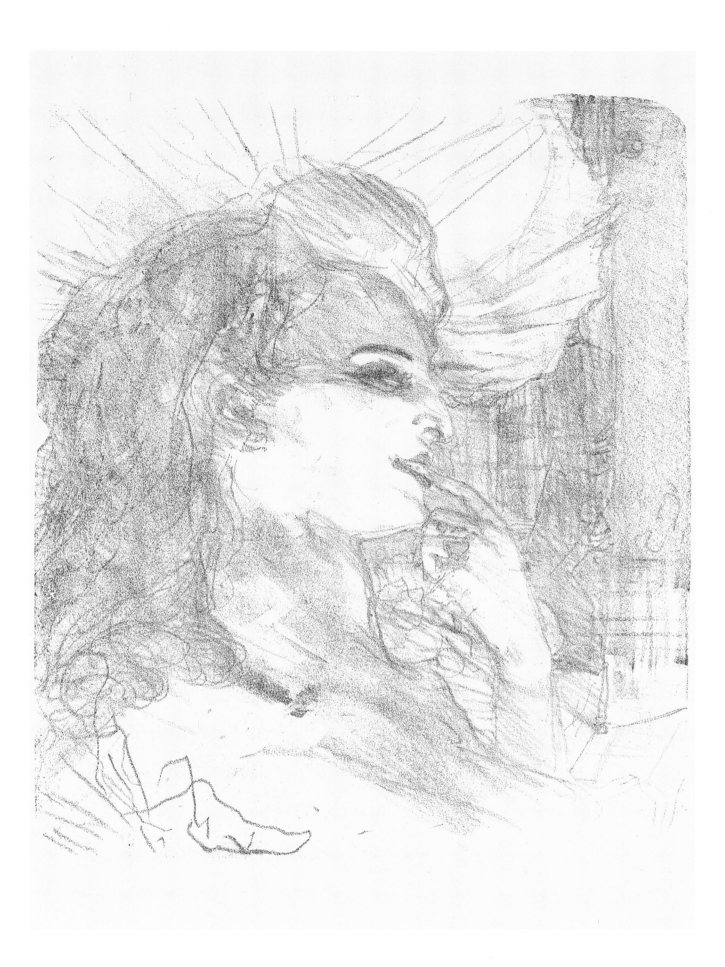

69. Emilienne d'Alençon 1898

W 253 D 161
Crayon lithograph with scraper in black
ink on white wove paper
One state only; edition for *Les XX* c. 1913
of 40 impressions
15-7/8 x 12-5/8 inches
SDMA 87:114

This lithograph is from the small edition
of the *Actors and Actresses* album pub-
lished c. 1913 by the Belgian society of
artists called *Les Vingts* (*Les XX*).[1] Shown
riding in a landau with its top back is
Emilienne d'Alençon (born 1896), who
began her career in 1889 at the Cirque
d'Eté. She danced at the Folies-Bergère,
Casino de Paris, and Menus-Plaisirs.[2]

1. Wittrock (1985), II, pp. 572 ff.
2. Museum of Modern Art (1985), p. 205.

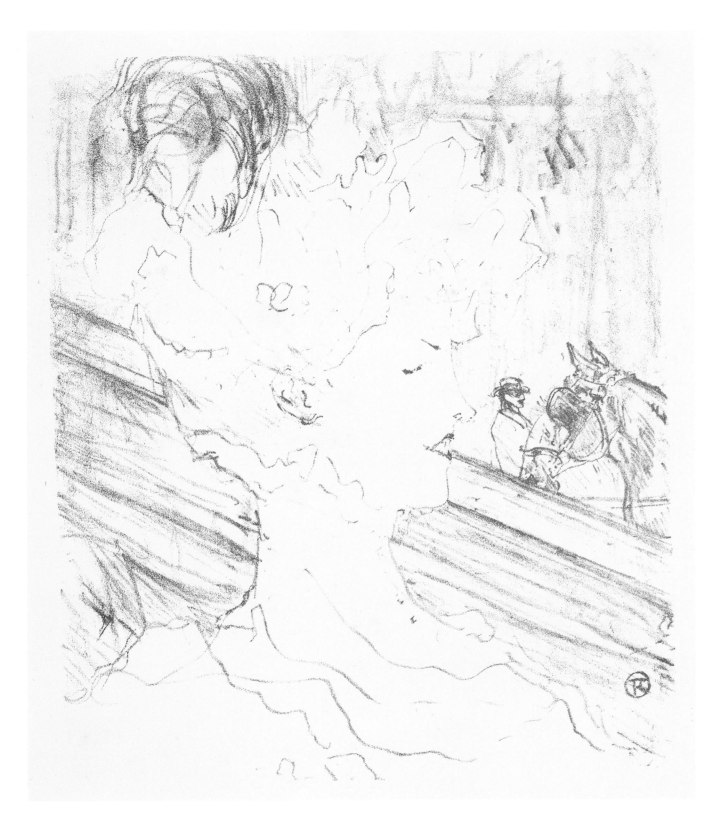

70. Louise Balthy 1898

W 256 D 157
Crayon lithograph with scraper in black
ink on wove paper
One state only; first edition before 1906
of c. 400 impressions
11-3/4 x 9-3/4 inches
SDMA 87:67

Riding in an open carriage beside a top-
hatted gentleman is the elegant Louise
Balthy (born 1869). She made her debut
at the Menus-Plaisirs and went on to per-
form at the Folies-Dramatiques.[1]

1. Museum of Modern Art (1985), p. 205

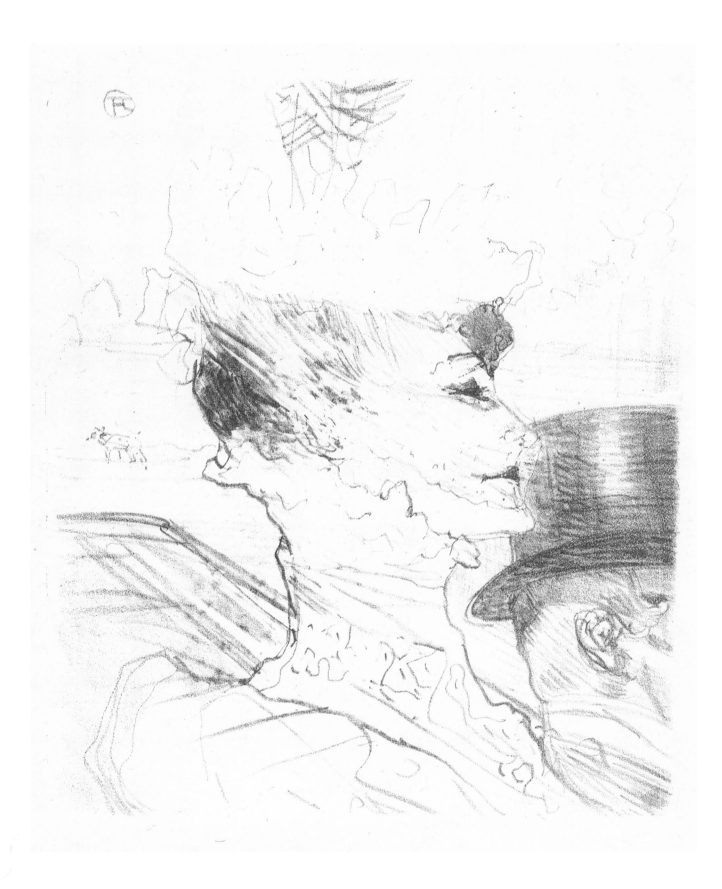

71. Cléo de Mérode 1898

W 258 D 152
Crayon lithograph with scraper in black
ink on beige wove paper
One state only; edition for *Les XX* c. 1913
of 40 impressions
11-5/8 x 9-1/2 inches
SDMA 87:58

One of the best of the Actors and
Actresses series is the tenth plate, *Cléo
de Mérode*, in which the dancer/singer is
shown seated in the audience of an evi-
dently serious choral performance on
stage in the background. Dressed in
an extravagant feathered hat and fur-
collared coat, perhaps she is caught
dozing by Lautrec, whose point of view
implies that he is seated in the row
behind her. The half-hidden profile, rich
blacks of her costume, and dramatically
foreshortened space make this composi-
tion one of Lautrec's most effective.
Cléo de Mérode (c. 1875-1966) was
born in Belgium and supposedly was a
mistress of the Belgian king. A star of the
Paris Opera, she made her American
debut in 1897.[1]

1. Museum of Modern Art (1985), p. 205.

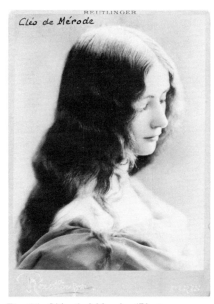

Fig. 55. Cléo de Mérode. (Photo:
Bibliothèque Nationale, Paris)

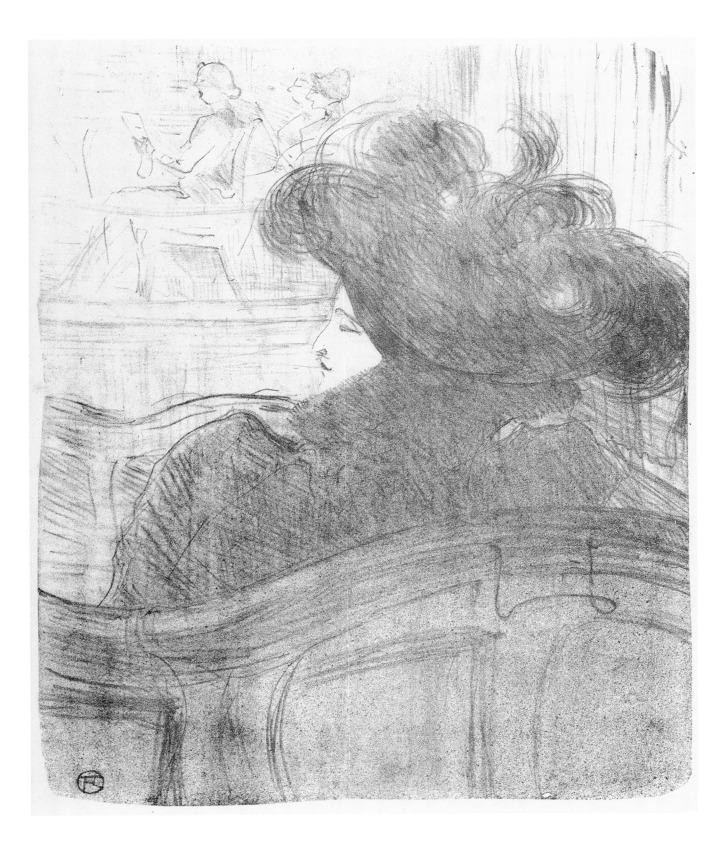

72. Frontispiece for *Yvette Guilbert* (Frontispice pour *Yvette Guilbert*) 1898

W 271 D 251
Crayon transfer lithograph with pen
transfer signatures, in black ink on laid
paper
One state only; first edition of 350
impressions
19-7/8 x 15 inches
SDMA 76:10 Bequest of Earl W. Grant

On the heel of the 1898 exhibition of Lautrec's paintings held in London, the British publishers Bliss and Sands published a portfolio of nine lithographs devoted to the comedienne and *diseuse* Yvette Guilbert.[1] The album was scheduled to coincide with the exhibition and with Guilbert's appearance on the London stage (which she cancelled, probably due to the Dreyfus affair.)[2]

The frontispiece portrays a faceless Yvette, who by this date was internationally famous and recognizable by her trademark of long black gloves. Standing before the prompter's box with head thrown impossibly back, she is about to launch into one of her expansive gestures. Lautrec had always pointedly characterized her and here captured the elegant panache of her bearing.

1. This portfolio is called the "English Series," to distinguish it from a similar Guilbert album that Lautrec made in 1894.

2. Adriani (1987), p. 32. For further information on Lautrec and his publisher regarding this album, see Schimmel and Cate (1983), pp. 118-143.

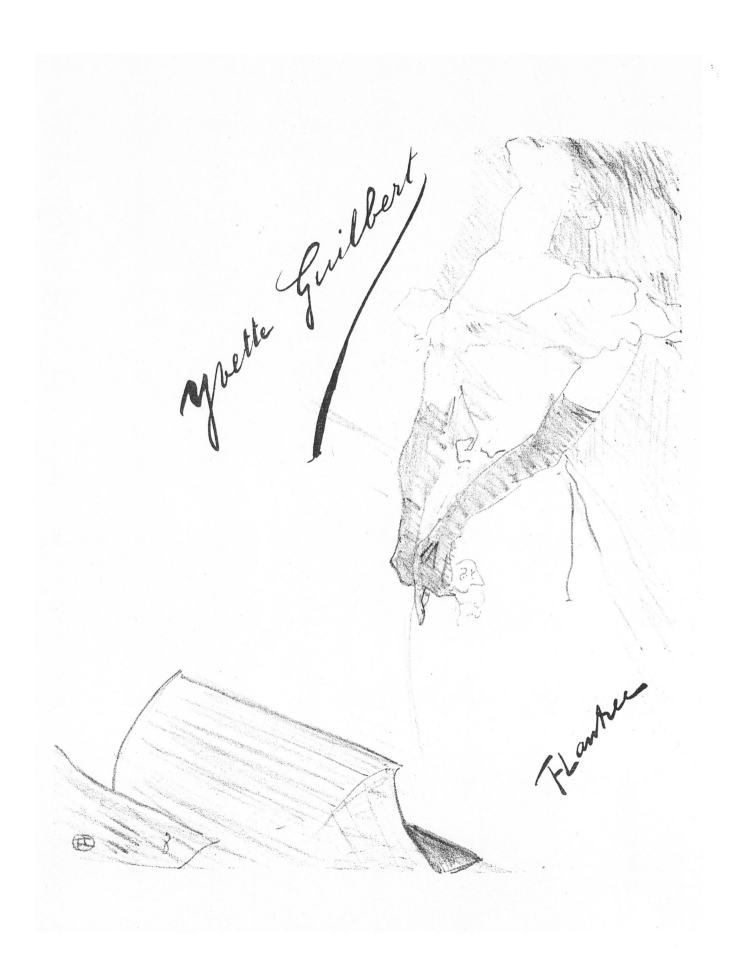

73. The Pony Philibert
(Le poney Philibert) 1898

W 284 D 224
Crayon lithograph in black ink on wove
paper
Stamped with red monogram, lower left
One state and one edition only
14-3/4 x 10-7/16 inches
SDMA 87:102

This very rare lithograph, printed in an edition of only c. 30 impressions, represents Philibert, Lautrec's favorite from the livery stable owned by Edouard Calmèse. The artist's close friend, Paul Leclercq, described Philibert as a fat sausage on little legs who became a person for Lautrec: "He demanded that I make his acquaintance and spoke of him as one would of a friend."[1]

The obvious delight taken in Philibert's curious and mischievous personality, so apparent in the extended neck and side-long glance in this print, substantiates André Rivoire's description of Lautrec's particular sensitivity to animals as his subjects: "Just as much as their form, and more than form, it is their character, actually their soul which he sought to grasp and express. He made portraits of animals just as he did of men."[2]

1. Leclercq (1921), pp. 24 f.
2. *Revue de l'Art*, "Henri de Toulouse," December 1901, p. 397.

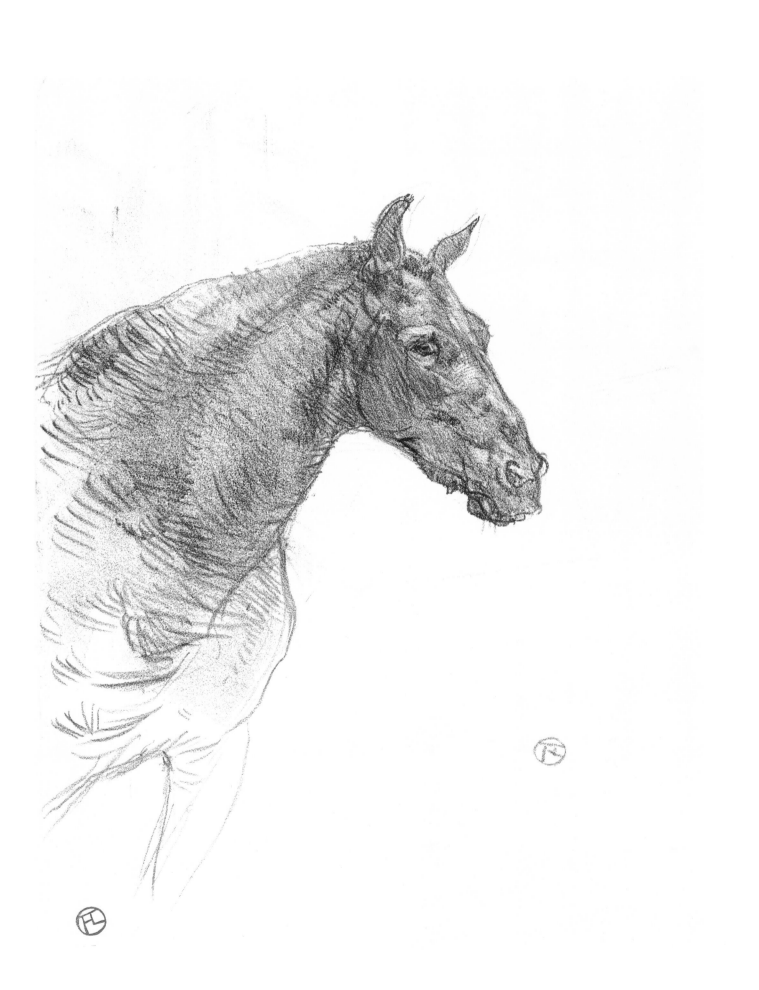

74. Di Ti Fellow—Englishwoman at the Café Concert (Di Ti Fellow—Anglaise au café concert) 1898

W 292 D 271
Crayon lithograph in dark violet-brown
ink on laid china paper
One state only; one edition only of 25
impressions
Signed in pencil and numbered with a
stamp, lower left
12-3/4 x 10-3/16 inches
SDMA 87:99

Di Ti Fellow may have been a short-
lived comic in the *café concert* circuit—
a sort of mustachioed lady who played
up the contrast between her mannish
appearance and feminine dress. Her
male audience was clearly not enthused,
as seen in Lautrec's depiction of her act.
Julia Frey has suggested that *Di Ti* may be
a phonetic spelling of the initials *D. T.* to
insure an English pronunciation of her
name. Englishness may have been cen-
tral to her stage personality, which is lost
to us beyond this very rare print.

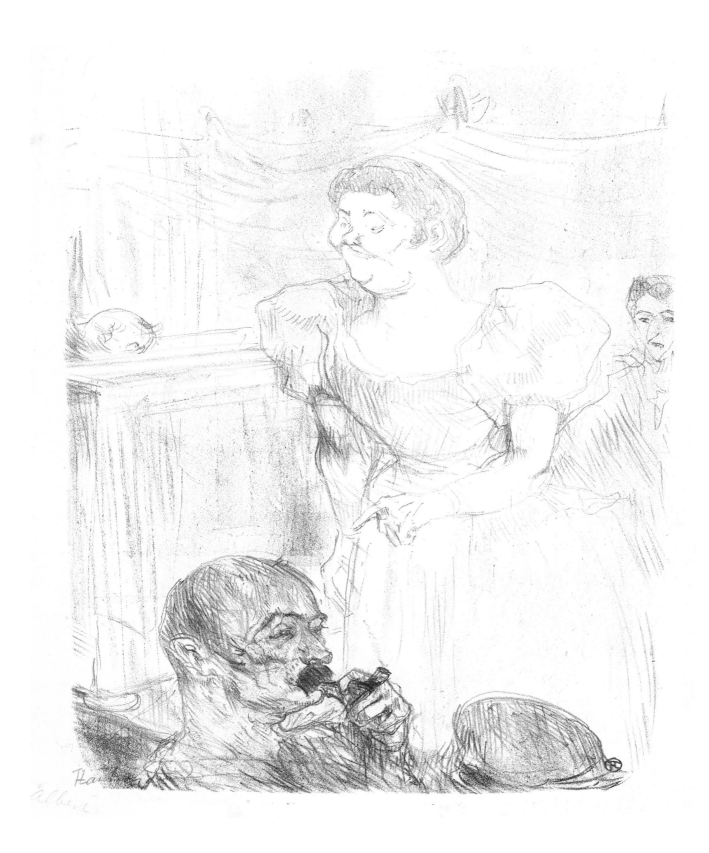

189

75. Guy and Mealy, in *Paris on the Move* (Guy et Mealy, dans *Paris qui Marche*) 1898

W 295 D 270
Crayon lithograph in dark violet ink on
imitation japan paper
One state only; one edition only, no. 14
of 100 impressions
Stamped with red monogram and signed
in pencil, lower left
10-3/4 x 9-1/2 inches
SDMA 87:100

From a front-row perspective, Lautrec
captured the animated showmanship of
this review which opened at the Théâtre
des Variétés late in 1897. Georges-
Guillaume Guy (1859-1917) and Juliette-
Josserand Mealy (born 1867) squint into
the footlights, the stark effects of which
were achieved entirely by using the
white of the paper and the lithographic
crayon. At a time when the artist sup-
posedly was losing his touch, the mas-
terful draughtsmanship of this litho-
graph, *The Pony Philibert* (cat. no. 73),
Promenade (cat. no. 76), and *The Jockey*
(cat. no. 77) bear witness to his continu-
ing abilities despite his worsening physi-
cal condition.

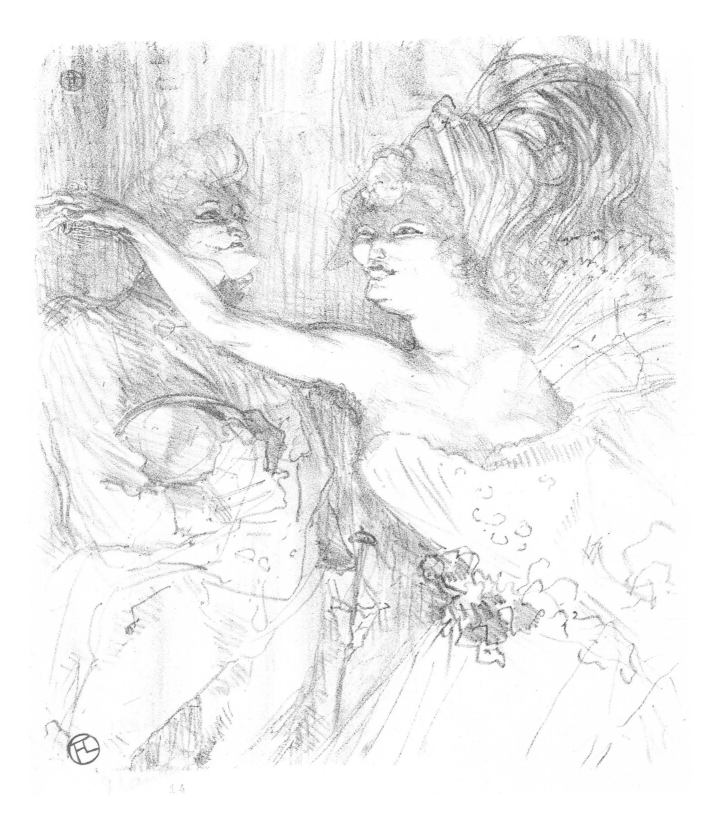

14

76. The Promenade
(Promenoir) 1899

W 307 D 290
Crayon lithograph in black olive-green
on japan paper
One state only, one edition only
Stamped with red monogram, lower left
18 x 14 inches
SDMA 87:105

Strolling the promenade gallery above the dance floor of the Moulin Rouge, these four figures are some of Lautrec's most sharply drawn personalities of the cabaret crowd. Two men give two ladies the eye in passing. The plump, feminine lady coyly glances at her companion who gives the men a "hands-off" message in her direct stare. As he did in several works, Lautrec enjoyed contrasting the feminine and masculine dress and attitudes of lesbians, many of whom he knew from the bars La Souris and Le Hanneton, and he also loved to observe the rituals and foibles of sexual pursuit. Here, with the men on the prowl, he created a marvelously ironic vignette, much like the amorous travesty of *Wounded Eros* (cat. no. 35).

Lautrec added a further parodical bite by casting his cousin Gabriel Tapié de Céleyran, the painfully shy and awkward doctor (of whom Lautrec said, "You have never seen anything beyond what has been brought to your attention")[1] as the ogler on the extreme left. And the photographer Paul Sescau (see cat. no. 101) is caricatured as a human camera, focusing in on the coquette with the entire thrust of his pointed face.

The sure drawing and range of tones in this lithograph are particularly impressive. *Promenoir* was published by Julius Meier-Graefe in the portfolio *Germinal*, which contained prints by nineteen artists, including Pierre Bonnard, Maurice Denis, Auguste Renoir, Auguste Rodin, and Edouard Vuillard among others.

1. Paul Leclercq, as quoted in Huisman and Dortu (1968), p. 154.

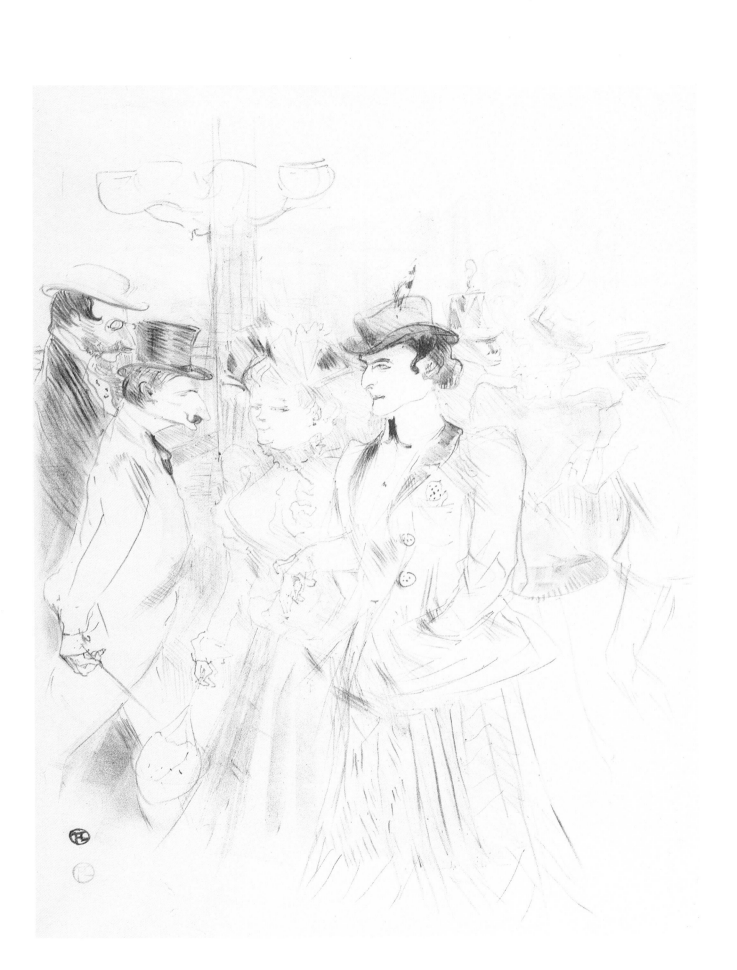

77. The Jockey
(Le jockey) 1899

W 308 D 279
Crayon, brush, and spatter lithograph
printed in six colors on china paper
Second state, second edition, 1899, of
112 impressions
20-1/2 x 14-3/16 inches
SDMA 87:104

The *Jockey* is one of the monuments of Lautrec's work. Dynamically composed and beautifully drawn, it was produced at the low ebb of his mental and physical health. Late in February 1899, Lautrec entered a psychiatric clinic where he remained until mid-May. During this period of confinement he began to revive, among other themes, his earlier interest in horses (see cat. nos. 1, 2). At the end of his stay, his printer Henri Stern and the publisher Pierrefort suggested that he make a series of lithographs of the racetrack, which Pierrefort would publish. Four prints were produced (W 307-310), but *The Jockey* is the only one published in editions, the other images remaining as trial proofs printed in black. The first edition of *The Jockey* also was printed only in black, and from watercolor experiments on a trial proof, Lautrec conceived the final six-color lithograph which was published as a second edition in 1899.[1]

Degas never made prints of the racetrack but in many paintings explored the theme in scenes of the race, spectators, and jockeys with their horses awaiting races in the Bois de Boulogne or at Longchamp. Certainly these works were an inspiration to Lautrec in a general sense, and it also appears in *The Jockey* that he specifically emulated the cool, muted colors of Degas' racing pictures, for example the blue-green and grey haze of *Jockeys before the Race*, which was described at the time as "semi-lunar brightness."[2] Similar colors are seen in the soft turquoise, brown, beige and blue inks of *The Jockey*.

Although they sketched the racetrack from life, Manet and Degas had looked to Géricault as a pictorial model (eg. *Races at Epsom*, 1821, Musée d'Orsay). Lautrec, too, who loved going to the track, recorded horses and racing scenes from life, but in this print he must have sought assistance from Eadweard

Mybridge's photographs of horses in motion, published in 1878-81, which reveal that at a point in the flying gallop, all four feet leave the ground. Lautrec shows precisely this moment, and intensifies the lunging movement through a play of foreshortening that exaggerates the disparity in scale between the horse's flank and head. His tendency to move in on his subjects from behind places the viewer in the exhilarating position of standing along the rail as the horses round the bend. The windmill in the background identifies the site as the track in the Bois de Boulogne.[3]

1. Wittrock (1985), II, p. 694. For the watercolor proof, see Dortu A.259.

2. C.1869-72, The Barber Institute of Fine Arts, The University of Birmingham; ill. in Moffett (1986), p. 257, p. 242, fig. 1.

3. See Cachin and Moffett (1983), p. 338.

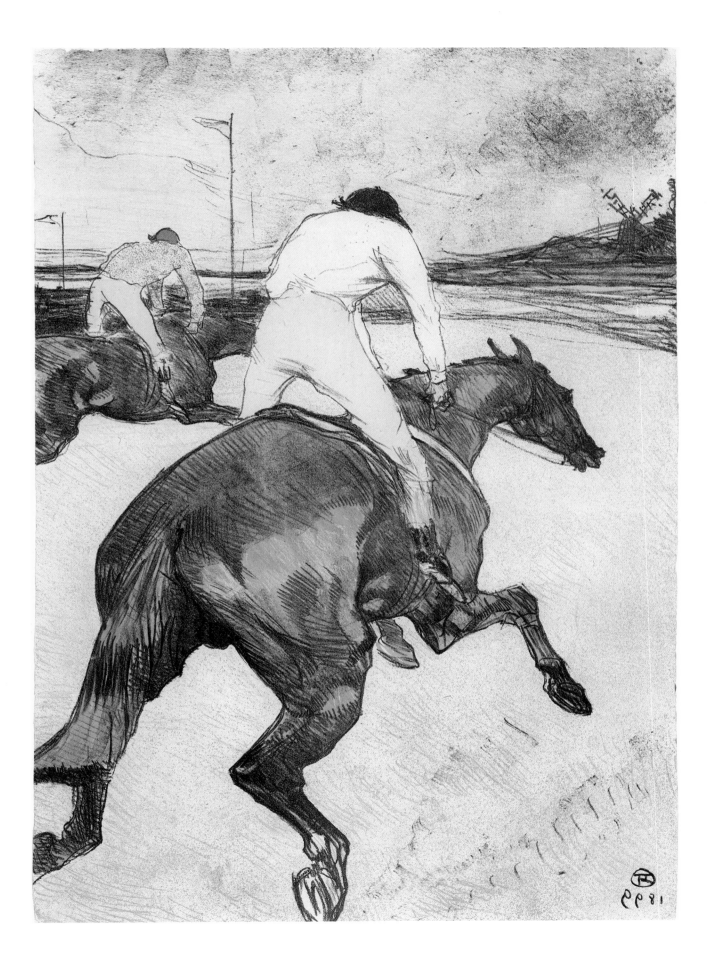

78. *Playthings of Paris*, Cover
(*Jouets de Paris*, couverture) 1900

W 332 D333
Crayon lithograph with scraper in black
ink on wove paper
One state only; one of six proofs before
addition of the text
8-1/2 x 4-3/8 inches
SDMA 87:108

The drawing of this clown, with its
"stick-figure" arms, hands and feet,
reveals a noticeable diminishing of
Lautrec's descriptive powers in the year
before his death. During the past decade
clowns had figured in his work as dis-
tinctive personalities—Footit and
Chocolat, for example—or as gamboling
jesters in the circus ring, while this is a
tragic monster barely capable of move-
ment. In its hideous mask, the mocking
humor of his earlier mode is recast into a
grotesque parody of Lautrec's own self-
caricatures and a brutal variation of his
most extreme distortions of Tapié de
Céleyran.

In 1901 the lithograph was printed as an
edition for the cover of Paul Leclercq's
book, *Jouets de Paris*,[1] and the same
image, reduced photomechanically, was
used as the cover illustration of his
Album de Paris, published in 1903.[2] The
collector's stamp in the lower right (Lugt
83) is that of A. F. Lotz-Brissonneau
(born 1840) whose collection of modern
prints was sold in 1918.

1. Joyant (1926-27), II, p. 94; Adhémar (1965),
 no. 368.
2. Wittrock (1985), II, p. 744.

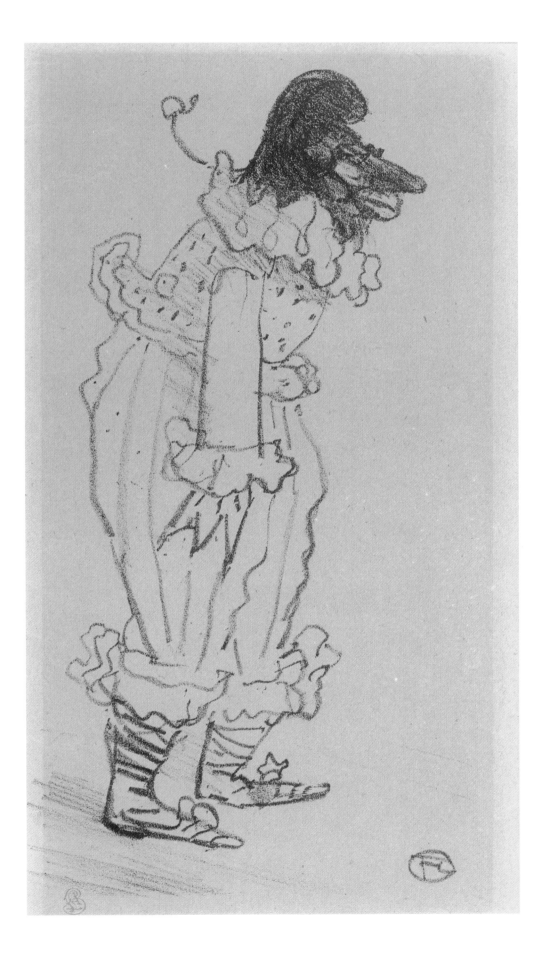

79. Zamboula-Polka 1900

W 333 D 334
Crayon lithograph with scraper in black
ink on wove paper
One state only; song sheet edition, 1900,
of c. 50 impressions
10-7/8 x 8-7/8 inches
SDMA 87:109

The title of a comic song by P. Valfe and
Désiré Dihau, *Zamboula-Polka* was used
as the cover of the song sheet published
by Georges Ondet.[1] The differing draw-
ing styles in the two figures suggest that
the dancer in black face was added to an
existing image of the piano player in
order to fit the pseudo-African title of
the song.

1. Joyant (1926-27), I, p. 96.

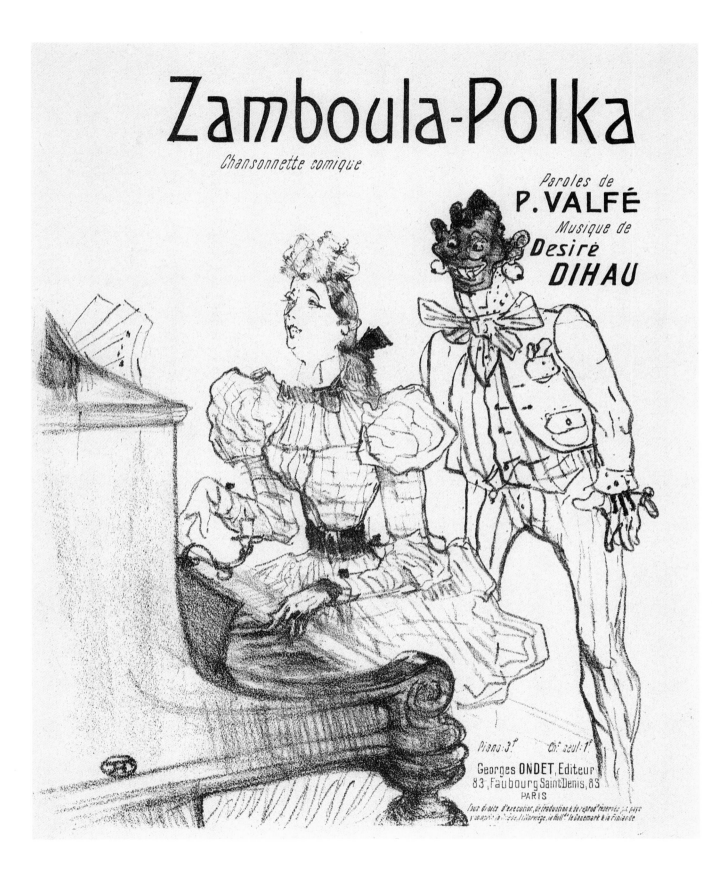

199

Posters (cat. nos. 80–109)

80. Moulin Rouge—La Goulue 1891

W P1b D 339
Brush and spatter lithograph in four colors on three sheets of wove paper
Artist's signature and text in upper part designed by the artist; text in lower part by another hand
75 x 46 inches
SDMA 87:19

Toulouse-Lautrec's first poster still stands as the most important in the history of lithography, perhaps in the history of advertising as well. Part of the success of *Moulin Rouge*—and it was immediately and immensely so—was its ability to arrest attention and implant itself in the viewer's mind. In terms of sheer scale it is unavoidable and its composition, startling and memorable.

> I still remember the shock I had [recounted Francis Jourdain] when I first saw the Moulin Rouge poster . . . carried along the Avenue de l'Opéra on a kind of small cart, and I was so enchanted that I walked alongside it on the pavement.[1]

Lautrec's first involvement in color lithography, *Moulin Rouge* departs entirely from the precedents of previous poster art. It virtually established his career. Although Jourdain had read the signature on the poster as "Hautrec," the artist's name and work immediately became known throughout Paris.

On October 5, 1889, the Moulin Rouge opened as the "rendez-vous du high life" at the foot of Montmartre. At once, its illuminated windmill vanes became a landmark, rotating above rooftops on boulevard de Clichy (p.46). A combined dance hall and cabaret, it housed a big dance floor, mirrored walls, and a fashionable gallery lit by round glass globes of gas lamps mounted throughout the interior. In the garden were an outdoor stage and an enormous wooden elephant with interior stairs leading to a glass-enclosed howdah (fig. 13), tame monkeys, and donkeys which ladies would ride after removing their stockings. It was described as a complete night resort.

On Wednesdays and Saturdays, as the poster advertises, masked balls were featured. The music was a brassy accompaniment to various new forms of the can can which shocked traditionalists and English families (a detail noted in Paris guidebooks) as "orgies and veritable saturnalia."[2] Professional dancers appeared on the floor, described in the 1898 *Guide de Plaisirs à Paris* as "a host of young girls who are there to demonstrate the heavenly Parisian Chahut dance as its traditional reputation demands, . . . with a physical elasticity as they do the splits, which promises just as much flexibility in their morals."[3]

When the music hall director, Charles Zidler, commissioned Lautrec to make the poster announcing the autumn season of 1891, the artist chose to depict the most outrageous dancer of the day whose name had become synonymous with the night-club (fig. 56). La Goulue (Louise Weber, 1870-1929), a provincial girl from Alsace who became the shameless queen of Montmartre, appeared at the Moulin Rouge when it first opened and scandalously danced the chahut with her long-limbed partner, a wine merchant by day named Jacques Renaudin (c. 1845-1906), who at night became Valentin Le Désossé, literally translated as "The Double-jointed." Lautrec portrayed the pair performing in the middle of the dance floor surrounded by a circle of spectators, of whom the viewer is one.

The choice of subject itself was revolutionary, and marked the first time that specific "stars" had been used to advertise an entertainment establishment.[4] Thus in his debut poster, Lautrec departed from the promotional gimmicks established by the grand master of poster art, Jules Chéret (1836-1932), who for two decades had accustomed the public to the anonymous *cherettes*— pretty, illustrational girls who, for example, rode about on donkeys beneath a windmill in Chéret's 1889 poster for the Moulin Rouge.[5] Lautrec's successor to these rococo frivolities was more substantive in every way, abstracting and economical, yet describing performers and setting with a specificity recognizable to anyone who had the vaguest familiarity with Paris nightlife.

Referring to his 1886 painting, *The Quadrille of the Louis XIII Chair at the Elysée Montmartre* (shown in fig. 22 as a magazine illustration), and to his most sophisticated dance hall painting to date, the 1890 *Dance at the Moulin Rouge*,[6] he developed the poster's com-

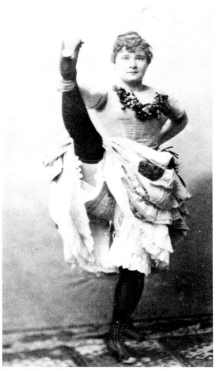

Fig. 56 La Goulue.

Continued on page 202

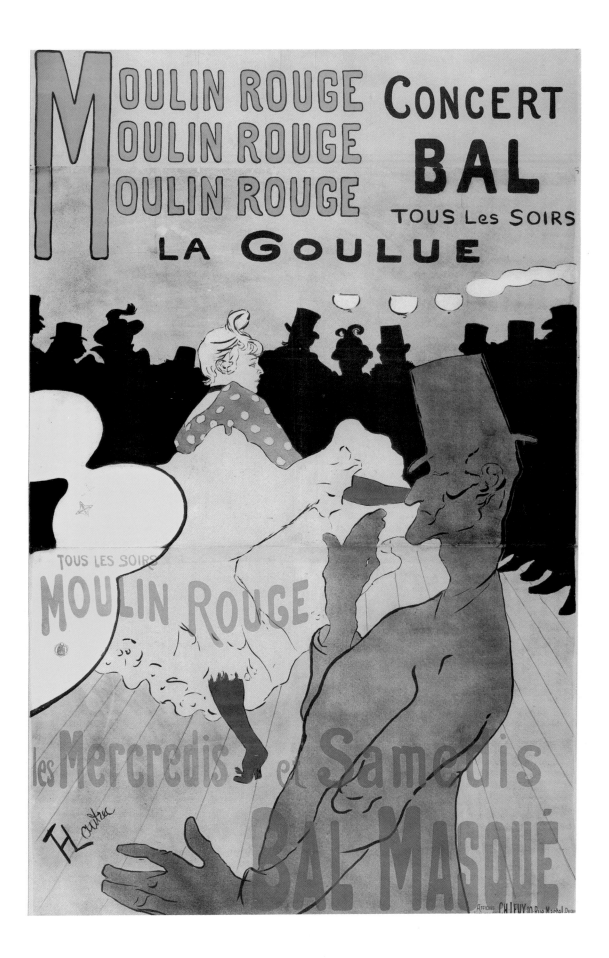

positional scheme, and plotted its details, outlines, and colors in two drawings and three paintings.[7] This sort of careful preparation is typical of most all of the posters, their visual immediacy belying the artist's preparatory process of building up naturalistic individuality and then reducing the image to its most telling aspects. In the poster, color and modelling are further reduced to flat areas of the primaries red and yellow; blue, spattered over the background and floor to create a sense of atmosphere; and black, used as outline and to silhouette the crowd of spectators. For the life-size silhouette of Valentin, Lautrec combined layers of red and blue *crachis* (spatter) to create a transparent grey-purple tint which allows the viewer to zip past this neutral "sign-post" to the magnetic white paper of La Goulue's pivotting derrière.

The poster's arresting design, which at the time would have been foreign to western visual habit, derives from the spatial distortion, asymmetry, and outlined areas of bright color found in Japanese woodblock prints.[8] Yet these were completely synthesized to answer self-imposed objectives of clarity and specificity, the outstanding innovations of Lautrec's poster art. Although the forms and techniques are reductively abstract, they carry the essential aura of the entire Moulin Rouge. The dance hall's bumpy panorama of hats, its glaring illumination, and atmosphere thick with "the odour of tobacco and rice powder," diffusely described in guidebooks and recorded in photographs (fig. 2, p.14), are understood at a single glance in Lautrec's poster. It must mark one of the great moments in the history of advertising, signalling the change from didactic description to experiential sensation.

It was typical of Lautrec's posters, however, that they also functioned outside the commercial world as works of art. The artist exhibited the *Moulin Rouge* at the Salon des Indépendants in March 1892, in an Antwerp exhibition, and again in 1893 at Galerie Boussod et Valadon, along with one of the Aristide Bruant posters and *Queen of Joy* (cat. no. 82).[9] The flamboyance of the entertainment posters, which made them so effective in the street, is based in sophisticated principles of abstraction and color which presaged twentieth-century Fauvism and Expressionism. Ironically Lautrec's posters, daily seen plastered on walls, were readily accepted by the same public which found his paintings, and later those of Matisse and Max Beckmann, so objectionable.

1. Huisman and Dortu (1968), p. 91.
2. Zeldin (1980), p. 315.
3. Adriani (1987), pp. 307 ff.
4. Adriani (1987), p. 124.
5. See Feinblatt, cat. no. 32. Illustrated posters had first appeared in Paris in the 1870s, and Chéret designed almost 1200 during his career.
6. McIlhenny Collection, Philadelphia Museum of Art; Dortu P. 361.
7. Dortu D. 3202, 3219, P. 400-402. See Adriani (1987), cat. no. 47, pp. 122 ff., for the large charcoal and oil sketch which served as the final pattern for the poster.
8. For the additional and related influence of the shadow plays (silhouettes against a white screen) presented nightly at the café Le Chat Noir, see Cate (1986), p. 19, and Thomson, in Wittrock (1985), I, p. 20, fig. 7.
9. Cate, in Museum of Modern Art (1985), pp. 82, 83.

81. The Hanged Man (Le pendu) 1892

W P2b D 340
Brush, crayon, and spatter lithograph in two colors on one sheet of beige wove paper, unmounted
23-1/4 x 31-1/4 inches
SDMA 87:23

A very rare poster, *Le Pendu* was commissioned by the Toulouse newspaper, *La Dépêche*, to promote its serialized novel, *Les Drames de Toulouse* by A. Siegel. The sheet was intended to be mounted in the upper right corner of a larger sheet containing the advertising text.

Set in the eighteenth century, the first of the three-part novel recounted the Calas affair, an innocent father wrongly executed for the murder of his son.[1] The poster illustrates the episode in which he discovers his son's hanged body, and Lautrec portrayed the scene with grim realism heightened by flickering candle-light. Departing from the flat areas of bright color in *Moulin Rouge* (cat. no. 80), he returned to the chiaroscuro and monochrome of Daumier's lithographs (e.g., *Rue Transnonain*, 1834). This may have been a purposeful emulation, giving the image an historical rather than journalistic appearance. The even, over-all spatter, imitative of the systematically cross-hatched backgrounds found in older prints, adds a further patina which sets the hanging as a remote fiction, in contrast to the eye-witness immediacy of *At the Foot of the Gallows* (cat. no. 87).

Due to its success in 1892, a second plate of *The Hanged Man* was published in 1895 as a small edition intended for collectors, clearly marked as the second pull.[2]

1. Feinblatt (1985), p. 16.
2. W P15; Wittrock (1985), II, p. 784.

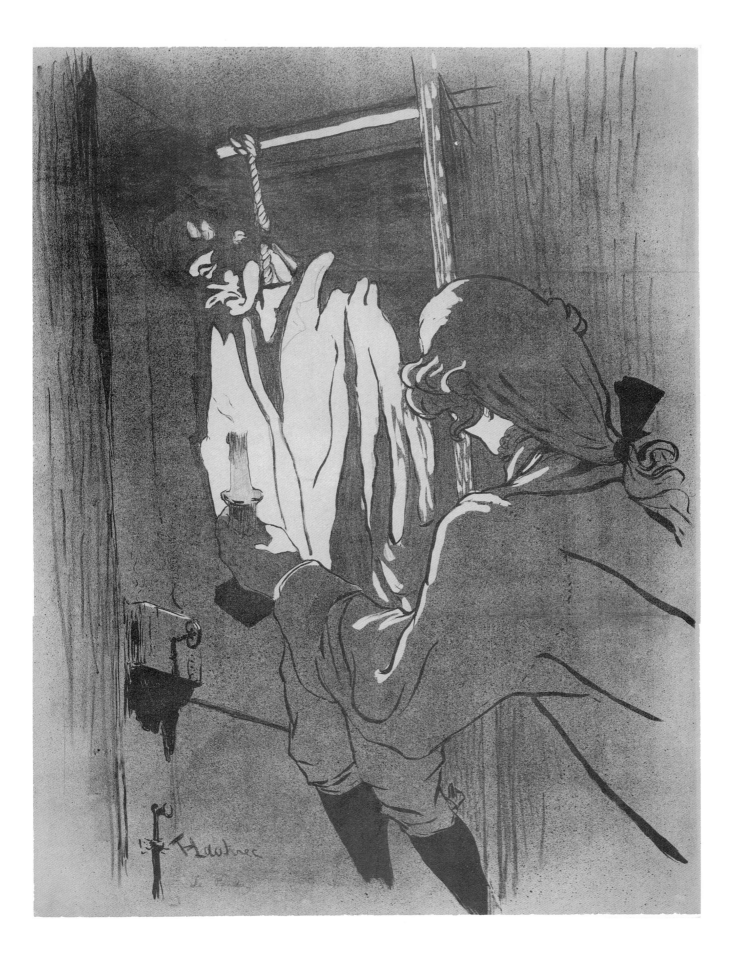

82. Queen of Joy (Reine de Joie) 1892

WP 3 D 342
Brush, spatter and transferred screen
lithograph in four colors on two sheets
of wove paper
Text by the artist
Artist's signature middle left
58-5/8 x 38-3/8 inches
SDMA 87:24

Lautrec's friend, Victor Dobrsky, who wrote under the name Victor Joze, commissioned this poster as a promotion for his new book *Reine de Joie, Moeurs du Demi-Monde*. The image also appeared as the title page of the *Fin de Siècle* magazine's June 4 issue in 1892 as an advertisement of this notorious book about the customs of the *demi-monde*. Despite the commercial instigation and purpose of the work, this was one of Lautrec's first posters to receive serious critical attention as a work of art. Reviewing an exhibition of posters at the Boussod and Valadon gallery in 1893, Thadée Natanson mentioned *Moulin Rouge — La Goulue* and *Aristide Bruant* (probably *Eldorado*)

and continued, "But it is the last one especially, that makes one thrill: the delicious *Reine de joie*, bright, pretty, and exquisitely perverse. . . ."[1]

From the book, Lautrec chose to depict the *demi-mondaine* heroine Helène Roland planting a calculating kiss on the gross banker Olizac. Pointed out many times, the characters are shown in the old tradition of the ill-matched pair—a young, sensuous woman and a lecherous old man, each using the other for a purpose. Primarily however, the man plays the fool, and Baron Rothschild, believing himself to have been portrayed by Joze as Baron de Rosenfeld, tried to confiscate both the novel and poster. By

then, however, the image was known throughout Paris.

With his usual sharp wit, Lautrec drew an analogy between the curving figure of Helène and the shapely glass wine ewer on the table, which seems to pucker its spout toward the heraldic shield on the plate set before Olizac. This pun is perverse indeed and again derives from old traditions of using vessels as an allusion to women. The sexual innuendo is obvious, and the combination of pitcher and coat of arms caricatures and reveals the nature of the prandial goings-on.

1. *La Revue blanche* no. 16, February 1893, p. 146, quoted by Cate, Museum of Modern Art (1985), p. 83.

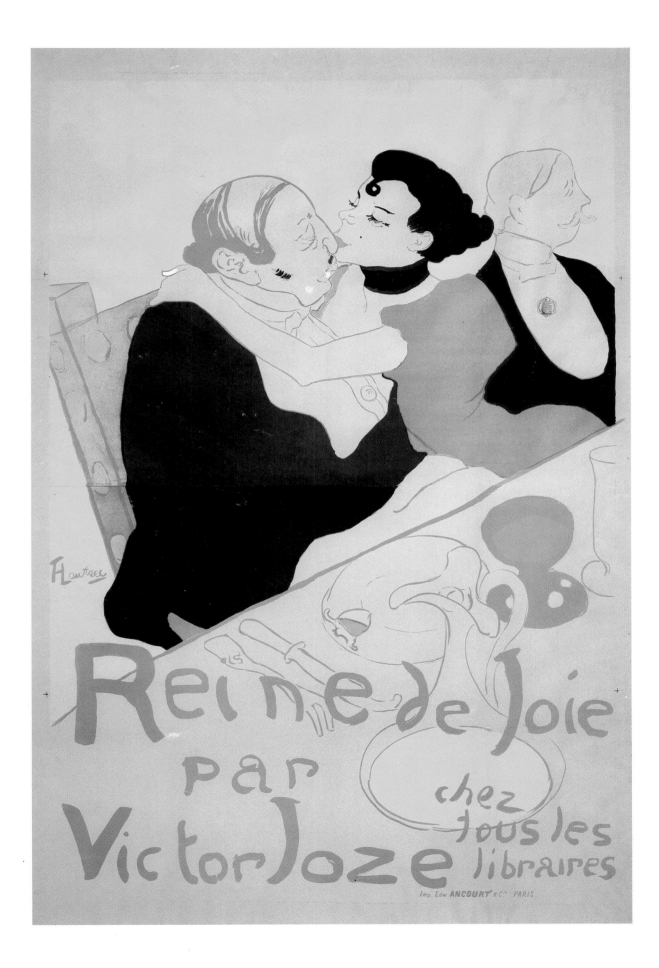

83. Ambassadeurs: Aristide Bruant 1892

W P4 D 343
Brush and spatter lithograph in five colors on two sheets of wove paper
Text by the artist; artist's signature, lower left
53-15/16 x 37-3/8 inches
SDMA 87:20

Fast on the overnight success of the *Moulin Rouge* poster, the singer Aristide Bruant (1851-1925) commissioned Lautrec to make the poster announcing his debut at the Ambassadeurs, a fashionable *café concert* just off the Champs-Elysées. Bruant had to threaten the café manager to underwrite the printing and display the poster but eventually won out, although Lautrec did not receive his fee (see cat. no. 27). He and Lautrec had known each other for years, since the mid-1880s when Bruant was performing in Montmartre at the Chat Noir and later at his own café, the Mirliton (the Reed Pipe), where he was host, song-writer,

and singer.[1] By the time of this poster, he had acquired an almost legendary reputation, which led to bookings at the up-scale "Les Ambass" and Eldorado (cat. no. 84).

A savvy performer and self-promoter, he developed a consistent look and act. In reality (fig. 57), he appears rather small and mild-mannered outside the costume, but the combination of felt hat, red shirt, and big boots contributed a bullying image to his French equivalent of billingsgate. He greeted his patrons with "Hola — there, it's your mug!"[2] Ladies entering the café were embarrassed by a Bruant-led chorus of the audience, "Oh, but how pale!"[3]

Drinks were served with insults, and satirical or sentimental lyrics sung in the crude argot of the streets. Master of his

stage, Bruant took on the power and authority of a belligerent host, controlling his guests who willingly fell into their own roles. The audience loved him.

Lautrec's poster *presents* rather than portrays Bruant. Standing in a doorway, a sinister silhouette lingering behind him, he cuts a grand figure holding broad dominion. Still wearing his gloves and carrying a walking stick, he enters the elite café as a ruffian just off the streets. Lautrec's long familiarity with Bruant, his act, costume and repertoire resulted in a daringly abstract summation which established the singer's image for the rest of his career.

1. See Cate, above, p. 33.
2. Mack (1953), p. 102. For a description of Bruant by a member of his audience, see Cate (1986), p. 167.
3. Zeldin (1980), p. 353.

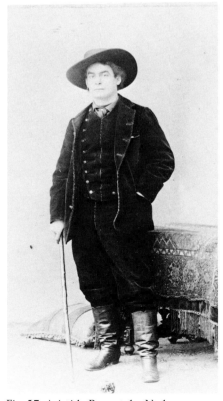

Fig. 57. Aristide Bruant, by Nadeau
(Photo: Bibliothèque Nationale, Paris)

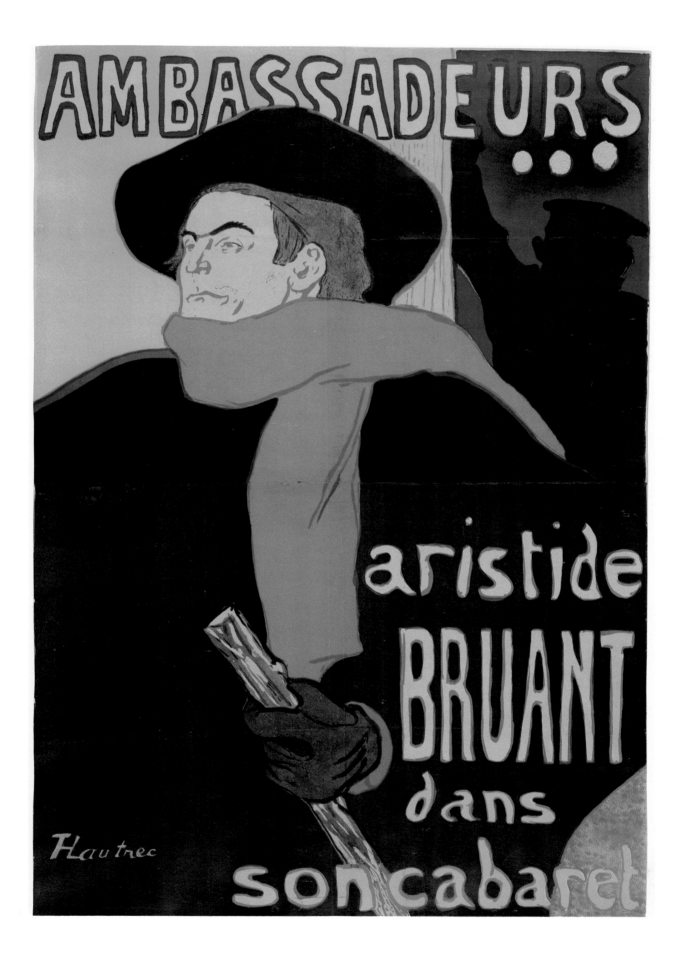

84. Eldorado: Aristide Bruant 1892

W P5 D 344
Brush and spatter lithograph in five colors on two sheets of wove paper
Text by the artist; artist's monogram lower right
53-1/2 x 37 inches
SDMA 87:22

For Aristide Bruant's appearance at the Eldorado (the top end of the *café concert* scale), Lautrec had the Ambassadeurs poster (cat. no. 83) printed in reverse. This would have been economical and also in line with Bruant's strategy of hammering a single image of himself into the public's mind. It worked. *La Vie Parisienne* complained, "Who will deliver us from the likeness of Aristide Bruant? . . . You can't go anywhere without finding yourself face to face with him."[1]

The poster is as aggressive—annoyingly so to the *Vie Parisienne*—as the singer's act, and is iconographically related both to the regal hugeness of Holbein's Henry VIII and the assertive, head-snapped postures of Japanese actor portraits.

1. Adriani (1987), p. 313.

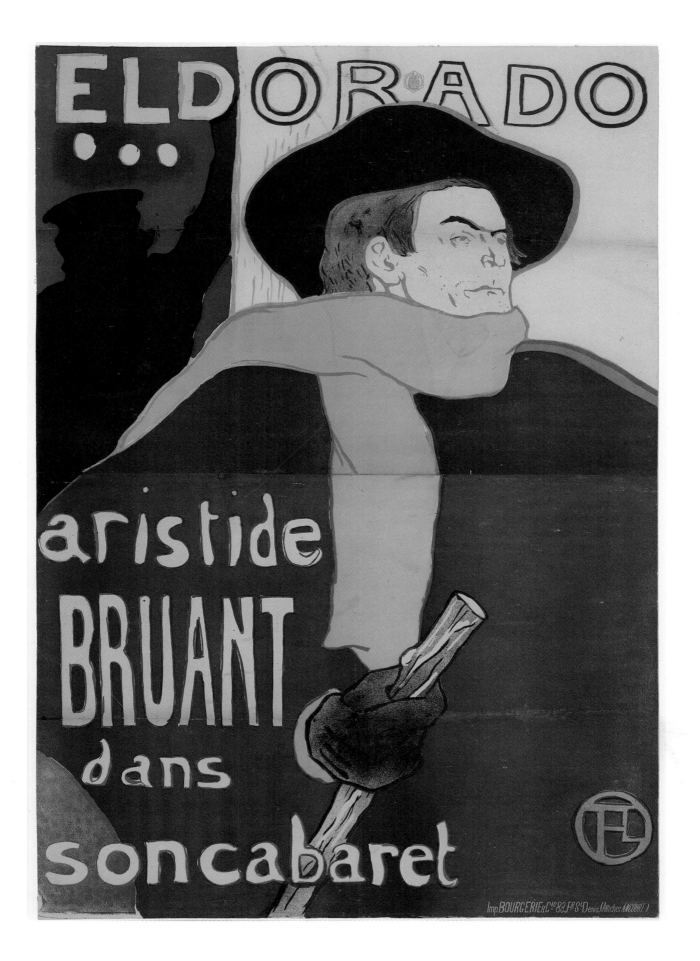

85. Jane Avril 1893

W P6b D 345
Brush and spatter lithograph in five colors on one sheet of wove paper
Text by the artist
50-1/2 x 37 inches
SDMA 87:32

Commissioned by the dancer Jane Avril to mark her debut at the fashionable *café concert* on the Champs-Elysées, Le Jardin de Paris, this poster must be counted among Toulouse-Lautrec's most daring designs.[1] Its relation to the compositional scheme of *Moulin Rouge — La Goulue* (cat. no. 80) is apparent in the looming heads of the musician and contrabass which hold a position on the picture plane similar to that of Valentin Le Désossé. But here Lautrec condensed the scenic expanse of the earlier poster into a graphically soldered unit. With no pretense at rational explanation, he pulled each end of the fiddle head into a cartoon-like "thought bubble" that encapsulates the dancer within its musical cell. It serves as an attention-grabber and also accompanies the rhythms of Jane's solo, repeating the shape of her skirts and relating her kicks to the musical source. Lautrec even added a mimicking choreographic flourish to the clef mark.

The imaginative framing device wittily exaggerates what had become a leitmotif in Degas' cabaret works from the previous twenty years — the cropped neck of the contrabass used to connect performers on stage in the background with the foreground orchestra.[2] Between Degas' formal convention and Lautrec's grotesque but effective parody stands the stylistic mediation of Japanese prints.[3] From such works as Hiroshige's *Ferry at Haneda*, in which the ferryman is radically cropped to only a pair of huge hands and legs (bristling with the stiff hairs which Lautrec liked to show), came the enframing structure and the abrupt transition to the focal point.[4] The sure, clean outlines encompassing the head and hand of the contraviolinist derive from techniques of the Japanese woodblock print, and this mad musician is not unrelated to Hokusai's caricatures of fierce monsters and warriors.

A publicity photograph of Jane Avril performing a high kick from the quadrille is thought to have served as Lautrec's model for the poster's preparatory oil sketch.[5] No indication of the stage, fiddle player or surrounding frame exists in the sketch, these elements belonging to a later phase in the development of the poster's graphic design, which is uncharted but so well-integrated, it must have been devised in drawings now lost. There remains in the frame, however, the sassy bravura of a sudden inspiration, suggesting that a specific, but as yet unidentified, source was quickly synthesized into Lautrec's own language.

After a deprived childhood, Jane Avril (1868-1943) rose to fame as a dancer, eventually married, and died, estranged from her son, as a poor widow in a Paris home for the indigent. The daughter of a *demi-mondaine*, La Belle Elise, and the Marchese Luigi de Font (an Italian count from whom Jane's mother extracted minimal support after he left her), Jane grew up poor, beaten, and emotionally unstable before beginning a career as a café dancer at the Moulin Rouge in 1889. The very opposite of La Goulue's, her dancing reflected her refined, sensitive nature. Described as a "delirious orchid,"[7] she appears several times in Lautrec's art, always as a beautiful melancholic, withdrawn into her own emotions or the quivering frenzy of her dance.

1. Commissioned probably by Jane Avril herself, the poster was first issued in a small edition of 20 impressions (W P6a). The larger editions (W P6b and c) were commissioned by the Jardin de Paris, printed by Chaix, and distributed by Edouard Kleinmann.

2. Lautrec was intimately familiar with a classic example, the portrait of the musician Désiré Dihau in *The Orchestra of the Opera*, or a version of it, which hung in the Dihau apartment where Henri often visited (1868-69, Musée d'Orsay, Paris). See Mack (1953), p. 60. He also would have known Degas' 1876 etching, *On Stage*, in which the head of the contrabass player and neck of his instrument are radically cropped. See Adhémar and Cachin (1974), no. 27.

3. See Cate, in Weisberg (1975), p. 109, cat. no. 166.

4. *Ferry at Haneda*, from *One Hundred Views of Edo*, c. 1858; Feinblatt (1985), p. 23.

5. See Griffiths in Wittrock (1985), I, p. 23, fig. 10. For the oil sketch (Dortu P. 482), see Stuckey (1979), p. 208.

6. Adriani (1987), p. 130; see Mack (1953), pp. 146 ff.

7. Described by Joyant, cited in Huisman and Dortu (1968), p. 108.

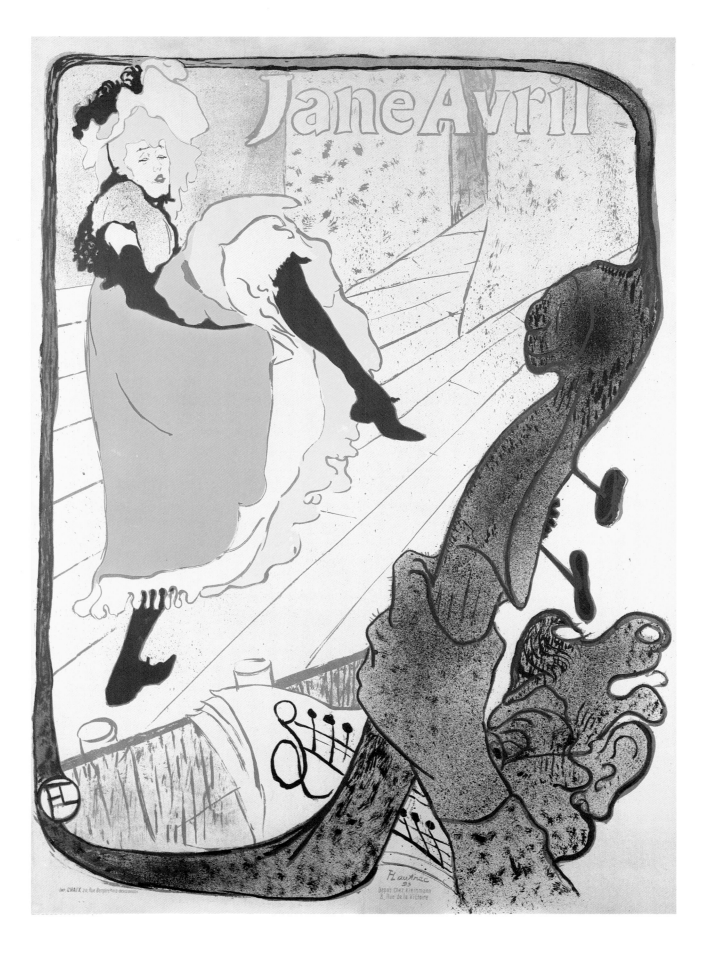

86. Caudieux 1893

W P7 D 346
Brush and spatter lithograph in four col-
ors on one sheet of wove paper
Text by the artist; artist's signature and
date, lower left
48-7/16 x 35-1/4 inches
SDMA 87:30

The comedian Caudieux prances past the prompter's box to make his entrance on stage at the Petit Casino. With wonderfully affected theatricality—arms held out, little legs moving like scissors beneath his paunch, lips pursed, hair oiled, in full stage make-up and evening regalia, with tails flying—he embodies the verve and decadence of the cabaret stage. In 1893 Lautrec also depicted him applying his make-up in a dressing room (inscribed "L'Homme Canon")[1] and included him in the Café Concert series (cat. no. 26).

The poster composition began with two quick sketches, recording Caudieux in performance (Dortu D. 3369, 3453), further developed in a large oil sketch[2] from which a tracing was made outlining the contours in ink. This served as a pattern on the keystone.[3] The methodical development resulted in the combined specificity of Caudieux's face and the abstracted, precisely cropped shapes of his coat and legs. Typical of Lautrec's irreverence for western realism, he set the viewpoint of the figure from below, and that of the stage floor from above—an eastern device which reinforces the flat, surface animation of the image and simultaneously conveys movement and setting.

1. Dortu P. 473.
2. Dortu P. 474. See Stuckey (1979), cat. no. 58, p. 203; Adriani (1987), cat. no. 57, pp. 142 ff.
3. Griffiths, in Wittrock (1985), I, p. 43. Dortu D.3324.

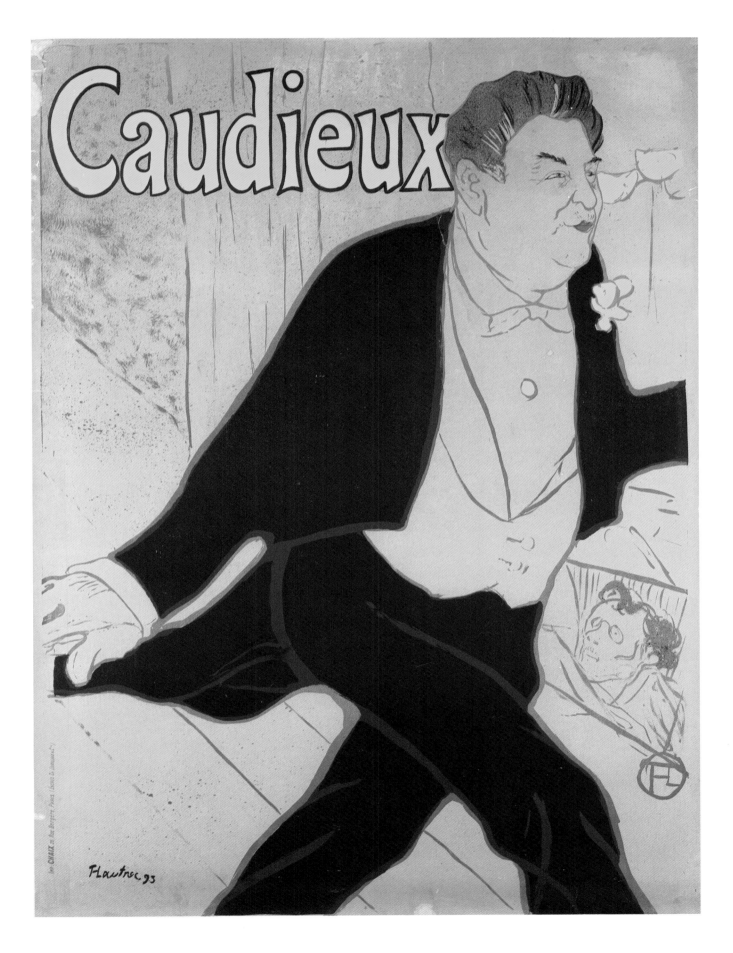

87. *At the Foot of the Gallows (Au Pied de L'Echafaud)* 1893

W P8 D 347
Brush, crayon, and spatter lithograph
with scraper in five colors on one sheet
of wove paper
Artist's monogram lower left; text by
another hand
32-1/2 x 23 inches
SDMA 87:27

One of Lautrec's rare nods to social realism is the poster commissioned by the magazine *Le Matin* to publicize the serialized memoirs of a chaplain at La Roquette prison. The Abbé Faure had witnessed thirty-eight executions, and the poster's stark composition and blood-red/black color scheme underscore its grisly subject.

Although the abbot's narrative was banally repetitive, Lautrec pictorialized it as a rivetting drama. With an eye to the sensational, he placed the view point in the lower left corner, exactly at the guillotine's lever, allowing the spectator to look up at the blade, across the neck notch and down into a basket opened to catch the severed head. This morbid fascination with the mechanics of decapitation invades the condemmed man's face, green with fear, as the executioner positions the body. Between them appears a priest, and locking the prisoner into an inescapable space and fate is a black barricade of horse guards.[1]

1. Sugana (1969), p. 124, suggests that rather than a direct drawing on the lithographic stone, a preparatory drawing by Lautrec was transferred to the keystone. The oil sketch, in a French private collection, is Dortu P. 511.

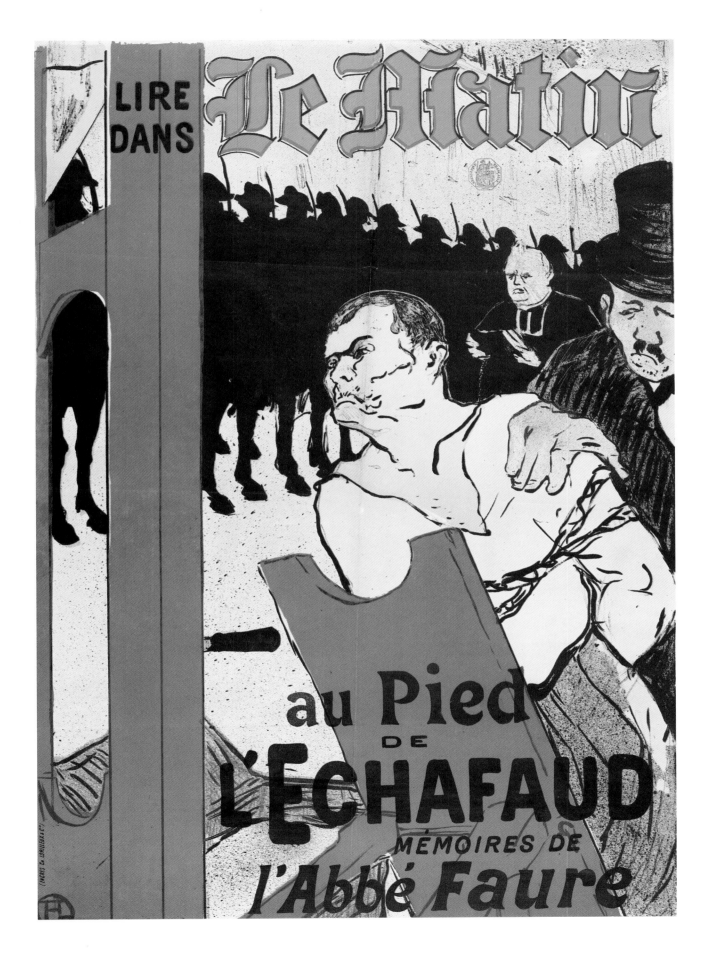

215

88. Aristide Bruant in his Cabaret
(Aristide Bruant, dans son cabaret) 1893

W P9c D 348
Brush and spatter lithograph in four colors on two sheets of wove paper
Text added by another hand after the artist's design; artist's signature and monogram, lower left
52-3/8 x 38-1/4 inches
SDMA 87:26

The third poster of Aristide Bruant, again commissioned by the singer himself, was issued in four editions, imprinted with various texts announcing performances at the Théâtre Royal, Alcazar Lyrique, and his "return to Montmartre."[1] Perhaps the most memorable of the Bruant posters, it stands as the heroic icon of the café era. Like Bruant's audiences, we see him only in terms of Lautrec's posters, no matter what visual information photographs (fig. 57) or Steinlen's depictions of the singer may convey.[2] The power of the image lies in its stark simplicity. By showing the figure from behind, looking over his shoulder, Lautrec was able to condense the swaggering personality into three bold shapes which had also become symbolic of Bruant himself— the great arc of black cape, red scarf, and black hat.

While general comparisons have been drawn between Lautrec's graphic style and Japanese prints, it is likely that for this poster the artist made specific reference to woodcuts of Japanese actors, for example Utagawa Kunisada's actor seen from behind (fig. 58).[3] Thematically related to his subject, Kabuki prints had similar goals of emphasizing individual personality through dramatic form and posture.[4] *Japonisme* had been pervasive in French painting and printmaking since the 1870s, and Lautrec was not only aware of its general esthetics, which had entered the realms of fashionable fad and art theory (see ill., p. 10, and cat. no. 90), but he also was familiar with Japanese prints first-hand through exhibitions held in Paris and his own acquisitions.

Aristide Bruant in His Cabaret has also been described by Welsh-Ovcharov as a pure example of *cloisonisme*, related to *japonisme* and Art Nouveau in its emphasis on linear clarity, and characterized by the in-filling of color into outlined shapes that is found in cloisonné enamels.[5] Although Lautrec did not espouse the Symbolist purposes to which *cloisonisme* led in the art of Gauguin and the Nabis, his use of nonwestern sources of form and decoration was in line with the most advanced art of his day.

1. Wittrock (1985), II, p. 772, W P9b and d.

2. Regarding Théophile-Alexandre Steinlen (1859-1923), see Cate (1986) p. 167 and color illust. no. 25 (which shows the influence of Lautrec).

3. Colta Feller Ives (*The Great Wave: The Influence of Japanese Woodcuts on French Prints*, New York, 1974, pp. 80-81) identified Lautrec's source as the woodcut by Katsukawa Shunsho, *The Black Danjuro*, c. 1781. See Castleman, in Museum of Modern Art (1985), p. 13 and fig. 3.

4. Cate, in Weisberg (1975), p. 64.

5. Welsh-Ovcharov (1981), pp. 38-41, 61, 342.

Fig. 58. Utagawa Kunisada (1786-1864), **Group of Seated Actors,** (detail), wood block print, San Diego Museum of Art.

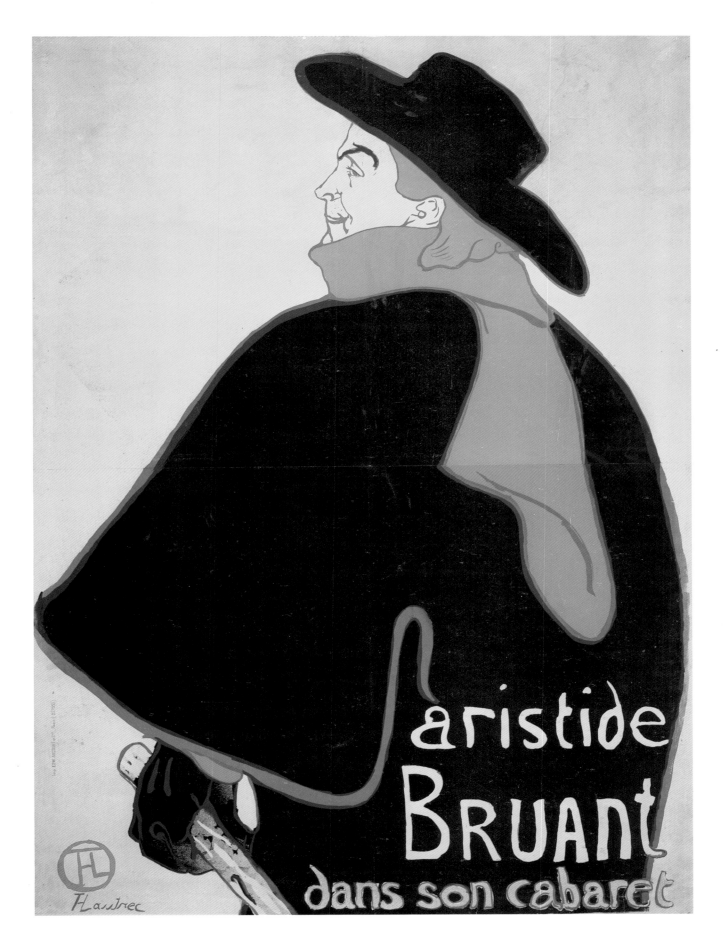

89. Aristide Bruant 1893

W P10c D 349
Crayon, brush, and spatter lithograph in
two colors on one sheet of wove paper
Text by another hand; artist's monogram
lower right
30-1/2 x 25-1/4 inches
SDMA 87:45

So recognizable were Bruant's stance and costume, that Lautrec portrayed him from behind with no indication of the face whatever, a variation on his "decapitations" of Yvette Guilbert, whose trademark of long black gloves was enough to identify her (cat. nos. 72, 90). By turning his back on the viewer, the figure is also invested with the insulting stage persona which Bruant had carried from his own Montmartre café, Le Mirliton, to the expensive nightclubs along the Champs-Elysées. He was known all over Paris.

The poster was commissioned in 1893 by Bruant, who used it for various purposes. Two editions advertise his performances— "Every night at the Mirliton" and "Coming soon to the Theatre."[1] A third, shown here, announces the 1895 publication of his second volume of songs, *Dans la Rue (On the Road)*, which followed a first volume published in 1888.[2] While Bruant selected Théophile-Alexandre Steinlen to illustrate both volumes, it is noteworthy that he did not commission the poster from the book's illustrator, but had Lautrec's 1893 poster imprinted with a new text reading, "The second volume of Bruant, illustrated by Steinlen, about to appear, on sale in all the bookstores and at the Mirliton."

In the late 1880s Lautrec had made drawings for cover illustrations of Bruant's song magazine, *Le Mirliton* (e.g., fig. 24); however they are few in number compared with the hundreds of illustrations and song sheets made by Steinlen, whose down-to-earth style was exactly in tune with the proletariat content of Bruant's lyrics and monologues. The need for a poster to advertise *Dans la Rue* brought the "literary" Bruant face to face with his public image, and he obviously opted to sell the book on his reputation as an entertainer, known to the public for the past four years through the Lautrec posters. Economy may have been another consideration, for either Bruant had a stock of un-imprinted posters, or the printer Chaix still had the stones from 1893. When *Dans la Rue* was published in 1895, the host of Montmartre already had gone into retirement at the age of forty-four. No further posters were needed.

1. Wittrock (1987), II, p. 774, W P10a and b.
2. Cate (1986), p. 163.

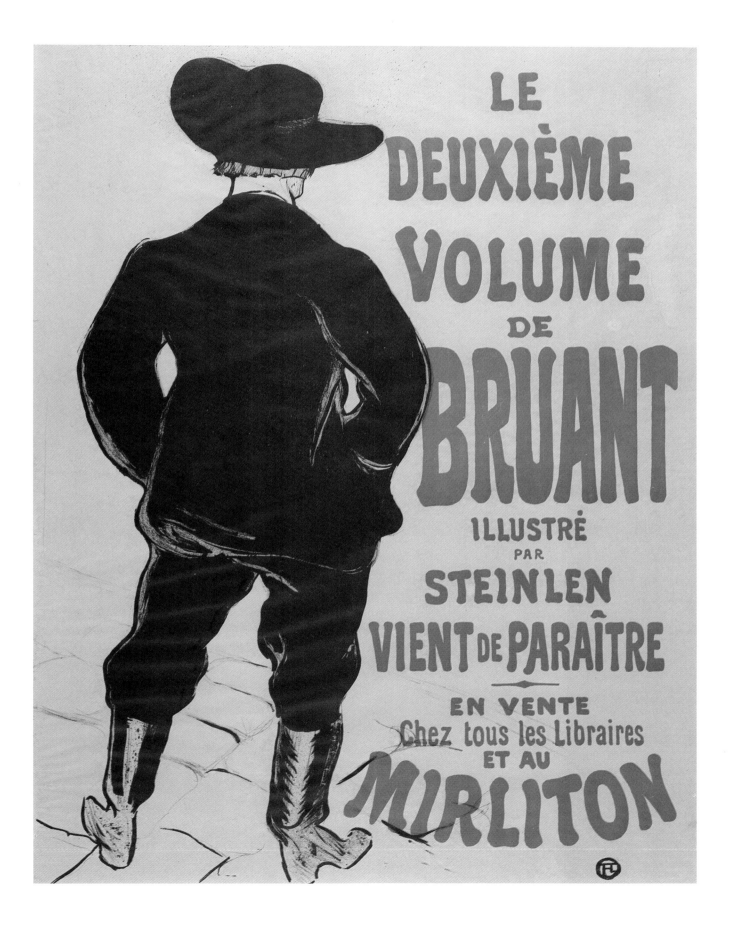

90. Divan Japonais 1893

W P11 D 341
Crayon, brush, spatter and transferred
screen lithograph in four colors
on one sheet of wove paper
Text by the artist; artist's signature, lower
right
30-15/16 x 23-7/16 inches
SDMA 87:21

Sitting in the audience of the short-lived Montmartre cabaret, the Divan Japonais, are Lautrec's friends, the dancer Jane Avril and critic Edouard Dujardin. On stage in the background is Yvette Guilbert, cropped by the edge of the image but recognizable by her black gloves. Avril is elegantly composed and withdrawn, dressed in chic gown and hat, and holding a fan over the ledge of the loge on which are set her little reticule and champagne glass. Jane's cultivated tastes and interest in art and literature place her comfortably in the company of the intellectual Dujardin, founder of the *Revue Wagnerienne* and contributor to Symbolist art theory.[1] Distractedly touching his cane to chin, he is interruped in mid-thought by Jane's shapely silhouette. As usual, Lautrec focused on the dramas enacted by the audience and here perfectly captured the ambivalence of the pair's feigned interest in the performance and their private, conflicting thoughts hovering just below the surface of social refinement.[2]

The poster, commissioned by Edouard Fournier, owner of the newly-renovated Divan Japonais, represents a complete summary of Lautrec's artistic interests and sources. Its composition is an exact reversal of Degas' landmark painting, *The Orchestra of the Opera* (1868-69, Musée d'Orsay, Paris), which established the motives of radically cropped stage, intervening orchestra punctuated by the neck of the contrabass, and foreground figures aligned diagonally. Degas' influence is implicit throughout Lautrec's art, but *Divan Japonais* is a direct borrowing; even Dujardin's cane is reminiscent of the bassoonist's instrument in Degas' orchestra. Stylistically, however, Lautrec looked to sources in Japanese prints, to which were linked the "cloisonnist" devices emerging in Symbolist art of abbreviated forms, clearly outlined and filled with color.[3]

He employed his sources with a certain degree of nominative purpose, and one might say that *Divan Japonais* is the most theoretical work of a decidedly non-theoretical artist. The name of the cabaret and its oriental decor[4] made the japanist diagonals, flattening of space, and curvilinear silhouettes employed by Lautrec appropriate and overtly meaningful. Similarly, Edouard Dujardin's presence in a Japanese context makes an unavoidable reference to his writings on the objectives and means of the abstracting style of art in which Lautrec participated. "Why retrace the thousands of insignificant details the eye perceives," Dujardin asked. The artist should single out his subject's essential traits and capture its character with the fewest lines and colors possible. Japanese art is a good example of this, he continued, and the techniques of Japanese prints, like those of modern artists, consist of outlines filled with areas of flat color, painted in compartments, something like the techniques of cloisonné enamel works.[5]

Dujardin basically summarizes the principles of Lautrec's art, and Lautrec's poster gives a pictorial synopsis of both the critic's views and the concerns of avant-garde painting since Manet. Viewed in this way, *Divan Japonais* poses itself as a provocative brain-teaser, full of cryptic "signs" and perhaps not too serious referents to the vast intellectualism of modern art that percolated at the café tables and was poured out in the journals. One of these symposia, represented in *At the Moulin Rouge* (1892-95, The Art Institute of Chicago),[6] included Dujardin and Jane Avril seated with other friends of Lautrec, while the artist himself wanders in the background. The poster bears a strong relationship to this masterwork, painted only a year before, and the witty concision of *Divan Japonais* stands as a light-hearted manifesto of the themes, personalities, and principles which informed Lautrec's art and environment.

1. Rewald (1982), p. 136.
2. See cat. no. 48.
3. Welsh-Ovcharov (1981), pp. 38-41, 343.
4. See Cate (1986), p. 160, fig. 184, for the *café concert* Divan Japonais.
5. Rewald (1982), p. 143, and Welsh-Ovcharov (1981), p. 24. Dujardin published these principles in an essay on Lautrec's friend, the painter Louis Anquetin, in the March 1, 1888, issue of *La Revue indépendante*.
6. Dortu P. 427; illust. in Sugana (1969), no. 309 and plates XXVII—XXIX.

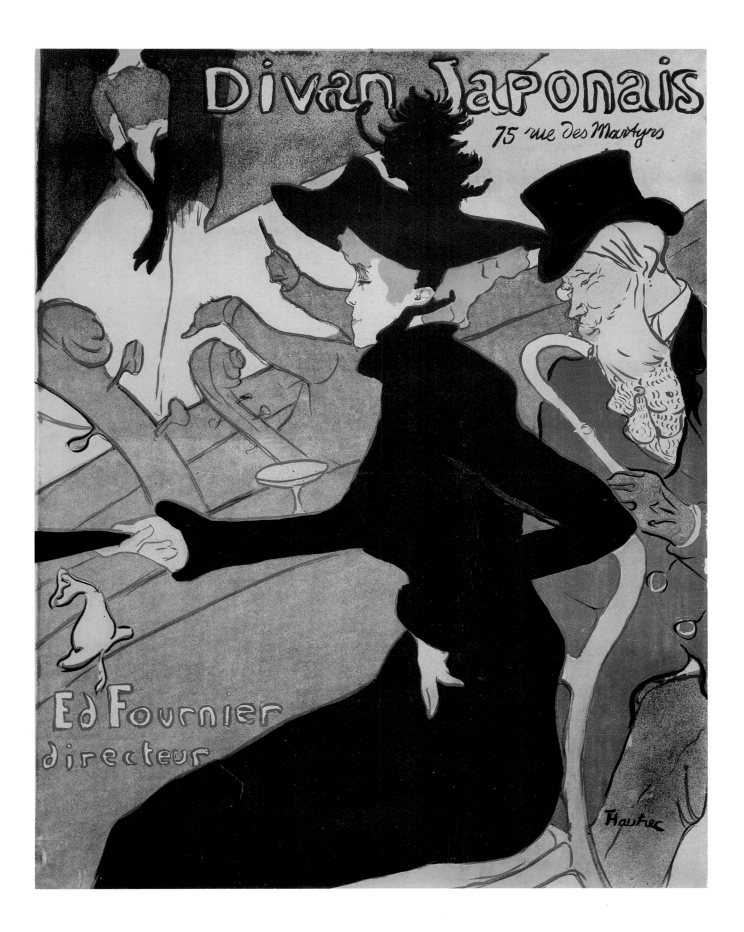

91. *Babylon of Germany (Babylone d'Allemagne)* 1894

W P12 D 351
Brush and spatter lithograph in three
colors on one sheet of wove paper
Text in blue ink by another hand
Artist's signature, date, and monogram,
lower left
47 x 33-1/6 inches
SDMA 87:43

The title of Victor Joze's novel about decadent Berlin society, *Babylone d'Allemagne* was made as the book's promotional poster, and a reduced version was used as the book jacket.[1] A series of satirical accounts of German corruption and debauchery, the novel and its title insultingly allude to Berlin as the whore of Babylon. The German ambassador to Paris strongly protested the book's publication, which nearly caused an international incident.[2] Although Lautrec avoided blatant issues of immorality by choosing a military theme (taken from a chapter in the novel), the combined image and title of the poster pointedly insinuate that "Babylonian" depravity characterized the very personification of Prussia, its proud military forces which had brought France to her knees in the war of 1870. Lautrec's poster therefore was perceived as both a moral and political slur on Prussian militarism.

In a brilliantly condensed space, a white-uniformed officer parades through a cobbled street bounded on one side by the striped sentry box (which in the book jacket version ran along the spine).[3] On the other, a flirtatious passer-by raises an admiring eyebrow. By showing the officer in a plunging perspective from behind, Lautrec involved the viewer as a street spectator, and also was able to introduce an element of caricature in the Kaiser-like sentry without turning the scene into a cartoon. The composition was devised in two oil sketches (Dortu P. 533 and 532) and three preparatory drawings of the horse (Dortu D. 3755, D. 3563, D. 3663), resulting in the beautiful surety of line in the final drawing on the printing stone.

1. Feinblatt (1985), p. 24
2. Mack (1953), p. 287
3. Feinblatt (1985), p. 24
4. Stuckey (1979), pp. 221 ff.

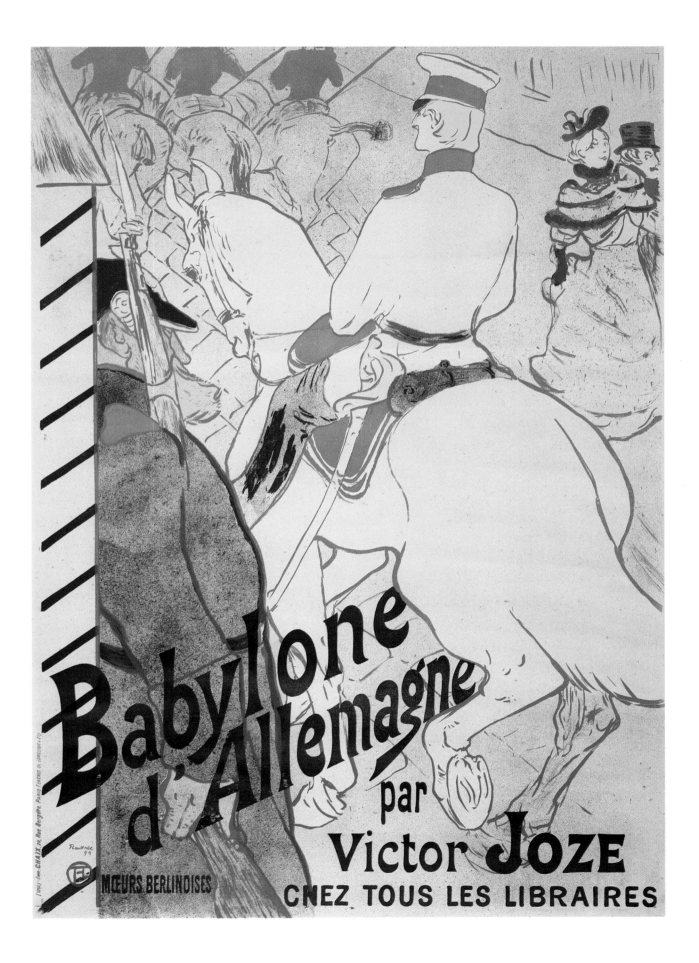

223

92. Confetti 1894

W P13 D 352
Brush, spatter and crayon lithograph in
three colors on one sheet of wove paper
Text by the artist
Artist's monogram, lower right
22 x 29 inches
SDMA 87:46

Perhaps the gayest of all Lautrec's
images, *Confetti* pays homage to the
pretty, spirited girls of Jules Chéret's
posters, although its abstraction deletes
much of Chéret's illustrative rococoism.
Also similar to Pierre Bonnard's 1891
poster *France-Champagne*,[1] a giddy half-
length girl is dizzily overwhelmed by the
product she advertises—confetti, made
by the London firm of J. & E. Bella, who
commissioned the poster. Originally
composed of plaster chips, not paper,
confetti had been contraband in Paris
since Mardi Gras 1892 when a rage of
confetti-throwing from balconies had
proven dangerous to passers-by.[2] The
"nouveau confetti" in Lautrec's 1893
masked ball painting consisted of paper
streamers, and that advertised here may
have been a new type as well, since Bella
was a paper manufacturing firm.[3]

In a preliminary oil sketch for the poster
(Bührle Collection, Zurich; Dortu P. 517)
Lautrec conceived the scene in naturalis-
tic terms, showing arms reaching over a
ledge, while in the final poster the
shapes of the figure flatten and merge
into decorative patterns, and the hands
emerge *on* the paper rather than in
space. The assertion of two-dimensional
design at the expense of naturalism gave
a visual punch to Lautrec's posters rarely
achieved by his contemporaries.

1. For Chéret, see Feinblatt (1985), Pl. 32-50; for Bon-
nard's poster, see Pl. 86.

2. Adhémar (1965), p. XV.

3. The Collection of the Steven Shaw Company, Inc.,
Newburyport, MA, ill. in Stuckey (1979), p. 198. For
J. & E. Bella, see Mack (1953), p. 311.

93. May Belfort 1895

W P14b D 354
Brush, spatter and crayon lithograph in
four colors on one sheet of wove paper
Text by the artist; artist's monogram,
lower left
31 x 23-5/8 inches
SDMA87:61

May Egan (called Belfort) was an Irish
singer who came to Paris via the London
music-halls and performed at the *café
concert*, Les Décadents, where Lautrec
first saw her in 1895. Although his early
biographer, Gustave Coquiot, described
Belfort's act as "a whole series of 'tarara-
boomdyays' and pathetic nonsense
anemically sung," the artist became fas-
cinated with her and, besides this pos-
ter, made her the subject of several
lithographs and paintings.[1] In most, she
appears as she does here, in the midst of
her act which featured the sexually sug-
gestive song,

> I've got a little cat,
> and I'm very fond of that,
> But Daddy wouldn't buy me a
> bow-wow . . .

Dressed in baby clothes and carrying a
black kitten, she sang in a simpering,
lisping voice but received favorable
reviews for her "Franco-English reper-
toire of affected gentility, entirely sweet
and delicate," her prettiness, and light
"Saxon" accent.[2] After a brief
appearance at the Petit Casino, for which
she commissioned this poster, she
retired from the stage due to ill health.
In reality May Belfort was said to be a
sadist and was the lover of May Milton
(cat. no. 95).[3]

1. Huisman and Dortu (1968), p. 110. Lithographs of
 May Belfort include W 114-119, 252. For paintings of
 her, see Dortu P. 587, 589.

2. Delteil (1920), no. 117.

3. Huisman and Dortu (1968), p. 113.

Fig. 59. May Belfort.

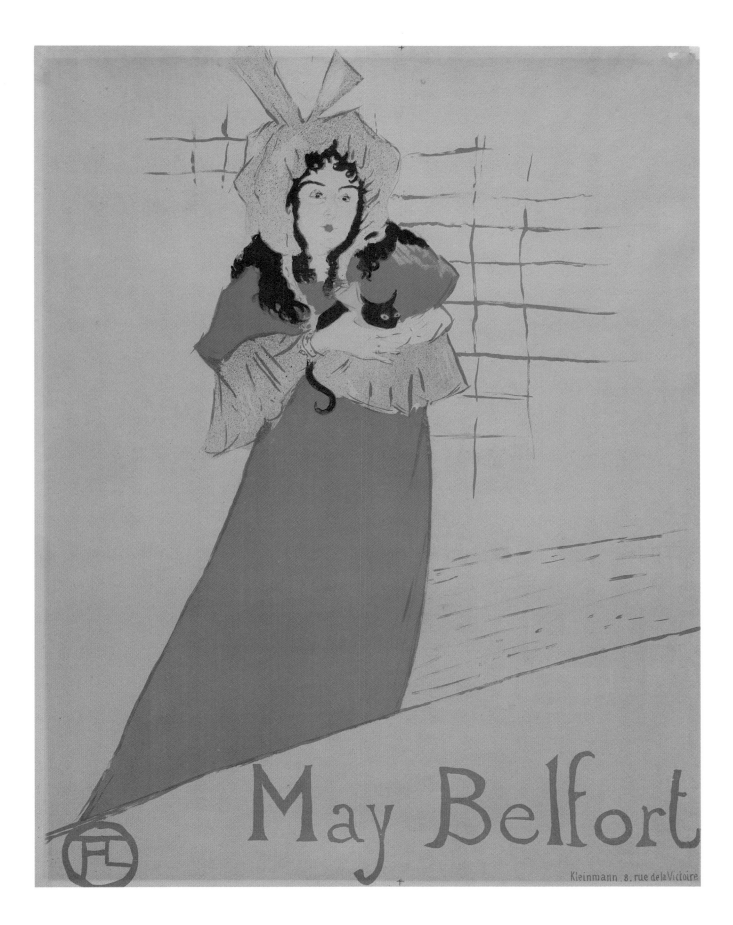

May Belfort

Kleinmann, 8, rue de la Victoire

94. *La Revue blanche* 1895

W P16c D 355
Brush, spatter and crayon lithograph in
four colors on two sheets of wove paper
Artist's monogram lower left; text by the
artist
49-3/8 x 35 inches
SDMA 87:65

Misia Natanson is enchantingly shown ice skating in a mutton-sleeve polka-dot coat, grey fur capelet and muff, and a veiled hat crowned with a fountain of feathers. Although her feet are unseen, a sense of gliding movement across the ice is implied in the open diagonals of her coat and out-stretched arm. Without an indication of setting, however, she appears as a free-flying winter angel who eludes precise definition or placement.

Perhaps this was Lautrec's intention, for Misia (1872-1950) was the "muse" at the center of a constellation of Paris's most avant-garde intellectuals. She fascinated them and held court for them. Vuillard was in love with her, Lautrec infatuated (fig. 60). Verlaine and Mallarmé wrote poems to her; Renoir, Vuillard, Bonnard, and Lautrec painted her portrait. Of several, Lautrec's best is the exquisite *Madame Natanson at the Piano* in which her grace, loose hair, and diaphanous dress evoke a Botticellian allegory.[1]

Since childhood Misia had been a pupil of Gabriel Fauré, and music became her

metaphor in Vuillard's and Lautrec's paintings, and in a poem which Mallarmé wrote to her on a fan. It would have been typical of Lautrec's imaginative powers to see another, more contemporary metaphor in the image of a beautiful woman ice skating.[2]

This poster was commissioned as a promotion for the immensely important journal *La Revue blanche*, which began in Belgium and was founded in Paris in 1891 by the brothers Alfred, Alexandre, and Thadée Natanson.[3] Misia was the young wife of Thadée, and it was through the journal that she and her husband became the social center of intellectual Paris. *La Revue blanche* was a strong supporter of Lautrec's work, and through it he expanded his circle of friends and contacts beyond the café, becoming close friends with the author Romain Coolus, who introduced him to progressive theatre, and the poet and writer Paul Leclerq. *La Revue blanche* provided Lautrec with intellectual stimulation, and the Natansons also played a role in his intimate life.

From 1895-97 he traveled with them, spent afternoons at their Paris apartment, and sojourned at their country houses in Valvins and Villeneuve-sur-Yonne. Like him, Misia was aristocratic, witty, impetuous, and socially independent of bourgeois concerns. Lautrec called her *L'Alouette* (The Lark) and flirted with her. The poster deletes entirely any private emotions the artist may have felt, but presents the muse as illusory as she was to the realities which constrained his personal life.

1. 1897, Kunstmuseum, Bern; (Dortu P. 642) ill. Stuckey (1979), p. 284.

2. Earlier in 1895, Lautrec had recorded a professional skating beauty in a lithograph (W 144) and three drawings, one of which was published by the magazine *Le Rire* in 1896; ill. in Museum of Modern Art (1985), p. 83, fig. 8. From the lithograph he reduced the figure of the skater as a remarque on the *Revue blanche* poster before the text was added. Wittrock, II, p. 786, ill. p. 787.

3. See Cate (1986), p. 24.

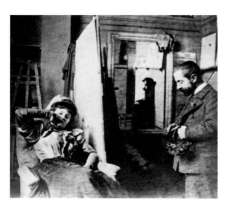

Fig. 60. Misia Natanson and Lautrec, photographed in Maxime Dethomas' studio, 1896. (Photo: Musée Toulouse-Lautrec, Albi)

95. May Milton 1895

W P17b D 356
Crayon, brush, spatter and transferred
screen lithograph in five colors on one
sheet of wove paper
Text by the artist
31-1/2 x 23-1/2 inches
SDMA 87:62

The English "Miss," May Milton per-
formed for only one season in Paris on a
small, undistinguished stage, then
departed for New York and was never
heard from again. She is remembered
entirely because of Lautrec's art, immor-
talized as the nightmarish head emerg-
ing from the corner of The Art Institute
of Chicago's painting, *At the Moulin
Rouge* (1892-95).[1] May Milton seems to
have fallen short of both beauty and
talent. Joyant described her as "a pale,
clownlike face, rather like that of a bull-
dog," and Coquiot gave an outrageously
offensive critique of Lautrec's 1895 por-
trait of May, belaboring not so much the
work's artistic quality as the dancer's
mouth.[2] Although he didn't prettify her,
Lautrec designed a rivetting blue poster
for her tour of the United States, and
supposedly intended it to be a pendant
to the red poster of her lover, May
Belfort (cat. no. 93).[3]

The preparatory drawing, in the Yale
University Art Gallery, reveals in sketchy
outlines the beginnings of the cal-
ligraphic contours which carry the verve
and meaning of the figure in the final
poster. Between the drawing and poster,
Lautrec reduced the image to its orna-
mental essentials, turning the white of
the paper into a unified positive shape,
sparsely defined with brush outlines and
four directional strokes. Pattern is con-
fined to the swirling underside of May's
skirt. Such minimal elements as surface
reversals, found in Japanese prints, and
the saturated royal blue background
create the poster's dazzle.

1. See Stuckey (1979), cat. no. 52, p. 187.
2. Huisman and Dortu (1968), p. 176. The portrait is
 Dortu P. 572. See Stuckey (1979), cat. no. 77,
 p. 247.
3. Adhémar (1965), no. 149; Feinblatt (1985), p. 27.
4. Dortu D. 3887; see Adriani (1987), cat. no. 84.

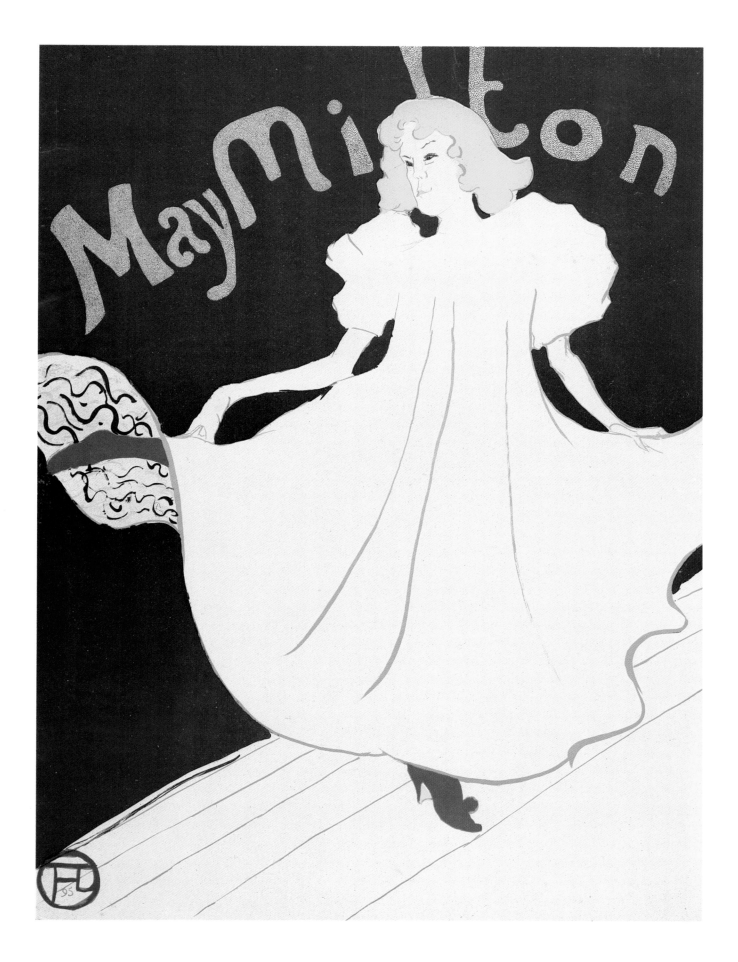

96. Irish and American Bar, rue Royale—*The Chap Book* 1895

W P18a D 362
Brush, spatter and crayon lithograph in
five colors on one sheet of wove paper
No. 51 of 100 impressions before text
Stamped with red monogram and
inscribed to Stern
15-1/2 x 22-1/4 inches
SDMA 87:87

During 1895 and '96, Lautrec repre-
sented the Irish and American Bar five
times.[1] It was patronized by the horse
racing set as well as coachmen, such as
the Rothschild's driver Tom, who is
shown here as the full-faced man in
livery at the bar. Also pictured is Ralph
the bartender, a San Franciscan of Chi-
nese and American Indian descent.
Located at 33, rue Royale, the Irish and
American Bar was one of Lautrec's
haunts where he would sit at his
reserved table and have "night cups" or
"rainbow cups" concocted by Ralph.

Commissioned as a promotional piece
by the Anglo-American magazine *The
Chap Book*, the poster was distributed to
collectors in a small edition before the
text was added. From this edition,
the Baldwin impression is unique in
Lautrec's signed inscription to his
printer, Henri Stern (see above, p. 41).

1. The bar is the setting of this poster; the drawing
 Chocolat Dancing in the Irish and American Bar
 (Dortu D. 4117); *May Milton at the Irish and Ameri-
 can Bar* (W 119; D. 123); and two watercolors made
 as illustrations for Romain Coolus's story, *Le Bon
 Jockey.*

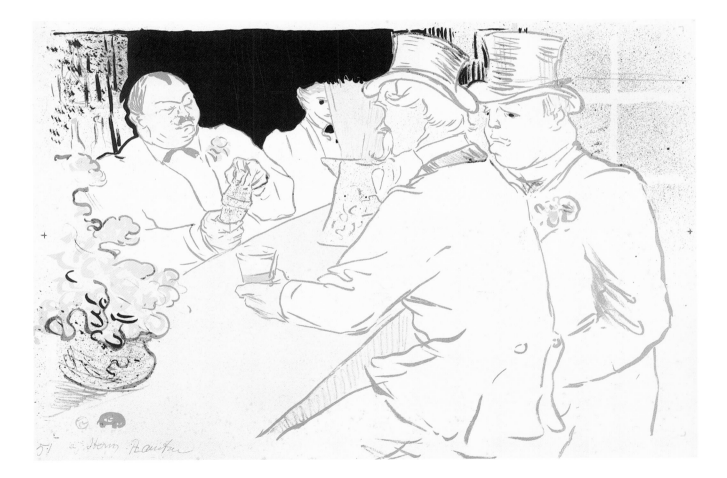

97. Irish and American Bar, rue Royale — *The Chap Book* 1895

W P18b D 362
Brush, spatter, crayon, and transferred
screen lithograph in five colors on one
sheet of wove paper
Artist's monogram, lower left; text by
another hand
15-1/2 x 22-1/4 inches
SDMA 87:88

Among the posters Lautrec made for journals,[1] this one possesses the strongest design and most varied handling of printing techniques. Lautrec's sure drawing of the figures contrasts with the "impressionistic" flowers and mirror behind the bar, and the gridded spatter representing a window on the right counters the solid blue area behind Ralph the bartender and his assistant.

Rather than indulge in local color, for example in the coachmen's top hats and coats which, of course, were black, Lautrec allowed these familiar forms to stand for themselves, reserving them from color and allowing an overall yellow spatter to suggest the effects of glaring, interior light. This brilliantly epigrammatic construct, however, was predicated entirely on the requirements of design rather than economy of printing. The color red, used solely on Tom the coachman's boutonniere, required its own color stone, a technical indulgence which delighted the artist.

1. They include *La Revue blanche* (cat. no. 94); *L'Aube* (cat. no. 102), and *La Vache enragée* (cat. no. 106).

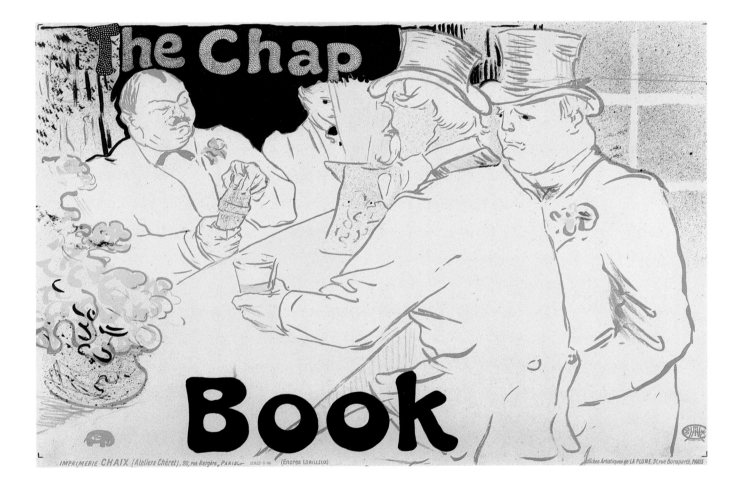

98. *The Alarm Bell*
(Le Tocsin) 1895

W P19a D 357
Brush and spatter lithograph in two colors on one sheet of wove paper
Artist's monogram, lower left
22-5/16 x 17-13/16 inches
SDMA 87:57

Sometimes called *La Châtelaine*, this poster was commissioned by the Toulouse newspaper *La Dépêche* (which in 1892 had published *The Hanged Man*, [cat. no. 81]), as a promotion for a serialized novel, *Le Tocsin*, by Jules de Gastyne. Printed in blue on a turquoise-green tint stone, the colors and spatter create an eerie moonlit atmosphere through which a woman walks as if in a trance. A bell just beneath the moon, the deep forest, and ghostly dog complete a scene of Munch-like mystery. Our impression is from a small number pulled before the text was added.

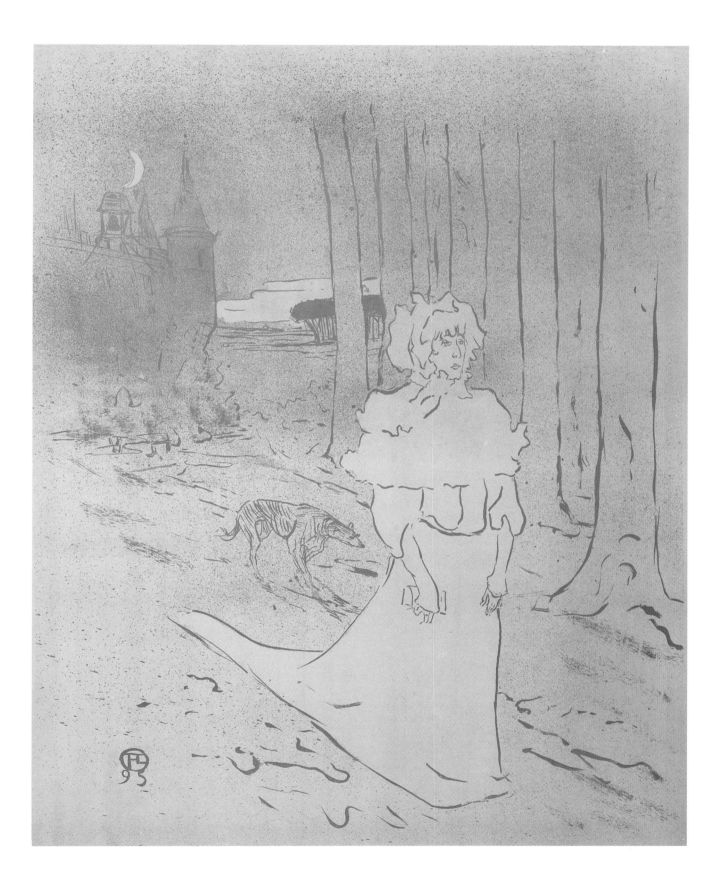

99. The Passenger from Cabin 54—Sailing in a Yacht (La passagère du 54—Promenade en yacht) 1896

W P20 D 366
Brush, crayon and spatter lithograph in
seven colors on one sheet of beige wove
paper
Third state; text by the artist
23-15/16 x 15-3/4 inches
SDMA 87:90

This poster was commissioned by the journal *La Plume* to advertise an international exhibition of posters in October 1896, one of a series of exhibitions sponsored by *La Plume* called the *Salons des cents*.[1] The image records an experience from Lautrec's previous August holiday.

Lautrec and Maurice Guibert had set off from Le Havre on the steamer *Chili*, which had an ultimate destination of Dakar via Bordeaux and then Portugal. Lautrec's usual point of debarkation was Bordeaux, from where he would proceed to his habitual vacation spot. Whether this was the plan or whether he and Guibert actually intended to visit Portugal and Spain is uncertain. The

story goes, however, that having fallen in love with the very sight of a beautiful fellow passenger bound for Dakar, Lautrec decided to follow her all the way to West Africa. He disembarked in Lisbon only at Guibert's refusal to go any farther. The two then travelled back through Madrid and Toledo.[2]

The lady on shipboard, whom Lautrec knew only as "the passenger in cabin 54," was indeed real. Lautrec had a photograph of her (fig. 61), and although he departed substantially from the snapshot, even changing her from a brunette to a blond, his memories of her on board the *Chili* inspired the poster. She is shown sitting under an awning in a gay

canvas deck chair with a blanket covering her knees. Off the port side, a steamer ploughs through whitecaps, and Lautrec, an avid sailor, included such nautical details as a lifeboat hanging from its davit in the upper left, a big bitt on the right, and an indication of the ship's pitch in the slanting rail and deck line. Oblivious to her descriptive setting, the woman is lost in reverie, abstractedly saving her place in a book and reading her own far-away thoughts on the horizon.

Toulouse-Lautrec was a master at catching this sort of uninvited glimpse into an anonymous and private world, whether the setting were a café table, a theatre box, or a brothel bedroom. Here especially however, the exoticism of a beautiful woman traveling alone—one of the great clichés of fantasy—tempted one of Lautrec's rare romantic conceptions. Like Misia Natanson (cat. no. 94), the anonymous passenger was a woman who personified a type of romantic love from which Lautrec would always be excluded. She became his muse in the creation of this evocative image and also of the art exhibition which the poster announced.

Bruce Davis recognized the references to the allegorical tradition of female figures symbolizing the arts made by Lautrec and by other designers of Salon des cent

Continued on page 240

Fig. 61. The passenger of cabin 54 onboard the **Chili**. (Photo: Musée Toulouse-Lautrec, Albi)

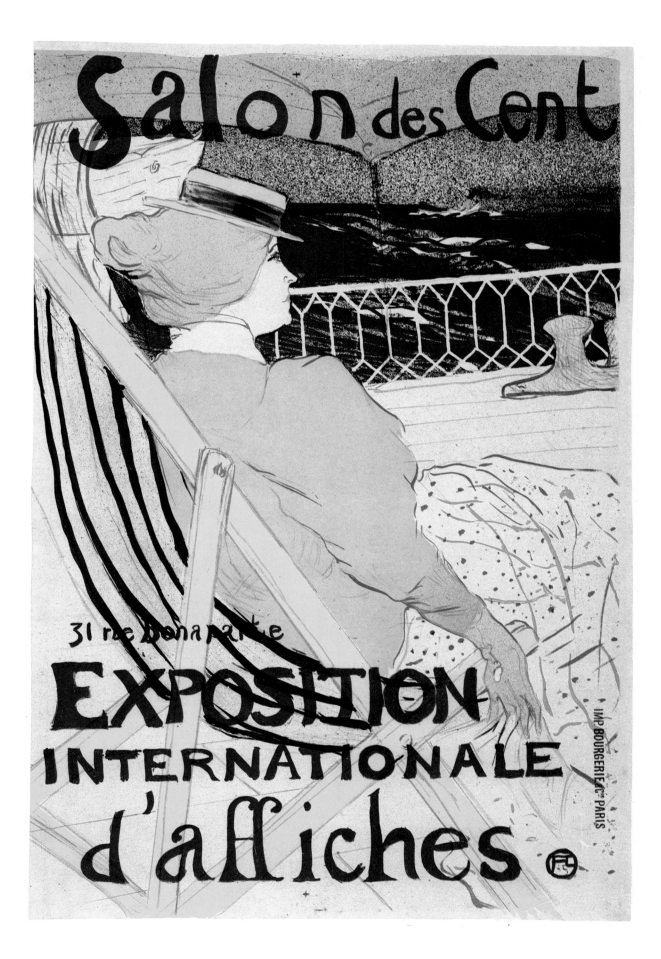

239

posters—Eugène Grasset, Alphonse Mucha, Pierre Bonnard, and Paul Berthon.[3] Certainly Lautrec was aware of this tradition, and it may have informed his decision to depict a woman for the poster *La Revue blanche* as well as *La passagère*. However, unlike his contemporaries (Bonnard excepted), who employed an old symbolical language in quasi-mythical females, complete with stock attributes of flowers, pens, brushes, and notebooks,[4] Lautrec created a subtle, "modern life" metaphor in which the freedom and range of memory and imagination is implicit. This in itself was a brilliant leap of imagination and makes *La passagère* one of his most original inner perigrinations.

1. From 1894-1900 the intellectual journal *La Plume* sponsored about fifty exhibitions called Salons des cents devoted to displaying the work of young artists of Lautrec's circle. This support combined with the journal's publication of avant-garde poets and writers gave *La Plume* a key position in Parisian intellectual life, parallel to *La Revue blanche* (cat. no. 97). It was at the Salon des cent in March 1896 that the *Elles* were first exhibited (cat. no. 51). See Cate (1986), p. 26.

2. Mack (1953), p. 324.

3. Bruce Davis, in Feinblatt (1985), p. 47, points out that Lautrec, Berthon, Bonnard, Grasset and Mucha used images of women on posters for the Salon des cent exhibitions, derived from the allegorical tradition dating back to the Muses of mythology.

4. See Feinblatt (1985), cat. no. 54, for Grasset's 1894 poster of a girl holding a pencil and notebook, looking at flowers; cat. no. 71, for Mucha's 1896 image of a half-length nude holding a pen and paintbrush; and cat. no. 96, for Berthon's 1895 woman in Greco-Egyptian garb, surrounded by flowers.

100. The Troupe of Mademoiselle Eglantine (La Troupe de Mademoiselle Eglantine) 1896

W P21c D 361
Brush, spatter and crayon lithograph in three colors on one sheet of wove paper
Artist's signature and monogram, lower left
Text by another hand
24-1/4 x 31-1/2 inches
SDMA 87:93

For the Eglantine dancers' London appearance, Jane Avril commissioned this poster which shows from left to right the members of the troupe—Jane Avril, Cléopatre, Eglantine (Wild Rose) and Gazelle. They were not well-received in London, where their performance was considered too tame and respectable.

The poster is a lively yellow and red, punctuated by red-brown legs stirring petticoats into a calligraphic froth. Although Lautrec made a preparatory oil sketch for the poster (Dortu P. 631), he based the composition on a photograph.[1] From both photograph and sketch he extracted the simplified lines of the poster, but maintained the sharp characterization of each dancer. Evidently jealousies divided the dancers into two camps, Avril and Eglantine against Cléopatre and Gazelle, and Lautrec seems to have enjoyed choreographing their squabble.[2]

1. Thomson, in Wittrock (1985), I, p. 33, n. 36.
2. Mack (1953), p. 150.

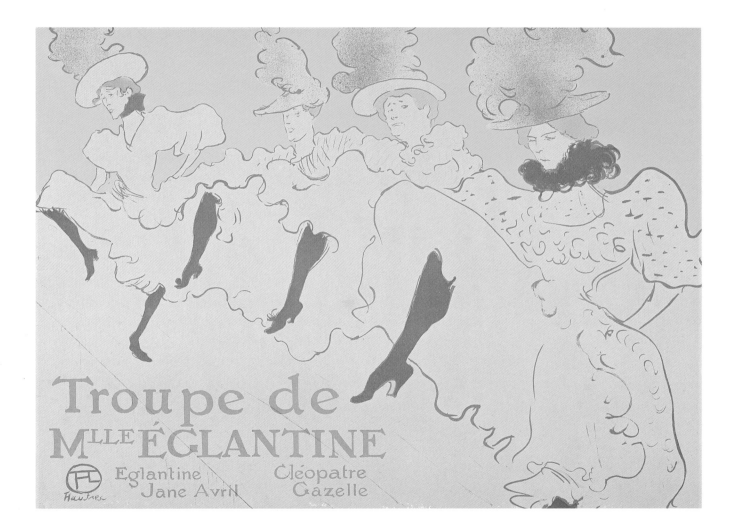

101. The Photographer Sescau
(Le Photographe Sescau) 1896

W P22b D 353
Brush, crayon, and spatter lithograph
printed in four colors on one sheet of
wove paper
Artist's monogram lower right; text by
another hand
23-5/8 x 31-1/2 inches
SDMA87:51

Commissioned as a promotion by the
photographer Paul Sescau (who made
the photograph of Lautrec reproduced,
p. 6), the poster caricatures this good
friend and fellow carouser of the artist.
In 1899 Lautrec depicted him in *The
Promenade* (cat. no. 76) wandering the
Moulin Rouge with Tapié de Céleyran,
looking for girls. He had a reputation of
enticing young ladies with his photogra-
phy and seducing his models once
inside his studio, or at least such was the
going joke. Here, Sescau's intended
model seems to race out of the picture
frame, cropped on three sides as she
flees his scrutiny. A marvellously nerv-
ous creature dressed for a masked ball in
a fluttery domino and mask, perhaps
she was posing in her costume until real-
izing the photographer's priapic inten-
tions behind his camera cloth. Her
lorgnette indicates that she had
inspected the situation, and the pattern
of question marks on her costume
reveals her quandary.[1]

This is Lautrec at his best, naughty but
wry, economic, and absolutely intrepid
in exploiting compositional incon-
sistencies. Indications of movement,
incongruous scale, flat pattern, cartoon-
like brevity, and ornate linearity tumble
together on an unspecified, arresting
field of yellow-green. The rarity of this
poster is marked by the lady's yellow
mask, found only in a few known
examples—in Albi, Baltimore, Chicago,
Copenhagen, Los Angeles, and the Bald-
win Collection.[2] In more common ver-
sions the mask was removed from the
yellow color stone.

1. Lautrec liked these patterned devices which he
 incorporated as ironic commentary in the 1892
 drawing *Aristide Bruant and his Cabaret at the
 Ambassadeurs* and the poster *L'Artisan Moderne* (cat.
 no. 103).

2. Wittrock (1985), II, p. 800, and Feinblatt (1985),
 p. 26.

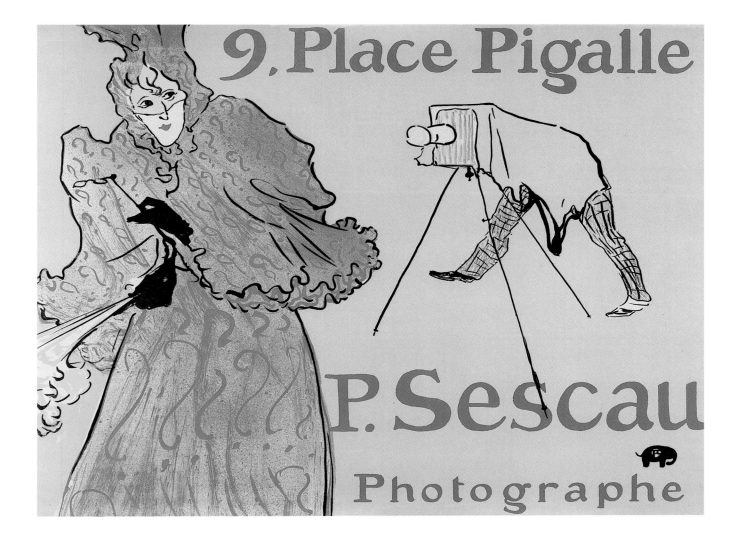

102. *The Dawn*
(L'Aube) 1896

W P23 D 363
Crayon, spatter and brush lithograph in
two colors on one sheet of wove paper
Artist's monogram, lower right; text by
another hand
24 x 31 inches
SDMA 87:69

L'*Aube* was an art review founded in the
spring of 1896,[1] and like its title, the
advertising poster for the magazine is an
image of early dawn. Although not the
most exciting of Lautrec's posters, it
conveys a wonderful light and atmos-
phere, by using the same spattered tur-
quoise ink as employed in *Le Tocsin* (cat.
no. 98) to effect darkness. Two dramatic
rays of light from the street lamp reveal a
driver muffled against the morning's
damp chill, as a beleaguered peasant
woman pushes the dustcart along a
steep street.

1. Adhémar (1965), no. 220.

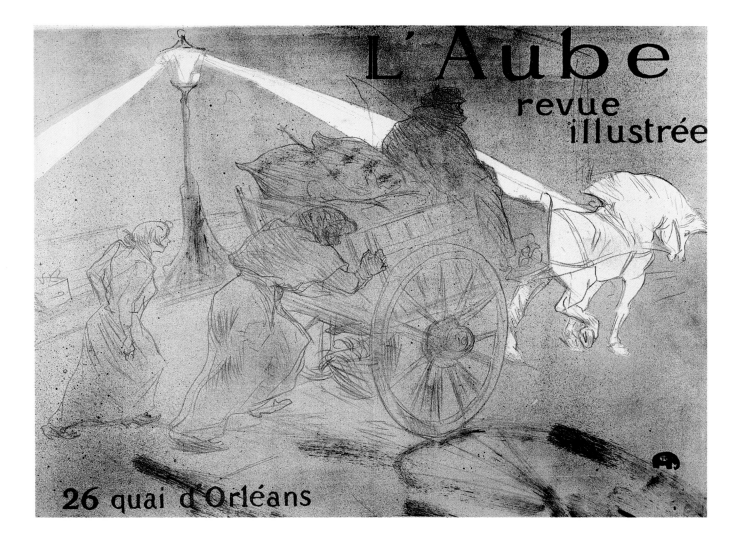

103. The Modern Artisan (L'Artisan Moderne) 1896

W P24a D 350
Crayon, brush and spatter lithograph
with scraper in four colors on one sheet
of wove paper
Artist's monogram, lower right
Text by another hand
37-7/16 x 25-3/16 inches
SDMA 87:42

L'*Artisan Moderne* was made for the publisher and designer André Marty to advertise his collection of "*objects usuels*" and "*bijoux artistiques*" produced in editions of 100 for sale in ten Paris shops indicated on the poster. Created in the broad range of media espoused by Art Nouveau, Marty's collection featured ceramic-ware, artistic jewelry, lampshades, and other objects of interior decoration.[1]

For the poster's subject, Lautrec devised a farcical scene based on the old lascivious theme of the doctor's visit. Found in seventeenth-century prints and paintings, by Jan Steen for example, and revived in eighteenth-century French art, this mild genre of eroticism portrayed bed-ridden young ladies visited by lecherous doctors. A maid and little dog invariably provided reactions that gave away their mistress's malady as love-sickness, while the doctor treated his patient in a variety of titillating ways.

Just as Lautrec translated into modern terms the Renaissance theme of the ill-matched pair in *Queen of Joy* (cat. no. 82), he parodied eighteenth century art in the rococo style of this poster but replaced the traditional doctor with a modern craftsman whose workers' smock, hammer, and tool kit are comic variants on medical accoutrements. The stock characters of surprised maid and lap dog reveal what he is about to fix,[2] and the wallpaper pattern of curvilinear exclamation marks both punctuates the joke and burlesques Art Nouveau decoration.

Lautrec may have been in collusion with his friends in this rascally spoof on Marty's collection. He included his own monogram and the name of the artist who designed the poster's text (Niederkorn) on the toolbox, and portrayed his friend, the Belgian jeweler and medallist Henri Nocq, as the visiting artisan.[3]

1. Wittrock (1985), I, p. 406, and Feinblatt (1985), p. 24. In 1893 Marty had commissioned the *Cafe Concert* series.

2. The slang term for these little dogs was obscene. See Richard Thomson, "'Les Quat' Pattes;' the image of the dog in late nineteenth-century French Art," *Art History* 5, no. 3 (September 1982), p. 329. Lautrec treated the theme again in an 1899 drawing, *The Doctor's Visit* (Dortu D. 4628), which includes Gabriel Tapié de Céleyran as the doctor, a maid receiving him, and a picture of a pert little lap dog hanging behind them.

3. Delteil (1920), no. 350, identifies the artisan as Nocq. In 1897 Lautrec painted a full-length portrait of Nocq (Dortu P. 639); ill. Stuckey (1979), p. 268.

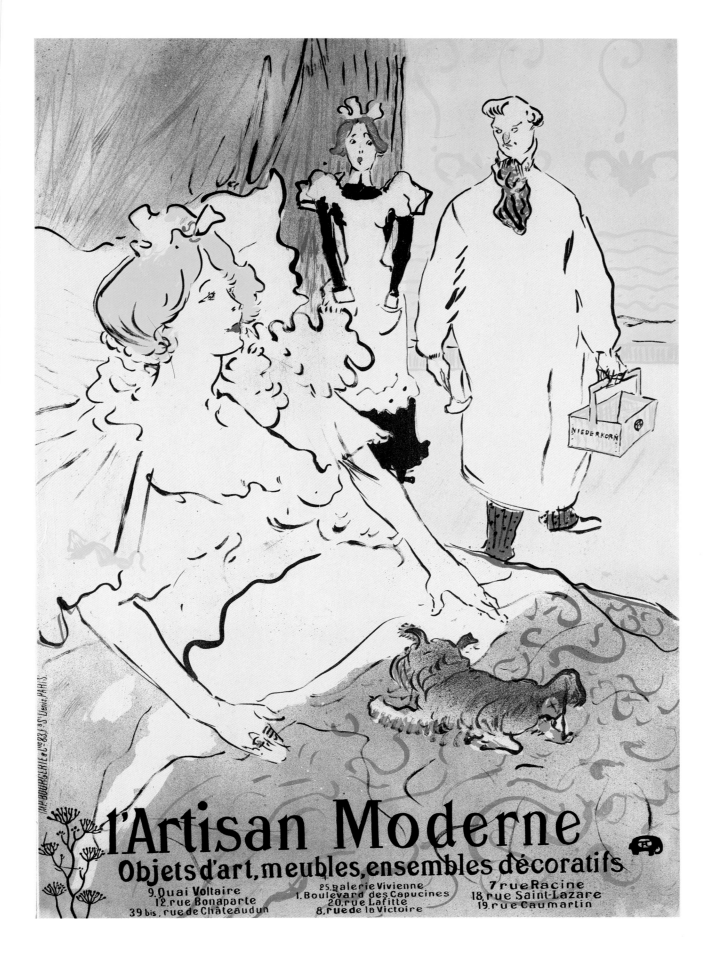

104. The Cyclist Michaël (Cycle Michaël) 1896

W P25 D 359
Brush lithograph printed in olive-green
ink on one sheet of wove paper in an
edition of 200
Artist's monogram, lower left
31-1/2 x 47-1/4 inches
SDMA 87:72

Following J. B. Dunlop's invention of the pneumatic tire in 1889, competitive cycling became the most fashionable sport in Paris.[1] Its rise in popularity was stimulated by the cycle manufacturing business which financed race tracks and supported a new sporting press in specialized magazines and news columns.[2] By the mid 1890s, cycling champions had become popular heroes, and the races at Vélodrome Buffalo and Vélodrome de la Seine were favorite places to go on Sunday afternoons. Lautrec went often in the company of Tristan Bernard, the author and playwright who had succumbed to cyclomania and become manager of the Buffalo and editor of *Le Journal des Vélocipédistes*. In 1895 Lautrec produced several lithographs and a portrait of Bernard set at the track,[3] and in 1896 he was commissioned to design a poster advertising bicycle chains.

Louis Bouglé was the French representative of Simpson bicycles and also manager of the racing champion Jimmy Michaël, shown here coming out of a banked curve and clocked on the straightaway by his trainer. Bouglé rejected the poster on the basis of its inaccurate rendering of the chain and sprocket, the very products he was promoting.[4] Although Lautrec left the lithograph unfinished (it is printed only in the olive-green ink of the keystone), he issued an edition of two-hundred, no doubt believing that a market for the print existed among Jimmy Michaël's fans.

1. Adriani (1987), p. 138.
2. Zeldin (1980), pp. 341 ff.
3. These include W 111, 141, 142; and Dortu P. 571, ill. in Stuckey (1979), p. 244.
4. Feinblatt (1985), p. 30.

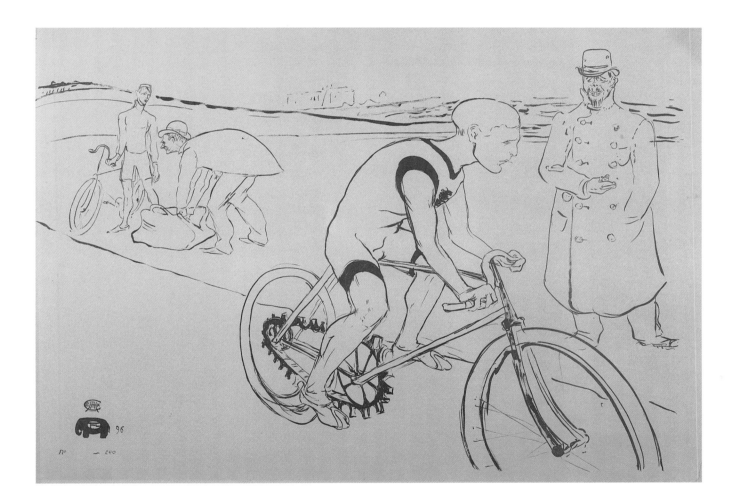

105. The Simpson Chain
(La Chaîne Simpson) 1896

W P26 D 360
Brush, crayon and spatter lithograph in
three colors on one sheet of wove paper
Artist's monogram lower right; text by
another hand
33-7/8 x 47 inches
SDMA87:71

Lautrec's second try at Louis Bouglé's
commissioned poster promoting Simp-
son bicycle chains is more successful in
every way than the initial design (cat. no.
104). He not only revised the chain to an
accurate scale (Bouglé's objection to the
first proposal), but infused the scene
with the excitement of a race, complete
with band playing in the infield. The first
attempt depicts a training scene, while
here dozens of cyclists are buzzing
around the track, hunching over in keen
competition that by contrast makes
Jimmy Michaël in the first design appear
stationary. Lautrec added to the illusion
of velocity by allowing some of the
wheels to disappear into invisible spins;
or is he simply having fun showing that
one Simpson chain is faster than two
peddlers? Bouglé accepted this second
poster which bears his racing pseudo-
nym, "Spoke," and the address of his
bicycle shop.

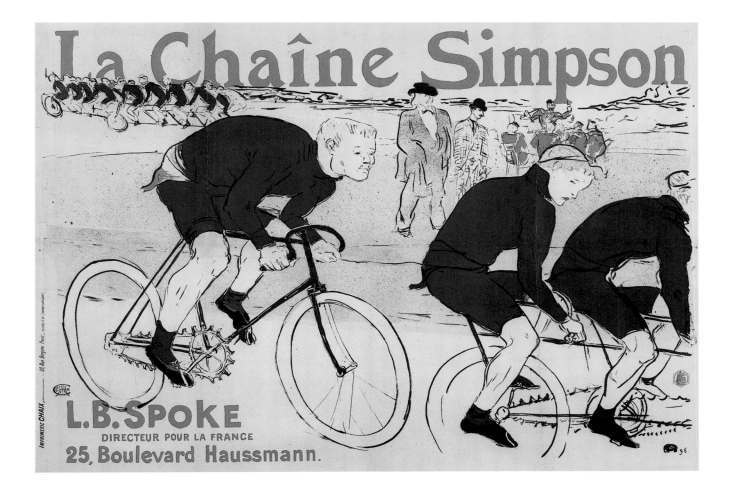

106. *The Enraged Cow (La Vache enragée)* 1896

W P27b D 364
Brush, crayon and spatter lithograph in
four colors on one sheet of wove paper
Artist's monogram and dedication *à l'ami
Simonet*, upper right
Text by another hand
32-1/2 x 23-5/8 inches
SDMA 87:94

To advertise Adolph Willette's journal *La Vache enragée* and its accompanying *Valchalcade*, a hurly-burly procession through the streets on March 17, 1896, Lautrec made a poster showing an enraged cow charging after an old man, as clowns on a tandem bicycle, a waiter, policeman and dog join the chase. The title is taken from the idiomatic expression for the hardship and struggle endured by young artists (see Cate, above, p. 32ff).

The poster's cartoon-like style and *pierrots* are recognizable references to Willette's own work. The journal, procession, and poster were created in the enthusiastic spirit of the same anti-establishment buffoonery expressed in such zany Montmartre "institutions" as the club des Hydropathes, the Chat Noir café ("a salon stood on its head"), the Société des Incohérents, and the Bal des Quat'-z-Arts.[1]

This last, the annual ball held by the art students, featured a so-called "cavalcade" of costumed artists and nude models, setting out late at night from the Moulin Rouge and arriving in the morning at the Ecole des Beaux-Arts. It was the prototype of Willette's *Valchalcade*,[2] and the anti-academic parade of the artists, as well as the flavor of montmartrian humor in general (waiters at the Chat Noir wore the formal attire of the Académie française),[3] set the tone of *La Vache enragée*.

Lautrec depicted the "determined" cow taking off after an academic critic. His type is recognizable in depictions from Breugel to Daumier, always bespectacled (blind), old and fustily attired (out of date). Here the artists chase him down the steep streets of their butte.

1. Shattuck (1968), p. 22; Cate (1986), p. 15.
2. Cate (1986), p. 187.
3. Shattuck (1968), p. 22.

107. At the Concert
(Au concert) 1896

W P28c D 365
Brush and spatter zincograph with
scraper in five colors on one sheet of
wove paper
Artist's monogram lower right; text by
another hand
15 x 10-3/4 inches
SDMA 87:68

Lautrec's only American commission
came from the lithographic ink man-
ufacturers Ault and Wiborg in Cincin-
nati. The poster is also his only work
printed on zinc rather than stone, and its
medium and small scale were dictated
by the necessity of sending the plates
across the Atlantic for printing.[1]

This poster is typical of the occasional
disparity between Lautrec's imagery and
the product meant to be advertised. Its
promotional lure, one used extensively
in the nineteenth century, is simply a
colorful depiction of a pretty young
woman. However, outside the commer-
cial context of its eventual use, the image
reveals the subtle psychological tensions
which Lautrec found in theatre
audiences.

Seated together in a loge, the man and
woman seem to be in two different
worlds, she, following the performance
with program in hand, and he, lost in a
melancholy reverie. The pair are reminis-
cent of Jane Avril and the critic Edouard
Dujardin in the poster *Divan Japonais*
(cat. no. 90), and the subjects have
sometimes been identified as Dujardin
or Dr. Gabriel Tapié de Céleyran with
Misia Natanson. However, it is more
likely that Lautrec portrayed the actress
Emilienne d'Alençon (cat. no. 79) with
his banker Henri Fourcade.[2]

1. Griffiths, in Wittrock (1985), I, p. 36. The plates are
 preserved at The Art Institute of Chicago.

2. For various identifications, see Sugana (1969),
 pp. 115, 124; Feinblatt (1985), p. 29. For a portrait
 drawing of Henri Fourcade, see Adriani (1987),
 p. 100 (Dortu D.3094). The preparatory oil sketch
 for *At the Concert* (private collection, France) is
 illustrated in Sugana (1969), no. 438.

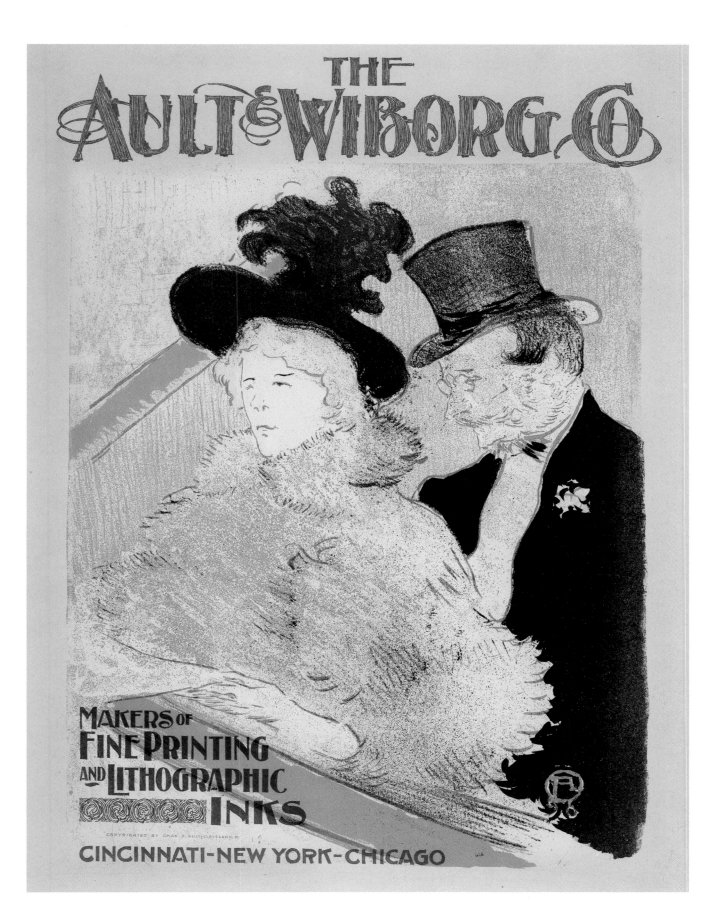

108. Jane Avril 1899

W P29b D 367
Brush lithograph in four colors on one
sheet of wove paper
Artist's monogram and date lower right;
text by another hand
22-1/16 x 14-3/16 inches
SDMA 87:103

In comparison with the poster made of her six years prior (cat. no. 85), both Jane Avril and Lautrec appear to have come under the sway of Art Nouveau. Jane's form-fitting dress departs entirely from the bonnets, aprons, petticoats, and full skirts of her earlier costume, and one might assume that her dancing had changed to a similarly sophisticated style. The snake, at which Jane feigns horror, was probably Lautrec's invention, but nonetheless reflects a voguish motif of Art Nouveau design that perfectly embodied the style's preference for curvilinear decoration. Lautrec used it here to complement Jane's twisting form and perhaps as a fanciful antonym to her delicately feminine personality. *Had* Jane danced in such a costume, which would have wiggled threateningly whenever she did, it would have been a marvellous act indeed.

The preparatory drawing for the poster does not show a snake, only a boa-like form wound around the dancer.[1] The drawing bears three color notations, and on this basis Griffiths and Adriani suggest that Lautrec's printer, Henri Stern (his name is imprinted along the right edge), may have transferred the drawing to the stone himself.[2] This seems unlikely. Not only does the poster depart from the colors noted on the drawing, but the transformation of the drawing's sketchy contours and boa into the sinuous silhouette and snake of the poster would have been more complicated than a straightforward tracing procedure. Familiar as Stern may have been with Lautrec's style (see above, p. 41), he could not have emended the drawing to the subtle elongations of Jane's figure in the poster, nor the snake's perfect ambivalence between costume and conceit.

Lautrec developed the colors on a trial proof of the poster printed in black.[3] At this stage Stern played a crucial part, for the fluid color transitions within the snake were achieved by multiple inking of one stone using a rainbow roller.[4] This effect as well speaks of the influence of Art Nouveau and completes the poster "in the spirit of 1900," as Adhémar described it.[5]

Perhaps because of its pronounced esthetic, the poster was rejected by Jane Avril's manager. Today it is considered one of the most compelling prints of Lautrec's nine-year career in lithographic printmaking. The end of his artistic term coincided with the close of a decade which had seen a renaissance in lithography, and the absence of Lautrec's continuing invigoration of the field, seen in this penultimate poster, is one of the factors which marked its decline.[6]

1. Dortu S. D. 29; ill., Adriani (1987), no. 121, p. 263.
2. Griffiths, in Wittrock (1985), I, p. 39; Adriani (1987), p. 262. Griffiths describes the drawing as "an unusually carefully finished preparatory design . . . complete with color notes." The drawing, however, is freely sketched, by no means detailed, and indicates royal blue as the color of the cuffs and black for the interior brim of the hat, colors which were not followed in the finished poster.
3. Dortu A. 262.
4. Griffiths, in Wittrock (1985), I, p. 41.
5. Adhémar (1965), no. 323.
6. See Cate, in Weisberg (1975), p. 65.

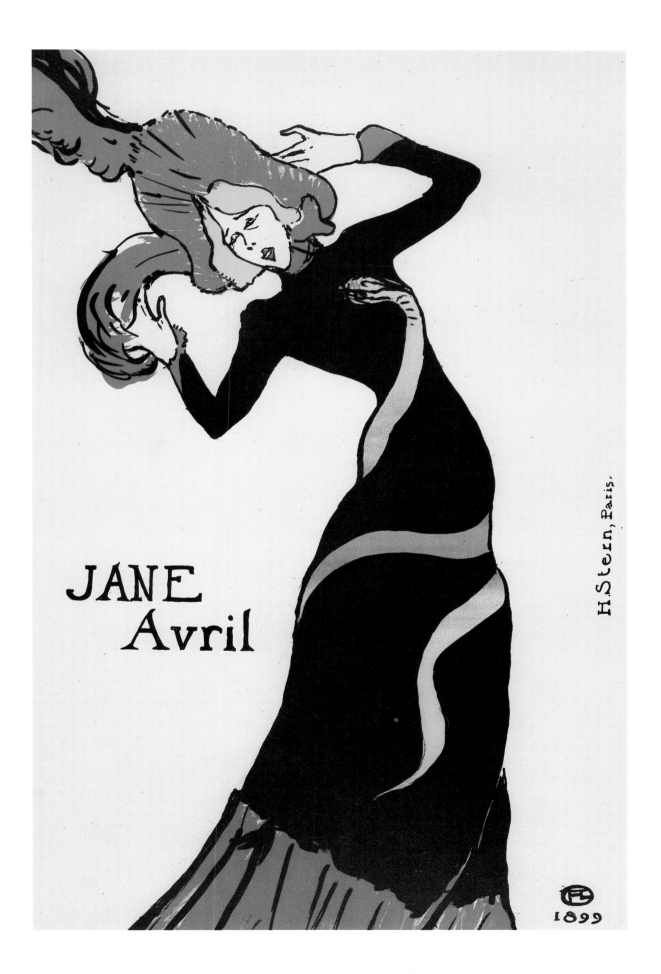

JANE
Avril

H.Stern, Paris.

1899

109. The Gypsy
(La Gitane) 1899

W P30 D 368
Crayon, brush and spatter lithograph in
six colors on one sheet of wove paper
Artist's monogram lower right; text
designed by the artist
35-3/8 x 24-5/8 inches
SDMA 87:107

Lautrec's last poster, extremely rare, advertises Jean Richepin's drama, *La Gitane*, which premiered at the progressive Théâtre Antoine in January 1900. Set in Granada, the plot follows the fatal attraction of various men to the heartless gypsy Rita. After suitors and husband kill each other off in jealousy, Rita merrily runs away with her younger brother-in-law.[1] In the lead role, portrayed here, was the actress and singer Marthe Mellot, wife of Alfred Athis Natanson of *La Revue blanche*, who was consistently cast as the seductive female.

For the poster design Lautrec revised his first thought to show Mellot as the exuberant dancing Rita (Dortu P. 717), retaining only a choreographic S-shape in her swaggering posture. She gives a pitiless jeer over her shoulder at one of her frantic lovers, a spider-man glued to the hilly Granada scenery, scrambling after a rival. In a gouache of 1897 Lautrec had recorded Mellot's distinctive profile as a mysterious Ibsenesque protagonist,[2] while here he contorted her face in grotesque hilarity.

A little more than a year and a half after the opening of *La Gitane*, Lautrec died on September 9, 1901, some two months before his thirty-seventh birthday. In 1900 he had returned to his alcoholic habit, suffered a cerebral hemorrhage which paralyzed his legs, and left Paris for good in July 1901. He suffered a stroke and died at his childhood home, Malromé. On September 10 an obituary appeared in the *Journal de Paris*:

> He did not overturn reality to discover truth, nor strive to catch something, where there was nothing. He contented himself with looking. He did not see, as many do, what we seem to be, but what we are. Then, with a sureness of hand and a boldness at once sensitive and firm, he revealed us to ourselves. . . . fixed forever by the artist's pitiless pencil.[3]

1. Feinblatt (1985), p. 32.
2. Stuckey (1979), p. 276, ill.
3. Quoted in Adriani (1987), p. 326.

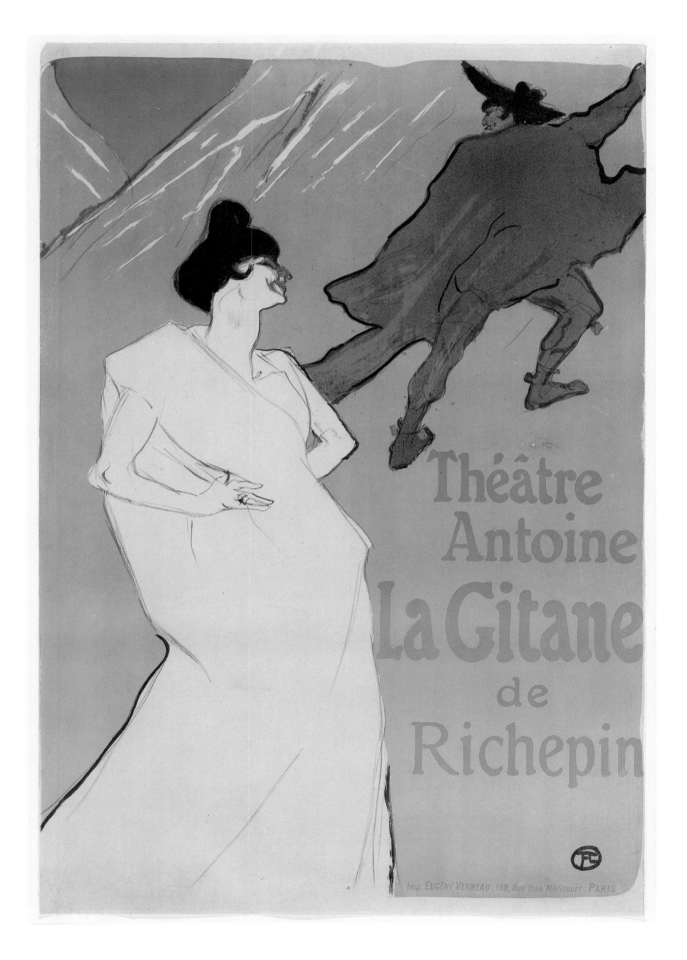

259

Henri de Toulouse-Lautrec, drunk, c. 1899. (Photo: Bibliothèque Nationale, Paris).

Bibliography

Adhémar, Jean, *Toulouse-Lautrec: His Complete Lithographs and Drypoints*, New York, 1965.

Adhémar, Jean and Françoise Cachin, *Degas, The Complete Etchings, Lithographs, and Monotypes*, trans. Jane Brenton (first published Paris, 1972), London, 1974.

Adriani, Götz, *Toulouse-Lautrec*, trans. Sebastian Wormell (first published, Cologne, 1986), London, 1987.

Cachin, Françoise and Charles S. Moffett, *Manet 1832-1883*, New York, 1983.

Cate, Phillip Dennis and Patricia Eckert Boyer, *The Circle of Toulouse-Lautrec*, The Jane Voorhees Zimmerli Art Museum, Rutgers, The State University of New Jersey, New Brunswick, 1985.

Cate, Phillip Dennis and Sinclair Hamilton Hitchings, *The Color Revolution: Color Lithography in France 1890-1900*, Santa Barbara and Salt Lake City, 1978.

Cate, Phillip Dennis and Bogomila Welsh-Ovcharov, *Emile Bernard, Bordellos and Prostitutes in Turn-of-the Century French Art*, The Jane Voorhees Zimmerli Art Museum, Rutgers, The State University of New Jersey, New Brunswick, 1988.

Clark, Timothy J., *The Painting of Modern Life, Paris in the Art of Manet and His Followers*, Princeton, New Jersey, 1984.

Cooper, Douglas, *Henri de Toulouse-Lautrec*, New York, 1966.

Delteil, Loys, *Le Peintre-graveur illustré*, vols. IX and X: *Henri de Toulouse-Lautrec*, Paris, 1920.

Dortu, M. G., *Toulouse-Lautrec et son oeuvre*, six vols., New York, 1971.

d'Esparbès, Georges et al., *Les Demi-Cabots, Le Café concert, Le Cirque, Les Forains*, Paris, 1896.

Feinblatt, Ebria and Bruce Davis, *Toulouse-Lautrec and His Contemporaries: Posters of the Belle Epoque from the Wagner Collection*, Los Angeles County Museum of Art, 1985.

Gauzi, François, *Lautrec et son temps*, Paris, 1954.

Goldschmidt, Lucien and Herbert Schimmel, *Unpublished Correspondence of Henri de Toulouse-Lautrec*, London and New York, 1969.

Guilbert, Yvette, *Chanson de ma vie*, Paris, 1927.

Homodei [Arthur Huc], "Toulouse-Lautrec," *La Dépêche de Toulouse*, 23 March, 1899.

Huisman, Philippe and M.G. Dortu, *Lautrec by Lautrec*, trans. Corinne Bellow (first published in French, 1964), New York, 1968.

Johnson, Lincoln F., "Time and Motion in Toulouse-Lautrec," *College Art Journal*, vol. XVI (1956-57), pp. 13-22.

Joyant, Maurice, *Henri de Toulouse-Lautrec*, two vols., Paris, 1926-27.

Leclercq, Paul, *Autor de Toulouse-Lautrec*, Geneva, 1954.

Los Angeles Municipal Art Gallery, *Toulouse-Lautrec, A Loan Exhibition of Paintings, Drawings, Prints, and Posters*, Los Angeles, 1959.

Mack, Gerstle, *Toulouse-Lautrec*, (first published 1938), New York, 1953.

Moffett, Charles S., *The New Painting, Impressionism 1874-1886*, The Fine Arts Museums of San Francisco, 1986.

Montorgueil, Georges, "Preface", *Le Café-Concert*, 1893.

Murry, Gale B., "Review of M. G. Dortu, *Toulouse-Lautrec et son oeuvre*," *The Art Bulletin*, vol. LX (March 1978), pp. 179-82.

Museum of Modern Art, *Henri de Toulouse-Lautrec, Images of the 1890s*, ed. Riva Castleman and Wolfgang Wittrock, New York, 1985.

Natanson, Thadée, *Un Henri de Toulouse-Lautrec*, Geneva, 1951.

Perruchot, Henri, *Toulouse-Lautrec*, trans. Humphrey Hare, Cleveland and New York, 1960.

Ray, Gordon N., *The Art of the Illustrated Book, 1700 to 1914*, (first published in 2 vols., The Pierpont Morgan Library, New York, 1982), New York, 1986.

Reed, Sue Welsh and Barbara Stern Shapiro, *Edgar Degas: The Painter as Printmaker*, Museum of Fine Arts Boston, 1984.

Renard, Jules, *Journal*, ed. and trans. Bogen and Roget, New York, 1964.

Rewald, John, *Post-Impressionism from van Gogh to Gauguin*, (first published 1956), New York, 1978.

San Diego Museum of Art, *The Baldwin M. Baldwin Collection of Toulouse-Lautrec*, San Diego, 1972.

San Diego Museum of Art, *The Baldwin M. Baldwin Foundation Collection, Graphics and Other Works by Henri de Toulouse-Lautrec*, San Diego, 1980.

Schimmel, Herbert D. and Phillip Dennis Cate, *The Henri de Toulouse-Lautrec and W. H. B. Sands Correspondence*, New York, 1983.

Stuckey, Charles F., *Toulouse-Lautrec: Paintings*, The Art Institute of Chicago, 1979.

Sugana, G. M., *The Complete Paintings of Toulouse-Lautrec*, New York, 1969.

Weisberg, Gabriel P. et al., *Japonisme: The Japanese Influence on French Art, 1854-1910*, Cleveland Museum of Art, 1975.

Wittrock, Wolfgang, *Toulouse-Lautrec, The Complete Prints*, 2 vols., London, 1985.

Welsh-Ovcharov, Bogomila, *Vincent van Gogh and the Birth of Cloisonisme*, Art Gallery of Ontario, Toronto, 1981.

Zeldin, Theodore, *France 1848-1945, Taste and Corruption*, (first published 1977), Oxford and New York, 1980.

Index of Titles